THE
EVOLUTION
OF EVIL

THE EVOLUTION OF EVIL

An Inquiry into the Ultimate
Origins of Human Suffering

Timothy Anders

Open ❄ Court

Chicago and La Salle, Illinois

© 1994 by Open Court Publishing Company

First printing 1994

Printed and bound in the United States of America.

Library of Congress Cataloging-in-Publication Data

Anders, Timothy.
 The evolution of evil : an inquiry into the
ultimate origins of human suffering / Timothy
Anders.
 p. cm.
 Includes bibliographical references and index.
 ISBN 0-8126-9174-1.—ISBN 0-8126-9175-X
(paper)
 1. Good and evil. 2. Evolution—Moral and
ethical aspects.
 I. Title.
BJ1401.A53 1994
155.7—dc20 94-38539
 CIP

. . . natural selection, in association
with genetics, allows us to observe
that man has basically the same
biological function as a fly or an
elephant—that is, to carry a tiny
germ cell which perpetuates itself, by
simple cell division, into the next
generation. The seemingly
astonishing discovery is thereby
made that nature (seen
metaphorically as an active power)
should have taken all the trouble to
evolve a sophisticated carrier called
"man", or alternatively, a "giraffe" or
a "whale", merely to perpetuate a
microscopically small single cell, while
a simple primordial organism like a
protozoon could have continued to
do the job just as adequately. . . .

Nature's achievement, therefore, in
having evolved the higher animals,
including man, is comparable to some
mad mechanical genius having
constructed an intricate computer
occupying an entire building merely
to solve the arithmetical problem of
adding one and one.

Gerhard Kraus
Man in Decline

Contents

Preface

One of the most obvious facts about human life is that it contains evil—evil, that is, in the very broadest sense of the word, the opposite of good. It is not at all obvious, however, why this should be so. Some of the greatest minds in history have tried to account for the existence of evil and often by their own admission have failed miserably. On occasion, in their despair of ever being able to solve the riddle, philosophers have attempted to argue that evil doesn't really exist at all and that even the worst things in life are ultimately for the good. This argument, of course, makes no sense whatsoever (one could just as well maintain that there is really no such thing as good, and that even the best things in life are ultimately for the bad), but this does not seem to bother much the theologians who put it forth. Sometimes secular philosophers also grapple with the mystery and try to explain evil by positing the existence of some sort of metaphysical force that is at the root of it all. But this answer is hardly more satisfying, because it leaves quite unexplained the existence of the metaphysical force, which in turn is the alleged cause of evil. It is all very well to say that evil has come into being because of the so-called 'Will to live', or because that's just the way things are, but then one is left to wonder why there should be a Will to live, or why things are as they are. Perhaps theologians and metaphysicians really do have something to offer to the resolution of the enigma of evil, but so far—after about 2,500 years of trying—they have yet to make any significant progress. And it seems no more likely now than before that they ever will.

And what of science? What does science have to offer to our understanding of the ultimate origins of evil? A great deal, it would seem and yet—curiously—scientists themselves have often been hesitant to furnish pertinent clues—at least until quite recently. In the last few decades, however, more and more scientists have come to realize that their discipline does indeed have much to offer toward the resolution of the enigma of evil and of other philosophical puzzles that have long been assumed

to lie outside the realm of scientific inquiry. In the meantime, many scientists continue to cling to the traditional view, insisting that the existence of evil is one of those profound philosophical mysteries with which science alone is impotent to deal and which properly belongs to the domain of either theology or metaphysics. Still other scientists refuse even to deal with the question, believing that it is not their job to explain evil, but to fight against it, and on occasion to argue that it need not exist. And while this is an understandable attitude, it does nothing to solve the mystery. If it is true, as some scientists suggest, that much evil is eradicable, this still does not explain why evil exists in the first place. And the fact that much human suffering is theoretically preventable only makes its actual occurrence all the more tragic.

We live in a world of things as they are, not in a world of things as they could be. And while it is a pleasant diversion to fill our imaginations with all sorts of better worlds, the world of our actual experience is the only one that we can call real. Of course utopian philosophers are still telling us, as they have been telling us since the days of Plato and his *Republic*, that if their policies were meticulously carried out, all evil would cease to exist in another couple of hundred years or so. But even if this were true (and there is virtually no evidence in its support), it would be of little consolation to those of us who do not expect to live quite so long. It is not my intent here to speculate about the potential solubility of human problems. For the moment at least, I shall leave that task to other authors. My sole purpose is to offer a completely rational explanation for the existence of evil and in so doing to contradict the many superstitious explanations to which the vast majority of humankind still gives credence.

It has been noted that the existence of evil is only a 'problem' in the philosophical sense if one presupposes that Nature is an essentially benevolent enterprise or that it is the creation of a benevolent deity or deities. If one makes no such presuppostion, then evil's existence ceases to be a philosophical problem. But it does not necessarily cease to be a mystery. Indeed, one can never fully explain the existence of evil merely

by denying the alleged benevolence of the universe. One must also provide a completely adequate account of the ultimate origins of human suffering. To supply just such an account is the primary goal of this book.

Philosophers sometimes distinguish between two 'kinds' of evil, physical evil (also known as the problem of pain and suffering) and moral evil (also known as social evil). 'Physical evil' is usually defined as the suffering and hardship that human beings endure as a consequence of disease, famine, bodily injury, floods, hurricanes, tornadoes, earthquakes, and other natural disasters and calamities. 'Moral evil', by contrast, as the name would imply, refers to the immoral and aggressive human behavior, such as murder, war, rape, assault, deceit, and theft, which victimizes innocent people. For some purposes at least, the distinction between these two kinds of evil is a useful one. But for my purposes it is not. And so throughout this book I have lumped the two together under the single broad category of 'evil'. It is my belief that the ultimate source of both physical and moral evil is the same, and that that common source is the capacity for suffering. If there did not exist sentient beings capable of suffering from them, after all, then disease and hunger would not exist. And such things as earthquakes, floods, and other natural disasters would not be evil because they would have no victims. Similarly, without the capacity for suffering that exists in all victims of immoral acts, there could be no immoral acts. And without the capacity for suffering that exists in all criminals (and potential criminals), there would be no criminality. To be sure, if no one ever suffered the pain and frustration of wanting but not having, then no one would ever be motivated to take what he wanted by force, and crime would have no purpose. The ultimate source of moral, as well as physical evil, in short, is the biological capacity for suffering. And if we are to find the root of all evil anywhere, we are to find it in this capacity.

I hasten to add, lest I be misunderstood, that it is not my intent to argue that *all* suffering is wholly evil, or that the words 'evil' and 'suffering' are synonymous. This is not precisely my belief. There may indeed be some forms of human suffering that

are so minor, or so benign, that they cause no one any great dismay or consternation and are therefore not really evil in the strictest sense. Indeed, if the only pain anyone ever had to endure was an occasional headache or stubbed toe, then I doubt whether the concept of evil would even exist; and philosophers would not need to speculate about the origin of evil, because there wouldn't be any origin of evil to speculate about. But as I shall argue in the chapters to come, most human suffering is neither adaptive nor benign, and much of it serves no purpose but to make life difficult, or even impossible, for the individuals in whom it occurs. What's more, even those forms of pain which appear superficially to be adaptive and therefore in some sense 'good', such as the pain that warns us that we are doing something that might damage our chances of survival, are not *wholly* good, for as often as not they are symptoms of underlying defects in the design of the human body and psyche, without which the 'warning signal' would be unnecessary.

The renowned geneticist Theodosius Dobzhansky once remarked that nothing in biology makes sense without evolution. And while most modern scientists are in complete agreement, many of them seem yet not to realize that the truth of Dobzhansky's statement applies as much to the biological capacity for suffering as it does to any other aspect of life. If we are to understand the ultimate roots of evil, we must understand the ultimate roots of suffering. And if we are to understand the ultimate roots of suffering, we must understand how the biological capacity for suffering evolved. As soon as we have done this, the riddle of evil is no more.

Why does evil exist? The answer is really quite simple, if you know where to look for it. The problem is that most people don't know where to look. And that is why, in their minds at least, the mystery persists. The plain fact of the matter is simply this. The human species, like any other, has been shaped into its present form by its own evolutionary past. Thus there is no aspect of human cognition, human emotion, or human anatomy that does not have its ultimate source in human evolution. And this applies as much to the nefarious aspects of human cognition, emotion, and anatomy as it does to the purely salutary

ones. In the present book, then, I shall present an account of human evolutionary history, with special emphasis on those aspects of our evolutionary past that have contributed to the many problems which we now face. My approach will be straightforward and, I hope, unequivocal. In the prologue and epilogue I shall argue that all theological and metaphysical 'solutions' to the riddle of evil are worthless and unnecessary, and that the only way to understand why evil exists is to study the evolution of the human species. In Chapter 2 I will challenge the popular conception of evolution as an essentially benign and progressive process. Most of the rest of the book, Chapters 3 through 9, will consist in an attempt to trace the evolution of those aspects of human anatomy and psyche that contribute most to the difficulties and hardships that being human often entails.

Contrary to popular belief, there is nothing providential about the process of evolution by natural selection, and I am convinced that it is the ultimate source of everything that is bad, as well as everything that is good, in human life.

Acknowledgments

I would like to thank Donald Symons of the University of California for reviewing portions of the manuscript of this book and offering a number of useful suggestions. Thanks also to Robert Sussman of Washington University, who provided me with some information about human evolution in general and the origin of bipedalism in particular. By no means do either of these fully endorse the ideas that I have expounded in this book.

Chapter One
The Roots of Evil

I doubt very much whether there has ever lived a man or a woman who has unhesitantly and wholeheartedly embraced human existence.

Edward M. Keating

All men by nature desire to know.

Aristotle

For as long as human beings have existed they have wondered about the many mysteries of life and of the world in which they live. And one of the mysteries about which they have wondered for a very long time is the mystery of evil. It is by all accounts one of the oldest and most provocative fields of human speculation. For at least as long as there have been philosophers and theologians, and presumably for as long as there have been human beings, men and women have grappled with the enigma of suffering and the apparent nonexistence of temporal justice. In the process they have created as many mysteries as they have solved, and raised as many questions as they have answered. Thus for the vast majority of humankind even today the riddle of evil remains just that—a riddle. Why, men and women still ask, is there so much pain and suffering in the world? Why is

there so much conflict, so much war, so much crime? Why is there disease and famine and drought? Why is there so much toil and hardship? And to what strange cosmic force or being do we owe the 'privilege' of our protean misfortunes? These questions, and others like them, are a part of every age and culture. They know no bounds of time or space. Nor are they the special province of professional thinkers. There has probably never lived a human being who did not at some time in his life wonder why the world, for all its beauty and wonder, should also be so replete with grief, sorrow, conflict, and utter madness.

This perennial preoccupation on the part of men and women to know the sources of their suffering is a remarkable one, but it is by no means difficult to understand or explain. On the contrary, it would be hard to imagine a human being who was aware of the ubiquity of evil and yet did not wonder why it should exist. Aristotle, after all, was right. Man is by nature a curious animal, and even if he cannot fully escape from the myriad ills which beset him, he would at the very least like to know why he has been condemned to endure them. Like an innocent man who is spirited away in the night and thrown into prison, without charge or trial, the human race demands—if nothing else—an explanation.

Unfortunately, man's quest for the sources of evil has long been impeded by ignorance, superstition, and prejudice. Until quite recently, in fact, positive knowledge about the ultimate causes of human suffering was essentially nonexistent. For most of history man has had to rely on his imagination to supply the answers that neither his intellect nor his experience could provide. For thousands of years, in other words, man has attempted to solve the mystery of evil by means of myth, legend, and philosophical speculation, leaving his progeny with little more than a legacy of lies and empty conjecture. It was not until the mid-nineteenth century that scientific knowledge about the origins of evil first became attainable. And in the meantime such knowledge has been disseminated at a laboriously slow pace. Often it has been actively resisted or repressed, and many people continue to deny that a rational explanation of evil is

really possible. A great many human beings, it would seem, prefer their myths and legends to positive knowledge, and reject out of hand rational explanations as inherently undesirable, or even nefarious. And so the myths and legends go on; they are perpetuated even in the face of empirical knowledge which shows them to be at best suspect, and at worst quite absurd.

The Origins of Evil in Religious Tradition

A good example of a legendary account of the origin of evil—and the one that is by far the best known in our own culture—may be found in the opening pages of the Book of Genesis: the story of Adam and Eve and their expulsion from the Garden of Eden. According to the biblical account, the first humans were blessed with health, happiness, and (on one interpretation) immortality, only to lose them all in exchange for an apple. The trouble apparently began when Adam and Eve chose to ignore the divine admonition not to partake of the fruit of the Tree of Knowledge. As punishment for their disobedience, they were banished from the Garden and cursed with a plethora of hardships and implacable desires. Thenceforth we find all of humankind condemned to hard work, painful childbirth, sexual taboos, and interpersonal conflict. As a consequence of their exile from paradise, Adam and Eve became miserable, and because of them we all suffer.

Perhaps the most charitable thing that can be said about this story is that there is no evidence to support it. Virtually all scientific data, including those from astrophysics, geology, and biology, clearly point to the conclusion that the Earth is far older than is suggested by the Book of Genesis. As such, everything in Genesis, including the story of Adam and Eve, is at best suspect and almost certainly not literally true. Even many people in the Judeo-Christian world who otherwise trust in the Old Testament as a source of religious inspiration have their doubts as to whether Adam and Eve ever really existed. The story of the Tree of Knowledge and the expulsion from the

Garden, as these people see it, is an interesting allegory, but as a potential solution to the age-old riddle of human suffering it is difficult to take seriously. Nor is it by any means as original as is sometimes assumed. On the contrary, by the time the Book of Genesis had been composed scores of similar legends had already been conceived in scores of other cultures. Even today there is hardly a primitive tribe on Earth that cannot tell you how their ancestors brought perdition upon themselves by incurring the wrath of an angry god.

Not all peoples, however, have their equivalent of the Adam and Eve story. In fact in some cultures an entirely different approach to the problem has been taken and very different solutions to the riddle of evil proposed. A classic example is that of ancient India, where the enigma of suffering was largely equated with the problem of apparent injustice, and where the resident sages sought to account for the former by explaining the latter. Like all people, both before and since, the founders of Brahminical and Buddhist speculation were struck by the seeming absence of justice in the temporal world: they saw that, as often as not, the guilty escape punishment while the innocent fall victim to cruel fates; that children inherit the sins of their parents; and that thousands of innocent beings suffer for the crime, or the mistake, of one. In the doctrine of karma—or the so-called 'transmigration of souls'—they found a nucleus around which to construct what seemed to them a plausible resolution to the whole enigma. If this world is full of pain and suffering; if misfortune and evil fall on both the good and the bad, it is because they are links in the eternal chain of natural causation by which the sins of one lifetime are expiated in another. Every sentient creature reaps as it has sown—if not in this life, then in one or other of the series of earthly existences by which it makes its way through the ages. The present distribution of good and evil is therefore a reflection of the accumulated sum of positive and negative merit; and injustice, in the end, is mere illusion.

The doctrine of karma raises more questions than it answers. If it ostensibly explains why temporal suffering should be so unevenly distributed, it does not very well explain why such

suffering should exist in the first place. On the contrary, it seems to presuppose the existence of the very suffering it is allegedly designed to explain. To wit, if no one ever experienced the pain and frustration of wanting but not having, then no one would ever be tempted to take what he wanted by force, in which case there would be no immoral behavior and therefore no need for the suffering which, according to the doctrine in question, is punishment for immoral acts. The circularity of the doctrine of karma is indeed its most blatant weakness, as many observers have duly noted. Wendy Doniger O'Flaherty, for example, has put it this way: "Karma 'solves' the problem of the origin of evil by saying that there is no origin—there is no beginning to time, simply an eternal cycle where future and past melt into one another. But this ignores rather than solves the problem . . ."[1] There are yet other difficulties. Perhaps the most frequent objection to the doctrine of the transmigration of souls is a strictly arithmetical one: it is difficult to see, indeed, how the alleged supply of souls can possibly keep up with the ever-expanding number of bodies they are given to inhabit. As many critics of karma have pointed out, the population of the Earth has been increasing exponentially ever since the idea of karma was invented, such that there are a lot more people alive today than there are old souls to be recycled. Obviously quite a few new souls must have been created afresh to keep the system going. But if so, what are the possessors of these new souls being punished for if they have no previous existences, and therefore no previous sins, requiring atonement in the present life? One must also wonder whether it really makes any sense to punish people for misdeeds committed during past lives of which they have no conscious recollection. It is difficult to see, for example, how a person could possibly be induced to reform his behavior by being punished if he has no idea what he is being punished for. And it is difficult to see how justice is truly served by punishing people today for sins committed during previous existences. If a person has no conscious recollection of his previous lives, then he is in effect a different person, and he is therefore no more responsible for misdeeds committed during previous incarnations than Julius Caesar is responsible for the

misdeeds of Adolf Hitler. Some would argue, I suppose, that abstract justice really is served by the kind of belated castigation demanded by the doctrine of karma. But if so, it hardly serves to make the world a better place, for it does nothing to alleviate the immoral behavior which it is allegedly designed to dissuade, and in some ways might even make it worse. Such punishment, indeed, can only serve to perpetuate, rather than mitigate, the endless cycle of misdeed and punishment that ultimately makes matters worse, rather than better, and which in the end only causes the total increment of human suffering and misery to expand rather than contract. The circularity, and indeed the absurdity, of the doctrine of karma becomes even more evident when we consider that much of the suffering that human beings endure is inflicted on them by other human beings, rather than by the raw forces of nature. To wit, if any injury that one man causes another is part of the scheme of cosmic justice by which the latter is getting just what he deserves, then how can the former (or any man, for that matter) be held morally accountable for his own transgressions? Yet moral accountability is a fundamental prerequisite of the whole system. With all these difficulties inherent in the doctrine, it is easy to see why belief in karma has never caught on outside the land of its origins and why, even in India, many Hindus behave as if they did not take it seriously.

The Stoic Theodicy

The doctrine of karma—for all its shortcomings—is a very long-lived one, dating at least as far back as the sixth century B.C., and perhaps even earlier. It is in fact one of the oldest explanations of evil of which we have any record. But there is yet another that is almost as ancient, and even more popular. It is known as 'theodicy', and it has its origins—as far as we can tell—in pre-Aristotelian Greece. The various forms of theodicy have been particularly influential in the West and for that reason bear close scrutiny.[2]

Among the earliest theodicists of whom we have any knowl-

edge are the Stoic philosophers of ancient Greece, including Zeno of Citium, Cleanthes of Assos, and Chrysippus of Soloi. As far as can be determined from fragmentary remains of their writings, the ancient Stoics apparently believed the universe to be an essentially provident and teleological enterprise. Indeed, they tended to equate all of nature with an omnipotent and omniscient deity, one of whose primary concerns was the welfare of humankind. Having committed themselves to such an anthropocentric and pantheistic conception of the universe, however, they were faced with an immediate philosophical dilemma: how to reconcile their belief in a provident and beneficent god with the apparent ubiquity of moral and physical evil in human life. They responded by creating various forms of theodicy, according to which evil is not so much evil as it is a 'kind' of good, or at least a necessary accompaniment of good, without which good itself would be impossible. Pain and hardship, the Stoics insisted, are not evils. Rather they are the necessary components of an overall wellbeing, without which human happiness would be unattainable.

Since the days of ancient Greece, the basic theodicist argument of the Stoics has been repeated over and over again by like-minded philosophers and theologians, many of whom seem to be convinced, as the Stoics apparently were, that evil exists for the simple reason that we could not bear to live without it. Indeed, even a philosopher like Arthur Schopenhauer, who as we shall presently see was anything but a theodicist—and who was certainly no Stoic—could not bring himself to believe that life could possibly be improved by being made easier. Imagine a world, Schopenhauer wrote, in which the lives of man are relieved of all want, hardship, and adversity, where work, worry, drudgery, and suffering are completely unknown, where, as in a fairy-tale land, all grows of itself, where birds fall to the ground ready-roasted and stuffed, and where each man finds his heart's every wish immediately and unfailingly fulfilled; what would be the result? In a world of unbounded luxury and ease, how would men occupy their time? What would they do with their lives? Some, according to Schopenhauer, would die of boredom, some would cut their throats,

while others would quarrel and murder and generally cause themselves more suffering than the present state of affairs obliges them to accept. If our world were any less replete with hardship, so the argument goes, all challenge would vanish, and we would be robbed of the zest that makes life worth living. Without misery, we would all be miserable, and that is why misery exists.[3]

The difficulties inherent in defending a view like this should be readily apparent, although there has never been any dearth of philosophers willing to spell them out. Besides the obvious logical contradiction of a life totally devoid of pain somehow being too painful to bear, there are inevitable problems associated with any attempt to write off *all* forms of evil and suffering as mere 'disguised blessings'. Consider for example the oft-repeated argument that pain and suffering are essential to human welfare because they serve as vital warning signals to the individual that something has gone wrong and needs to be corrected. Among the many philosophers who have advanced this point of view is Frederick Copleston. In his *A History of Philosophy*, Copleston states the argument thus. Consider the pain that is often associated with tooth decay. Although this is certainly an inconvenience, it nevertheless serves a definite adaptive function in that it tells us that the tooth has gone bad and that we should seek medical care as soon as possible. If the pain associated with dental decay did not occur, Copleston argues, we would be even worse off than we are, for we would lose most of our teeth before we realized that there was a problem. Ultimately, then, dental pain is to our own benefit, and as such is not really evil at all.[4]

At first blush this line of argument might seem sound enough. But there are in fact numerous difficulties with it, not the least of which is that it begs the question. That is to say, it presupposes the existence of the very evil it is allegedly designed to explain: tooth decay. *Given* that tooth decay exists, Copleston argues, it is better that such decay be accompanied by pain than by no pain. Yes, *given* that tooth decay exists. But why does such decay exist in the first place? Unless one can answer this question—and Copleston does not try to answer

it—then the problem is merely pushed back one step, rather than solved. Consider as an analogous example the pain that is often associated with the passage of kidney stones. It is a fairly well-known fact that when kidney stones are being passed they often cause excrutiating pain. Why does this pain exist? A Coplestonian theodicist might argue that such pain is necessary because it serves as a warning signal to the individual that a stone is being passed and that medical care should be sought immediately. But this argument leaves completely unanswered the question as to why kidney stones exist at all. Since many human beings lead happy and productive lives without ever forming or passing kidney stones, it is clear that the existence of such stones is not essential to either human survival or wellbeing. What's more, even if we presuppose the existence of such things as tooth decay and kidney stones (which is a lot to presuppose), the problem remains that the degree of pain involved in such cases is often far in excess of what is needed to serve as an effective warning signal. A further problem with the Coplestonian argument is that it seems to imply that *all* human pain serves a definite adaptive function. But this is simply not the case. Indeed, as I shall argue in the chapters to come, perhaps most forms of pain and suffering endured by human beings possess no adaptive value whatsoever, and contribute little or nothing to either the survival or the wellbeing of the individuals in which they occur. In the third chapter of this book, for example, there is a rather detailed discussion of the ultimate causes of chronic back pain in human beings. And this is perhaps as good an example as any of the unadaptiveness and uselessness of most forms of human suffering. Back pain is a widespread problem, and often persists despite the availability of myriad forms of treatment. As I shall argue two chapters hence, much lower back pain is ultimately traceable to inherent defects in the 'design' of the human skeleton. Were it not for these inherent structural defects, most back pain would not occur. And there would be no need to explain its existence, either by means of theodicist pleading or scientific demonstration. Similarly, the intense pain which many women suffer in the process of giving birth has no adaptive function and no

survival value. Like back pain, the pain of childbirth is ultimately explicable in terms of inherent flaws in the 'design' of the human body.

Or consider the pain and suffering that are often endured by the victims of congenital disease or malformity, such as cystic fibrosis, sickle-cell anemia, congenital blindness, and all the rest. Once again, the pain and hardship that are often associated with these inherent defects have no survival value and no adaptive function. They exist, as we shall see, not because they are adaptive, but in spite of the fact that they are maladaptive. Consider finally the intense suffering that is often associated with various forms of incurable and terminal disease. Especially in the latter case, the physical discomfort of the dying patient possesses no inherent value and serves only to make his last anguished days all the more anguishing. Even if it be conceded that certain forms of pain and suffering have a distinct disciplinary or survival value—at least when they occur in moderate doses—this does not explain why unadaptive forms of pain exist, or why suffering often occurs with an intensity that ultimately causes more harm than good. Nor does it explain why senseless pain often persists long after its message has been noted or its lesson learned. Indeed, it is only by rejecting the Coplestonian theodicy out of hand that we can even begin to account for such anomalies or to make some sense of the many human ills which contribute nothing to either survival or happiness and which often render both of these difficult or impossible.

Is Evil Good?

The argument that all suffering is ultimately to our own benefit, because it helps us to survive and to be happy, would perhaps be an acceptable one if in fact no one ever died and no one was ever unhappy. But obviously this is not the case, and so the argument is unconvincing. All the evils from which pain and suffering are supposed to spare us and which, according to the argument just outlined, don't exist, do in fact exist, and so it

makes no sense to argue as if they don't. If the purpose of pain is to ensure our survival, then what is the purpose of death? If the purpose of suffering is to make us happy, then what is the purpose of unhappiness? If the purpose of work is to prevent us from dying of boredom, then what is the purpose of work so dull that it kills? If the purpose of the pain of tooth decay is to prevent us from losing our teeth, then what is the purpose of tooth loss? And what of the person whose life is so replete with pain and suffering that he cannot bear to live, and so kills himself: is his suffering good? In what sense? Of course theodicists occasionally address themselves to difficult questions such as these. But when they do, their replies are not very satisfying, and as often as not are logically contradictory. Perhaps their most common answer to these objections is that even apparently senseless pain—pain that has no survival value and that does not facilitate either happiness or the pursuit of happiness in any way—is not really senseless, but rather is punishment for evil deeds. According to this view, whenever a man suffers a seemingly pointless injury, either at the hands of nature (as in the case of a hurricane or a flood) or at the hands of another man (as in the case of a violent crime), the suffering he endures is not really senseless at all, but rather is just punishment for his own evil deeds. But this line of argument involves almost precisely the same difficulties that are inherent in the doctrine of karma. Once again, if no one ever suffered the pain and frustration of wanting but not having, then no one would ever be motivated to take what he wanted by force, in which case there would be no immoral behavior and therefore no need for suffering as punishment for immoral acts. And, once again, if any injury that A causes B is a part of the scheme of cosmic justice by which B is getting just what he deserves, then how can A (or any man, for that matter) be held morally responsible for his own actions? If Smith injures Brown, and Brown's suffering is just (because the latter is being punished for his own sins), then Smith is innocent. But if Smith is innocent, then so is any man who commits an apparent misdeed—in which case Brown must be innocent too. But if Brown is innocent, then his injury is not just after all, and at this point the whole argument

collapses of its own circularity. Circular reasoning, indeed, seems to be a hallmark of theodicist pleading in general. A further problem with the pain-as-punishment philosophy (and one that it shares with the Coplestonian theodicy discussed in the foregoing section) is that it cannot account for the hardships and difficulties that are so often endured by persons who suffer from congenital defects. Since fetuses, generally speaking, are not capable of misbehavior, no innate disease or deformity can possibly be construed as a just punishment to its victim. (For that matter, even if fetuses were capable of misbehavior, this would still not explain congenital defects, for such defects have their origin at the moment of conception, not at the moment of birth. And I doubt whether anyone would be taken seriously if he were to suggest that unfertilized egg cells or sperm cells are capable of immoral behavior.) There are yet other problems with this and other like forms of theodicy, but all such philosophies suffer from the same fundamental flaw, and that is simply this: that it is not so much their purpose to explain the existence of evil as it is to explain evil out of existence. No matter how bad a thing may seem to be, according to the theodicist conception of the universe, it is ultimately for our own good, even if it destroys. Whether the apparent evil be murder, mayhem, or madness, it is not so much an evil as it is a 'kind' of good, inflicted on us for our own benefit (or because of our just deserts), and for which we ought to be duly grateful. But this philosophy is not only absurd; it is downright dangerous. If there is no such thing as evil, then there is no such thing as an evil act; and if there is no such thing as an evil act, then even the most heinous crimes must be regarded as 'good' and therefore moral and justifiable. Theodicists never argue that such things as rape and murder are justifiable, and in fact they frequently denounce these and other similar crimes as grotesque and inhumane. In the process they unwittingly betray the blatant inconsistency of their own arguments and highlight the awkwardness of their attempts to philosophize evil away. In the end, good is still good and evil is still evil, and no amount of theodicist rhetoric, however elegantly composed, will ever change that.

Evil, then, is no mere illusion or epiphenomenon, but a very real fact of human life. And while it apparently plays little role in the lives of some fortunate few, its impact on the lives of many, if not most humans, is appreciable. We are thus led back to our original question: what is the ultimate root of evil?

The Metaphysics of Evil

Probably no man in the history of Western thought has considered this question more thoroughly than Arthur Schopenhauer, a nineteenth-century German metaphysician whose entire career as a philosopher was devoted to the formulation of a theory of human suffering. The written transcript of his lifelong deliberations makes up his magnum opus, *Die Welt als Wille und Vorstellung* (The World as Will and Representation), with its four books and 50 supplementary chapters. In this massive work Schopenhauer lays out a theory of evil which, though demonstrably flawed, approaches reality much more closely than do either popular theodicies or Adam and Eve stories. No discussion of the problem of suffering, in any event, would be complete without a consideration of his ideas.

According to Schopenhauer, every animal species is endowed by nature with a characteristic array of bodily adornments and instincts which are the means of its survival and perpetuation. The totality of these means of survival Schopenhauer calls the "Will to live". Claws, teeth, fins, gills, and wings are all instruments of the Will, as are the fangs of the snake, the hunting instincts of the lion, the spawning habits of fish, the keen eye of the hawk. Everywhere the creatures of nature are continuously striving to survive and reproduce so as to maintain their kind, in accordance with the universal Will. In this respect, humans are no different from any other animal: we, too, come equipped with a specific set of adaptations, the ultimate purpose of which is to ensure our continued survival. But there is one important difference. In man, the Will to live manifests itself primarily in the form of desires, rather than well-defined instincts. And this, according to Schopenhauer, is where the

trouble begins, because human desires are ultimately unsatisfiable and as such represent a continual source of frustration and disappointment. For Schopenhauer, indeed, desire itself, as the expression of a need or want, is a form of pain, any relief from which is by necessity ephemeral. What we call pleasure or happiness is but a temporary cessation of desire brought about by temporary satisfaction. Inevitably satisfaction turns to boredom, and the endless pursuit of more pleasure. Schopenhauer writes that "All striving springs from want or deficiency, from dissatisfaction with one's own state or condition, and is therefore suffering so long as it is not satisfied. No satisfaction, however, is lasting; on the contrary, it is always merely the starting point of a fresh striving. We see striving everywhere impeded in many ways, everywhere struggling and fighting, and hence always as suffering. Thus that there is no ultimate aim of striving means that there is no measure or end of suffering."[5] The desire for pleasure is boundless; satisfaction is limited and transitory; we are thus doomed to disappointment, and the stronger a man's desires the more certain is his unhappiness.

The Will, too, is the ultimate source of all conflict between individuals and the harm they do one another. This is because, as a man's frustration grows, so too does the likelihood that he will cause unhappiness to others as his Will seeks to assert itself at the expense of his fellows. Inevitably the Will to live, manifesting itself in the form of egoism, self-assertion, and jealousy, leads to clashes of interest which cannot be resolved except at some cost to either or both parties involved. Hence the human realm is a vast battlefield in which the universal Will, as objectified in each individual, is at odds with itself. And it is in this sense of manifold conflict and frustration that all the woes of man lie in germ.

That there is at least a grain of truth to Schopenhauer's reflections should be evident to anyone who has known the pain and dissatisfaction that result when dreams and desires are consistently frustrated by a hostile universe. To be sure, Schopenhauer's delineation of the characteristic dilemma of the insatiable Will that can never be fully satisfied or appeased

is unparalleled in the history of Western letters. In many ways he seems to have captured the essence of the human tragedy. But did he solve the riddle of evil? Schopenhauer himself was apparently quite convinced that he had. And it is perhaps understandable that this should be so. After all, his system lacks most of the inconsistencies and contradictions that are so characteristic of theodicist pleading, and of other erudite attempts to philosophize evil out of existence. Even his most fervent opponents concede that he was an unusually insightful man, and that his philosophy is expressed with a rare precision and clarity. For this reason, and in spite of his extravagances, Schopenhauer is still taken quite seriously today, especially by those who can empathize with his point of view, and his philosophy is still being debated in academic circles. For all its insight and forcefulness, however, Schopenhauerian thought is not without its weaknesses, as his critics never tire of pointing out.

Perhaps the most common charge levelled against Schopenhauer is that his philosophy is overly pessimistic and therefore unrealistic. It is often maintained, for example, that Schopenhauer was a bitter, disappointed and frustrated man who erroneously projected his own unhappiness onto the rest of humankind, and that his inveterate pessimism blinded him to the good things in life. But this is not a very fruitful line of criticism, and it is in many ways beside the point. One might just as well argue that the writings of philosophers like Aristotle and Leibniz are overly optimistic and therefore unrealistic. Such authors, it might be argued, led unusually fortunate and contented lives, and they erroneously assumed everyone to be as happy as they. (Aristotle, for example, might have had a very different attitude about life if he had been born a slave rather than a free man, or if he had been constrained to devote his years to menial labor rather than philosophical contemplation. And Leibniz might not have been so quick to assume that this is the best of all possible worlds if he had been born with, let us say, a half-dozen genetic defects, or if he had personally fallen victim to some of the misfortunes that do not seem nearly so bad when they happen to others as when they happen to oneself.) In

the end, all philosophers are either happy or unhappy, and if we are going to dismiss the writings of any particular philosopher on the basis of his satisfaction or lack of satisfaction with life, then we are going to have to throw out philosophy altogether, in which case the philosophy of Schopenhauer's critics becomes as worthless as that of Schopenhauer himself. As the reader may have guessed, I am not generally inclined to agree with Frederick Copleston, but he is certainly correct when he points out that Schopenhauer's philosophy may have a value of its own, regardless of the *kind of man* that propounded it.[6] And the problem of suffering raised by his system remains a very real one whether Schopenhauer was disappointed and disillusioned or not. Of course it must be admitted that Schopenhauer was in fact a pessimist, and that his laments about the hardships of life were on occasion extraordinarily lugubrious. Still, in my view, the single major flaw of Schopenhauer's philosophy lies not in his pessimism, but in his metaphysics. As we have seen, the essential component of Schopenhauer's metaphysical system is the so-called "Will to live". But there is little reason to believe that any such thing actually exists, at least in the sense that Schopenhauer intended. It is precisely his need to invent such a fictitious entity which shows, more than anything else, that his whole approach to the problem could not possibly have been correct.

Like most of his contemporaries, and like most of his fellow philosophers, Schopenhauer assumed the question of the origin of evil to be a metaphysical one, as if it were somehow beyond the scope of scientific inquiry. But it now seems clear that this assumption was a mistake. Since Schopenhauer's time the scientific study of man and his nature has progressed with amazing rapidity, and with it has come the realization that the metaphysical approach to the mystery of evil was from the very beginning wholly inadequate, indeed misguided. When we try to analyze human suffering and understand its origins, metaphor and symbol are quite out of place: Garden of Eden stories and abstractions like the 'Will to live' are interesting allegories, but they are not facts. Perhaps Schopenhauer would have seen this, had he enjoyed the benefit of the vast reservoir of scientific

knowledge to which twentieth-century man has ready access. But alas he was born too soon for that; the scientific revolution that was ultimately to lay the foundation for a final resolution to the enigma of evil was only just beginning as Schopenhauer approached his death. That scientific revolution was given its greatest impetus by one man, Charles Darwin, and it is to the life and discoveries of the latter that the discussion now begins a gradual turn.

The Darwinian Revolution

In the mid-nineteenth century, the French positivist philosopher Auguste Comte wrote that science, and science alone, can ultimately be counted on to supply the definitive explanation for any observable phenomenon in the real world. It is only when men lack scientific knowledge, he insisted, that they turn to other means of explanation. Whatever the thing to be explained, Comte argued, mythology inevitably yields to metaphysics and metaphysics in turn to science. Thus in any field of human inquiry one may observe a "Law of Three Stages": at first the phenomenon is conceived in *theological* terms, and all experience is explained by the will of some deity or superhuman being—as when the sun and the stars were gods, or the chariots of gods; later, the same phenomenon reaches the *metaphysical* stage, and is explained by philosophical speculation—as when Thales of Miletus concluded that the primary stuff of all things was water; finally the phenomenon is reduced to positive *science* by empirical observation, hypothesis, and experiment, and its various aspects are explained through an appeal to natural law. The 'will of God' yields to such abstruse concepts as Plato's 'Ideas' or Schopenhauer's 'Will to live', and these in turn give way to the facts of science.[7]

Whether Comte's 'Law' of Three Stages applies to *every* field of human inquiry is open to debate, but in the case of the mystery of evil, the stages are clearly there. For thousands of years people satisfied themselves with mythological and metaphysical explanations for the existence of evil because, for

thousands of years, there was nothing else available. Then came evolutionism, and with it the foundation for a new, *scientific* explanation.

It is probably safe to say that, prior to the turn of the nineteenth century, the vast majority of Westerners believed the human species to be the product of some sort of special creation, having come into being in its present form at some specific moment in the not-so-distant past, without the benefit of animal ancestry or intermediate stages of development. The creationist thesis retains some following even today. But there have always been exceptions, and the history of Western letters is conspicuously dotted with iconoclastic thinkers who had very different ideas about the ultimate origins of man. One such thinker was Anaximander, an early Greek scholar who was among the first to challenge the notion of special creation. In the sixth century B.C., Anaximander proposed a rudimentary form of evolutionism which, though crude by modern standards (and not really evolutionism at all in the Darwinian sense), was nonetheless way ahead of its time. Having speculated that moisture is the ultimate source of life, Anaximander reasoned that the first organisms must have originated in the sea, and that all land-living forms were ultimately descended from fishlike creatures. Pursuing a similar line of reasoning, he was able to deduce the animal origins of man. In the beginning, he argued, human beings must have been generated by other species, for while other animals can quickly find nourishment for themselves, man alone requires a prolonged period of nursing. Therefore had he been originally as he is now, he would never have been able to survive.[8]

These ideas were, of course, both brilliant and highly original, but they did not catch on, either in Greece or anywhere else. On the contrary, only a handful of individuals, as far as we know, sided with Anaximander in adopting some semblance of evolutionary thought. One of these was Empedocles, who insisted that the adaptations we see in the organic world are the results of the generative power of nature, and not the products of an omnipotent deity. In the meantime, however, Aristotle took a strong stand against the innovative

ideas of Anaximander and his followers and in fact dismissed the whole notion of organic evolution altogether. In contrast to the evolutionists, Aristotle confidently proclaimed that man and all other animal species are eternal and immutable, and from this conviction he would not be moved. The consequences were indeed unfortunate, for Aristotle was one of the greatest thinkers of all time, and his ideas were to exert a powerful influence on dozens of subsequent generations of scientists and philosophers, few of whom dared question his authority. In the end Aristotle's misguided opposition to evolution set back the scientific study of human origins some two thousand years.[9]

But the stifling effect of Aristotle's anti-evolutionism did not last forever. With the coming of the Renaissance, evolutionary thinking experienced a slow but unmistakable resurgence. Particularly in the sixteenth, seventeenth, and eighteenth centuries, challenges to the Aristotelian 'wisdom' became increasingly more popular, despite loyal opposition from the lay public and especially from the Church. By the late 1700s the concept of evolution had achieved widespread acceptance among the most innovative thinkers of the time. Throughout this period, however, no one could explain just how or why evolutionary change occurs, or by what mechanism it is brought about. For centuries these mysteries lingered. Then, in the early 1800s, Jean Baptiste de Lamarck proposed the first genuine *theory* of evolution, suggesting that adaptive organs and limbs tend to grow stronger or more effectual with habitual use while less beneficial appendages atrophy and wither away as their utility wanes. But this idea—along with many other aspects of Lamarck's theory—eventually proved itself to be flawed, and in the meantime has been universally discredited by biological scientists. Ultimately it was Charles Darwin who, while by no means completely rejecting the ideas of Lamarck, devised a more viable theory of evolutionary change and ushered in a new era in the scientific study of adaptation.

It is still a popular belief that Darwin was the first to have hit upon the idea of evolution as an explanation for the origin of species. But as the foregoing discussion clearly shows, this is not at all the case. In fact many writers before him had suggested

that old forms of life might on occasion give rise to new ones. Nevertheless, Darwin's contributions to the advance of evolutionary science were enormous: no individual, either before or since, has done as much to promote our understanding of human and animal origins. For all the occasional flashes of brilliance and originality among his precursors, Darwin was the first person to devise a feasible theory of evolution, namely natural selection, and the first to marshal overwhelming support for that theory, confirming it time and time again with numerous examples and well-thought-out arguments. Even Lamarck, Darwin's most insightful forerunner, had neglected to assemble empirical facts to support his evolutionary conjectures or to provide a comprehensive explanation of the possible mechanisms of evolutionary change. Darwin was the first author to deal with the subject on a strictly scientific basis. Moreover, it was Darwin who brought the first workable theory of evolution to the attention of the Western world—and with impressive results. Within ten years of the publication of his *Origin of Species*, in November of 1859, there was hardly a competent biologist in the world who did not accept the fact of evolution. Finally, and perhaps most significantly, it was Darwin who succeeded in popularizing the notion that man, like any other creature, was not a special creation, but the product of millions of years of gradual evolution.

The implications of Darwin's theory were manifold. First, the frank disclosure of man's animal origins robbed the human species of its privileged status as the prized product of nature and demolished the anthropocentric view, so popular among Christian philosophers of the time, that the world and everything in it were made for humankind. Next, the establishment of the fact of human evolution laid the foundation for an unprecedented understanding of human nature: as Darwin frequently intimated in his writings, there is hardly an aspect of human anatomy or behavior that is not ultimately explicable in terms of the selective pressures of man's evolutionary past. Finally, although Darwin himself apparently failed to realize it, scientific evolutionism provided the basis for the ultimate resolution of the long-standing enigma of evil. Clearly, if living

beings are capable of suffering, while inorganic substances are not, then it should be possible to discern the ultimate origins of suffering by explaining how the biological capacity for suffering first evolved. And if man suffers in ways that no other animal can (as I believe is the case and as I attempt to show in the chapters to come), then it should be possible to trace the origins of all forms of human malaise to the peculiar circumstances of man's unique evolutionary history. With the triumph of evolutionary theory, in other words, the puzzle of evil was effectively reduced to a few simple questions, to wit, 'How did the capacity for pain and suffering evolve?' and 'What are the evolutionary roots of the peculiarly human forms of suffering?'

Evolution and Evil

Curiously, however, at least until quite recently, very few Darwinian scientists have managed to discern the intimate connection between the evolutionary origins of man and the ultimate causes of human suffering. On the contrary, for much of the history of evolutionary science, most Darwinian scholars have repeatedly denied that there is any connection between human evolution and human suffering, preferring to believe that evil has historic rather than prehistoric roots. At times they have gone to great lengths to convince the public that evolution is essentially a benign process which is ultimately responsible for our strengths but not our weaknesses. Fundamentalist theologians, in the meantime, have continued to oppose evolutionary theory altogether because of the threat it poses to their explanation for the origin of evil, as depicted in the biblical account of the Fall of Man. As for secular philosophers, the majority of these still write as if Darwin had never existed, preferring the abstruseness of their own metaphysical speculations to the practicalities of science. A few modern thinkers from both philosophy and science have gone so far as to suggest that the existence of evil is an unsolvable mystery, a definitive solution to which will never be and indeed *can* never be found.[10]

Throughout the history of Darwinian science, however,

there have always been at least a few sporadic exceptions. One of the most notable of these was Élie Metchnikoff, a Russian biologist whose indictments of evolution appear in his book, *The Nature of Man*, published just after the turn of the twentieth century. Metchnikoff's professional familiarity with the human body led him to the conclusion that much of man's physiology is as baneful as it is beneficial, and he was perceptive enough to see that the same applies as regards the human psyche; with an insight uncommon for a man of his time he recognized evolution as the ultimate culprit. Are not the multitudinous forms of pain and suffering to which the human organism is uniquely susceptible ultimately explicable in terms of man's unique evolution? he asked.

Metchnikoff's question was plain enough, but the answer was slow in coming. For several decades after the publication of his provocative speculations, his ideas were largely ignored by serious scientists, most of whom were conspicuously disinclined to acknowledge the existence of any imperfections in the evolutionary process leading to man. On infrequent occasions, however, the question has been resurrected by popular writers who were not burdened by professional commitments to the benevolence of nature or to the aggrandizement of the human species. Among these were Edward M. Keating, author of *The Broken Bough;* Charles Harrison, whose views are expounded in a little book called The *Neurotic Primate,* and Robert Ardrey, whose most notable works include *African Genesis* and *The Territorial Imperative.* Like few professional scholars of their time, all of these men were insightful enough to realize that man's present problems are inexplicable without reference to his prehistoric past, and in their respective books each made an ambitious attempt to discern the specific evolutionary roots of the peculiar human capacity for suffering and conflict. Unfortunately none of them possessed any professional knowledge of the causes and modes of evolutionary change, and their particular theories are both badly flawed and greatly oversimplified. Understandably, neither Keating nor Harrison has attracted any serious attention from the academic community. As for Robert Ardrey, the best that can be said about him is that he was an

eloquent but misinformed writer. His speculations concerning the evolutionary origins of human conflict were both daring and adroit, but essentially unenlightening.

Since the publication of Ardrey's books, however, the search for the ultimate causes of human conflict and suffering has been taken over by more informed evolutionists, many of whom have recently adopted a more realistic, if less favorable appraisal of the evolutionary process than had been traditional among their nineteenth-century and early twentieth-century predecessors. In the last three decades in particular, an increasing number of evolutionary scientists has come to realize that the life of our Pleistocene forebears was not all fun and games, and that the difficulties these proto-humans inevitably encountered in the eternal struggle to survive were only perpetuated by their ever-growing ability to overcome them. This 'new' interpretation of human evolution has not yet fully seeped down to the public at large, and there is still some considerable opposition to it in the evolutionary sciences themselves. Thus most people continue to believe that evolution is an essentially benign and perfective process, and that its ultimate product, *Homo sapiens,* is the sublimest manifestation of three-and-a-half billion years of progress. Before I can begin to trace the specific evolutionary roots of various human problems, I shall first have to devote a chapter to a discussion of this and other popular myths concerning the evolutionary process and how it works.

Chapter Two
Natural Selection: Good or Bad?

Natural selection is not always good, and depends (see Darwin) on many caprices of very foolish animals.

George Eliot

. . . though evolution does not produce the best of all possible worlds, it has clearly produced ours.

David Barash

There are many widespread myths and misconceptions about evolution, but none is more popular—or more misconceived—than the idea that evolution is basically a good thing. The myth is indeed a pervasive one, and for much of the history of evolutionary science it has been accepted and indeed nurtured by most evolutionary scientists themselves. Darwin, for example, seems to have viewed the evolutionary process as an essentially benign one that always does the right thing, as it were, and that always promotes the welfare, as well as the survival, of every individual being. And until quite recently the majority of Darwin's followers has adopted essentially the same point of view. In the last few decades, more and more evolutionary scientists have come to reject the traditional view and now

believe that evolution is anything but benign, and certainly not progressive. Nevertheless, many experts still seem to be convinced that the evolutionary process is characterized by continual and unremitting improvement, and that *Homo sapiens* is the supreme product of three and a half billion years of evolutionary progress. In the writings of some Darwinian scientists, there seems to be a curious ambivalence about the whole matter, which apparently stems from their inability to reconcile their own anthropocentric biases with the empirical data of evolutionary investigation. Pick up any recent textbook on evolution in general (or on human evolution in particular), indeed, and chances are that somewhere in its pages you will find an explicit statement on the part of the author that progressive evolution is a myth, that every species alive today is as much the end product of evolution as any other, and that therefore none is absolutely superior or inferior to any other. But read further and chances are that you will also find, in the very same text, frequent repetitions of such standard phrases as 'evolutionary advance', 'evolutionary improvement', 'evolutionary advantage', and other such implicit suggestions that the author really does believe in progressive evolution after all.

In spite of often explicit statements to the contrary, it is evident that many scientists still cling to the notion of benign and progressive evolution, and still regard all evolutionary change as essentially good or desirable. In recent decades this notion has come under increasing attack, and more and more scientists are now insisting that there is no such thing as evolutionary advance, and that all apparent progress in evolution is illusory. But old ideas die hard, and it is still a popular view that evolution by natural selection is an essentially perfect process that rarely, if ever, makes a mistake, and that always makes organisms better and better as the process goes along. Why does this idea persist? What is its intrinsic appeal? And why is it still so popular, even when there is so much evidence to refute it? I can think of at least three reasons why the idea of progressive evolution continues to be so popular and so difficult to debunk. These are: 1. anthropocentrism, which will be defined here as the belief in the absolute superiority of humans

over all other species; 2. belief in the benevolence of nature; and 3. political utopianism. I think it is more than merely coincidental that two or more of these biases often go hand in hand in the writings of a particular evolutionary scientist, and that such a scientist is much more likely than others to insist that evolutionary advance is a more or less integral characteristic of the history of life.

The Anthropocentric Prejudice

Certainly one of the most pervasive prejudices that has distorted the popular (and, all too often, even the professional view) of natural selection is anthropocentrism. For a variety of reasons human beings like to think of themselves as the prized products of nature, and are often taken aback, indeed insulted, by even the slightest suggestion that they are not absolutely superior to every other species. This attitude is understandable enough, and it would perhaps be surprising if it did not exist. Indeed, it is probably inevitable in a creature that is consciously aware of its own existence and that so often exploits the 'lower' animals for its own utility. As some scientist once remarked, if lions could think, they would be 'leocentric', and if insects could think, they would be 'entomocentric'. It is perhaps forgivable, then, that humans should often be so possessed of such an intense pride in themselves as a species and should be prone to assume that the whole natural world revolves around them. But this attitude cannot help but impede a truly disinterested and accurate appraisal of the evolutionary process. Unfortunately, as it so happens, just about every evolutionary scientist who has ever lived has been a human, and so it remains today. It is probably the case, too, that the vast majority of people who choose to become anthropologists do so precisely because they are especially fond of their own species. It is therefore not difficult to understand why so many evolutionary scientists, especially anthropologists, have often found it so difficult to shed their anthropocentric biases and to look upon the human species (and the evolutionary process that created it) with the

same dispassionate objectivity with which a physicist might look upon the Newtonian laws of motion or that a mathematician might view the principles of probability. In fact until quite recently blatantly anthropocentric statements were still commonplace in the anthropological literature, and only in the last few decades or so have they begun to give way to more objective points of view. Even today, it is not all that hard to find unabashedly anthropocentric arguments in the writings of some of these scientists. However understandable their attitude may be, it seems to be the case that anthropocentric bias has misled many evolutionists into the unsupported belief that natural selection is a benign process, and that evolution itself continually 'strives' to produce ever better and more perfect organisms. As we shall presently see, however, this conception of the evolutionary process has little basis in fact, and the prejudices that have given it rise still cloud many people's understanding of the process by which life evolves.

The Benevolence-of-Nature Prejudice

Another bias which seems also to have influenced the popular conception of evolution is the belief in the benevolence of nature. Apparently many people, including some evolutionary scientists, are yet convinced that nature is an essentially beneficent force and that it always has our best interests 'at heart'. This is anything but a novel viewpoint, of course, and it is by no means restricted to those who profess a belief in evolution. In fact belief in the benevolence of nature is probably as old as humankind itself, and praises of nature permeate the writings of Western thinkers from Plato to the present. Just why human beings should be so convinced of this idea, despite obvious evidence to the contrary, I do not know. But I can offer the following guess. Human beings are very much aware of the fact that they cannot fully escape from nature. However skillful they may be at protecting themselves from the onslaught of nature's forces, through the construction of artificial abodes, the maintenance of dikes and dams, the manufacture of tools,

clothing, and the countless other cultural artifacts which shield them from the vicissitudes of the weather and other natural hazards, humans can never get away from nature. We cannot change natural laws, nor are we as powerful to combat nature as we might like to believe. Since man cannot help but live within nature, then, it is to his advantage to reconcile himself with the forces of nature and to convince himself that those forces are essentially 'on his side'. Thus philosophers and scientists throughout the ages have skillfully circumvented all contradictory evidence, and have managed to perpetuate the idea that nature and everything in it exist for the ultimate good of humankind. The Roman Stoic Marcus Aurelius went so far as to suggest that nature is *wholly* good, and that human beings suffer only insofar as they refuse to resign themselves to this fact. The seventeenth-century Dutch philosopher Benedict de Spinoza adopted a similar approach, suggesting that nature is not only benevolent, but synonymous with a benevolent god. This, to say the least, is a peculiar point of view. The whole notion of pantheism is so patently absurd that one must wonder how anybody could seriously embrace it. And yet, when one considers just how much there is to be gained by believing in the benevolence of nature, and how completely that benevolence is asserted by equating nature with the godhead itself, then the pantheistic point of view becomes understandable, if not believable. The truth of the matter, however, is that nature is anything but benevolent; and as I shall attempt to show in the closing pages of this chapter, human welfare is perhaps the least of its 'concerns'.

Political Utopianism

Yet another prejudice which seems to have distorted some scientists' understanding of the evolutionary process is political utopianism. A few Darwinian scientists have dedicated themselves to the proposition that it would be possible, given the proper political and social framework, to establish a utopian society where all human beings would be exuberantly happy

and where all would live in complete peace, harmony, and contentment from the moment of their birth until their ecstatic final breath. As a correlate of this political philosophy, these evolutionists have adopted an attitude of extreme hostility toward any suggestion which might tend to challenge their utopian ideal. They often reject out of hand the slightest intimation that the various forms of human suffering with which we are familiar might ultimately be traceable to evolutionary causes. Once again, this attitude is understandable (who wouldn't prefer such a utopia to the kinds of society in which we now live?), but in my view it can only distort one's interpretation of the evolutionary process. If we proceed from the assumption that human problems are relatively superficial, and in any case cannot possibly have evolutionary roots, then we are unlikely to find such roots, no matter how hard we search for them, and no matter how much they might actually exist. Political utopians have by and large been unable to find evolutionary origins of human problems, and for the most part have refused to look for them. When one approaches the subject without utopian prejudices, however, then it is not difficult to find inherent imperfections in the process of natural selection. And it is not difficult to see how these imperfections are ultimately at the root of our current troubles.

Is Evolution Progressive?

The idea of the progressiveness of evolution is almost as old as the idea of evolution itself, and almost as popular. Ironically, one of the first individuals to express a belief in evolutionary progress, or at least something closely akin to it, was a man who did not believe in evolutionary change itself, Aristotle. Aristotle rejected the whole notion of evolutionary change, insisting that all species are permanent and immutable. Nevertheless, he also maintained that some forms of life are inherently superior to others, and he suggested that the 'higher' forms were logically, if not temporally, derived from the 'lower'. Aristotle further left no doubt as to which organisms he considered to be the

superior, and which the inferior. On his 'scale of being', as it has been called, inanimate matter occupies the lowest position of all. Next come, in ascending order, the lower forms of plants, the higher plants, sponges, jellyfish, other shellfish with soft bodies protected by shells, creatures with the body divided into segments (such as insects and spiders), water-breeding animals with jointed limbs (such as lobsters, shrimps, and crabs), squid, octopuses, fishes, reptiles and amphibians, birds, and mammals. Finally, at the very top of Aristotle's ladder of life, there stands man.

This conception of nature, as one might expect, was just anthropocentric enough to command widespread popular acceptance, and it did and has through a long parade of years. Particularly during the thirteenth and fourteenth centuries, when translations of Aristotle's works became widely available for the first time, the idea of the 'scale of being', or *scala naturae*, was taken up with great enthusiasm. Throughout this period a great many philosophers embraced the Aristotelian belief that there is a clearly defined purpose or predetermined goal in nature. Like Aristotle, these scholars believed that all organisms form a single series from low to high, from simple to complex, culminating in man. With the coming of scientific evolutionism in the eighteenth and nineteenth centuries, the possibility of a connection between the 'scale of being' and evolutionary development clearly suggested itself, and few failed to discern it. Pre-Darwinian evolutionists generally took for granted that evolution was an 'upward' progression, from worse to better, from simple to complex, from the most primitive organisms (the Infusoria, as they were called) to the most advanced: man. Throughout much of this period, Jean Baptiste de Lamarck assumed a leading role in the movement to deify the evolutionary process, using every opportunity at his disposal to express his teleological convictions. Thus in his classic *Philosophie zoologique,* published in 1809, he wrote that "nature, in successively producing all species of animals, beginning with the most imperfect, has caused their organization gradually to become more complex" and further that "man assuredly represents the type of the highest perfection that nature could

attain to: hence the more an animal organization approaches that of man the more perfect it is." If there remained any doubt about Lamarck's position, he removed it in 1815, when, in the introduction to his *Histoire naturelle des animaux sans vertèbres,* he wrote that

> if one runs through the series of known animals from one end to the other, arranged according to their natural affinities and beginning with the most imperfect ones, and if one goes up thus from class to class, from the *infusoria* which begin this series to the *mammals* which end it, one will find by considerations of the stage of organization of the different animals incontestible proofs of the *progressive* complication of their various structures; finally, one will be convinced that the reality of the progression in question is now an observed fact and not an act of abstract reason.[1]

This "observed fact" was subsequently embraced by most evolutionists of the time, the greater number of whom were more than glad to discover this newfangled rationalization for their own heartfelt belief in the absolute superiority of humankind over all other species.

Darwin, for his part, had very different ideas. On the basis of his exhaustive studies of geographic variation and extinct species, he flatly rejected the Lamarckian notion that there is any sort of *inherent* drive for progress in the evolutionary process. It was in this spirit that he once reminded himself never to use the terms 'higher' or 'lower' when comparing species. He further noted that, in spite of continual selective pressures, no animal ever achieves perfect adaptation to its surroundings. Early on in the *Origin of Species* he wrote that "no environment can be named in which all the native inhabitants are now so perfectly adapted to each other and to the physical conditions under which they live, that none of them could be still better adapted or improved."[2] Darwin's feelings about evolutionary progress are somewhat ambivalent and he frequently ignored his own admonition not to refer to some species as higher or lower than others. Thus while the notion of a necessary, built-in drive toward better forms was very much

alien to his way of thinking, he nonetheless believed that some incidental progress could occur as a by-product of the inevitable workings of natural selection. As such, he concluded, most lineages can be said to have improved over time as the fortuitous consequence of unremitting selection for superior adaptation.

Since Darwin's time dozens of arguments, both for and against progressive evolution, have been advanced, and no general consensus of the experts is readily discernible. From what I have been able to gather it would seem that, for most of the history of evolutionary science, up to about the mid-1900s, the majority of scientists tended to side with Darwin, concurring that, while there is no inherent drive toward perfection in the evolutionary process, as Lamarck had insisted, some incidental progress can nevertheless be said to occur as an inevitable outcome of continual natural selection. And this point of view is still being championed by some evolutionary scientists, for example the eminent biologist Ernst Mayr. In his 1982 book, *The Growth of Biological Thought,* Mayr expresses his essential agreement with Darwin, suggesting that incidental progress does indeed occur, and citing several specific examples of evolutionary developments which Mayr deems to be genuine improvements. Mayr also suggests that his point of view is the predominant one among contemporary evolutionists.[3] Whether Mayr is correct in this assertion is difficult to say, because so many evolutionary scientists are so equivocal in their characterization of evolutionary change. As I have pointed out, some evolutionists argue that there is no such thing as progressive evolution, but otherwise intimate that they do indeed believe in evolutionary improvement. Some evolutionary scientists, however, are quite unequivocal on this matter, and nowadays there is certainly a lot of opposition to the notion of evolutionary progress within the professional ranks. Many biologists now question whether *any* evolutionary change is genuinely progressive, either in the Lamarckian or the Darwinian sense. Some have suggested that *no* evolutionary trend constitutes unmitigated improvement, and that all apparent advance from worse to better forms of life is wholly illusory. Perhaps the most

unequivocal challenge to the notion of evolutionary progress occurred in 1966, when biologist George C. Williams published his landmark book *Adaptation and Natural Selection*—a small but powerful volume which has quickly become a classic in its field. In this work Williams presents cogent challenges to many of the traditional assumptions of Darwinian science, including the idea that there is any sort of progressive trend in the evolutionary process. His critique is both methodical and comprehensive: one by one, he catalogues every argument that has ever been proposed in favor of progressive evolution and, one by one, destroys them. He states bluntly that all prior belief in the alleged progressiveness of evolution was based on misconception and anthropocentric bias.

In criticizing the idea of organic progress, Williams goes much further than had anyone before him: in his analysis of evolutionary change, he finds no justification either for the inherent, 'orthogenetic' progress of Lamarck or for the 'incidental' progress of Darwin. He writes: "I doubt that many biologists subscribe to the view of evolution as a deterministic progression toward man, but there is widespread belief in some form of aesthetically acceptable progress as an inevitable outcome of organic evolution."[4] Williams goes on to deny that this "aesthetically acceptable" brand of progress is any less illusory than the orthogenetic variety. In stark contrast to his predecessors, he insists that "there is nothing in the basic structure of the theory of natural selection that would suggest the idea of *any kind* of cumulative progress" (Italics added). No one, he says, would ever have deduced progress from the theory itself. Rather the concept of evolutionary advance "must have arisen from an anthropocentric consideration of the data bearing on the history of life."[5]

Early on in his review, Williams points out that no single standard by which to measure progress has been agreed upon—a fact which makes the whole issue somewhat problematical from the start. Progress, he notes, has meant different things to different people. Thus some authors define progress as an increase in mophological or behavioral complexity, others as any evolutionary trend in some arbitrarily designated direction,

still others as an increase in the effectiveness of adaptation, and so forth. Williams insists that neither these nor any other criteria yet proposed are completely objective, and as such do not provide an indisputable basis upon which to formulate impartial judgments. As a particularly notorious example he cites the naive idea that an increase in structural complexity is synonymous with progress. It is widely assumed, as Williams notes, that the simplest organisms are the most primitive, while the more complex ones represent a higher degree of evolutionary development. Thus the bacteria, which number amongst the simplest creatures in existence, are generally classified as the lowliest of all living things, while man, being the most complex, is traditionally awarded the top spot on the evolutionary ladder. Among all intermediate organisms, too, there is an alleged correlation between relative complexity and evolutionary advance. But Williams suggests that this idea is misconceived, arguing that an increase in morphological complexity does not necessarily imply progress, or *vice versa*. Most people, he writes, would readily concede that the modern jet-powered aircraft is a more advanced machine than the old propeller-driven craft. But this need not imply that the improvement has involved an increase in complexity. On the contrary, in its basic plan the jet is actually much simpler, but it represents a greater achievement of engineering, and is in almost every respect a superior engine. In fact the jet has rapidly replaced its ancestor in both military and commercial applications. The propeller-driven aircraft may not be facing total extinction, but its utility in most fields has long since diminished to nothingness, and it has lost considerable ground in many others.

What applies to man-made machines, Williams goes on to suggest, applies equally to living beings. In the world of organic nature, as in the world of human artifice, adaptive changes do not always entail increases in complexity, and increases in complexity do not necessarily imply improvement. In many animal populations evolutionary development has involved a *reduction* in number and complexity of parts. Among some groups of parasites, for example, evolution has led to the loss of organs and a degeneration of the nervous system; and in

vertebrates, reductions in numbers of teeth and skeletal components has been quite common. It is as usual for adaptive evolutionary change to be accompanied by structural simplification as by complication. Complexity of structure, where it occurs, is not necessarily beneficial of itself; on the contrary, it carries with it certain inherent disadvantages, since it inevitably results in a greater probability of mechanical failure. The most structurally complex organisms are also the most highly susceptible to physical and psychological breakdown.

The history of life on Earth is replete with examples of simple organisms far outstripping their more complex counterparts, both in terms of resilience and longevity: the 'lowly' springtail has survived with little change for the past 300 million years, outliving countless so-called 'higher' animals, like the mastodon, the saber-toothed tiger, and the very humanlike australopithecines; sharks still exist in great numbers, while their reptilian competitors have all become extinct; during the Pliocene epoch (between five and two million years ago) many of the 'higher' mammalian carnivores and primates passed into oblivion, while at the same time the more 'primitive' mammals and lower groups were largely unaffected. Clearly, the notion of evolutionary progress through increasing complexity is wholly inconsistent with the empirical fact that the springtail, and other 'primitive' organisms like it, have remained relatively unchanged for hundreds of millions of years while at the same time their less conservative offshoots were 'advancing' all the way to extinction.

To some observers progress in animal evolution means an increase in the specialization of tissues. Thus it is sometimes pointed out that mammalian tissues are physiologically more specialized than those of a fish, while fish tissues are in turn more specialized than those of a fiddler crab, and so on. Such specialization, moreover, normally corresponds with an increase in the variety of organs and limbs that can develop, which in turn is associated with an increase in the variety of behaviors and physiological functions that can be accomplished. But, according to Williams, this is only one side of the

story. It must be borne in mind, he insists, that tissue specialization is acquired only at a price, that being the concurrent loss of the ability to regenerate severed parts. He points out that the most primitive organisms actually have the *highest* degree of regenerative ability, and that this ability tends to be lost as one 'ascends' the evolutionary ladder. Flatworms, for example, regenerate better than reptiles, and reptiles better than mammals. Thus while a lizard can readily regenerate a lost tail, a human being cannot regenerate an amputated arm. Furthermore, Williams notes, the concept of progress as tissue specialization would ultimately result in a peculiar and distinctly unappealing hierarchy of life forms. This is because such cell-constant organisms as rotifers and roundworms have the most specialized tissues of all, and by the present criterion would have to be classified higher than humans.

There are other arguments in favor of progressive evolution but Williams dismisses them all as equally untenable. Almost without exception the criteria of ostensible progress "adhere to the forms of an earlier orthogenetic doctrine even though the doctrine is almost unanimously discredited. It would be in line with current practice to note that evolution has, in fact, produced an organism of special interest, such as man or the horse. Progress is then arbitrarily designated as any change in the direction of man or horse."[6] As Williams sees it, there is no particular harm in using terms like 'progress' and 'advance' to indicate conformity to common evolutionary trends or approach to some arbitrarily designated final stage, but "the acceptance of the term in this sense can disguise its use in other senses." Thus mammalogists, on the basis of objective and factual evidence, classify the primates into suborders, families, and species, and then arrange these categories in linear fashion, with prosimians at the beginning and man at the end. Unfortunately, "the acceptance of this classification then makes it easy to imply that progress toward man is a recognized evolutionary principle that has operated throughout the history of the primates." Williams concludes: "I suspect that evolutionary progress and the inevitability of man may seem like scientific

ideas only because of our heritage of such orthogenetic terms as 'higher' or 'advanced' organisms and the fact that a list of taxonomic categories has to have a beginning and an end."[7]

True evolutionary progress, if it could be said to exist at all, would involve the *accumulation* of adaptations—the acquisition of new adaptations without the simultaneously loss of old ones. But according to Williams this simply does not occur. At no time is a new adaptation ever evolved except at the loss of an already established one, so that there is no real gain, and nothing that could possibly merit being called 'progress" The original four-legged animals became better walkers only at the price of becoming inferior swimmers. The mammals developed versatility through tissue specialization, but in so doing forfeited the ability to regenerate lost parts. Chimpanzees and other 'higher' primates evolved arms and hands, but thereby lost their front legs. The elephant gained virtual immunity from predation by evolving enormous size, but in the process greatly increased its requirements for food. And so on. In every case evolutionary change meant, not *improvement,* but *adjustment* to changing circumstances and changing selective pressures. Evolution, with whatever trends it may have entailed, was never anything more than a by-product of the maintenance of adaptation. At the end of a million years of evolving a given organism would almost always be somewhat different in appearance from what it was at the start, Williams concedes, but in every important respect it would still be exactly the same: it would still show adaptation to its particular circumstances, it would still face competition from its rivals, it would still have to struggle to survive and reproduce, and ultimately it would still end up very dead—oblivion is the inevitable fate of every living thing, whatever its position on the 'scale of being'.

Sometimes evolution occurs very slowly, sometimes very fast. But the point is that it never occurs quite fast enough to keep up with the *need* for change. So long as the external environment continues to change, intense natural selection is required just to enable existing organisms to maintain the same level of adaptive stability. Moreover, since every organism is itself a component of its own environment, every evolutionary

change in it is also a change of the environment to which it must adapt by continuing to change. Living things must therefore always be catching up with the environmental changes caused by their own and each other's evolution. This tendency of the physical and organic environment to decay more rapidly than its inhabitants can evolve is what Leigh Van Valen has dubbed the 'Red Queen' principle,[8] named for the character in Lewis Carroll's novel *Through the Looking Glass*. As the Red Queen tells Alice, so long as the world is changing, we must keep moving just to stay where we are. And if we want to get anywhere, we must go faster still.

If all this seems too abstract or hypothetical, or if the reader remains convinced of the necessity or inevitability of evolutionary progress, consider a specific example of an evolutionary change that has actually led to a *decrease*, rather than an increase, in adaptive efficiency. Hundreds of millions of years ago, when our ancestors were still living in the sea, they extracted oxygen from their acqueous environment by means of their gills, just as the fishes do today. In the course of their adjustment to life on the land, however, they gave up their gills and evolved a new kind of breathing apparatus, the lung. This of course is precisely the organ that we use today to get our oxygen and which we share with our fellow mammals and other land-living vertebrates. Does this mean, then, that lungs are superior to gills in their respiratory efficiency, and that therefore the evolution of the lung constitutes a genuine evolutionary advance? Not at all. The gill is a superior respiratory machine, and does a much more efficient job of extracting oxygen from its environment. Lungs evolved to replace gills, not because they are superior, but simply because they are more appropriate in a terrestrial environment. Were gills capable of functioning in the air, as well as in the water, then it is doubtful whether the lung (or lung-equipped creatures such as ourselves) would ever have evolved. When, however, some 360 million years ago or so, there was a drying up of inland waters and some fishes tried to save themselves by crawling from one shrinking pond to the next, they needed some breathing mechanism other than a gill to keep themselves alive during their precarious overland treks.

As water became scarcer and scarcer, and repositories of water ever more dispersed, some of these fishes, faced with the imminent prospect of suffocation, learned how to breathe without their gills. Using their swim bladder (a small sack of air inside their body that had evolved some time earlier, perhaps as a supplement to the gill, perhaps as a means of maintaining buoyancy in the water), they began to take advantage of the rich supply of oxygen in the air, and the swim bladder soon came to serve the function of a rudimentary lung. Subsequent refinements in the design of that lung eventually transformed it into a full-fledged respiratory machine. It was not by any means a perfect solution to the problem of the early terrestrialized fishes; but at least it allowed them to survive in a new and largely hostile habitat. The evolutionary replacement of the gill by the lung in land-living animals did not necessarily constitute an advance from a primitive to a more perfect state; nor did it by any means involve a net improvement in adaptive efficiency. It was at best a makeshift solution to a difficult adaptive problem, and it certainly did not make better breathers out of poorer ones. Perhaps some evolutionary changes are more genuinely progressive than this one. But science has yet to produce a single unequivocal example of such a change. As the case of the gill and the lung clearly shows, organisms in the course of their evolution do not become better and better adapted to their particular environment through continual improvement and refinement of already existing adaptations. Rather they are forced on occasion to adjust to new habitats, usually because of some environmental crisis, and in the process acquire new adaptations which, while allowing them to survive, do not necessarily make them any better off than they were before, and in the end may even make them worse off.

This suggestion that an animal might actually be worse off, rather than better off, after an evolutionary change may strike some readers as being so outlandish, so counter-intuitive, and so contrary to ingrained popular belief about how the evolutionary process works, that it will be difficult to take seriously. But I believe that the position is defensible, and the reasoning behind it is relatively simple. When an organism is forced to adapt to

new environmental conditions, as we have just seen, it usually (though by no means always) acquires new adaptations, if it manages to survive at all. But these new adaptations are not absolutely superior to the old ones; they are simply more appropriate for the new conditions. So in this sense the animal is really no better off than it was before, but has simply maintained the same level of adaptive efficiency. And in this sense at least there has been neither a loss nor a gain—only an adjustment. But let us suppose that the new adaptation inevitably brings with it certain new difficulties and hardships, or new forms of pain and suffering, that did not exist before. In such a case we could reasonably say that the organism is actually worse off, rather than better off, as a consequence of the evolutionary alteration. In my view, it is precisely the inability or unwillingness of some evolutionary scientists to take account of these new difficulties that has misled them into seeing evolutionary progress where in fact none has taken place. Ernst Mayr, for example, has argued that a certain amount of incidental progress is almost inevitable in evolution, and has suggested that such phenomena as photosynthesis, multi-cellularity, warm-bloodedness, and parental care—to mention but a few of the evolutionary innovations that have occurred since the origin of the first living things—can hardly be described as anything but progress.[9] Can't they? I hesitate to take issue with Mayr, because he is such an eminent scholar, because he has contributed so much to the advance of biological science, and because in many other matters I am inclined to agree with him. But I see nothing progressive in the evolutionary developments that, according to Mayr, are unequivocally progressive. Like most others who believe in evolutionary progress, Mayr has simply failed to take into account the costs, as well as the benefits, of evolutionary change. If one considers only *survivability* and *reproductive fitness*, leaving other factors out of the equation, then it is easy to come to the conclusion that evolution is progressive. But when one considers the drawbacks, as well as the benefits, of any particular evolutionary change, then the matter is not nearly so clear-cut, and what seemed at first sight like progress appears upon closer examination to be anything

but. As I have just suggested, the same adaptation that contributes to survivability and reproductive success can also create new forms of pain and hardship, such that the end result represents anything but an improvement. The costs of evolving are often enormous, and they are not always compensated for by the gains.

As an illustrative example, consider the phenomenon that in layman's terms is known as 'warm-bloodedness', and that in more technical jargon is usually referred to as *endothermy* or *homeothermy*. Some biologists (including, as we have just seen, Ernst Mayr) have argued, or at least implied, that warm-bloodedness is inherently superior to cold-bloodedness, and that the evolutionary transition from the latter to the former is as clear a case as any of genuine progress from worse to better. To be sure, the advantages of warm-bloodedness are manifold and demonstrable, and at first sight its intrinsic superiority would seem to be a matter of self-evidence. But there is another side to the story. However advantageous it may be under certain environmental circumstances, warm-bloodedness is an expensive adaptation to maintain, and its drawbacks are no less demonstrable than its benefits. A careful examination of *all* relevant factors reveals that the case for the alleged superiority of endothermy is not nearly so overwhelming as is sometimes assumed.

Perhaps the best-known of all cold-blooded animals are the reptiles. Technically they are known as *ectotherms,* which simply means that they gain their body heat from the external surroundings, as contrasted with endotherms, like mammals and birds, which must generate their heat internally. Unlike humans and other endotherms, the ectothermic reptiles do not maintain a constant body temperature; rather their internal temperature tends to fluctuate somewhat, in accordance with temperature changes of the external environment. Generally speaking, as the outside temperature goes up or down, so too does the reptile's body temperature—although the animal may also make use of an array of behavioral adaptations to minimize the fluctuation. For the most part this kind of response poses no particular problem, at least not so long as the outside tempera-

ture remains relatively stable and undergoes no sudden drops or prolonged periods of unusual cold. Should this happen, however, the reptile's body temperature may sink to dangerously low levels, resulting in sluggishness or even death. Against such unpredictable changes of climate the ectotherms have little natural defense. Warm-blooded animals, by contrast, have evolved a sort of internal thermostat which allows them to maintain a constant body temperature, even in the wake of considerable outside variation. As a consequence their survival is much less threatened by extremes of cold. By virtue of their warm-bloodedness, birds and mammals are able to survive and even flourish under climatic conditions that would be fatal to reptiles and other ectotherms. One result is that mammals and birds have been able to invade almost every habitat from the equatorial rainforests to the polar ice fields, while reptiles are more restricted in their range and are much less adaptable to mountaintops and arctic climes.

So far, the warm-blooded animals appear to have a distinct advantage—but there is a catch. The problem is that, along with their warm-bloodedness, birds and mammals have simultaneously evolved a greatly increased need for food. Because they depend on an internal system of body-temperature regulation, warm-blooded animals must take in solid nourishment in relatively large doses so as to keep that system amply supplied with fuel. Cold-blooded animals, by contrast, get most of the energy they need directly from the sun; as such their need for food is much less urgent. A cold-blooded reptile can get by on about one-tenth as much food as a mammal of comparable size. The average chameleon can survive on a diet of one large insect per day, and some species of snake eat no more than a dozen times a year. Many endotherms, by contrast, must spend the greater part of their waking lives foraging, feeding, and fending off competitors. Because of their urgent food requirements, warm-blooded animals generally lead much more hectic and more hazardous lives. Many have evolved aggressive and territorial instincts as an aid in the protection of limited resources; on occasion they engage in fierce battles to defend their territories, sometimes with fatal results. Meanwhile, among

most free-ranging populations of warm-blooded birds, it has been estimated that fully one-third of all adults, and over four-fifths of all adolescents, die of starvation each year.[10]

That humans, like other mammals and like birds, are warm-blooded creatures, is a matter of common knowledge, but the inherent disadvantages of warm-bloodedness are much less popularly known. Whether human beings, like many other endotherms, are by nature aggressive and territorial, is a matter of controversy, and the debate will not be taken up here. It seems certain, in any case, that much human conflict involves competition over scarce resources, and that a scarcity of resources, where it occurs, is as much a function of our warm-blooded nature as it is a matter of genuine scarcity. If we *needed* less food, then our conflicts over food would be proportionately less frequent and less severe. Moreover, it is a fact that one of the reasons that we humans much work in order to earn a living is because of our great need for food, which in turn is a function of our evolutionary heritage as warm-blooded creatures. Finally, the widespread occurrence of human starvation is in part a consequence of our critical need for solid nourishment.

The benefits of warm-bloodedness cannot be denied and should not be ignored. Under conditions of extreme cold, endothermic animals often enjoy a distinct 'advantage',[11] at least insofar as their ability to stay alive is concerned. But warm-bloodedness, for whatever 'advantages' it may bestow, inevitably carries with it enormous costs: if it has added something to raw survivability under specific environmental circumstances, it has also made life more difficult, and in some ways more perilous. In the end it has created pathways to death that had never existed before. One can only imagine how many billions of warm-blooded birds, mammals, and humans have met their demise whilst in the pursuit of food which, had they not been warm-blooded, they would never have needed.

To the extent that it entails both 'advantages' and disadvantages, moreover, warm-bloodedness is no different from any other characteristic trait of our species. There is no human adaptation, either physical or psychical, the evolution of which

has not brought with it new kinds of suffering and hardship, including and especially those which are customarily spoken of as man's most triumphant advances. Traits like bipedalism, intelligence, adaptability, sexuality, sociality, and all the other hallowed 'blessings' of our existence have each, in one way or another, contributed to the difficulties that being human often entails. The specific disadvantages of these and other distinctly human traits will be discussed in detail in later chapters—for now, suffice it to say that none of them represents anything that would even remotely qualify as an evolutionary advance.

Is Evolution Perfective?

Belief in the progress of evolution is closely correlated with the misconception that natural selection always comes up with the best possible solution to any adaptive problem. Thus popular myth still has it that no new adaptation ever arises unless it is destined to be of some benefit to its possessor; that every adaptation, once established, inevitably undergoes further refinement until it is perfected or optimized; that maladaptive traits are always and invariably selected against; and finally, that any trait that ceases to have a viable function will be quickly lost in the process of evolution. Unfortunately, none of this is true. Natural selection is often powerless to prevent harmful traits from evolving in the first place, and is often quite ineffective in weeding them out once they occur. Those who assume otherwise are simply giving nature too much credit. It is almost a platitude that there is no perfection in nature or any of her processes, but it's sometimes forgotten that natural selection is no exception to this rule. Indeed, given the material it has to work with, there is only so much that natural selection can do, and certain imperfections of design are the inevitable results of its inherent limitations.

Evolution, as Francisco Ayala has noted, is essentially a two-step process. In the first step genetic variation is created by the occurrence of random modifications in the individuals of a population. In the second step, beneficial modifications are

adopted and harmful ones discarded through natural selection. Reduced to its simplest terms, evolution is nothing more than that, and at first sight one would hardly expect that in so simple a process anything could possibly go awry. But the process isn't really so simple at all. On the contrary, when examined in its full detail, evolution reveals a horde of complications and imperfections, and there is in fact no end to the maladaptations that it can create and, once having created, maintain.

Evolution begins with the creation of new variation, a relatively rare occurrence which comes about when the genetic material, in the process of being transmitted from parent to offspring, undergoes a sudden and irreversible change. In most cases genes replicate themselves with amazing fidelity, such that daughter genes represent exact copies of their parents, and, all other things being equal, produce like effects. On occasion, however, a gene is subject to some unusual environmental stress and fails to duplicate itself with complete fidelity. Such genes of modified type are known as *mutations,* and they represent the ultimate source of all evolutionary change. Clearly, it would be a fortunate circumstance indeed if every mutation were of some adaptive value to the organism in which it occurs, but this turns out not to be the case. On the contrary, most mutations are actually harmful, causing decreases, rather than increases, in adaptive stability. And while this fact may strike some people as counter-intuitive, there is no mystery why it is so. Mutations, after all, are essentially random occurrences, and as such they arise without reference to their potential adaptiveness in the environment. That is to say, a mutant trait is no more likely to appear in an environment in which it would be useful than in one in which it would be detrimental. Indeed, since a population is usually more or less adapted to its environment, sudden changes will almost always be maladaptive, just as a large random change in the construction of a watch, say, is not likely to improve its functioning. As to the degree of their deleterious influence, this varies from case to case: some mutations are only mildly damaging to health or vigor, while others are sublethal, killing off most of the carriers. Still others are totally destructive, causing incurable diseases or fetal deaths. (According to

recent estimates perhaps the majority of all human beings have inherited mutant genes, most of which are associated with hereditary diseases, malformations, and frailties of various kinds, such as diabetes and muscular dystrophy. The total store of human suffering that results from such maladaptive mutations would be difficult to calculate but it is certainly enormous and it will only tend to increase as mutation rates go up.) Whatever the odds, however, not *all* mutations are deletetious. Some are neutral in their effect, while others actually exercise some measureable benefit. It is the latter that are the basis of most *adaptive* change.

Once new traits have been created by random mutation (and genetic recombination), there is a general tendency on the part of natural selection to favor the good and eliminate the bad, such that, over the course of several generations, harmful traits tend to be weeded out while adaptive modifications gradually spread to all members of the population. But it doesn't *always* work this way: because of inherent complications in the process, natural selection does not invariably eliminate maladaptive traits, nor does it always favor beneficial ones. From start to finish there are any number of impediments which prevent evolution from operating at ideal efficiency; moreover, even when those impediments are wholly absent, the results are not always for the good.

One of the severest limitations of natural selection is that it cannot either favor or militate against individual traits in isolation from the organisms in which they occur. Generally speaking, natural selection operates on the organism as a whole, not on a separate part of the body or an isolated genetic component. (It is the organism as a whole that either thrives or perishes, not any of its parts or attributes.) The fitness that is selected is the general capacity of the organism to survive and reproduce, not the adaptiveness of different organs and behavioral abilities taken separately. As such the adaptive value of any particular animal is always a matter of a balance of 'advantages' and disadvantages, strengths and weaknesses, assets and liabilities. It is rarely possible for natural selection to completely eliminate the bad without affecting the good, and in

the interest of preserving an overall selective 'advantage', the weaknesses are often maintained.

The situation is further complicated by the fact that there is no simple, one-to-one correspondence between genes and the traits they produce. That is to say, genes do not determine each a separate trait; they determine, jointly and severally, the development of all the traits that an organism possesses at every stage of its life cycle. Thus sometimes a single gene has multiple effects, while at other times a complex of several genes acts in tandem to produce a single trait or system of traits. As a consequence, useless and even harmful traits may be favored by natural selection if they are components of genetic syndromes which also contain some selectively 'advantageous' features. Consider for example the human coccyx, a small triangular bone at the base of the spinal column which represents the only remaining vestige of our ancestral tail. Since the coccyx has long since ceased to be of any adaptive value, one might ask why the gene which affects its development hasn't been lost. The answer seems to be that there *is* no such gene. That is, there is no gene which alone determines the development of the coccyx and nothing else. In the embryo, the coccyx is only a small part of the axial skeleton, which also includes the vertebral column and the skull. The formation of this axial skeleton, which begins with the growth of the embryo, is an integral part of the basic developmental pattern in all vertebrates. In order to get rid of the coccyx, then, evolution would have to effect some drastic changes in the basic embryonic processes of organ formation and differentiation. But the net effect of such changes would be decidedly negative, and so the coccyx remains, however useless it may have become.

A further impediment to the effective elimination of unadaptive genes stems from the fact that such genes are not invariably unadaptive; that is to say, under certain conditions, a normally disadvantageous gene may have little or no effect on its carrier. Under such circumstances, it may completely escape the discriminatory pressures of natural selection. This kind of thing is particularly commonplace among sexually-reproducing

species, like humans, where the mechanics of inheritance are, to say the least, complicated.

It is fairly common knowledge that every human infant inherits 50 percent of its genes from its mother and the other 50 percent from its father, although the precise nature of the resultant admixture is considerably less well-known. In somewhat oversimplified terms, the process of gene-transmission goes like this. Under normal circumstances, every new individual inherits 23 chromosomes from each parent. After fertilization, each chromosome from the father pairs up with its corresponding 'sister' chromosome from the mother, producing 23 matched pairs. The result is that for every gene on a particular chromosome of the father there is a gene coding for the same trait at the corresponding location, or *locus*, of the sister chromosome of the mother. Thus in the new individual there are actually two genes, or *alleles*, which 'try' to influence the development of any particular trait. If the two corresponding alleles for a specific trait match, the individual is said to be *homozygous* for that trait; if they do not match, the individual is said to be *heterozygous*. For example, if a baby inherits a gene for blue eyes from its father and a gene for brown eyes from its mother, it is heterozygous for eye color. If both parents contribute an allele for blue eyes, then the child is homozygous for eye color. In heterozygous individuals, the two disparate alleles sometimes act in concert to produce an intermediate or hybrid effect; other times one gene represses the effect of the other, in which case the repressed gene is said to be *recessive*, the active one *dominant*. Because recessive genes in heterozygous individuals have no effect on the actual appearance or behavior of the organism, natural selection cannot affect them. That is to say, if a gene does not affect its carrier, then selection cannot affect the gene. As an example of this phenomenon consider cystic fibrosis, one of the more common recessively inherited diseases of humanity. Victims of this genetic defect usually fail to thrive and generally die before adolescence. We might therefore expect the gene for cystic fibrosis to be the object of intense negative selection and on its way to oblivion. Unfortunately this

is not the case, because cystic fibrosis strikes only those who are homozygous for the trait. And while the latter almost always die at an early age, the deleterious gene continues to be transmitted by heterozygous carriers, who themselves are not afflicted by the disease.

In this particular example, and in many others like it, the effect of the recessive gene in heterozygous individuals is essentially neutral. That is to say, the heterozygote for cystic fibrosis is neither adaptively inferior nor superior to someone who inherits no cystic fibrosis gene at all. But heterozygosity and neutral effect do not always go hand in hand. On the contrary, in some instances heterozygotes may actually enjoy a distinct adaptive 'advantage' over either homozygote with two copies of the same allele. In such cases a gene that is completely lethal in homozygous combinations may actually be favored by natural selection, if indeed its effects in heterozygous individuals are demonstrably beneficial. The most infamous example of this phenomenon—technically known as 'heterozygote advantage'—occurs in humans. It is the sickle cell trait.

Sickle cell anemia, an inherited disease, is currently a serious debilitating condition among many black populations. A child who inherits the sickle cell trait has only about one-fifth as much chance as other children of surviving to maturity. In fact the vast majority of sickle cell anemics die in childhood or early adolescence. Those few who survive to adulthood are afflicted with a chronic illness punctuated by painful crises when blood supply is cut off from various body organs. Because sickle cell anemia is such a devastating disease, scientists were for many years at a total loss to explain why natural selection had done nothing to eliminate the gene which causes it. By the mid-1950s, however, the mystery had been solved.

It is now known that sickle cell anemia afflicts only those individuals who inherit the sickle cell gene from *both* parents, in other words those who are homozygous for this trait. A child who receives the sickle cell gene from one parent and a normal hemoglobin gene from the other is usually not susceptible to the disease. On the contrary, heterozygotes, in addition to being protected from sickle cell anemia, seem also to enjoy a

greater resistance to malarial infection than do individuals with two normal blood cells. Apparently the sickled cells of hetero-zygous individuals resist invasion by the malarial parasite, and as such the heterozygote is conferred a high degree of immuni-ty. It is this selective 'advantage' which maintains a high frequency of a gene which is so devastatingly harmful in double dose but decidedly beneficial in single dose. Since people with normal blood cells are often weakened or killed by falsiparum malaria, the sickle gene will continue to be favored so long as malaria exerts its selective influence.[12]

Sometimes a congenital disease may escape negative selec-tion even though it is transmitted by a dominant allele because it does not interfere with effective reproduction. A classic example is Huntington's disease. Victims of this hereditary disease suffer a progressive and severe degeneration of the nervous system, which leads to physical and mental incapacity and ultimately to death. But the onset of the disease occurs at various ages, and in many cases the victims appear normal in youth and even into middle age. As a consequence the victims of Huntington's disease often marry and raise large families before the onset of symptoms. By this time, however, the deleterious gene has already been passed on to the next generation, and the death of the original victim is of no evolutionary consequence. The same principle applies to many kinds of inherent weaknesses and vulnerabilities, as for example the Caucasoid susceptibility to skin cancer. In most European populations, skin cancer has always been and still is primarily a disease of the post-reproductive period, which means that it has been largely unaffected by natural selection. (It seems that the life span of prehistoric man was considerably shorter than ours, so that the former usually didn't live long enough to get skin cancer. Consequently his vulnerability to the disease could not have been selected out. Recent increases in the life span of *Homo sapiens* have resulted in proportionate increases in the incidence of skin cancer, an unfortunate circumstance which natural selection has done nothing to prevent.) Susceptibility to appendicitis is yet another frailty which continues to plague humankind, even though the organ from which the disease

emanates seems to have lost whatever adaptive function it may once have had. (It's sometimes assumed that we must be losing our appendixes because we no longer need them, but this is not necessarily the case. The human appendix will become extinct only if individuals born without appendixes consistently produce more successful offspring than those born with them. This may or may not be happening, but even if it is, the process will take hundreds or even thousands of generations. In the meantime, the appendix will continue to exact a heavy toll of death and suffering in almost every human population.)

The list of other known genetic deformities that afflict mankind is distressingly long, and gets longer every year. Almost everyone is familiar with cystic fibrosis and sickle-cell anemia, but there are dozens of other congenital defects, including achondroplasia, a disease of the cartilagious growing ends of leg bones; fragilitus osseum, which causes recurrent bone fractures; phenylketaneuria (PKU), haemophilia, porpheria, galactosemia, Wilson's disease, Tay-Sachs disease, Parkinson's disease, albinism, congenital nephrosis, and so on. Some of these maladies, like cystic fibrosis and anancephaly, are so debilitating as to be incompatible with survival. Others, while not lethal, are so severely limiting that the lives of their victims are significantly blighted, as for example in the cases of Down syndrome, haemophilia, dental malocclusion, androphasia (dwarfishness), pyloric stosis, and deafness.[13] Some recent evidence also suggests that a genetic component may be involved in the etiology of a variety of psychiatric syndromes, including schizophrenia, depression, alcoholism, manic-depression, and even a propensity to commit suicide.[14] Moreover, estimates are that for every known or suspected genetic defect, there are several more yet to be discovered. Some researchers now believe that there may be as many as four thousand such defects in the human genome. And with further research the number may go even higher. In every case mutation has created the maladaptive gene, but natural selection has been powerless to get rid of it.

Natural selection is not completely impotent, whatever the extent of its limitations. On occasion it actually does succeed in

eliminating harmful traits, although one would be hard-pressed to find an example of this phenomenon in the human lineage. In the case of complex organisms such as ourselves, the job of weeding out bad traits without affecting good ones has become a virtual impossibility. As for the other essential task of selection, favoring beneficial characters, it is generally more successful in this realm—although here, too, there are limitations. I have already mentioned that the organism as a whole is the target of selection, not any of its individual characters, so that it is sometimes impossible to improve one component of the whole without simultaneously damaging some other. As a consequence every living thing is a bundle of selective compromises, no single attribute of which is ever likely to be optimized or perfected. Indeed, even if selection were always able to operate at maximum efficiency, always favoring beneficial traits and always eliminating deleterious ones, the results would still be something less than completely desirable. Beneficial innovations, after all, would first have to be generated by mutation; and mutations, as we have seen, are essentially random occurrences; they are not made to order, and they cannot be counted on to produce the best possible response to any particular adaptive need. If mutant genes are sometimes favored, it is only because they sometimes represent the best available alternative from which natural selection is able to choose. The assortment always leaves much to be desired. Even if it were possible for selection to maximize all beneficial mutants, the end result would still be decidedly unsatisfying, and far from ideal.

The process of evolution by natural selection, unfortunately, is incapable of foresight, purposeful design, or planning. Rather, it is automatic, mechanical, planless, and opportunistic. And while its products are sometimes a source of wonder and fascination, its results inevitably fall far short of perfection. Nature patently does not and cannot produce perfect organisms. Even an animal that is more or less 'perfectly' adapted to its particular environment is not a 'perfect' organism in any absolute sense, for—as I shall argue in Chapters 4 and 5—the more perfectly adapted an organism is to its peculiar environment, the more susceptible it is to extinction when that environ-

ment undergoes rapid or cataclysmic change. Conversely, the more adaptable an organism is to varied environments, the less it is adapted to any one in particular. A genuinely perfect organism—if there were any such thing—would be one that was both perfectly adapted to its native habitat and at the same time infinitely adaptable to any other. But because adaptiveness and adaptability tend to be mutually exclusive, no such organism has ever evolved or could evolve. Given that natural selection is the process by which life develops, genuine perfection is a theoretical impossibility, and the apparent perfections of nature appear as such only to those who view them with an uncritical and uneducated eye.

Does Evolution Mean 'Survival of the Fittest'?

Most evolutionary scientists would probably prefer that the popular adage 'survival of the fittest' had never been invented. Indeed, few contemporary biologists still use the phrase—except paralinguistically—and with good reason. As we shall see, 'survival of the fittest' does not at all adequately represent the nature of the evolutionary process, nor does it accurately reflect the workings of natural selection. At best the popularity of this aphorism has succeeded in giving the general public some rough idea of what evolution is all about; unfortunately, that rough idea is essentially incorrect.

Contrary to common belief, Charles Darwin did not coin the phrase 'survival of the fittest'. Rather it was the brainchild of British philosopher Herbert Spencer, a man whose ideas about evolution were not always accurate. True, Darwin used the phrase on occasion in the later editions of his *Origin of Species,* but somewhat reluctantly, it seems, and only at the urging of friends. For his part Darwin preferred the term 'natural selection', which he had invented himself. He did, however, succumb to pressure from his colleagues, many of whom thought the term 'natural selection' was too suggestive of an intelligent being that was supposedly doing the selecting. Were it not for Darwin's reluctant decision to follow this

dubious counsel, it is quite probable that Spencer's phrase 'survival of the fittest' would never have made its way into the vernacular. But alas, with the publication of the fifth edition of the *Origin of Species,* the damage had been done, and professional evolutionists have been trying to undo that damage ever since.

The first problem with Spencer's choice of terms is the implication that, in evolution, survivability is the fundamental measure of fitness, and therefore that natural selection always favors better survivors over poorer ones. This is not the case. What is really being favored by natural selection is not survivability *per se,* but rather the ability to survive *and reproduce*—or what biologists call 'reproductive success'. The 'fittest' organisms, from a strictly evolutionary point of view, are not those that lead the longest or healthiest lives, but rather those that produce the greatest number of successful offspring. Survivability is favored only indirectly, that is, only to the extent that survival is a prerequisite to reproduction—obviously no organism can reproduce unless it first lives. But where there is a conflict between longer life and increased prolificity, the latter will always be favored over the former. According to George C. Williams, the early onset of aging and death has actually been favored in many lineages, because in them the same genetic changes that shortened life span have led to greater fecundity in youth.[15]

As for the word 'fittest', most non-biologists take this to mean 'best', but this is only true if by 'best' one means most reproductively successful. The term *fitness,* when used in the evolutionary sense, refers to reproductive success alone, and does not necessarily have anything to do with health, vigor, longevity, or any other trait which humans might deem aesthetically desirable. The 'fittest' individuals are not necessarily stronger, taller, more robust, or more resilient than their less fit competitors. All that is indicated by a high fitness value is a relatively greater ability to contribute to the gene pool of the next generation by leaving larger numbers of offspring. It is in any event quite incorrect to assume that only the fittest survive, as Spencer's phrase would tend to imply. All but the least fit

may be said to be favored by natural selection. This is because, in the competition for reproductive success among members of a population, it is sufficient to be just good enough to get by, and not at all necessary to be superlative in any way. Selection, in other words, is more a mechanism for eliminating the worst than promoting the best. It actually favors the moderately fit and the marginally fit as well as the very fit, and in so doing tends to perpetuate the very weaknesses and imperfections that impede ideal adaptation. (Imagine, for example, a hypothetical organism that is very far from being the fittest of its kind, and yet somehow manages to survive and reproduce, despite all its shortcomings, and largely by virtue of an obstinate resolve to endure. In some ways its success may seem a good thing, but the problem is that its offspring will tend to inherit all its own shortcomings, and in turn will be faced with all the same obstacles to survival. If the offspring in turn manage to survive and reproduce, then they too will pass on their same genetic equipment, however imperfect, to the next generation. Indeed, in such a case it will be the strong instinct to survive that will be favored by natural selection, perhaps at the expense of physical adaptations which might otherwise serve to make the organism more perfectly adapted anatomically to the environment it inhabits.)

Does Evolution Occur 'for the Good of' the Species?

It seems to be a common belief that nature's prime 'concern' is for the survival and welfare of the species as a whole, rather than individual organisms. Thus many people still assume that all natural selection occurs at the level of, and for the good of, the species. But this idea, however popular, is almost entirely wrong. Evolutionary scientists are now largely agreed that the prime focus of natural selection is the individual organism, not the group or the species, which is not necessarily to rule out the very possibility of selection at the group or species levels. In fact some evolutionary scientists have recently suggested that selection may occur at a number of different levels. According to

these theorists, natural selection may be 'hierarchical', with some selection occurring at the level of the individual, some occurring at levels 'above' the individual (at the level of the group, the species, or even the ecosystem), and some occurring at levels 'below' that of the individual (at the level of the gene, or perhaps even at the level of the DNA molecules of which genes are largely composed). The following brief history of the so-called 'levels of selection' controversy may help clarify current opinion on this important topic.

The 'good of the species' idea is a very old one. It predates modern evolutionary theory by several thousand years. It was already an integral part of Judeo-Christian cosmology in biblical times, and has enjoyed widespread currency ever since. Even Darwin was at first misled by this popular idea, assuming that whatever competition there exists in nature must be one of species against species rather than individual against individual. Darwin's preconceptions, however, were severely shaken when, in 1838, he happened to reread a copy of Malthus's famous *Essay on the Principle of Population*. Malthus's thesis was simple: since living things tend to multiply geometrically, and since the means of support can at most be multiplied arithmetically, there inevitably ensues a struggle for survival as competitors scramble for available resources.[16] Eventually Darwin came to realize that this struggle for existence due to competition is a phenomenon involving individuals, not species. In any given population, he reasoned, it must be those individuals that have the most appropriate combination of adaptations for coping with the environment—including competitors and enemies— that have the greatest chance of surviving and of producing successful offspring, always at the expense of those that are less adapted.

Darwin did not assume, however, that cut-throat competition is the universal law of nature, or that every living being is wholly at odds with every other. In fact he knew from his own observations of animal behavior that this was not at all the case. As he frequently observed, animals often co-operate with one another, and sometimes even go out of their way to help one another. Darwin believed, however, that such examples of

co-operation could be accounted for without abandoning the idea of individual selection, and without necessarily assuming that such co-operation occurs 'for the good of the species'. As he noted, and as most present-day scientists would agree, almost all examples of intra-specific co-operation are better interpreted as instances of enlightened self-interest than as self-sacrificial martyrdom performed 'for the good of the species'. In nature, Darwin reasoned, there often arise cases where the best way for an individual to promote its own survival and reproductive success is by co-operating with other individuals. In such cases, natural selection can be expected to favor co-operative behavior, whether such co-operation serves the interests of the group as a whole or not. In sum, whenever the interests of two individuals overlap, they can be expected to co-operate with each other for their own mutual benefit. And there is no need to invoke group selection or species selection pressures to account for such interactions.[17]

All this seems plausible enough, and it is almost entirely supported by empirical evidence that has come to light since Darwin's day. Almost all recent research in the field of animal behavior has tended to confirm Darwin's interpretation of social life and his insistence on the primacy of the individual organism as the unit of selection. For this and other reasons, Darwin's ideas on this matter are now widely accepted by evolutionary scientists, most of whom concur entirely with the Darwinian model of individual selection and the Darwinian interpretation of social co-operation as a kind of enlightened self-interest. The basic model of individual selection, however, has never been universally accepted, and challenges to it have been fairly common throughout the history of evolutionary science. Apparently some scientists have been so overwhelmed by examples of social co-operation and apparent self-sacrifice in the animal world that they have been unable to accept the Darwinian model and have turned to group selection, or even species selection, as an alternative. One such scientist is the Scottish biologist V.C. Wynne-Edwards who, in 1962, posed what was perhaps the most dramatic challenge to the Darwinian model in a voluminous book entitled *Animal Dispersion in Relation to*

Social Behaviour. In this oft-cited work, Wynne-Edwards argues that almost all social behaviors—including apparently self-interested ones—are really group-related adaptations that have evolved to ensure the survival of the population by preventing the occurrence of overcrowding. According to this theory, populations that do not control their numbers tend to over-exploit essential resources in their environment, leading eventually to the extinction of the entire group. Natural selection will therefore favor those groups that avoid destroying the supply of foodstuffs on which their survival ultimately depends. In this process of 'group selection', populations that maintain an optimum size—that size at which available resources are neither under- nor over-exploited—will tend to survive and replace populations that fail to practice reproductive restraint. In every case the individual must subordinate its best interests to those of the population as a whole, restricting its own reproductive output so as to prevent overcrowding and imminent extinction.

This hypothesis is a provocative one, and for that reason it attracted quite a bit of attention when it was first proposed back in the early 1960s. Since then, however, it has been universally rejected by professional evolutionary scientists and has even been revised by Wynne-Edwards himself.[18] One of the commonest objections to his thesis is that it too easily writes off all self-interest on the part of individual group members. In fact almost all the examples of apparent altruism and self-sacrifice cited by Wynne-Edwards in his *Animal Dispersion* have since been alternately, and more parsimoniously, explained as cases of disguised self-interest. As such there is no need to invoke group selection pressures to account for them. An even more fundamental objection is that the self-regulation of numbers upon which much of Wynne-Edwards's argument is built has not been shown to occur. There is no conclusive evidence that animals, either consciously or unconsciously, restrain their reproductive output so as to maintain an optimum population size. Indeed, populations are by no means always as stable as Wynne-Edwards seems to have assumed: they do sometimes over-exploit their habitats and do sometimes suffer extinction.

Obviously, if animals are attempting to avoid just this sort of instability through their reproductive behavior, then they are not doing a very good job of it. And it is difficult to imagine a natural mechanism by which they might improve their performance in this regard. With these and other devastating objections having been raised against his theory, it is not difficult to see why even Wynne-Edwards himself has altered his earlier views, and now offers no defense of his original position.

Does this mean, then, that group selection is an impossibility? Apparently not. Some experts now believe that selection can and does occur at the level of the group, at the level of the species, and at many other levels as well. According to these theorists, Wynne-Edwards's particular model of group selection may have been wrong, but this does not necessarily rule out the possibility of group selection *per se.* The ecological conditions which give rise to selection at the group level may be different from those which Wynne-Edwards had imagined, but they are not necessarily any less real or even any less frequent. And just what, precisely, are the ecological conditions which are supposed to give rise to selection at the group level, according to these theorists? A good question, and one which most of them have found very difficult to answer. In fact whenever group selection theorists stop theorizing and start looking for empirical data to support their point of view, they usually find more difficulties than data. Some of these theorists, to be sure, have managed to create group selection in the laboratory, but such laboratory experiments are not compelling precisely because they involve highly artificial conditions the kinds of which are not likely to occur in natural populations. As many Darwinian selectionists (most notably among them George C. Williams) have pointed out, natural populations tend to be extremely intransigent to group selection pressures. Imagine, for example, a population of 100 animals consisting of 50 self-interested individuals, each of which strives to survive and reproduce as best it can, without particular regard for group benefit, and 50 altruistic individuals, each of which foregoes personal reproduction and stands ready, if necessary, to sacrifice itself for the good of the group. How will each kind

of individual fare? The answer, as many Darwinians have pointed out, is all too obvious. The self-interested individuals will propagate themselves *ad libitum* and produce as many offspring as practical restraints allow. The altruists, in the meanwhile, will produce few or no offspring, and their genes, as a result, will begin an ineluctable march toward oblivion. Thus within a single generation, or perhaps a few generations, all self-sacrifice for the good of the group (and all genes which tend to promote such self-sacrifice) will be eliminated from the population, and self-interestedness will come to dominate social behavior. Under such conditions—and such seem to be the characteristic conditions of natural populations—group benefit simply cannot over-ride individual self-interest, and group selection cannot take hold.

In spite of this and other similar theoretical arguments, the idea of group selection has not been entirely abandoned. Some scientists still believe that selection can occur at super-individual levels, and arguments for this position are still being put forth with no lack of enthusiasm. Thus for the moment the debate remains unresolved, and no doubt it will remain so for some time to come. Apparently more data will have to be collected before the controversy can be definitively settled. In the meantime, the professional literature on the 'levels of selection' question has become so voluminous that I cannot begin to consider it here in any detail. Yet in spite of the disagreements, there are at least three tentative conclusions which may be drawn at the present time concerning the relative significance of individual, as opposed to group or species levels of selection. First, it is evident that most (if not all) selection occurs at the level of the individual organism. Indeed, even if we assume group selection and species selection pressures to be both frequent and potent, it is obvious that they have by no means completely superseded selection at the level of the individual organism. And those few scientists who, like Wynne-Edwards, have attempted to write off individual selection altogether have been almost universally contradicted by their professional colleagues. In short, the popular notion that all selection occurs at the level of the species, or 'for the good of'

the species, is essentially incorrect.[19] Second, if most (if not all) selection occurs at the level of the individual, we would expect most competition in nature to occur among members of the same species, rather than between members of different species. And this, by and large, is just what we find. Examples of *intra*specific competition are so numerous that they could easily be cited by the hundreds, while cases of *inter*specific competition are much rarer by comparison. Since conspecifics are similarly constituted and have similar biological needs, they are much more likely to come into conflict with one another than are members of different species. Thus most observable competition in nature, especially competition for access to mates, occurs among conspecific organisms. Finally, it is not necessarily the case, as some scientists have intimated, that group selection is inherently and wholly benign, especially not from the point of view of the individual group member. Apparently some evolutionists, in particular those who like the idea of group selection, are under the impression that selection at the level of the group or species is a 'good' thing because it supposedly tends to mitigate conflicts between competing individuals and therefore to promote group harmony and stability. According to this way of thinking, group selection is entirely to the benefit of the individual, as well as the group, and is therefore preferable in some subjective or aesthetic sense to individual selection. But is it really? As Edward O. Wilson has pointed out, group selection does not necessarily lead to greater co-operation among individuals: in fact it may even promote aggressive and murderous behavior. Suppose, for example, that a population has become too crowded, so that a reduction in population growth would be beneficial to the group as a whole: in such a case an individual 'altruist' would be acting in the interest of group survival if it spent most of its spare time cannibalizing other members of the population.[20] Thus selection at the level of the group or species does not necessarily promote either co-operative behavior or individual welfare and may actually militate strongly against both. This is a point which Arthur Schopenhauer attempted to make more than a

century ago. Like most of his contemporaries, Schopenhauer believed that nature's prime concern was for the 'good of the species'. But unlike most of his contemporaries, and unlike most group selectionists today, he did not regard this as an optimistic proposition. On the contrary, as he noted, to the extent that group survival or species survival is the primary goal of nature, then the survival of individual organisms becomes completely subordinate to that of the group as a whole. And in such cases the welfare of the individual becomes entirely secondary. Here is how Schopenhauer put it:

> it is not the individual that nature cares for, but only the species; and in all seriousness she urges the preservation of the species. . . . The individual, on the contrary, has no value for nature, and can have none, for infinite time, infinite space, and the infinite number of possible individuals therein are her kingdom. Therefore nature is always ready to let the individual fall, and the individual is accordingly not only disposed to destruction in a thousand ways from the most insignificant accidents, but is even destined for this and is led towards it by nature herself, from the moment that individual has served the maintenance of the species.[21]

The assumption that group selection is a 'good' thing is a fallacy. And individual selection is no better. To the extent that selection occurs at the level of the individual organism, it tends to promote conflict of interest between competing individuals. And to the extent that selection occurs at the level of the group or species, the survival and welfare of the individual become ever less important, and individual self-sacrifice becomes ever more necessary for the maintenance of group or species survival. As such the answer to the next question should perhaps be obvious even before it is asked.

Does Evolution Occur 'for the Good of' the Individual?

As I have just suggested, the answer is definitely 'no'. It may be true that most selection occurs *at the level of* the individual

organism, but it does not necessarily follow, and it is not true, that selection occurs *for the benefit of* the individual. Indeed, when one considers the relative longevity and the relative sensitivity to pain of individual organisms as opposed to groups, species, genes, and DNA molecules, it is clear that neither the survival nor the welfare of individual organisms counts for very much in the natural scheme of things. In fact the individual organism is by far the most short-lived of all the entities just mentioned: populations or species often persist for millions or even tens of millions of years, as do genes and DNA. But individual organisms seldom last more than a decade or two, and many of them perish after only a few hours, days, or weeks. As regards sensitivity to pain—here there is no comparison at all. Individual organisms are the only entities in nature that experience pain. Genes and DNA molecules do not suffer pain, nor do populations or species, except insofar as the individual organisms of which they are composed do so. It would appear, in short, that the benefit of the individual organism is of precious little significance to the eternal processes of nature. Why should this be the case, then? Why does the welfare of the individual count for so little in the evolutionary scheme of things? In recent years many scientists and philosophers have attempted to answer this question, and although their explanations have on occasion taken the form of psuedo-scientific and quasi-metaphysical argumentation, it is quite possible to account for the apparently lowly status of the individual organism without resorting to metaphysical pleading. As I have mentioned, much selection occurs *at the level of* the individual organism, but not necessarily *for the benefit of* the individual. And the explanation for this paradox is relatively simple. As Richard D. Alexander and Gerald Borgia have noted,[22] the individual organism may be the *unit of selection,* but it is the gene that is the *unit of inheritance.* That is to say, when complex organisms reproduce themselves, they do not literally reproduce themselves *in toto.* Rather they pass on a small part of themselves, their genetic material, to their offspring, after which the latter develop into entirely new individuals. Thus the

only part of the parent organism that survives in the offspring is the former's genes, and the DNA molecules of which those genes are largely composed. Since only genes can survive from generation to generation, it is ultimately the survival of the genetic material itself that 'matters'. Natural selection can be expected to favor those organisms that pass on the greatest amount of their genetic material to the next generation. Whichever traits are useful in preserving and perpetuating the genetic material will tend to be favored, whatever their effect, good or bad, on the individual organism itself. Thus if a trait that contributes to the reproductive success of genes also happens to cause the organism itself a great deal of pain, this is of no consequence to the selective process *per se*. The gene itself, after all, does not experience pain. And if it can increase its own survival ability by increasing the capacity for pain of the organism in which it is encased, then it will be to its own adaptive 'advantage' to do so. The central role of the organism itself in this process is to perpetuate the genetic material which it carries in its body. And in this scheme of things the welfare or comfort of the organism itself simply does not matter, and is of no evolutionary significance.

There seems to be a popular misconception that natural selection invariably favors the evolution of mechanisms that lead to increases in the health and wellbeing of the individual organism, but as should be obvious by now, this simply isn't the case. Generally speaking, each organism is selected for on one basis and one basis only, its average ability to contribute to the gene pool of the next generation. Its relative health or happiness is of no particular relevance. Darwinian fitness is reproductive fitness, not necessarily fitness for social or aesthetic wellbeing. As Donald Symons has pointed out, natural selection favors organisms that maximize their reproductive potential; it does not necessarily favor simplicity over complexity, co-operation over conflict, happiness over malcontent, or a long life over a short one. If miserable, ill-tempered, and sickly individuals produce more successful offspring than their happy, good-natured, and longevous competitors, then natural selection will

favor the spread of misery, pugnacity, and sickliness. The essential 'aim' of nature is the perpetuation of genetic material; the quality of life is of no evolutionary consequence. David Barash explains:

> Let us imagine two alternative alleles, A and A', competing for a given locus in the gene pool of a population. Assume that A differs from A' in that it predisposes its carriers to be less reproductively inclined than does A'. What would be the fate of these two alleles? In many ways, the carriers of A (the less reproductive alleles) may be healthier, happier, and possibly even live longer. But A would quickly disappear from the population, to be replaced by A'. In other words, evolution by natural selection would insure that populations would be composed of individuals, each of whom has the capability and inclination to reproduce. Insofar as living things experience any evolutionary imperative, it is the imperative to reproduce.[23]

Michael Ghiselin, in his *The Economy of Nature and the Evolution of Sex,* makes a similar point. He writes that "we have evolved a nervous system that acts in the interest of our gonads, and one attuned to the demands of reproductive competition. If fools are more prolific than wise men, then to that degree folly will be favored by selection. And if ignorance aids in obtaining a mate, then men and women will tend to be ignorant."[24]

Evolutionary change does not and cannot produce genuine improvements in the quality of life. It does, on occasion, create new capacities for joy and pleasure, but these are never evolved except in conjunction with equal and equivalent capacities for pain and suffering. The pleasureableness of sexual intercourse might be cited as an example. Clearly the capacity to enjoy sexual activity is highly adaptive, and for that reason it has been favored by intense natural selection. But the pain of sexual frustration is just as adaptive, and has been favored just as intensely. Indeed, pain and frustration in general tend to be selected for, rather than against, because they often aid the genes in perpetuating themselves through the many generations of their long-suffering carriers. Sensitivity to pain tends to increase, rather than decrease, as evolution plods along.

Is Nature Benevolent?

The assumption that natural selection operates for human benefit is a corollary of the popular notion that nature in general is beneficent, that whatever is natural is good, and that whatever is good is natural. For thousands of years, and perhaps for as long as they have existed, human beings have been inclined to believe that nature is a benign creator and nurturer; that she exists primarily to serve mankind; and that that human action is best which is modelled after her consummate example. Praises of nature pervade the pages of Western thought from Plato to Rousseau, and are by no means uncommon even today. To the extent that belief in the essential benevolence of the universe has suffered any erosion at all, credit must go to those rare thinkers who have taken the time to expose the true nature of nature.

It was in the eighteenth and nineteenth centuries that the glorification of nature reached its most extravagant heights, and inevitably sparked a revolt. One of the leading figures in that revolt was British essayist and philosopher John Stuart Mill. Most of Mill's contemporaries were fully convinced of the benevolence of nature; some went so far as to advocate that human society be patterned after the cosmic model. Mill, for his part, had very different ideas, and he did not hesitate to express them in writing. In 1854, he completed a rather remarkable essay in which he posed sweeping challenges to every traditional assumption of his time about nature and its workings. The piece, entitled simply 'Nature', was first published in 1874 as part of Mill's *Three Essays on Religion,* and has, in the meantime, attracted uninterrupted attention from scientists and philosophers alike. Today it remains one of the most caustic indictments of nature every committed to print.

If there be any doubt about the true spirit of nature, Mill suggests in his essay, one need only contemplate the barbarity of her works and the crassness of her disregard for human welfare. Nature, he writes, "impales men, breaks them as if on the wheel, casts them to be devoured by wild beasts, burns them to death, crushes them with stones like the first Christian

martyr, starves them with hunger, freezes them with cold, poisons them by the quick or slow venom of her exhalations, and has hundreds of other hideous deaths in reserve such as the ingenious cruelty of a Nabis or a Domitian never surpassed." All this, Mill goes on to say, nature does with the most callous disregard of both mercy and justice, slashing her way through the forest of humanity with an angry sword, bringing down the best and the noblest along with the meanest and the worst, destroying even those who are engaged in the worthiest and most honorable of enterprises, and often as the direct consequence of noble deeds. Without the slightest hint of compunction, "she mows down those on whose existence hangs the well-being of a whole people, perhaps the prospects of the human race for generations to come."

Next to destroying life, Mill writes, is the destruction of the means by which we live; and nature does this, too, "on the largest scale and with the most callous indifference." A single hurricane destroys a village or a district; a drought dessicates the crops upon which thousands depend; a torrential flood washes away our homes, our property, and our food; a tiny change in the chemistry of an edible root starves a million people. Tornadoes, typhoons, earthquakes, and tidal waves, like marauding bandits, swallow up the wealth of the rich and the little all of the poor with equal fervor, leaving in their wake nothing but a trail of desolation and despair. "Everything, in short, which the worst men commit either against life or property is perpetuated on a larger scale by natural agents." Even the love of 'order' which is thought to be an emulation of the ways of nature is, according to Mill, a contradiction of them. "All which people are accustomed to deprecate as 'disorder' and its consequences," he writes, "is precisely a counterpart of nature's ways."

If Mill's attack against nature seems rather harsh, it must be borne in mind that it was by no means unprovoked—nor was nature herself the sole provocation. Rather his essay was, in large part, an editorial reply to the pastoral thought and ethical naturalism that had pervaded eighteenth- and early nineteenth-century Europe. One of Mill's prime targets was Alexander

Pope, who, along with Jean-Jacques Rousseau, represented the movement to make nature a test of right and wrong, good and evil. In his own essay on the subject Pope had gone so far as to declare that "whatever is, is right," including, presumably, war and murder and disease and famine. Mill was quick to expose the sophistry of Pope's reasoning, pointing out that human behavior which echoes the violent behavior of nature is justly punished by men. "In sober truth," Mill argues, "nearly all the things which men are hanged or imprisoned for doing to one another are nature's everyday performances. Killing, the most criminal act recognized by human laws, nature does once to every being that lives, and in a large proportion of cases after protracted tortures such as only the greatest monsters whom we read of ever purposely inflicted on their fellow living creatures."[25] Natural justice and natural innocence, according to Mill, are myths. Violence and crassness are the marks of nature, not peace and justice. To the extent that man achieves any civil progress at all, he does so by conquering nature, not by submitting to its dictates.

Less than twenty years after the appearance of Mill's critique, the renowned evolutionist Thomas Henry Huxley launched a similar assault, insisting that the external forces of the cosmic process (evolution by natural selection) are largely at odds with human striving. In a series of essays beginning in 1888, Huxley argued that nature is a violent and brutal process, inflicting universal suffering on humanity regardless of desert. Men and nature have been at war throughout human history, he declared; it is only the intervention of human systems that has reduced the harshness of the clash. As Mill had done before him, Huxley criticized Pope's famous dictum that "whatever is, is right", and rejected the idea of 'living according to nature' as a misguided ethic—a sort of 'applied Natural History', worthy only of slobbering sentimentalists.

From a completely intellectual standpoint, Huxley wrote in one of his essays, "nature appears a beautiful and harmonious process, from certain premises in the past to an inevitable conclusion in the future." But if it is regarded from a more human point of view; if we allow our moral sympathies to

influence our judgment and permit ourselves to criticize nature as we criticize one another, "then our verdict . . . can hardly be so favourable." The characteristic feature of the cosmic process, Huxley declared, is not harmony or contentment, but rather "the intense and unceasing competition of the struggle for existence." Indeed, struggle and flux are integral components of the process of organic evolution, as Malthus's classic essay on population had so clearly implied. Without the struggle to survive that ensues whenever an unlimited number of rivals competes for limited resources, evolution would not occur, and life as we know it would not exist.

Huxley contrasted the state of nature, and the process of evolution of which it is the outcome, with the 'state of art' produced by human intelligence and exemplified by a garden. In the state of nature, he wrote, living things tend to multiply without limit, far exceeding the capacity of the environment to support them. The result is a continual struggle for existence in which hundreds compete for the place and nourishment adequate for one, and where the weak and unfit are consumed by famine and drought. In the artificial confines of the garden, by contrast, multiplication is carefully controlled and restricted by human intervention. Each plant is provided with sufficient space and nourishment, protected from frost or drought, and in all other respects exempted from the need to struggle or compete for resources. The characteristic feature of the state of nature, Huxley wrote, is the intense and unceasing competition of the struggle for existence. In the garden that struggle has largely been eliminated by the removal of the conditions which normally give rise to it. It is only by counteracting the forces of nature, in other words, that reproductive competition can be restrained and the struggle for survival largely brought to a halt. Like the garden, the kind of society in which most of us would like to live is one where the need to compete has largely been eliminated by the conquest of nature and the establishment of artificial security.

As to the popular thesis that the sentient world is, on the whole, regulated by principles of benevolence, Huxley would have nothing of this. It may be true "that sentient nature affords

hosts of examples of subtle contrivances directed towards the production of pleasure or the avoidance of pain; and it may be proper to say that these are evidences of benevolence. But if so, why is it not equally proper to say of the equally numerous arrangements, the no less necessary result of which is the production of pain, that they are evidences of malevolence?" If the products of nature seem at times beautiful and harmonious, it must be remembered that they are evolved only through a process of eternal struggle, conflict, and wholesale extinction. "We are told to take comfort from the reflection," Huxley once wrote, "that the terrible struggle for existence tends to final good, and that the suffering of the ancestor is paid for by the increased perfection of the progeny. There would be something in this argument if, in Chinese fashion, the present generation could pay its debts to its ancestors; Otherwise it is not clear what compensation the *Eohippus* gets from his sorrows in the fact that, some millions of years afterwards, one of his descendants wins the Derby."[26]

Huxley was one of the very first Darwinians, and he was apparently one of the first to realize that evolutionary changes never appear except at a price; that the price paid usually involves an increase in the capacity for pain and hardship; and that the workings of natural selection proceed without reference to the needs or strivings of the creatures involved. In the meantime, Darwinian scientists have all too often overlooked these essential truths and have tended to paint a rosier picture of nature and natural selection than is merited by the facts. There have, to be sure, always been exceptions. As I noted in the closing paragraphs of the preceding chapter, the Russian biologist Élie Metchnikoff was not at all impressed by the evolutionary process and believed it to be the ultimate cause of man's defective anatomy and psyche. And in the 1930s an iconoclastic anthropologist named Earnest Albert Hooton tried his best to dispel the popular conception of evolution as an essentially benign and perfective process. We human beings are wont to deify natural selection, Hooton once wrote, as if it were some sort of beneficent guide and omniscient controller of biological affairs, instead of a concatenation of purposeless

forces and unpredictable results. But selection would better be conceived, he wrote, like Justice, "blindfold, equipped with a primitive set of scales, and slashing about in the dark with an unwieldy sword."[27] Human characteristics like benevolence, foresight, and intelligence, Hooton argued, are the products of evolution, not its antecedents. Unfortunately, he wrote, the course of evolutionary change is not determined by intelligent choice, but by the whim of external circumstance. And perhaps the only wonder is that the adaptations it produces are as effective as they often are,

This is not the sort of thing that most people would like to believe, but as we learn more and more about the evolutionary process it becomes more and more difficult to believe otherwise. It is for just this reason that in the last two or three decades in particular, as evolutionary science has experienced an information explosion, an appreciation of the inherent imperfections of the evolutilnary process has become increasingly prevalent among professional scientists, although it seems as yet not to have made much headway among the public at large. Let us move on to consider in some detail the specific course of human evolution so that we may see just how the inherent imperfections of the process have created the many flaws in the design of the human body and psyche.

Chapter Three
The Mechanical Misfit

Man usually either considers himself a self-made animal and consequently adores his maker, or assumes himself to be the creation of a supreme intelligence, for which the latter is alternately congratulated and blamed. An attitude of humility, abasement, contrition, and apology for its shortcomings is thoroughly uncharacteristic of the species Homo sapiens, except as a manifestation of religion. I am convinced that this most salutary of religious attitudes should be carried over into science. Man should confess his evolutionary deficiencies, and resolve that, in future, he will try to be a better animal.

Earnest Albert Hooton

The story of human evolution is filled with puzzles. And it is likely to remain so for some time to come. As much as anthropologists would like to be able to tell us just how and why the human species evolved the way it did, they cannot. And the reason, in a word, is evidence—or more correctly, a lack thereof. As recently as 1970, the total inventory of prehuman and proto-human fossils collected by anthropological field workers would scarcely have filled the cabinet space of an average-sized kitchen. And while the size of that inventory has grown considerably since, it still comprises far too scant a basis upon which to reconstruct 15 million years of prehuman and early human evolution. Until many more fossils are uncovered, until much more evidence comes to light, the interpretation of human prehistory will remain largely a matter of guesswork,

and a great deal of what we would most like to know about the hows and whys of human evolution will remain distressingly obscure, if not wholly mysterious.

The situation is not entirely bleak, for at least two reasons. First, the fossil record is not nearly as scant as it once was and it is continually growing. The 1970s was a particularly fruitful decade for fossil-hunting anthropologists, and if the success they experienced in the 1970s continues, it is only a matter of time before many of the puzzles of human prehistory are cleared up, or at least rendered less obscure. Second, fossils themselves are by no means the only source of information we have concerning the events that must have taken place during the formative stages of human evolution. There is, too, the comparative evidence—comparisons between the behavior and anatomy of modern nonhuman primates and those of our presumed ancestors. We know that the nonhuman monkeys and apes have been much more conservative in their recent evolution than were our own ancestors, and it is quite probable that in some respects they represent earlier stages of human evolution. Of course, comparisons of this sort must be made with the utmost of caution. Contemporary apes and monkeys are not fossilized prehumans, and there is no question but that they have done quite a bit of evolving on their own since their ancestors diverged from the lineage that eventually led to modern man. Nevertheless, in some aspects of their anatomy and social behavior they are much more reminiscent of prehumans than we are. As such they provide important clues concerning earlier stages of human phylogenetic development. When these clues are combined with the actual fossil record, they yield a great deal more than would be possible on the basis of fossil evidence alone.

On the basis of these two sources of knowledge, then, we can reconstruct with some accuracy a broad outline of human pre-history, even while ignoring those details which can only be filled in by future evidence. This much, for the time being, seems evident. Ten million years ago—and perhaps as recently as six million years ago, according to some evidence—our ancestors were still much more apelike than humanlike. Indeed,

our late Miocene forebears showed only the slightest hint of what they were eventually to become. They were still primarily arboreal creatures, spending most of their time in the trees, although they may on occasion have descended to the forest floor or even ventured out onto the open grassland. When they travelled on the ground, they may have done so on all fours, as most ground-living monkeys do today, or they may have walked on their hind legs, as some apes do, but they were not in any event the efficient bipeds that we are. They could not speak, although they probably communicated with one another by means of vocal calls and bodily gestures. They had no 'families' as we know them, nor any but the most primitive rudiments of culture. They were probably capable of some degree of tool use, and they may even have manufactured tools from perishable items, like grass or sticks. But they certainly did not fashion tools from stone or metal. Like modern monkeys and apes, their bodies were covered with a thick coat of scraggly hair. And their brains were, by our standards, pitifully small. In almost every aspect of their physical and mental development, in short, they were distinctly unhumanlike. But all that was to change, and change very dramatically. By the time of the dawn of modern man, some 40,000 years ago, these peculiar apish creatures had somehow acquired a completely upright posture, developed a vast material culture, sprouted an enormous and versatile brain, learned how to speak, shed most of their protective covering of hair, changed their way of life and subsistence, and organized themselves into cohesive societies. The end result was, of course, modern man—a creature whose uniqueness is largely a function of the many evolutionary changes just mentioned. And one of the jobs of anthropologists today is to explain how and when these important changes took place.

Of course no anthropologist today can in fact account for all these changes. As I have already pointed out, the fossil evidence is still far too scant to provide conclusive proof for any particular scenario of human evolution, although many such scenarios have been suggested. In this chapter I shall outline one such scenario and will consider some of the many imaginative

hypotheses that have been put forth to account for the evolutionary changes that transformed our apelike ancestors into us. More important—and more germane to the purposes of the present inquiry—I shall discuss some of the many negative repercussions of man's recent evolution, including and especially the many defects in the design of the human body.

What follows, then, is neither a tribute to the 'remarkable' design of the human organism, nor a definitive statement as to how our ancestors got from there to here. It is at best a tentative outline of man's recent evolution, complete with all the hedgings and hawings that have become *de rigueur* in the writings of professional anthropologists. It should by no means be accepted as established truth, not even where the hedgings and hawings have inadvertently been omitted. It may, however, give some idea of how the human species evolved, and why that evolution was not accomplished without some considerable difficulty.

The Origin of the Primates

Man is a primate, and the story of the primates begins some 70 million years ago, in the immense tropical forests of what are now North America and Europe. (At the time, these two continents were still interconnected by way of Greenland and much warmer than they are today.) The immediate ancestors of the primates were ground-living creatures, resembling rather the moles and hedgehogs of today. For over a hundred million years, these diminutive, unobtrusive creatures scuffled about on the ground in the shadows of their mammoth overlords, the dinosaurs. There they spent most of their time skulking in the underbrush and searching for the seeds, insects, and other small prey on which they fed. By about 65 or 70 million years ago, however, some of these little creatures had begun to venture out of the brush and to climb up into the trees. Just why they did this, no one can say for certain, although one plausible suggestion is that they were chasing prey, like tree frogs, lizards, or perhaps arboreal insects. In any case, once they had

gotten into the trees, they found good reason to stay there. The arboreal habitat represented a rich and largely untapped reservoir of foodstuffs. Here the nimble newcomers could feast on a veritable bonanza of leaves, nuts, fruits, birds' eggs, and even small reptiles, when they could be caught. Eventually great hordes of insectivorous mammals made the ascent into the trees to take advantage of the vast arboreal bounty.

Having committed themselves to a new habitat and a new way of life, however, the early primates were faced with the immediate problem of having to adapt themselves to their new circumstances. And this was not necessarily going to be an easy matter. To be sure, the arboreal habitat was a bountiful one, but it was also a hazardous one, and survival in it would require certain abilities which the ancestral insectivores did not necessarily possess. There was the constant danger of falling, and the need to negotiate one's way through the branches without losing one's footing. The food, too, was very different from that which had been available on the ground, and new skills would be required to harvest it. Accordingly the early primates were subjected to some rather keen selective pressures, forcing them to adapt to their new way of life. Eventually, of course, they adapted, but not before they had undergone a host of evolutionary changes, both behavioral and anatomical, the cumulative effect of which was to transform them from ground-living insectivores into fully acclimated arboreal primates.

It is possible, of course, that the early insectivores were already somewhat prepared or *pre-adapted* for life in the trees, even before they had begun their initial ascent. And it may have been just this preparedness that allowed them to adjust so successfully to their new environment. It may very well be, for example, that while still on the ground the tiny insectivores had begun to chase prey through the underbrush, and to evolve traits that were of use to them in securing that prey. Among these traits might have been such things as binocular vision, for example, which would have allowed them to locate and track the prey, and prehensile digits on the forelimbs, which would have given them the ability to make their way nimbly through the underbrush and to grab hold of their quarry. According to

anthropologist Matt Cartmill, in fact, this is precisely what happened. As Cartmill sees it, the beginnings of primate evolution, contrary to traditional wisdom, took place on the ground, not in the trees; and it was not necessary for the insectivores to climb into the branches in order to evolve three-dimensional vision or manual dexterity.[1] Cartmill's suggestion is a compelling one, and he may very well be right, at least in part. Perhaps, as he suggests, the trend toward primate adaptation did indeed begin on the ground. But it seems clear that the trend did not end there; and it is unlikely that primates as we now know them would ever have evolved had the primordial insectivores remained on the forest floor. Surely with the ascent into the trees selective pressures for the traits just mentioned would have intensified, and it was therefore only in the trees that the primate way of life, with all its attendant adaptations, reached its fullest flowering. Take for example the evolution of prehensile limbs. On the ground, the insectivores may have had some use for grasping forelimbs, but in the trees the ability to grasp would have been of even greater utility. And selective pressures for such an adaptation would have been all the keener. Thus it was not long before the tree-dwelling primates had developed co-ordinated pairs of grasping hands and feet, each with five digits, and each with large toes or thumbs capable of being opposed to the outer digits. Once equipped with these fully prehensile limbs, the arboreal primates were able to negotiate their way through the trees with greatly enhanced facility. Their capacity to investigate potential sources of food was also considerably refined. This is because the forelimbs could be used to lift objects toward the eyes for visual examination, toward the nose for smelling, and toward the mouth for tasting, chewing, and ingesting. In this way prehensile limbs became not only useful means of grasping branches and travelling along them, but also instruments of research and investigation. Eventually they would also prove useful in yet other ways, in particular for the making and using of tools.

Tree life also put a premium on the development of visual acuity in preference to the other senses, and the early primates

evolved accordingly. In particular the sense of smell was of much less value in the trees than it had been on the ground: thus the long snouts of the primates underwent progressive diminution as their olfactory system gradually atrophied. On the other hand, keen vision was enormously important, owing to the complex and three-dimensional nature of the arboreal habitat. As a consequence the visual sense became much more developed in the primates. In most land-living mammals, the eyes are situated on opposite sides of the head, so that there is little or no overlap of visual fields. The animal can see almost all around itself, but its depth perception is very poor. The world it perceives is essentially two-dimensional. By contrast, the eyes of the primates have rotated to the front of the head, resulting in a considerable overlap of fields of vision and the ability to see in three dimensions. This 'stereoscopic' vision is of inestimable value to tree-dwellers, who must be able to judge distances when moving rapidly from branch to branch or when leaping from tree to tree. Also, the evolution of color vision was apparently of great import to the primates, who needed to be able to distinguish various colors in the dense and kaleidoscopic foliage of the tropical forest. Without this ability, it would have been very difficult for them to discern edible fruits against the predominantly green backdrop of the forest habitat. With their capacity to see the world in color and in three dimensions, the arboreal primates were eventually able to make sense of their new environment; by and by they became every more adapted to it.

Finally, the inherent dangers and complexities of life in the trees demanded an increased sense of awareness on the part of the early primates. On the ground, there had never been any particular need for superior brain power. After all, chasing insects and fleeing from predators were relatively simple activities, and they required no great degree of adaptive intelligence. But the forest canopy was a more treacherous and multidimensional habitat, and in it the ability to vary one's responses to the often unpredictable conditions must have been of enormous value. This entailed not only an awareness of the various aspects of the environment, such as its seasonal and scattered food

supply, but also a capacity to learn from experience. Furthermore, since the exigencies of life in the branches demanded agility, balance, and muscular co-ordination, the corresponding areas of motor control in the brain became elaborated, as did those areas concerned with the perception and integration of visual stimuli and the storage of visual and auditory memory. As a consequence selective pressures worked toward a continual refinement of the primate brain and its allied systems. Eventually primate intelligence would outstrip that of any other group of organisms yet evolved.

The primates, in sum, had become fully adapted arboreal animals and, in evolutionary terms at least, enormously successful ones. Indeed, for several dozen million years after their initial ascent into the trees, they flourished, establishing themselves throughout the tropical world. And, in the course of time, they diverged into the many distinct forms that we know today. These include about 200 species, usually divided into two main groups or suborders: the prosimians (tarsiers, lorises, and lemurs), and the anthropoids (monkeys and apes). Of these the prosimians evolved first, diverging into recognizable forms within 10 or 15 million years after their original separation from the insectivore stock. About 20 million years later, the first anthropoids emerged, giving tantalizing hints of the monkeys and apes into which they would eventually evolve. By the onset of the Miocene epoch, some 25 million years ago, the age of the apes had dawned and a throng of species poured onto the African stage.

During the period immediately following their emergence, the monkeys and apes enjoyed widespread success in much of the world, especially in Africa. For several million years they proliferated throughout the extensive reaches of the plush tropical forests until their ecological niche had become almost completely saturated. Throughout this period the various species of arboreal primates, including the ancestors of man, pursued similar evolutionary courses, each of them clinging to life in the dense foliage. And had the climate remained unchanged and the habitat stable, they probably would have stayed right where they were, in the trees. But as it turns out,

the climate did not remain unchanged and the habitat did not remain stable. Beginning about 16 or 17 million years ago, according to current geological estimates, the tropical climate began to turn drier and drier. The heavy rains, so essential for the maintenance of the trees, slowly abated. A steady reduction of rainfall gradually dessicated the huge forests, leaving in their stead scattered patches of woodland, tree savanna, and open grassland. As the trees became scarcer, so too did the amount of food available in them, and competition for that food became proportionately more intense. Eventually some of the primates must have attempted to escape from this competition by climbing down from the trees and seeking food elsewhere. Of these, many apparently found that they could procure more food on the ground than in the overpopulated trees. As a result they began to spend increasing amounts of time on the forest floor, eventually abandoning the trees altogether. And at least some of them took the final step of leaving the forest completely and taking up permanent residence on the open plains. Among those who made this latter transition were the immediate ancestors of *Homo sapiens.*

At this point the whole story of human evolution gets very fuzzy. Unfortunately, at the present time there exists very little fossil evidence bearing on the important evolutionary events that must have taken place during the period of forest dessication. It's impossible to say just how long it took our ancestors to adjust to life on the ground, or just when or how that adjustment was completed. And speculation on these matters abounds. Some experts have suggested that our ancestors went through a rather lengthy period of semi-arboreal, semi-terrestrial existence before they finally completed their transition to full-time life on the ground some two million years ago or so. Others disagree, insisting that our ancestors had already become fully terrestrialized by four million years ago or more. Some recent evidence strongly suggests that the former is the more likely of these two possibilities but the matter is still open to debate. There is in any case one thing about which all anthropologists seem to be agreed: the adoption of a terrestrial mode of life by our apelike ancestors was the single most crucial

turning point in the evolution toward humanity. Indeed, it was precisely this shift in habitat from the forest to the plains that brought with it many of the most important evolutionary changes that eventually separated man from the other apes. It was on the ground, for example, that our ancestors first became habitual bipeds. It was on the ground that they lost their protective coat of hair and became functionally naked. It was here that they first took to hunting as a major subsistence activity. It was here that they adopted an entirely different and much more elaborate social system. It was here that they evolved their enormous brains and high intelligence. It was on the ground, in sum, that man became man, and all humans alive today, for better or for worse, owe their existence to the success of our early ancestors in adjusting to their new, terrestrial habitat.

Unfortunately, the success of our ancestors in adapting to life on the ground, however spectacular, was not wholly unqualified. As we shall see, many of the structural changes they underwent during the course of their terrestrial evolution were less than satisfactory. And if we owe our existence to our ancestors' having abandoned their aboriginal habitat to make a go for it on the ground, we also owe many of our most troublesome physical defects to that same evolutionary event.

The Bipedal Primate

When man's ancestors first climbed down from the trees in search of food, it is not known how they got themselves about on the ground. Perhaps, like some modern apes—the gibbons, for example—they walked on their hind legs from the very start. Perhaps, like the terrestrial monkeys, they travelled from place to place on all fours. Or perhaps, like the modern chimpanzees, they alternately walked now on four legs, now on two. Whatever the extent of their locomotory versatility, however, and whatever the extent of their bipedal prowess, they were not at first as fully adapted to upright walking as we are today. But in the course of their adjustment to life on the ground, that is

precisely what they became. The result is that today, man is the only mammal that habitually walks on two legs and maintains a completely erect posture while doing so. This rather remarkable evolutionary development has long been the object of anthropological speculation, and continues to be so today. Thus questions like the following still puzzle the experts: When and why did our ancestors begin to stand upright? How long did it take them to make the adjustment to habitual bipedalism? What were the selective 'advantages', if any, of a two-legged gait? And how did the ability to walk upright contribute, if at all, to our ancestors' survival and reproductive success? As of yet no definitive solution to any of these puzzles exists, although a plethora of suggestions has been put forth. Here I shall consider a few of these suggestions, and then proceed to discuss some of the many consequences that human bipedalism has entailed.

One oft-cited hypothesis, a version of which was first proposed by Darwin in 1871, and a somewhat revised version of which was current in anthropology texts of the 1950s and 1960s, is that bipedalism evolved in tandem with tool use. According to this model, the early prehumans probably used simple wood and stone tools for various purposes. They may, for example, have used stones to break open bones to get at the nutritious marrow inside, or used sticks to dig up roots. Or, they may have found it useful to brandish sticks or throw stones as a means of self-defense against terrestrial predators. These kinds of tool use—the latter in particular—may have encouraged bipedalism, since a two-legged animal is much more adept at throwing sticks and stones than a four-legged one. Furthermore, as tool use became ever more common, the early pre-humans probably began carrying their tools around with them, providing yet another incentive for erect walking. (For a habitual tool user, the most useful way of getting around is on two feet, since this frees the hands for carrying.) Bipedal walking in turn increased the tendency toward more tool use, and so on. Thus our ancestors became more and more bipedal as they became ever more dependent on the use of tools, and as it became increasingly necessary for them to carry those tools from place to place.[2]

Another hypothesis is that our terrestrialized ancestors stood on their hind legs so as to be able to see over tall grass and scan the horizon for predators. The reasoning behind this idea is simple. Since primates living on the ground are vulnerable to attack from lions, leopards, and other predators, bipedalism may have helped the early prehumans to detect their enemies before it was too late to escape. The 'advantages' of an upright gait in this context however may have been more than offset by the disadvantages that the slower running speed of a biped entails. A more elaborate, and more imaginative hypothesis has recently been put forth by anthropologist Owen Lovejoy of Kent State University. According to Lovejoy, bipedalism evolved in conjunction with a new reproductive strategy, a strategy the ultimate effect of which was to increase reproductive output and therefore reproductive success. What follows is a greatly condensed and oversimplified version of Lovejoy's intriguing hypothesis.[3]

The trouble with most apes, Lovejoy points out, is that they have a very slow birth rate, and therefore a very minimal reproductive success. This is because most apes can only care for one offspring at a time, and as such can only give birth about once every five years or so. But the pre-human apes, according to Lovejoy, were different, because they evolved the ability to divide their parental care among two, three, or even four infants at a time. How did they do this? If Lovejoy's hypothesis is correct, by becoming less mobile, moving around less, and using up less energy. By restricting her movements, the pre-human mother was relieved of the burden of carrying her offspring from place to place. Instead she used her energy to make more babies and to care for them after they had been born. Thus she was able to become ever more prolific, and ever more reproductively successful. Her increased reproductive success, however, created an entirely new problem of its own. For as the pre-human female began to space her children closer and closer together, food requirements increased drastically (there being more mouths to feed) just as less mobility was making food harder to get. Eventually the mother needed help in order to provide for her growing number of dependent children. In

order to procure that help, she selected a 'mate' and entered into a reciprocal food- and sex-sharing agreement with him. The female, for her part, agreed to restrict her sexual favors to her mate, and to reject sexual advances from other males. In return for this, her mate agreed to gather food from distant sources and bring back a portion of his find to his sedentary female and their offspring. This is where bipedal behavior came into play, because males who were able to walk upright for long distances were better equipped to carry food, and more likely to get some of that food back to the children they had fathered. The females, in the meantime, were also helped by erect walking, since this freed their hands for feeding and carrying babies. The ultimate result was human bipedalism as we now know it.

This is an ingenious theory, and ever since it was first put forward about a decade ago, it has garnered quite a bit of attention from the anthropological community. From what I have been able to gather, however, most of that attention has been decidedly negative. So numerous have been the objections to Lovejoy's scenario that I cannot even begin to discuss them all here, but Lovejoy, for all his ingenuity and adroitness in defending his theory, has yet to convince his professional colleagues that it is right. Apparently many of Lovejoy's detractors find his theory to be a bit *too* imaginative, and not consistent with currently available evidence. As of this writing, and in spite of his many critics, Lovejoy continues to defend his idea steadfastly. In the meantime, alternative theories continue to be put forth at an impressive pace and Lovejoy's model, like most, may eventually drown in the competition.

What then are some of these alternative theories? There are a great many. And not all of them are as complicated as Lovejoy's. Consider, for example, the 'conservative' hypothesis of anthropologists Henry McHenry and Peter Rodman. According to these experts, our ancestors walked on two legs for the simple reason that it was the most energetically efficient way for them to travel about on the ground, and because it offered the additional benefit that it allowed them to carry objects (such as tools, babies, and food) in their hands. Many other authorities

have also suggested that the ability to carry objects from place to place may have played some role in encouraging bipedal behavior among our terrestrialized ancestors. And at least one expert has hypothesized that upright walking was primarily a means by which our ancestors avoided exposing too much body surface to the direct rays of the mid-day tropical sun.[4]

Which one of these theories is the correct one? Quite possibly none of them. A group of upstart anthropologists has recently suggested that the whole approach to the problem of the origin of bipedalism, as put forth by such theorists as Charles Darwin and Owen Lovejoy, is completely off the mark, because it assumes that our ancestors were basically four-legged creatures when they first descended from the trees and that they only later learned to stand on their hind legs. According to these theorists, who include J.H. Prost of the University of Illinois and Jack Stern and Randall Susman of the State University of New York at Stony Brook, our ancestors were already upright bipeds while still living in the trees, and did not need to become tool users or stone throwers or baby carriers in order to be transformed into two-legged animals. According to Prost, Stern, and Susman, our tree-dwelling ancestors were already pre-adapted for two-legged walking when they began their descent and would probably never have become efficient bipeds had they not been thus pre-adapted. The evolutionary scenario envisioned by this new wave of anthropologists goes something like this. Many millions of years ago, when our ancestors were still more or less full-time arborealists, there evolved certain basic anatomical changes, the cumulative effect of which was to prepare these tree-dwellers for their as yet unforseen future as upright walkers. While still living in the trees, these animals acquired the habit of vertical climbing, using their feet to push themselves upward and their hands to grasp overhead branches, almost as if they were ascending a ladder. This kind of behavior encouraged the evolution of a more or less orthograde posture, and feet and legs that were well-adapted for supporting the weight of the upper body. After several million years of evolution in this direction, our ancestors were able to walk upright, and with a more or less

erect posture, whenever they descended to the ground. Then, as the tropical forests began to dry out, these newly terrestrialized apes, our forebears, strode from one clump of trees to the next without great difficulty. As the dessication continued, and patches of trees became ever more distant, walking behavior increased proportionately, and evolutionary pressures for an even more efficient bipedal gait intensified. Further refinements in the feet, the legs, the pelvis, and allied structures led to ever more efficient bipedalism. Eventually, by about two-and-a-half million years ago or so, the process of bipedal evolution was essentially complete, and our ancestors walked just as we do today.[5]

How does this new theory compare with the old ones? Apparently quite favorably. The idea seems to have caught on pretty well in the anthropological community, and many experts now accept it as a much more plausible scenario than the older theories. It should not be assumed, however, that the Stern-Susman model, or any of the other models here discussed, constitutes a definitive solution to the riddle of bipedal evolution. It does not—at least not for the time being. As of this writing, to be sure, the fossil evidence is still equivocal, and expert opinion is still divided. Unfortunately, we may never know for certain just why or when bipedal behavior evolved, since we may never be able to amass all the evidence that would be needed to decide the matter conclusively. In the meantime, perhaps the most important thing is not so much how or why we became bipeds as the very fact that we did. It is, after all, the consequences that we must live with. And it is to a consideration of these consequences, both good and bad, that the discussion now turns.

The Scars of Human Evolution

Human bipedalism is, to say the least, a remarkable adaptation. Indeed, given the difficulties involved, it is something of a wonder that nature was able to accomplish it at all. We tend to take our ability to walk for granted, because we do it with such

great facility, but in fact it is no simple task. When compared with the four-legged stride of other mammals, the human gait is actually an amazingly complex feat. "Without split-second timing," writes British authority John Napier, "man would fall flat on his face; in fact with each step he takes, he teeters on the edge of catastrophe."[6] For all its apparent simplicity, human walking is a sophisticated balancing act in which the muscles of the hips, back, legs, and feet are alternately contracted and relaxed according to precisely synchronized messages from the brain and spinal cord. It is a highly efficient adaptation, underlain by a superb co-ordination of bone and muscle, brain and nerve. But it is by no means an unmitigated blessing. In fact bipedalism was achieved only with great difficulty, and not without complications that have created monumental imbalances in the human skeletal and circulatory systems. When man took to standing up straight, he may have gained certain 'advantages' over his quadrupedal cousins, but he has paid a severe price for the privilege. As we shall soon see, back trouble, foot ailments, painful childbirth, and circulatory failure are just some of the adverse results of upright posture.[7]

The many problems engendered by our bipedal gait have been amply documented by numerous authorities, but no one has done a more thorough job of this than physical anthropologist Wilton M. Krogman. In 1951, Krogman discussed some of the structural weaknesses associated with upright walking in an article written for the *Scientific American.* The article was entitled, simply enough, 'The Scars of Human Evolution'. In it Krogman explains how the shift to an upright gait exerted nefarious effects on almost every part of the human anatomy, especially the skeleton. Most deleteriously affected were those parts directly connected with erect walking, but many other areas were also less than satisfactorily modified. "Although man stands on two legs," Krogman writes, "his skeleton was originally designed for four. The result is some ingenious adaptations, not all of them successful."

Krogman compares the design of the basic mammalian skeleton to that of the cantilever bridge, both of which are designed on similar principles. The shape and function of the

quadruped backbone, he writes, closely resemble their coun-
terparts in the arched cantilever of the bridge: the vertebrae of
the forward part of the backbone are slanted backward and
those of the rear forward, so that the thrust is all to the apex of
the arch. The four limbs of the quadruped mammal are
analogous to the piers or supports of the bridge, the trunk and
abdomen representing the load suspended from the weight-
balanced arch. In front the main bridge has a jointed crane (the
neck) and with it a grappling device (the jaws). All things
considered, it is a sound design—one that has served four-
legged animals quite well for hundreds of millions of years. But
when this finely balanced structure was suddenly upended on
the hindlimbs of man, the result was a monumental mechanical
imbalance. The many advantages of the cantilever-like system
were summarily lost, and the spinal column was suddenly
forced to accommodate itself to the considerable stresses of
vertical weight-bearing. This it did by reshaping the single-
curved arch into an S-curve, but the outcome was something
less than ideal. In order to permit twisting and bending, the
shape of the vertebrae was altered to that of a wedge, with the
thicker edge in front and the thinner edge in back. This allows
the vertebrae to pivot on their front ends as on hinges, rather
like the segments of a toy snake. Unfortunately, it also weakens
the backbone, especially in the lower back area, where the
wedge shape is most pronounced. Thus the human vertebral
column makes for a very poor weight-support mechanism.
Heavy lifting or any similar stress is likely to cause the lower-
most lumbar vertebrae to slip backward along the slope of the
next vertebra. As a result trouble often develops at certain
critical points of curvature, most particularly in the lumbar
region, where many backaches originate. Another problem is
herniated or 'slipped' discs, which are annoyingly frequent in
humans.

By far the weakest point of the human backbone, according
to Krogman, is the unstable lower end of the vertebral column.
This is where we reap most of the adverse consequences of
standing up on our hind legs. It is a crucial zone of the body,
serving both as a pathway for reproduction and as a pivotal

point for the junction of the backbone, the hind end of the trunk, and the legs. The principle components of this highly complicated junction are the sacrum and the pelvis. Even before the evolutionary transition to bipedal walking, the pelvis was already somewhat of an overburdened structure, serving not only as part of the general skeletal framework, but also as a channel for the urogenital and digestive systems, and the coupling to which the muscles of the legs are attached. When our hominid ancestors adopted an upright stance, the delicate pelvis was forced to take on yet another burden, that of bearing the entire weight of the upper part of the body. Two additional changes then occurred so as to adapt the pelvis for shifting the weight of the trunk to the legs. First, there was an increase in the area of contact between the sacrum and the iliac bones, resulting in a strengthening of the so-called sacroiliac articulations. Second, the sacrum was pushed down somewhat, so that its lower end is now below both the hip socket and the upper level of the pelvic articulation. These adaptations, unfortunately, have generated a whole new set of problems of their own. First of all, they have created an area of instability in the lower part of the vertebral column, which often results in 'slipped sacroiliacs' and obscure 'low back pain'. (Krogman notes that the phrase, 'Oh, my aching back' has an evolutionary significance.) Furthermore, the shift in the position of the sacrum has resulted in an encroachment on the female pelvic cavity, thereby narrowing the birth canal and rendering it too small for comfortable parturition. The result is that human childbirth is generally painful and often dangerous. The process of parturition exposes both the mother and her infant to sizable risks of accidents and infections. For a woman with a small pelvis the rigors of childbirth can be excrutiating, even fatal. No other animal has this problem.[8]

The frantic reorganization of the skeletal system has also resulted in the shortening of the iliac bones, which has increased the distance between the lowest rib and the top of the ilium. This rearrangement in turn has produced a glaring weakness, namely the weakening of the lower abdominal wall, which has only muscle to support it. Subsequent evolutionary

changes have since strengthened the abdominal musculature to a certain degree, but those muscles are still far from adequate to maintain pressure on the internal organs. The abdominal wall thus offers little resistance to the compressed organs, a situation which predisposes humans to various kinds of herniation, especially those of the inguinal and lumbar varieties. Today these afflictions are particularly common in tropical Africa, where strangulated hernia is a not infrequent cause of death. As recently as 1961, Albert Schweitzer offered this account of the problem among native populations:

> . . . hernia . . . afflicts the negroes of Central Africa much more than it does white people. . . . They also suffer much oftener than white people from strangulated hernia, in which the intestine becomes constricted and blocked, so that it can no longer empty itself. It then becomes enormously inflated by the gases which form, and this causes terrible pain. Then after several days of torture death takes place, unless the intestine can be got back through the rupture into the abdomen. Our ancestors were well acquainted with this terrible method of dying, but we no longer see it in Europe because every case is operated upon as soon as ever it is recognized. . . . But in Africa this terrible death is quite common. There are few negroes who have not as boys seen some man rolling in the sand of his hut and howling with agony till death came to release him.[9]

There are yet other problems in the area of the abdomen. For example, by standing up straight, man has inadvertently exposed a vast area of vulnerable front to a hostile world and left his vital organs almost completely unprotected. Nature has in part compensated for this blunder by creating the lower belly wall, which consists of three sheets of muscle with criss-crossing fibers, but the design is inadequate. It has resulted in a triangular area in the wall that is now virtually devoid of muscular support. Pot bellies and other troubles of the internal organs represent some of the deleterious side-effects of this imperfect modification.

Still another part of the body that causes us a good many problems, owing to inherent imperfections in its design, is the foot. Like many other parts of our anatomy, the foot was largely

molded into its present form by the exigencies of two-legged walking. And, like many other parts of our anatomy, it has been somewhat less than ideally modified to serve its present purposes. The most conspicuous difficulty occurs near the center of the foot, where the two axes cross each other to form the arch. This arrangement, although it permits a more solid footing, is decidedly weak, and often breaks down. The result is 'fallen arches' or 'flatfoot' — a condition which exposes certain nerves in the foot to considerable pressure, causing severe pain. Bunions and calluses, too, continue to bear testimony to the fact that our feet have never been fully healed by the forces of natural selection into really efficient units.

Blood circulation is another factor that has been adversely affected by upright posture. Since the first mammals were all four-legged creatures, Krogman notes, the basic mammalian heart evolved primarily in response to the need to pump blood at or below its own level. But when humans took to standing on two legs, the heart was catapulted upward, and its task was made much more difficult. In modern humans, blood returning to the heart from the veins of the lower torso and legs must overcome up to five feet of gravitational pull. Varicose veins and heart failure are just some of the problems that result from the habitual overburdening of a pumping mechanism that was originally designed for quadrupedal animals with pronograde bodies. The veins of the lower end of the large intestine have also been adversely affected, for when they were upended into a vertical position, they became more susceptible to congestion, the usual result of which is hemorrhoids.

Another serious problem is the danger to the circulation along the vertebral column. Two large blood vessels, an artery and a vein, run down this column. At the level where these vessels divide into two branches, one for each leg, the left-sided vein crosses under the right-sided artery. In a four-legged animal this presents no problems. But in an erect biped the situation is quite different. Here the two vessels must cross a sharp promontory bone at the junction of two vertebrae, and the organs piled up in the pelvis exert great pressure on them.

During pregnancy, this pressure may build up to such an extent that the vein is nearly pressed shut, making for a very poor drainage of the left leg. This is the so-called 'milk leg' of pregnancy.

Finally, the adoption of a bipedal mode of locomotion has brought with it certain changes in the structure of the head and neck, and these too have been something less than completely beneficial in their effect. Among the most important of these changes were: 1. the final reduction of the snout, 2. the centering of the head on the vertebral column, and 3. an increase in the size of the muscles for turning the head (the sternocleidomastoids). This latter development has been particularly problematical, according to anthropologist Bertram Kraus, who notes that the evolutionary enlargement of the sternocleidomastoid muscles has produced a delicate and troublesome mastoid process. The problem, writes Kraus, is that this mastoid process is filled with numerous bone-lined cells which are focal points for infection radiating from the upper respiratory tract. Before the widespread use of antibiotics this kind of infection (known as mastoiditis) was a serious affliction, often leading to drastic surgery and frequently to death. The reduction of the snout, meanwhile, has caused a marked decrease in the size of the human facial bones and a proportionate diminution of the space needed for the teeth. As a consequence we often get malocclusion in children and impacted wisdom teeth in adults.

A Sweaty and Thirsty Naked Animal

Homo sapiens is a relatively hairless species. Unlike most other land-living mammals, humans possess virtually no coat at all, and except for some conspicuous tufts of hair sprouting from the top of the head (and a few other places), we are functionally naked. Particularly when compared with the other living primates, the human dearth of body hair is striking. The bodies of all other apes and monkeys are still covered with long, coarse

hairs. But the length and density of human hairs have become so reduced by comparison that they have been rendered effectively useless.

Why, then, should this be the case? Why did our ancestors, who were presumably every bit as hairy as their contemporary primate cousins, shed their covering of fur and become 'naked apes'? Why did they relinquish the hairy coat which for so long had protected their hides from bruises and abrasions, insulated their vital organs, prevented too rapid loss of heat, and shielded their tender skin from the harmful effects of direct exposure to the rays of the sun? When and why did the reduction of hair take place, and what, if anything, was its adaptive significance? As the reader may well have guessed, there are no definitive answers to any of these questions. The denudation of the human body is still very much an evolutionary puzzle, and it will probably remain so for some time to come, there being very little in the way of concrete evidence to provide pertinent clues on the matter. A number of imaginative theories have been put forth to account for this peculiar development, and in the absence of anything better, I shall now briefly review a few of the more plausible of these.

By far the most oft-cited explanation for the relatively hairless condition of man—and one that still enjoys widespread currency in anthropology texts—is that it evolved as a cooling device. According to this theory, our ancestors began to shed their fur when they left the shady confines of the forest to take up residence on the open plains. Away from the trees, the ground-living proto-humans needed to develop an efficient cooling mechanism so that they could maintain a constant body temperature under the hot African sun. In time they evolved highly profuse sweat glands, which secrete water and bathe the body in moisture. Evaporation of sweat would then cool the surface of the skin by removing latent heat. This process would not work, however, if the body were covered with long dense hair, which would tend to inhibit evaporation and get clogged with dried sweat, so that the animal would continually be wrapped in a chilling blanket. Hence the evolution of a marked decrease in hair density.[10]

This theory has been around for some time now, and as I have just suggested, it is still widely accepted among professional anthropologists. It has never been universally accepted, however, and in the last couple of decades it has met with numerous objections. It has been noted, for example, that few of the other mammals, and none of the other primates that labor under the African sun have lost their hair. Lions and jackals are not naked. Nor is the patas monkey, a savanna-living primate that has evolved a capacity for effective sweating without losing its reflective coat. Thus there is some question as to whether the human loss of hair could have occurred in order to enhance the efficiency of sweat evaporation. At least one physical anthropologist, Russell M. Newman, has recently argued that human sweating could only have increased *after* the coat of hair had begun to thin out, not before.[11] According to Newman, the early pre-humans had already begun to shed their fur even before migrating to the savanna. Once there, the combination of increased exposure to the sun's rays and a greater absorption of solar energy by the naked skin created a greatly increased heat load. This constituted an enormous disadvantage requiring some form of compensation. The result was a heightened dependence on thermal sweating for the dissipation of heat.

This alternative to the traditional cooling device theory, originally proposed by Newman in 1970, would seem to be perfectly plausible, except for the fact that it does not explain why the hair loss began in the first place. More recently, however, primatologists Gary G. Schwartz and Leonard Rosenblum have made a suggestion which nicely complements Newman's hypothesis. Schwartz and Rosenblum[12] have determined, on the basis of hair density studies of 23 primates, that increasingly massive primates have proportionately fewer hairs per unit of body surface. In other words, the smallest apes and monkeys have relatively dense coats of hair, while the larger ones have corresponsingly thinner coats. These data have led Schwartz and Rosenblum to the conclusion that our ancestors probably started to lose their hair as they got bigger, at a time when they were still living in the forest. By the time they moved to more open country their coat had already become relatively

thin, so that it was ill-suited to reflect the constant heat of the tropical sun. At that point sweating took over as the principal means of heat loss, while the already paltry coat of hair underwent still further reduction.

A not entirely different yet even more innovative approach to this evolutionary puzzle has recently been taken by anthropologist P.E. Wheeler of Liverpool Polytechnic.[13] According to Wheeler, human nakedness and the sweating response may have evolved in close conjunction with the emergence of bipedal walking on the African savanna. Wheeler's reasoning, if I understand him correctly, goes rather like this. Most mammals that roam the plains of East Africa, in stark contrast to ourselves, have not lost their reflective coat of hair. And the reason, according to Wheeler, is that they, unlike us, are not bipedal. On the basis of model experiments, Wheeler has calculated that a four-legged animal on the plains of East Africa exposes about 17 percent of its total body surface to the direct rays of the midday sun. Thus its reflective coat serves a critical function in re-radiating solar heat. Our own bipedal ancestors, by contrast, because of their upright gait, would have exposed only about seven percent of their body surface to the rays of the overhead sun. Thus by standing on two legs our ancestors reduced by some 60 percent their direct exposure to midday solar radiation. Under such circumstances a dense coat of hair would have reflected very little sunlight, and would therefore have been relatively useless. In fact it would have been more of an encumberance than an asset. As such natural selection can be expected to have favored a general loss of body hair, except from the head, where the rays of the midday sun would have hit most intensely, and where the covering of hair might therefore have maintained its usefulness. In the meanwhile, some alternative means of heat loss for the rest of the body would have been essential. And it was apparently for this reason that the sweating response evolved. In Wheeler's view, then, it was the unique combination of bipedal walking and savanna living that precipitated the unique evolutionary response of body denudation and increased sweating.

At present no one can say for certain whether this theory, or

any of the other competing theories yet proposed, is correct. In the absence of definitive evidence for any particular scenario— and no such evidence is presently available—the puzzle of the denudation of the human body will remain unsolved. In the meantime, it is clear that this peculiar evolutionary development, for whatever reasons it may have occurred, has been something less than wholly beneficial in its effects. If our loss of hair has given us an efficient cooling device in tropical climes, it has also left us singularly unprotected against the onslaught of rain and cold and all the other elements that are nature's eternal gifts to man. Ironically, it has also exposed our skin to the actinic rays of the sun, making us in some ways even more vulnerable to heat exhaustion than we might otherwise have been. This is especially true of dark-skinned peoples, whose skin absorbs as much as 20 percent more heat than does the skin of whites. Meanwhile the exposed skin of Caucasoids has rendered them especially susceptible to painful sunburn and to such varied diseases as skin cancer, psoriasis, and acne.

As for the sweating response that seems to have evolved in conjunction with the loss of hair, this too is a highly imperfect adaptation, one which causes us no few difficulties and hardships. Indeed, at least one biologist, namely William Montagna, has described the human propensity for sweating as a "major biological blunder."[14] According to Montagna, sweating drains the body of enormous amounts of moisture, which require almost constant replenishment. It also depletes the system of sodium and other essential elements. And, since we have never evolved an efficient method of replacing lost body water, the results are nothing short of disastrous.

The many problems associated with human sweating and the loss of body hair are discussed in some detail by Russell Newman in his 1970 article, 'Why Man is Such a Sweaty and Thirsty Naked Animal'. According to Newman, most domestic animals, and many wild ones, possess the ability to increase the frequency of their drinking under conditions of unusual heat stress; some have acquired a capacity to rehydrate themselves each time they drink. A notable example is the camel—an animal that is well-known for its amazing ability to ingest

massive amounts of water in very brief periods of time. (Some individuals can take in as much as 25 gallons in ten minutes.) Other mammals, like the donkey, the guanaco, and the sheep, are also prolific drinkers, each of them capable of replacing lost body water quickly and efficiently. But man, as Newman notes, is different. Unlike other members of his class, the human animal has never evolved the ability to drink frequently or profusely. Among mammals, in fact, he is one of the least capable of rapidly ingesting water. Humans generally reach satiety after drinking less than a quart of water and cannot consume more than two quarts in a ten-minute period. Thus, ironically, man possesses a greater dependence than almost any other mammal on thermal sweating but a lesser capacity to replace lost body water through rapid drinking. In general humans must resort to frequent drinking in order to prevent even moderate dehydration. Where such frequent ingestion is impractical or impossible, they often become dangerously dehydrated: and yet they do not and cannot diminish sweating to fit their state of hydration. Under conditions of persistent heat, humans are highly susceptible to tissue dehydration and continually dependent on frequent and relatively small drinks of water. The end result is that man suffers from a unique trio of afflictions: hypotrichosis corpus (lack of body hair), hyperhydrosis (excessive loss of moisture), and polydipsia (excessive thirst).

The Makeshift Animal

The process of evolution by natural selection, as we have seen, is still commonly believed to be an essentially progressive and perfective one that always does just the right thing, at just the right time, and that always produces perfect adaptation. The truth, of course, is otherwise. Nature frequently makes mistakes as she tries to adjust existing forms to new habitats and new ways of life. Unfortunately, nature cannot simply destroy old life and create it anew each time changing conditions merit an adjustment. Rather she must adapt old forms to new habitats,

making do with whatever innovations are afforded by mutation and the random reshuffling of genes. As such every extant organism—including and especially *Homo sapiens*—is a makeshift, the end product of thousands of millions of years of unsatisfactory compromises between heredity and environment. Perhaps the only wonder is that the adaptations we observe in the world of organic nature are as functional as they often are.

"Man," as Earnest Albert Hooton has so eloquently put it, "is a makeshift and made-over animal . . .

> In the course of evolution, his ancestors have functioned as arboreal pronogrades and brachiators or arm-progressing tree-dwellers—not to mention more remote stages involving other changes of habitat, posture and mode of locomotion. This protean history has necessitated repeated patching and reconstruction of a more or less pliable and long-suffering organism. The bony framework has been warped and cramped and stretched in one part or another, in accordance with variations in the stresses and strains put upon it by different postures and by changes in body bulk. Joints devised for mobility have been re-adapted for stability. Muscles have had violence done to their origins and insertions, and have suffered enormous inequalities in the distribution of labor. Viscera have been pushed about hither and yon, hitched up, let down, reversed and inverted. In making a new machine out of an old one, plenty of obsolete spare parts have been left to rattle around inside. There are no few evidences of ungifted, amateur tinkering.[15]

To this it might be added that nature's misguided tinkerings are at least as evident in the design of the human psyche as in the design of the human body. (The word 'psyche', indeed, or 'mind', if you will, as it is frequently used, and as I use it here, is nothing more than a shorthand and somewhat metaphorical way of referring to the functioning of the human brain, just as the work 'vision' is a shorthand way of referring to the functioning of the eye.) Like the body, the human psyche is only imperfectly designed, and its inherent defects are the root cause of the many forms of mental suffering to which the human animal is either especially or uniquely susceptible. The brain may well

be the most defective part of our anatomy. Ounce for ounce, it causes us more trouble than any of the organs or appendages it was designed to control. Of course it cannot be denied that much psychological pain suffered by human beings is proximately caused by environmental factors, just as much physical pain is environmentally induced. But mental suffering, as I shall argue in the next several chapters, is more pronounced in humans than in any other animal, and therefore cannot be understood without reference to evolutionary causes. The ultimate source of mental suffering, in sum, can only be discerned through a study of the evolution of the human brain and intelligence. Let us next consider in some detail how the human brain evolved and why that evolution was not accomplished without a host of nefarious results.

Chapter Four
The Maladaptable Species

. . . the recent rapid evolution of human intelligence is . . . the cause of . . . the many serious problems that beset us.

Carl Sagan

One must go to considerable trouble in the laboratory to make an animal crazy by building up erroneous identifications. The route to craziness for human beings is practically effortless.

Stuart Chase

One of the most remarkable developments in the history of life on Earth—and certainly one of the most significant from humankind's point of view—has been the recent rapid growth of human brainpower and intelligence. As a consequence of this singular evolutionary occurrence, man stands quite apart from all other animals. He is by far the most intelligent animal that has ever evolved, or is ever likely to evolve. He is also the most adaptable, the most flexible, and the most educable. No other animal can learn as much, do as much, or adjust to as many different kinds of circumstances. Even our closest living relative, the chimpanzee, falls far short of the human model, both in terms of intelligence and behavioral flexibility. As Harvard zoologist Edward O. Wilson has put it, human beings are so much more complex and more flexible than chimpanzees that

"there is no scale on which the intelligence of the two species can be usefully compared."

Exactly why there should be such a huge gap between human and nonhuman intelligence, no one seems to know, but this is a relatively recent development in evolution. Three million years ago, no such disparity existed. Three million years ago, our ancestors were barely smarter than chimpanzees, and their brains were no bigger than gorilla brains. As recently as two-and-a-half million years ago, the total cranial capacity of our East African forebears—the australopithecines—was only about 500 cubic centimeters, or roughly that of the modern chimp. Beginning about two-and-a-quarter million years ago, however, and for reasons that are still being debated, the proto-human brain suddenly exploded. By the time of the emergence of the first members of the human genus, about two million years before the present, the braincase had expanded to a capacity of about 650 c.c.'s. The next million years saw an even more rapid increase—from 650 to almost 1,000 c.c.'s. Within another several hundred thousand years, the brain had grown to an average size of 1,400 c.c.'s, equalling that of modern man. Between the australopithecines and the first representatives of the genus *Homo,* in other words, there was an increase in cranial capacity of between 40 and 50 percent per million years. After that, the proto-human brain grew at the fantastic rate of almost 75 percent per million years. The total increase from australopithecine to modern man was more than threefold. The end result was the enormous human brain as we now know it, with all its unique powers and capacities.

Does this mean that humans today are exactly three times as smart as were their ancestors of three million years ago? Not necessarily. There is no direct correlation between absolute brain size and intelligence, either in humans or in any other animal. Intelligence seems to be more a function of the ratio of brain size to body size, and since there was a notable increase in the size of the human body during the last three million years, we would expect there to have been proportionate increases in the size of the brain without there necessarily having been any significant increase in intelligence. Nevertheless, the proto-

human brain did grow at a much faster rate than the proto-human body, and there is evidence that in its internal design the brain has undergone continual refinement throughout the Pleistocene. All things considered, it is evident that human intelligence has expanded enormously in the last two-and-a-half million years. Whatever the relationship between brain size and intelligence, it is clear that, in the human case at least, the two have evolved more or less in tandem. Anything we can learn about the evolution of the human brain will also tell us a great deal about the evolution of human intelligence, and *vice versa.*

The recent evolution of human intelligence has long been a focal point of anthropological speculation, and it still is. Throughout the years numerous theories have been proposed in order to account for this important evolutionary development. But to date none has achieved widespread acceptance, and none has been definitively proven. As in so many other cases, when it comes to the question of human intellectual evolution, there are still many more theories than there are supportive data. And until this situation changes, the exact reasons for the growth of human brainpower will remain obscure. I shall briefly review here some of the many theories that have been put forth, and will follow this discussion with a consideration of the varied consequences which the evolution of human intelligence has entailed. As the reader may well imagine, I do not consider all of these consequences to have been entirely beneficial.

The Evolution of Human Intelligence

One of the first *bona fide* theories ever proposed to account for the evolution of human intelligence stressed tool use as the ultimate causal factor. According to this hypothesis, our ancestors probably began to use simple tools some several million years ago, manipulating physical objects to whatever purpose suited them. Taking advantage of the manual prehensibility and dexterity they had acquired in the trees, they used stones to crack open nuts, or brandished sticks to defend themselves against rivals or against the many feline predators that shared

their habitat. Eventually tool use acquired some significant survival value, at which time the more skillful tool users must have been favored by natural selection. Since the ability to use and make tools was largely a function of intelligence, selection for effective tool use meant selection for bigger and better brains. In time there arose a positive feedback loop in which greater intelligence led to more tool use, and more tool use in turn to ever greater intelligence. The ultimate result was the enormous human brain as we know it today.

This scenario may have been considered plausible at one time, but it no longer commands acceptance among contemporary scientists. Today almost all experts agree that tool use alone could not have shaped the course of man's mental evolution. After all, many other animals use tools, but none of them has ever experienced the kind of massive brain growth that characterized human evolution. Other factors must have contributed to the explosive expansion of human intelligence, which is not necessarily to say that tool use played no role in determining the course of human intellectual evolution. Its role may have been crucial. Many authorities have suggested, for example, that habitual tool use by our ancestors must have led to significant changes in subsistence activity and social life. And these changes in turn may have created the selective pressures that eventually catapulted the human brain into its present dimensions. What, then, might have been these changes in subsistence and social life? A good question, and one to which many answers have been proposed. Our ancestors have gone through quite a few social and subsistence changes throughout the course of their evolution. And as we shall see, each one of them has been posited as a 'prime mover' of human intellectual development.

According to some authorities, one of the most important changes that occurred during the formative stages of human evolution was the shift from a primarily vegetarian to a hunting-and-gathering mode of subsistence. All available evidence suggests that our remote ancestors were essentially vegetarian in their habits, feeding on whatever plant foods their hands could procure and their stomachs digest. At some indiscernible

point, however, they acquired the ability to hunt. And once having acquired this ability, they never lost it. At first they no doubt pursued relatively small prey, like rodents and perhaps other primates more diminutive than themselves. Eventually, however, they acquired the ability to bring down large game, including zebras, antelope, and perhaps even giraffes and elephants. How did they manage this? According to some theorists, by manufacturing weapons of ever-increasing sophistication and by organizing themselves into co-operative bands. In order to hunt big game, so the theory goes, our ancestors had to learn how to work together, co-ordinating their movements in military-style ventures requiring precise timing and an elaborated system of interpersonal communication. As hunting became an increasingly integral component of their life style, selective pressures favoring cleverness and cunning became ever more intense. The end result was a continual sharpening of wits, and a considerable increase in brain power.[1]

Another suggestion, this one put forth by anthropologist Richard Leakey, is that the complex social structure that prevailed among the early hunter-gatherers was crucial in bringing about rapid increases in intelligence. According to Leakey, hunting could not have been the sole determinant of man's mental evolution, because it comprised only a small part of the proto-human life style, and was practiced primarily by males. Females, for their part, spent most of their time gathering fruits, vegetables, and eggs, and caring for children. And their gathering activities were of considerable import, for it is doubtful that the males would ever have developed a sufficient degree of hunting skills to provide a consistent supply of meat for themselves and their mates. As often as not, their hunts were unsuccessful, and they returned to the hearth empty-handed. In such cases they relied heavily on the foodstuffs that had been gathered by the females. The males, in turn, generally reciprocated after a successful hunt, sharing their protein-rich quarry with the females and young. Leakey goes on to argue that this emerging pattern of reciprocal food-sharing may have had a significant influence on the growth of the human intellect. As he sees it, the increasing complexity of social relationships that

accompanied the evolution of the hunting-and-gathering economy gave enormous impetus to the refinement of proto-human intelligence. The intellectual demands of making and maintaining social alliances, of political maneuvering for advances in social status, and the countless other pressures of social life were all important engines in the evolution of human intelligence. "Although there can have been no single force responsible for the extreme development of the human intellect," Leakey writes, "the demands of social intercourse provided a major thrust in the growth of the human brain. The intellectual exigencies of a gathering-and-hunting economy, and the accompanying advantages of technology, must also have played their part."[2]

Along similar lines, it has recently been suggested by a good many experts that communicative behavior, especially linguistic behavior, may have been the most important driving force leading to the emergence of human intelligence. The basic idea here is simple. As the social and economic lives of our ancestors became increasingly more complex, the need for interpersonal communication became proportionately more intense. Men and women needed to be able to communicate with one another about how and when to exchange food. They needed to be able to inform one another where and how to find food, and where to distribute it. Men needed to be able to organize their hunting forays and to 'discuss' their strategies in advance. Men and women alike needed to be able to 'teach' their offspring how to make and use tools, and how otherwise to prepare themselves for adult life. Under such conditions, the ability to communicate linguistically would have been highly 'advantageous' and therefore highly favored by selection. And since the brain is by far the most important speech organ, any selection for linguistic behavior would have been selection for increased brain size. Throughout the formative stages of human evolution, then, those who could communicate most effectively were at a selective 'advantage,' and therefore inherited bigger brains than did their competitors.[3]

Yet another idea—this one much more provocative and more controversial than the aforementioned, but in many ways

also much more compelling—is that inter-tribal warfare among prehistoric peoples may have been the prime mover of human intellectual evolution. In recent decades this idea has in fact been advanced by at least a score of scientists, and its roots are more than a century old. As long ago as 1871 Charles Darwin, in *The Descent of Man and Selection in Relation to Sex,* argued that prehistoric men probably fought with one another from time to time, and that in such disputes (whether over women, over territory, or both) it was the cleverest individuals who were most likely to be successful, both militarily and reproductively, and thus most likely to pass their intellectual aptitudes on to the next generation. Over the course of time this sort of selection could have led to significant increases in human intelligence and flexibility. More recently, in the late 1940s, the famed British anthropologist Sir Arthur Keith, in his *A New Theory of Human Evolution,* suggested that warfare may have been quite common in prehistoric times, and that it probably played a crucial role in the emergence of human intellectual powers.[4] This idea, however, was not well received at the time, perhaps because the recent occurrence of two world wars disinclined scientists and laymen alike to be receptive to even the remotest suggestion that warfare might be inherent in human nature or in human life. And the notion of prehistoric warfare, in many people's minds, carried with it just such an implication. By the late 1960s and early 1970s, however, the idea experienced a resurgence, especially with the writings of Robert Bigelow of the University of Canterbury, New Zealand, and Richard D. Alexander of the University of Michigan. Almost simultaneously, and quite independently of each other, these two scientists devised remarkably similar theses concerning the influence of warfare and inter-tribal aggression on the growth of the human brain. Alexander in particular has stated the case rather forcefully, and has argued it on repeated occasions over the last two decades.[5] Although his ideas are anything but unchallenged on this point, his reasoning is compelling, and if I understand it correctly, runs something as follows.

If human social groups had originally evolved as hunting-and-gathering tribes, and if the principal rationale for their

existence was to procure game, then it is doubtful that these groups would ever have grown beyond a membership of perhaps a dozen adult individuals. This is because successful hunts can be carried out by a relatively small number of men—no more than four or five making an effective hunting unit. Larger groups, indeed, would have been actively disfavored, for as social groups grow in size, so too do their problems and conflicts. The larger the social group, for example, the greater is the likelihood of disease and parasite transmission, and the greater is the likelihood that individuals will come into competition with one another over such things as food, sleeping sites, and mates. Thus unless there was some compelling outside reason for groups to grow larger they would have tended to remain much smaller than they actually did. Why, then, did human social groups continue to grow in size beyond that which is necessary for effective hunting and food gathering? Consider this: in many animal species, especially those that are social and territorial, larger groups usually win out over smaller ones in territorial disputes. Under such circumstances selection can be expected to favor increased group size as an 'advantage' in inter-group competition. According to Alexander, this is precisely the kind of selective pressure that operated on human populations throughout prehistory. As he sees it, in prehistoric times human groups would have grown larger as competition for land and resources intensified, with each increase in the size of one group giving rise to similar increases in competing groups. (All this implies, of course, that throughout human prehistory there was at least an occasional territorial dispute, and that in these disputes at least some individuals were seriously injured or killed. The evidence that such lethal competition did in fact occur among prehistoric humans will be considered in greater detail in a later chapter.) Assuming for the moment that territorial disputes did in fact occur among prehistoric humans (and such disputes need not have been very frequent to have had an impact on genetic evolution), then there would have been natural selection for the cleverest warriors; for these would have been the most consistently successful in inter-tribal combat. As the sophistication of war strategy and war technolo-

gy increased, selection for expanding intelligence would have intensified further still, providing ever more impetus for brain expansion. Increasing intelligence in turn would have led to further increases in warfare technology and strategy, and therefore even more intelligence. Eventually human intelligence spiralled almost out of control, in runaway fashion, and in the end transformed a chimpanzee-like brain into that of the modern human.

As an adjunct to this scenario Alexander has recently suggested that competition within groups, as well as between groups, may have played an important role in the evolution of human cognitive abilities. As he sees it, proto-humans, like their modern descendants, probably tried on occasion to influence and manipulate one another's behavior by various kinds of deceit, propaganda, and treachery. And those who were most skillful at such manipulation would have been at an adaptive 'advantage.' If one individual, for example, was clever enough to persuade others to behave in *his* best interests, rather than their own, then he might simultaneously promote his own reproductive success while detracting from theirs. Such deceit, of course, requires cunning, along with a keen awareness of one's own interests and how these differ from the interests of others. Under such conditions the sharpest wits would tend to win out over the dullest ones, and a continual increase in adaptive intelligence and conscious awareness would have been the result. At the same time those individuals who were clever enough to recognize deceit when they saw it, and sophisticated enough to avoid being entrapped by it, would be at a selective 'advantage.' Thus both the ability to deceive, and the ability to avoid being deceived, may have led to an elimination of the dullest minds and an increasing refinement of social awareness and manipulative skills.

Assuming that human intelligence evolved for one or all of the aforementioned reasons (and no one really knows for sure why it evolved), a number of important questions immediately suggest themselves. What is the significance of our having evolved such an enormous intellect? How does our intelligence affect our perception of the world and the way we live our lives?

What does it mean to be the most intelligent and the most adaptable organism that has ever evolved? Obviously I am not the first author who has addressed questions such as these, and the answers I proffer here are admittedly not always entirely original. But I do hope that they will be stimulating. And I am confident that they will be surprising to those readers who are not accustomed to thinking of human intelligence as a double-edged sword.

The 'Advantages' of Human Intelligence

One does not have to search very long or hard in the annals of Western thought to find subjective appraisals of human intelligence, or comparisons between nonhuman and human forms of intelligence. And in most cases these comparisons take the form of unabashed pleading for the absolute superiority of the latter. An excellent example, and one which illustrates the antiquity of this line of thought, may be found in Aristotle's biological treatise *On the Parts of Animals.* In this work Aristotle compares human intelligence and adaptability with their counterparts in other animals and unhesitantly declares the human form to be superior in every way. In the matter of self-defense, for example, Aristotle saw nonhuman animals as entirely too specialized. For the most part, he wrote, each animal has but one mode of defense, and this it cannot change; as such it must perform all its activities and even, so to speak, 'sleep with sandals on', never laying aside whatever serves as a protection to its body. Man, by contrast, is flexible enough to adopt numerous modes of defense, each of which can be altered to suit the circumstance. The human hand, for example, is at once a talon, a hood, or a horn at will, according to the immediate needs of its owner. It is also a spear and a sword and whatever other weapon or instrument it is capable of manufacturing. In almost every other way, too, Aristotle insisted, man possesses an unmatched versatility and enjoys all the privileges that this versatility entails.

Aristotle, of course, was by no means alone in this way of

thinking. In fact his one-sided assessment of human adaptability has been echoed again and again since his time, often enjoying widespread and uncritical acceptance among laymen and philosophers alike. A variant of his argument was revived with particular fervor in the seventeenth century by such rationalist philosophers as Descartes, Leibniz, and Spinoza, all of whom adopted an idealistic optimism based on the belief that human behavior, because it is so pre-eminently flexible, can readily be molded to suit socially constructive goals. It has only been with the coming of evolutionary theory, however, that this trend of thought has reached its zenith, and has begun to permeate the pages of scientific as well as philosophical writings. Many evolutionary scientists seem to be in essential agreement with Aristotle and like him have been quick to point out the limitations of animal instincts as compared with human flexibility and intelligence. Their arguments have been repeated time and time again and to a certain extent are still current in the professional literature. One recent scientist who stated the case with particular forcefulness was the geneticist Theodosius Dobzhansky. In many of his writings Dobzhansky presented enthusiastic defenses of the Aristotelian line of thought, echoing the ancient view that intelligence is absolutely superior to instinct. What follows is a synthesis of his basic argument.[6]

If primitive organisms can be said to enjoy any 'advantage' over their 'higher' counterparts, Dobzhansky writes, it is that they are born fully prepared by their genes to deal with the problems of making a living and staying alive. The individual needs no training or preparation for the procurement of sustenance or self-propagation. With almost no effort, it does just what it must to ensure its continued survival. It does, instinctively, exactly what it should do at precisely the right time. Why, then, has the general trend in evolution seemingly been away from rigid instinct and toward ever more flexible behavior? The answer, according to Dobzhansky, is that the instinctual wisdom animals are born with—for all its apparent advantages —actually has some severe adaptive limitations. Experimentation has shown, for example, that when an animal is displaced

into an environment for which it is not adapted, its innate behavior may lose its appropriateness. In such cases the animal continues to follow its instincts blindly, doing exactly the wrong thing and thereby damaging its own chances for survival and that of its offspring. In fact nature abounds with examples of behaviorally inflexible species failing to adapt to new and unusual circumstances and becoming extinct as a consequence. Ironically, then, the more efficiently an organism is adapted to a particular environment, the more fatally dependent it is on the accidents of environmental change. The more superbly it is suited to a particular set of circumstances, the more susceptible it is to extinction when faced with radical changes in environmental conditions. The more precisely attuned an organism is to a certain set of natural conditions, the more effectively is it confined to the environment in which those conditions exist. Man, by contrast, has largely escaped these adaptive limitations by evolving the capacity to adjust his behavior to suit his circumstances, however unstable they may be. If a particular mode of human behavior is maladaptive, it can be altered to become more appropriate, in contrast to the instinctive behavior of other animals, which is much less modifiable. It is precisely this flexibility of behavior that allows humans to survive in situations where less educable creatures would quickly perish. Equipped with a supreme intelligence and adaptability, man is capable of surviving in a wider range of environments than any other animal. He can function successfully in the arctic or in the tropics or almost anywhere in between; he can survive in the desert or in the jungle or even in the sea. He possesses an unparalleled ability to overcome nature and in so doing to postpone his demise in ways that are well beyond the reach of even the most versatile nonhuman animals.

This sort of anthropological braggadoccio is not nearly as common in the scientific literature as it used to be, but as recently as the 1960s and 1970s it was still fairly routine, and even in the 1990s it has by no means completely subsided. One well-known author who has repeatedly argued in favor of the absolute superiority of the human mode of adapta-

tion is anthropologist M.F. Ashley Montagu. In his many writings, Montagu has frequently reiterated the basic Aristotelian argument, as he did for example in his 1976 book *The Nature of Human Aggression.* In the following passage from that work, we see how clearly the anthropocentrism of Aristotle is still evident in modern scientific discourse: "It is a main difference between humanity and other animals," Montagu writes, "that the latter rely upon the body and its capacities by which adaptation to the environment may be implemented—as, for example, by the development of structures which may be used for defensive purposes—whereas humanity has evolved by the opposite principle, namely, by escape from the constricting bondage of reliance upon organically determined predispositions, to the freedom of what has been called 'the superorganic,' to the human-made way of adapting oneself to the challenges of the environment."[7] Humans, in other words, are superlatively capable of acquiring learned responses in situations where instinctive responses would be inadequate or even fatal. And it is precisely this capacity which makes us so different from, and so superior to, all the other animals that roam the earth.

Or does it? Perhaps the matter is not so simple as writers like Montagu suggest. It may very well be, as they argue, that behavioral flexibility has its 'advantages,' and that in certain situations at least adaptive intelligence can be a handy tool. But it does not necessarily follow that intelligence and behavioral flexibility are inherently superior to instinctive behavior. Nor does it follow that, in evolution, the former are invariably favored over the latter. And it is certainly not the case that intelligence has no inherent drawbacks of its own. In fact it can be demonstrated—as I will show—that none of these things is true. The fact of the matter, as we shall see, is that intelligence is *not* inherently superior to instinct, that more intelligent organisms are *not* invariably favored over less intelligent ones, and that intelligence, even where it can be said to possess some positive adaptive value, is by no means unmitigatedly advantageous—either in the biological or the colloquial sense.

It is simply a mistake to assume, as Montagu and others like him seem to have done, that intelligence has no disadvantages.

In fact it has a great many, and as we shall see, its drawbacks are precisely proportional to the amount of intelligence evolved.

The Price of Behavioral Flexibility

One of the most obvious trends in evolution, it would seem, is the emergence of more intelligent from less intelligent forms of life. Indeed, in almost any lineage we choose to examine, the trend seems to be away from instinctual behavior patterns and toward ever greater degrees of intelligence and flexibility. In the primate lineage, for example, the evolutionary growth of intelligence seems to have coincided almost precisely with the emergence of new species. Thus we find humans to have been descended from apelike creatures, apes from monkeylike creatures, monkeys from lemurlike creatures, and so forth. In each case the more recently evolved forms are also the more intelligent. One gets the impression, in short, that evolution inevitably proceeds from lesser to greater forms of intelligence, and that the opposite trend is not only unlikely, but probably impossible. But is it really so? Apparently not. As many scientists have recently documented the evolutionary trend as regards behavioral flexibility and intelligence is not the one-way street that it was once presumed to be. Rigid behavior patterns often evolve from more generalized forms of intelligence, and evolutionary movements in this direction may be the more common type. As we shall see, it is only because trends from lesser to greater intelligence are more conspicuous, and more likely to catch the eye of anthropocentric observers, that they have often been assumed to be the general rule.

One scientist who has challenged traditional beliefs in this regard is Edward O. Wilson of Harvard University. According to Wilson, the emergence of stereotypical behavior patterns from more generalized learning capacities is probably a common occurrence in evolution—more common than the opposite development. It is only relatively rarely, he suggests, that flexibility of behavior evolves and ultimately gives rise to cumulative increases in intelligence. He explains:

When exploratory behavior leads one or a few animals to a breakthrough enhancing survival and reproduction, the capacity for that kind of exploratory behavior and the imitation of the successful act are favored by natural selection. The enabling portions of the anatomy, particularly the brain, will then be perfected by evolution. The process can lead to greater sterotypy —'instinct' formation—of the successful new behavior. The caterpillar accidentally captured by a flying sphecid wasp might be the first step toward the evolution of a species whose searching behavior is directed preferentially at caterpillars. Or, more rarely, the learned act can produce higher intelligence.[8]

Another scientist who has arrived at essentially the same conclusion and expounded it in even more elaborate fashion is anthropologist Donald Symons. Like Wilson, Symons points out the error in assuming that behavioral flexibility is invariably adaptive, suggesting that this error is largely the product of anthropocentric bias. According to Symons, learning capacities frequently have disadvantages compared with innate behavior, and it is only our human bias which leads us to believe otherwise. "Since human adaptation depends so profoundly on learning abilities," Symons writes, "we sometimes are inclined to imagine that there is an inherent advantage—almost a moral superiority—in such abilities and to forget how rare they are: adaptation in most animal species depends very little on learning abilities."[9] In fact innate behavioral patterns often evolve from more generalized abilities to learn. Symons explains:

> Both the sophisticated learning abilities and the sophisticated 'innate' responses of living animals must have evolved from the more rudimentary abilities of ancestral animals to respond to their environments in adaptive ways. An animal that learns a particular adaptive response to a given stimulus situation after 20 exposures to that situation (learning trials) will have a reproductive edge on conspecifics that are unable to learn the response at all. Subsequent generations—in which the learner's progeny will be disproportionately represented—may contain individuals capable of learning the response with even fewer learning trials. If invariably it proves adaptive to exhibit the

response in that particular situation, natural selection may eventually produce animals that exhibit the response the first time they encounter the situation; that is, with no learning trials. The response has become 'innate'. A rudimentary learning ability thus may become increasingly refined and specific through the operation of natural selection and terminate in an 'innate' response. More rarely rudimentary learning abilities become the basis for the evolution of higher intelligence.[10]

In sum, wherever rigidly programmed instincts are more conducive to reproductive success than the capacity for flexible response, selection can be expected to favor the former over the latter. And if Wilson and Symons are correct, this may be the more common occurrence.

In the first edition of his book, *Animal Behavior: An Evolutionary Approach,* John Alcock discusses some specific ways in which innate behaviors may be more adaptive than learning capacities. According to Alcock, learning is adaptive only when environmental unpredictability of some biological importance to an individual is reliably present in certain situations. When there is a completely predictable relationship between an environmental cue and a biologically appropriate response, a rigidly programmed behavior is usually the more adaptive strategy. In some cases flexibility may actually be harmful, even fatal. This is because, in many environments, the organism needs to be able to respond correctly the *first* time to a particular stimulus; otherwise it might not live long enough to learn a more appropriate response. Among cockroaches, for example, the individual that does not flee the first time it senses the approach of a mouse or a rolled-up newspaper is likely to die before it has a chance to produce any offspring, and its unadaptive genes will have been summarily eliminated from the population. Meanwhile, genetically programmed behaviors can also be useful to predators, especially to those that rely on instincts to guide their selection of prey. The wasp, *Philanthus tragulum,* for example, is a specialist food selector which feeds exclusively on honeybees; it wouldn't survive very long if it had to learn which of the thousand or so available species it is best suited to prey on. The *Philanthus* wasp that knows instinctively

that it is supposed to eat honeybees is the one that has the best chance of survival. In many other instances, too, innate behaviors are actually more reliable and more efficient than equivalent learning abilities would be. Closed genetic programs are particularly important in species that are short-lived or that reproduce only once—for them the reliability provided by innate reactions is absolutely essential. According to Alcock, "innate behavior is advantageous if the consequences of an initial mistake are great or if the cost in time and energy required to learn the correct response is high . . . there is no advantage associated with behavioral modifiability in predictable and unchanging environments. Programmed responses are widespread because animals that base their behavior on relatively simple signals provided by important objects in their environment are likely to do the biologically proper thing."[11]

There are many environments in which flexible behavior is indeed the more adaptive strategy. Otherwise the so-called 'higher' forms of intelligence would never have evolved. But even where intelligence and behavioral flexibility can be said to be adaptive, in the sense that they contribute to reproductive success, they are by no means unmitigatedly advantageous. And they do not lose their drawbacks simply by acquiring some adaptive value. On the contrary, the drawbacks remain, and they are always directly proportionate to the degree of flexibility evolved. As we have just seen, the primary 'advantage' of behavioral flexibility is that it allows the organism to acquire proper responses to variable or unpredictable conditions. By the same token, however, it also allows the organism to acquire *im*proper responses. And there is never any guarantee that the animal will learn the proper rather than the improper thing to do. In cases where it learns the latter rather than the former, its behavior may turn out to be every bit as maladaptive and as destructive as that of the cockroach that runs into, rather than away from, the mouse or rolled-up newspaper. Moreover, the greater the degree of flexibility an organism evolves, the greater is the likelihood that it will develop maladaptive behaviors. Thus it is no coincidence that it is precisely the most intelligent organisms alive today that generally exhibit the widest array of

maladaptive behaviors. Unfortunately, intelligence and behavioral flexibility can be as baneful as they can be beneficial. And their maladaptive aspects are nowhere more evident than in the case of man. Humans are often loath to admit it, but their capacity for maladaptation and irrationality, as well as for adaptive learning and insight, is unparallelled in the animal kingdom. And ironically it is precisely because they have evolved such an enormous intellect that this is the case. With characteristic succinctness, Donald Symons sums up the situation thus:

> . . . intelligence is a two-edged sword. . . . the more flexible an organism is the greater the variety of maladaptive, as well as adaptive, behaviors it can develop; the more teachable it is the more fully it can profit from the experiences of its ancestors and associates and the more it risks being exploited by its ancestors and associates; the greater its capacity for learning morality the more worthless superstitions, as well as traditions of social wisdom, it can acquire; the more co-operatively interdependent the members of a group become the greater is their collective power and the more fulsome are the opportunities for individuals to manipulate one another; the more sophisticated language becomes the more subtle are the lies, as well as the truths, that can be told.[12]

Human flexibility and human vulnerability are inseparable. And no animal is as flexible or as vulnerable as man.

There can be no doubt but that man is the most adaptable animal that has ever evolved. But by the same token he is also the most *mal*adaptable animal that has ever evolved. That is to say, he has a greater capacity than any other animal for acquiring maladaptive patterns of behavior, and a greater tendency to maintain those behaviors once he has acquired them. No other animal suffers from neurosis or psychosis as frequently or as easily as man. None is more susceptible to behavioral disorder, and none is more likely to acquire habits of blatant self-destruction. There is nothing in the nature of man that ensures that his acquired behaviors will always turn out to be more adaptive than their equivalent instincts in other animals. On the contrary, history shows that human behavior,

on the average, has probably always been at least as maladaptive as that of any other species, and if recent trends are not soon reversed, the ill-effects of human maladaptive behavior, such as overpopulation and environmental destruction, may become irreversible. It's precisely those who deny human maladaptability and who fancy the human species to be the supreme product of nature who are least likely to offer effective cures for the ills just mentioned. With all due humility, let us consider the nature and extent of human maladaptability, and try to appreciate its evolutionary roots.

The Maladaptable Species

Until quite recently, it was extremely rare to find an anthropology book in which the problem of human maladaptability was even reluctantly acknowledged, much less openly discussed. A notable exception is Weston La Barre's 1954 publication, *The Human Animal*. In many respects, *The Human Animal* is a completely orthodox and typical anthropology text. But in at least two ways it is outstanding. First, the writing itself is extraordinarily eloquent and lucid. Second, and more significant, it contains an unusually frank discussion of human maladaptability—a topic which most anthropologists prefer to leave undiscussed. But La Barre, unlike most of his professional colleagues, did not skirt the issue. Rather he attacked it head-on, acknowledging that man is a learning species, and that the trouble with a learning species is that it can learn a lot of bad, as well as good, things. According to La Barre, human maladaptability manifests itself primarily in two ways: first, in the capacity to acquire beliefs that have no basis in fact; and second, in the capacity to acquire behaviors that are not adaptive. As La Barre argues and as we shall see, it is largely as a consequence of these peculiar capacities that man suffers from the various forms of neurosis and psychosis to which he is supremely susceptible.

One of the distinguishing characteristics of the human infant, as compared with neonates of other species, is that the

former comes into the world with far fewer adaptive instincts, and is therefore much less prepared to deal with the problems of staying alive and earning a living. At birth the human infant possesses virtually no innate knowledge at all, and none of the skills it will eventually need to survive. Rather it must learn as it goes along, taking advantage of whatever tuition is provided by its personal experience and by its social milieu. Even into adulthood it never stops learning, and its need to learn never ceases. What it actually learns, however, is by no means always beneficial. The primary 'advantage' of being able to learn, as we have seen, is that it allows the individual to adjust to whatever social and ecological circumstances are prevalent at the time. But the *ability* to learn implies the *need* to learn, and the *need* to learn is inextricably tied up with the vulnerability to improper learning. As Weston La Barre notes, a child's primary source of knowledge about the world is almost always that child's culture, and the sad fact is that cultures are rarely accurate guides to reality. La Barre goes so far as to suggest that the folklores of the world consist *primarily* of beliefs that are not only not true but that could not possibly be true. He further suggests that this ability to 'know' things that are not so is a unique peculiarity of man among animals, and arises as a consequence of his natural ignorance and gullibility. Man alone among animals, La Barre writes, has the ability to be spectacularly wrong, and wrong over long spans of space and time. And while all culture arises from an attempt to solve human problems, the end so earnestly sought is only rarely the end actually achieved. "Culture," explains La Barre, "can be a bane as well as a boon. The solitary animal has no way of perpetuating mistaken solutions to problems; if a mutation is anti-adaptive, the animal dies. And if the environment changes, a one-time adaptation may become a lethal trait. When the animal dies, all his possible progeny die with him. But culture has its own peculiar progeny and social descent, and quite ignores biological heredity . . . culture may include traits that are nonadaptive, but 'immortal' over long periods of time; and several cultures may embody these lethal traits."[13] In other words, maladaptive traits that are genetically determined tend to die out along with their possessors, and they

don't recur unless created anew by genetic mutation. But maladaptive cultural traits, because they are products of the human imagination, are much more difficult to eradicate. And even once having been eliminated, they can crop up again and again.

Culture is not *always* baneful, and not *all* culturally-transmitted traits are unadaptive. Some, perhaps most, cultural traits do indeed secure real adaptation, else the human species would never have survived as long as it has. At least on occasion, however, cultural 'solutions' are little more than precipitous and misbegotten defense mechanisms which, while allowing some degree of psychological homeostasis and 'peace of mind,' ultimately cause more problems than they solve. Examples of this sort of 'solution' could easily be cited by the score, although I shall restrict myself here to only three. Each of these is extracted from La Barre's book, and each illustrates quite well the absurd lengths to which humans will sometimes go in their misguided attempts to adapt themselves to their environment, and to one another.

According to La Barre, many peoples in Southeast Asia suffer from an infection known as *sparganosis,* which is caused by an embryonic worm. The worm itself is normally a parasite of frogs, but it is acquired by humans through the native practice of applying split frog poultices or compresses of frog tissue to inflamed areas, especially to the eyes. The custom was apparently taken over from the Chinese, who were once influential in the area. The rationale of the Chinese 'cure' is twofold: inflammation produces heat, frogs are cold-blooded, hence frog tissue will remove inflammation; also, inflammation of the eye is often due to worms, and since frogs eat worms, frogs applied to the eye will reduce inflammation. But of course this 'remedy', though thoroughly well-intentioned and logical in Chinese folklore terms, does not at all have the desired effect. Obviously a technique for infecting human beings with sparganosis is no cure for sparganosis. It may give 'peace of mind' to a person with a sore eye, but it will only make his sparganosis worse. Or, if he didn't already have sparganosis to begin with, the treatment will only ensure that he gets it.

A similar maladaptive custom occurs among the Dinka tribespeople of eastern Africa. Apparently the Dinka believe that the members of the totemic Crocodile clan can swim in the rivers of the upper Nile without being molested by crocodiles, since these animals are thought to be their blood relatives. A member of the Crocodile clan will not hesitate to swim a river, even at night, enjoying complete confidence that he will not be harmed. Unfortunately, the crocodiles themselves do not seem to know the difference between Crocodile clan members and other Dinka, or if they know they seem not to care. Statistics indicate that Crocodile clan members suffer a higher mortality rate than do the members of any other Dinka clan, owing to their greater readiness to brave infested waters. The lesson, as La Barre notes, is simple: "What you don't know *will* hurt you." And if you happen to be a member of the Dinka Crocodile clan, it can even kill you.

Consider finally the Koryak tribesmen of Siberia. According to La Barre, the members of this tribe are enjoined by religious belief to sacrifice their dogs on a yearly basis, lest the gods who 'own' and control the wild game would not bless them with good hunting. In hard ecological fact, however, the Koryak can ill afford to dispense with their dogs, which are valuable to them in many ways and often mean the difference between life and death. Thus, in the pursuit of a factitious security, the Koryak actually lessen their already slim chance for survival. Were it not for the fact that they can get new dogs from nearby tribes (who lack the Koryak's dog-killing superstition), the Koryak themselves might long since have become extinct.[14]

These might seem at first sight like extreme examples. And the average Westerner is probably inclined to believe that the blatantly maladaptive superstitions of the Koryak and the Dinka are relatively rare, being restricted to a few 'backward' societies. But is this really so? La Barre suggests that it is not. In truth, he writes, *any* given culture, at *any* give point in time, is bound to exhibit a considerable inventory of neurotic customs and fatuous beliefs. *All* cultures, according to La Barre, are full of fraudulent sparganosis cures, deluded Dinka Crocodile clans, suicidal Koryak dog sacrifices, and all manner of irration-

al and self-destructive superstitions. *All* cultures "are loaded with useless (even dangerous) baggage. . . . Ethnology is full of examples of economic systems like Kwakiutl potlatching (the prestige-enhancing destruction of property) that impoverish rather than enrich; social organizations like the Hindu castes that minutely separate rather than unite man and man in society; political systems (every absolutism in the world, primitive or civilized, ancient or modern, is an example of these) that destroy rather than give a voice to the natural power and dignity of the individual man; and religions (perhaps the reader can think of his own examples) that hamper rather than enhance our seeking for truth." La Barre goes so far as to equate culture with psychosis, insisting that there is "no discernible difference" in content between the two. Cultures and psychoses, he writes, differ only in the number of their respective communicants:

> This is no doubt an alarming statement, thus to equate cultures with psychoses. And do not all cultures allege their own categorical rightness—anyway *ours* must be right! But cultures and psychoses are identical in these ways: qualitatively, in being symbol-systems; functionally, in being anxiety-allaying; and also operationally, in being mere human hypotheses to be tested by reference to the real world.
>
> Indeed, psychotics and the bearers of a culture are further alike in refusing to put belief to the test, or in not being aware of why reality testing is necessary. The psychotic rests his case on a blindly defended emotional need to believe; the tribalist supports his belief in finding the same emotional will to believe in his fellows. The tribalist uses his *society* for purposes which can only properly be served by the real world: that is, as a source of infallible knowledge and as a test for truth. Both psychotic and tribalist alike mistake their needed beliefs for Nature.[15]

Part of every culture is thus 'defense mechanism', and the function of culture and psychosis alike is to be 'homestatic', that is, to maintain preferred equilibria.

Culture is a major source of misinformation and miscue that can lure the developing human away from the path toward sanity. Unfortunately it is by no means the only such source.

There is, too, the individual's own peculiar upbringing, which, if inconsistent or chaotic, can render healthy adjustment to life and society difficult or even impossible. Thus the individual, to use La Barre's words, can be 'doubly damned'—he can suffer not only from the collective madness of his culture, but also from his own neurotic (or psychotic) maladjustment to the world. In the latter case he suffers from a malady which is largely restricted to the human animal, mental illness.[16]

Human beings, as we have seen, differ from other animals in that they possess fewer innate responses and benefit less from the security of a regular and predictable environment. The developing human must acquire its responses as it goes along, learning by experience what other animals already know by instinct: how to earn a living, how to find a mate, how to get along with one's fellows, how to avoid being exploited by others, and so forth. Man, like any other animal, is born with a host of biological needs, but unlike other animals he is not born with a knowledge of those needs or how to satisfy them. At birth the human infant is less well-equipped than any other animal to deal with the world into which it is thrust. In order to fulfill his most basic biological requirements, the human animal is obliged to endure a lengthy and often arduous education, and for all his efforts he has no guarantee whatsoever that anything he learns will be of any use to him. Throughout this educational process, any number of improper responses may be acquired and any amount of maladaptation effected. The precise nature and extent of the improper learning and of the maladaptation vary a great deal from individual to individual and from society to society. But there is no culture on Earth that does not have some method for producing a maladapted human. And although some societies are more conducive than others to the nurturance of a healthy psychological development, none seems to have eliminated mental problems entirely (see the next chapter). There are so many mental disorders to which the human animal is either uniquely or especially susceptible that a comprehensive discussion of their proximate causes would fill many volumes. It seems pretty clear that because of the peculiar nature of man's psychical evolution, mental disease is

largely a human problem. It is rare, if not entirely unknown, among most free-ranging nonhuman species. And even in the artificial confines of the laboratory, the range of neurotic and psychotic symptoms exhibited by nonhuman animals falls far short of the human model. This is a fact which Weston LaBarre has expressed with particular clarity in *The Human Animal.* He writes:

> Man is the only animal that knows how to make mental illness. No wild animal can have a psychosis arising from a confusion of cues and symbolisms and appropriate reaction patterns. The external reality which conditions the animal, and to which its genetically-provided instincts are adapted, is too consistent to lead it into such error
>
> It is true that some animals can be made 'neurotic'. But the interesting fact is that it takes human beings to do it. Reality is too holistically honest, too nonseductive, and too serenely ever the same to confuse the wild animal with antic contradictions. It takes the human psychologist to manipulate the laboratory situation even to make neurotics of experimental animals, as has been done with pigs, sheep, and dogs. But because of the great difference of ability between human and infra-human animals in symbolic thinking, we believe those psychologists are right who say that only humans can become psychotic—so deeply and persuasively deranged in their symbolic systems as to be unable to cope with reality. Other animals can at most be made only neurotic—taught to be confused about cues concerning food and punishment in a given laboratory situation and reduced in that context to the quivering immobility of indecision.[17]

These statements require some updating. When they were first put forth some three-and-a-half decades ago, they presumably evoked little controversy or disagreement. In the meantime, however, numerous cases of neurosis among free-ranging non-human animals have been observed. And many psychologists now believe that it is possible to produce genuine psychosis in laboratory animals. The gist of La Barre's message, however, remains intact. If man is not the *only* animal capable of becoming neurotic under natural conditions, he is certainly *more* susceptible to neurosis than any other animal. And if he is

not *uniquely* susceptible to psychosis, he is certainly *more* susceptible to psychosis than any organism that has ever evolved. Moreover, he is probably the only animal that is capable of genuine psychosis under completely natural conditions.

There is no such thing as a schizophrenic rat, or a manic-depressive gazelle, or a suicidal toad. Nonhuman animals are protected from such afflictions by their genetically-transmitted instincts and by their much simpler nervous systems. When an animal's environment undergoes sudden or massive change, it either adapts to the new set of objective circumstances, or, failing that, succumbs and dies. But humans are not so fortunate. When a human being maladjusts to his social environment, his life goes on, however painful or disfigured it may have become. Whatever the extent of his despair or desperation, he must endure the pain until he has set things straight, or, failing that, put an end to his own existence. In the latter case he betrays a kind of suffering that no nonhuman animal in the history of life has ever had to endure. It is as a consequence of man's unique mental evolution that he has acquired a unique capacity for mental anguish and mental disease. And as we shall see, this capacity is but a small part of the price he has had to pay for the privilege of his supreme intelligence.

The Cost of Intelligent Awareness

If Weston La Barre was one of the few anthropologists who recognized some of the negative, as well as the positive, implications of the evolution of human intelligence, he was certainly not the only writer to have done so. Throughout the history of Western letters there has always been an occasional philosopher, poet, or novelist who tried to show that intelligence is not all that it's cracked up to be, and that it might have drawbacks as well as advantages. Perhaps the most ardent proponent of this point of view was Arthur Schopenhauer, the German philosopher whose ideas were discussed briefly in the opening chapter of this book. On the basis of his own personal

experience, and on his insight into the experience of human-kind in general, Schopenhauer concluded that intelligence and the capacity for suffering are directly proportional to each other: the greater the intellect, the greater the capacity for pain, and the greater the susceptibility to sorrow and unhappiness. In order to see that this is the case, Schopenhauer writes, one need only compare the relative intelligence of man to that of the other animals, or the intelligence of the genius with that of the average person. In either case one will see that it is the more intelligent creature that possesses the greater capacity for pain and suffering. Schopenhauer's full argument runs rather like this: he suggests first, that in the plant there is no sensibility, and therefore no pain; second, that a certain very small degree of suffering is manifested in the 'lowest' species of animal life; third, that the capacity to feel and suffer is somewhat more pronounced, but still limited, in the case of insects and other invertebrates; fourth, that pain of a high degree first appears with the complete nervous system of the vertebrates; fifth, that it continues to increase as consciousness ascends and intelligence increases, until it reaches its pinnacle in man; and, finally, that the more a man knows—the more intelligent he is—the more pain he suffers. The capacity for feeling pain, in other words, increases with knowledge and intelligence, and therefore reaches its highest degree in man. And the more intelligent a man is, the more acutely is he aware of the hazards and disappointments of life, as well as its joys and pleasures; thus the man who is endowed with genius suffers most of all. Indeed, Schopenhauer refuses to admit that a being more intelligent than man could possibly exist, either here or on any other planet, for with his enlarged intelligence he would find life too excruciating to be supported for even a single moment.[18]

A similar point of view was expressed by the philosopher Eduard von Hartmann, who lived just after Schopenhauer's time, and who is often considered Schopenhauer's intellectual successor. Like Schopenhauer, von Hartmann is convinced, and he endeavors to show, that suffering increases with the development of the intellect, or rather that sensitivity to pain is largely a

function of intelligent awareness. Complete freedom from pain, according to von Hartmann, exists only in the mineral kingdom, which represents a sort of zero of the senses, above which living creatures struggle constantly to avoid suffering. From any point of view, he writes, it is clear that those creatures whose nervous systems are most sensitive bear a greater burden of suffering than their less impressionable brethren. In 'descending' the scale of being, therefore, it is easy to see that plants are less burdened by pain than animals, and animals less than men. The horse, whose sensibility is pronounced, leads a more painful existence than the swine, or even the fish, whose happiness at high tide is supreme. The life of the fish is happier than that of the horse, the clam is happier than the fish, the life of the plant is happier still, and so on 'down' to the simplest forms of organic being, where consciousness expires and suffering ends.[19]

To the modern reader, these comparisons between the relative happiness of clams and swine may seem ludicrous, even absurd. And perhaps they are. Human beings are probably the only creatures that are capable of genuine happiness—or unhappiness—at least in the sense that these words are normally understood. And it therefore makes little sense to speak of horses and pigs and fishes as being either happy or unhappy. Still, it can hardly be denied, as both Schopenhauer and von Hartmann suggest, that man's intelligence has given him an unparalleled capacity for pain and sorrow. Their musings provide a good illustration of the fact that man, because he possesses intelligence to a superlative degree, suffers more than any other animal from the inherent drawbacks that adaptive intelligence entails. It is abundantly clear, as Schopenhauer points out, that our intellect has given us at least as many negative as positive capacities.

Intelligence and Warfare

In the writings of some anthropologists and other scientists the argument is sometimes advanced that human warfare is not an expression of human instinct or predisposition. "War is not in

our genes," so it is claimed, and we must therefore look to other causes for its genesis. The rationale behind this oft-stated argument seems to run something like this. Nonhuman organisms may be 'driven' by their genes to behave in certain ways, and may not be able to control their innate impulses, aggressive or otherwise. But humans are much more flexible in this regard, because in the course of our intellectual evolution, we humans have eschewed almost all of our instincts in favor of intelligent self-control. Thus as compared to other animals, we have few if any rigid instincts, and certainly no innate drive toward aggression or warfare. All the armed conflicts of history, according to this point of view, are nothing more than the adverse results of neurotic cultures and misguided learning, without which neither civilized nor uncivilized man would experience the slightest natural inclination to acquire land, property, or anything else through violent or treacherous means.

Stated in such terms, this argument seems sound enough. But when it is tested against the real world, it tends to break down rather badly. When we leave the realm of theory and speculation and actually compare the warlike behavior of humans to that of other animals, we find virtually no empirical support for the contention that humans, as compared with other species, are not genetically prone to violence or war. If the argument just cited were valid, then we would expect to find relatively frequent warfare in nonhuman animals, and little or none in humans. But the truth is just the reverse. Warfare has been a relatively frequent occurrence for at least several thousand years; and there is evidence (some of which will be mentioned in Chapter 7) that it may have been just as common in prehistoric times. By contrast, war as we know it is virtually unknown in the rest of the animal world. It would appear that, if anything, there is something about our genetic constitution, as compared to that of other animals, which actually makes us *more,* not less, prone to war.

One of the most obvious differences between humans and other animals is that we, unlike them, have evolved the capacity to manufacture artificial weapons of ever-increasing sophistication, and therefore ever-increasing destructiveness, beginning

with simple stones and clubs, and proceeding thence to the spear, the bow and arrow, the sword, the rifle, the cannon, the tank, and finally the nuclear bomb. Since weapons such as these are one of the principal factors that make human warfare so deadly and so destructive, and since the lack of such weapons is one of the factors that makes war among animals virtually impossible, the argument that our evolved intelligence has somehow freed us from the propensity toward war is a hollow one indeed. On the contrary, if anything, our intellectual evolution seems to have made warfare more easy and much more destructive. Human intelligence is itself a weapon of war and is routinely used to construct arms, devise strategies, plan attacks, organize propaganda campaigns, and so forth. (It may even be, as theorists like Richard Alexander and Robert Bigelow have suggested, that it was precisely the need to make war which led to the evolution of human intelligence in the first place.) The acquisition of such an enormous intellect has also given us humans a capacity to increase our numbers artificially and thus to overpopulate the globe to a point where warfare becomes increasingly more likely, more frequent, and more lethal. In the twentieth century alone more than one hundred million people have been killed in war—a greater number of humans than existed during most of the previous history of the Earth, and a greater number than all the nonhuman vertebrate species on the planet have ever killed of their own kind in organized aggressive encounters. Perhaps there is something like a World War II in the natural history of some nonhuman animal, but in my survey of the ethological literature I have yet to come across it.

The evolution of intelligence in the human species seems to have facilitated armed conflict and aggression in yet another way. Along with our intelligence, we have evolved the capacity for culture, and indeed the need for cultural adaptation in order to survive. The 'advantage' of this kind of adaptation, of course, is that it allows us to survive in a wide array of ecological contexts. Because we humans are such flexible animals, each human group has the ability to develop its own peculiar culture and to establish rules, mores, customs and

beliefs which it deems most appropriate for its particular habitat and way of life. Our tremendous adaptive flexibility, in other words, has provided us with the capacity for much cultural diversity, and it is precisely this capacity which makes it possible for us to adapt to a great variety of environments and to develop many different ways of exploiting similar environments. One of the disagreeable consequences of our cultural diversity, however, is that it tends to make us ethnocentric: each person seems naturally disposed to look at his own culture as superior to all others and to be reluctant to recognize members of other cultures as deserving of equal respect. Ethnocentrism is a world-wide phenomenon, and it is no less common in hunting-and-gathering societies than it is in contemporary industrialized states. All peoples tend to look upon members of other cultures as subhuman and therefore not deserving of the same ethical treatment that is normally afforded to 'real' human beings. Many peoples have given themselves names that reflect their own ethnocentric view of the world. One group of the !Kung San of the Kalahari, for example, call themselves by a name that literally means 'the real people'. Apparently to this group of the !Kung, other peoples are not genuinely human. In their language the words for 'bad' and 'foreign' are one and the same. Similarly, the Yanomamo Indians speak of their world as 'the real world', and all other people are equally disparaged as 'foreigners'. According to anthropologists Davydd Greenwood and William Stini, it is almost a universal trait of human groups to believe so strongly in their own cultures that they have great difficulty taking other cultures seriously as legitimate designs for living. Unfortunately, this kind of ethnocentrism makes inter-cultural misunderstanding and intergroup hostility extremely facile. Greenwood and Stini explain:

> Members of other species do attack and even kill one another, but the human dimension of culture adds a whole new set of differentiations by which members of the same species can maltreat each other. This is a basic element in human aggression. Culture confers on our species an immense plasticity of responses, but the very nature of this plasticity contributes to great differentiation between cultures and the potential for severe

hostility between them. Those people not culturally intelligible to each other find each other immensely threatening

It is then not surprising that the increasing commitment of our species to cultural means of adaptation and the gradual historical development of diverse subsistence, social, political, and religious systems has itself increased the violence of our intraspecies relationships. The more different cultures are, the more difficult to control aggression by recognizing our common humanity. Thus the present level of human aggressiveness, though not excusable, is intelligible as a product of human history. As cultures have become more differentiated, aggression among them has become more dissociated, more violent, and less controllable.[20]

Of course the problem of human aggression cannot be explained solely in terms of man's proclivity for ethnocentrism or his capacity to devise and manufacture artificial weapons. The motivations for aggressive behavior are much more complex than that. To be sure, as much as human beings may dislike or distrust one another, they do not normally fight one another unless they have something to fight about. That is, conflict of some sort is usually a prerequisite to violence. And where there is no genuine conflict of interest, there is little motivation for violent behavior. Still, it is an obvious fact that conflict of interest is a widespread phenomenon among human beings, and in Chapter 7 I shall discuss some of the reasons why this is the case. For now suffice it to say that, when interpersonal or intercultural conflicts do arise, as they often do, man's tendency toward ethnocentrism and his lack of aggression-inhibiting instincts make violence all the more likely to occur. And, as strange as it may seem, our possession of an enormous and unsurpassed intellect is at least in part to blame for this being so.

The Limits of Human Adaptability

Man is the most intelligent animal that has ever evolved, but how intelligent is he? Is he *infinitely* intelligent? Can he learn to

do *anything,* under *any* conditions? Are there no limits to his educability, or to the amount of information his brain can store and process? Can he learn *any* task with equal ease? And can he readily unlearn any behavior that ceases to be of use to him?

Man is the most adaptable species that has ever evolved, but how adaptable is he? Is he *infinitely* adaptable? Can he adapt to *any* conditions, at *any* time? Can he adapt with equal facility to *any* situation, whatever its nature? Is there no limit to how easily or how rapidly he can alter his behavior to meet changing conditions? Can he endure any amount of change in any given period of time?

To my knowledge, no scientist or philosopher in the history of Western thought has ever answered all these questions with an unqualified and unequivocal 'yes'. Even J.B. Watson, who overestimated human adaptability perhaps as much as anyone ever has, readily admitted that the native ability of human beings to learn and to alter their behavior, however impressive, is not boundless.[21] There are in fact at least three independent sources of evidence which clearly point to the conclusion that human intelligence is not infinite, and human adaptability not without its limits. There are, first of all, various forms of artificial intelligence, such as that possessed by computers, that in some ways at least far outstrip even the most accomplished human mind. Second, there are numerous examples of nonhuman animals performing feats of learning that even the cleverest people cannot match. And finally there are certain rare learning abilities which are possessed by only a few humans (such as idiots-savants and mnemonists) and that are virtually unknown in the rest of humanity. Of these three sources of evidence, perhaps the first is the most obvious, and it is the most recent. Although the dawn of the computer age occurred only a short time ago in historical terms, by now almost everyone has used a computer, or at least a calculator, and is therefore keenly aware of the amazing cognitive abilities possessed by these machines. Computers—as almost everyone knows—can store and process information much more quickly and efficiently than humans can. There is hardly a man or a woman on earth who can

perform mathematical calculations or recall stored information as efficiently or as effortlessly as can even the simplest computer. Recently Robert Sinsheimer has discussed the limitations of human cognition, as compared with computer processing, in an article written for the *American Scientist*. After discussing some of the many things that computers can do but that humans cannot, Sinsheimer comes to the following conclusion:

> I think the computers first made us aware of one of the more evident limitations of the biological brain, its millisecond or longer time scale. Computers flashing from circuit to circuit in microseconds can readily cope with the input and response time of dozens of human brains simultaneously or can perform computations in a brief period of time for which a human brain would need a whole lifetime.
>
> Similarly I believe that we will come to see that our brains are limited in other dimensions as well—in the precision with which we can reconstruct the outside universe, in the nature and resolution of our concepts, and the content of information that may be brought to bear upon one problem at a time, in the intricacy of our thought and logic—and it will be a major contribution of the developing science of psychobiology to comprehend these limitations and to make us aware of them, to the extent that we have the capacity to be aware of them.[22]

And it is not just computers that outstrip humans at various kinds of learning. As surprising as it may seem to those who are accustomed to thinking of humans as unsurpassed in every learning capacity, there are in fact many kinds of routine learning in the animal world that humans would be hard-pressed to duplicate. Even so-called 'primitive' organisms like insects are sometimes able to learn things that most humans would, to say the least, find taxing. The nest-finding behavior of the digger wasp, *Philanthus triangulum*, is a classic example. When a female of this species selects a nest site, she digs a burrow and adopts it as her home base. When she is hungry, she leaves the burrow, scrapes sand over the entrance, and then flies off in search of bees. Later, she has no difficulty in relocating the tiny concealed entrance to her nest, even though she may have travelled many hundreds of yards in search of

prey. How does she manage this remarkable feat? Apparently by learning and remembering the location of certain landmarks that lie in the proximity of the site of the nest. Before leaving the area of her nest she makes a brief orientation flight—lasting as little as six seconds—during which she memorizes the landmarks surrounding the concealed nest entrance. Upon her return she finds the nest by recalling the landmarks. Few humans (with the possible exception of a memory expert known as an 'eiditiker') would be able to memorize and relocate a concealed site on the basis of such a brief orientation. Another wasp, *Ammophila pubescens,* performs even more prodigious feats of memory. Unlike most other digger wasps, this species provisions several nests (up to 15) simultaneously. Not only is the wasp able to learn and memorize the location of each of her many nests, but she brings the proper number of insects to each nest, providing larvae in various stages of development with just the amount of food they will be able to eat before their next feeding. Thus a small, recently hatched larva, which can ingest two or three caterpillars per day, is given just that amount, while a large, older offspring receives three to seven. A full-grown larva, in the meantime, is offered no food at all. Rather its burrow is sealed off and it is left to mature underground. In discussing *A. pubescens,* animal behaviorist John Alcock writes: "The learning abilities of this wasp should give pause to those who automatically equate complex learning with mammals only."[23]

These comparisons between the relative intelligence of wasps, humans, and computers serve to illustrate two important points: first, that human intelligence is anything but infinite; and second, that intelligence varies—from species to species and from individual to individual—in its qualitative as well as its quantitative aspects. Intelligence does not evolve as a generalized capacity to learn just anything, under just any circumstances. Rather it consists of specific aptitudes and learning abilities, each of which evolves in response to specific environmental exigencies. Thus animals differ not only with regard to how much they can learn, but also with regard to what they can learn, when they can learn it, and how easily they can learn

different things. In general, one animal is said to be more intelligent than another if the former possesses a greater variety of aptitudes and learning capacities. But in many cases the less intelligent animal may actually do better when it comes to certain types of learning. As we have just seen, even humans are sometimes outstripped by mere insects, and the prodigy of computers sometimes makes human learning look like a paltry thing by comparison.

The human capacity for learning is impressive, but it is not infinite. And the human mind is extremely flexible, but it is not equipotent. Like any other species, we humans come into the world with certain innate predispositions for learning and behaving; and although these predispositions can sometimes be overcome, the very fact that we have to exert effort to overcome them is evidence that they do indeed exist. The human mind has sometimes been compared to a computer that is set up or 'wired' in a particular way and is thus predisposed to receive and process certain kinds of information, but not others. If the proper input is received, then the computer (the mind) stores it and goes on to the next task. But if you confuse the system—if you overload it with complex or conflicting signals—then the machine can very easily break down or even blow its fuses. The human mind is in some ways an amazingly sophisticated machine, but it is not without its limitations.

Is man infinitely adaptable? Can he adjust to *any* circumstances? Can he change his behavior at will? Once again, the answer seems to be 'no' on all counts. If man is restricted with regard to what he can learn and how quickly he can learn it, he is even more restricted with regard to how readily he can unlearn habits and behaviors that he has already acquired. Humans, as we have seen, have a greater capacity than any other species for maladaptive behavior, and they tend to take maximum advantage of this capacity. Every human being is born into a particular society whose customs and beliefs are already thoroughly established. Through the normal process of enculturation he acquires most of these customs and beliefs, unconsciously accepting them as the most effective way of dealing with reality, however impractical or illogical they may

be. Unfortunately, by the time the individual has reached intellectual maturity it may be too late for him to recognize the absurdity of the beliefs he has embraced. He has learned his cultural lessons so well that much of his behavior takes the form of automatic responses to the cultural stimuli he encounters. And although it would often be to his advantage to change those responses, they may resist modification with all the stubbornness of a rigidly-programmed reflex.

In many traditional scientific writings it is argued or implied that acquired behaviors are inherently easier to modify than instincts. This view is still somewhat prevalent, and does not seem to have undergone any great erosion, in spite of the recent consensus that there is really no rigid dichotomy between instincts and acquired behaviors. (According to most experts nowadays, *all* behavior results from an interaction between genetic and environmental factors.) According to the traditional conception, the instinct is in the very nature of the beast; it is as much a part of the animal as are its bones or its flesh. But acquired behaviors, supposedly, are different; they are superimposed on the animal by external reality, and are therefore part of external reallity, not of the animal itself. They are like articles of clothing, to be put on, taken off, or changed at will, and with minimum effort. But is this really the case? There may be something in it, but it's not the whole story. Humans can sometimes change their behavior as easily as they change their clothes, and in their ability to effect such changes they are unparalleled in the animal world. But however much a human behavior may be 'learned' and therefore 'non-instinctive', once it has been ingrained through years of indoctrination or habit, it is not necessarily any easier to modify than an equivalent 'instinct' would be. Even among humans, acquired habits and behaviors are often difficult, at times impossible, to extinguish. One need only contemplate the pain and anguish that a drug addict suffers during his attempted withdrawals and how seldom those attempts are unsuccessful. Or consider the countless humans who are held on a leash by their addiction to alcohol, cigarettes, or gambling, and the pain they often endure while trying to set themselves free from such addictions. Consider too

the fact that, in almost every known society, persons who suffer from depression, affective psychosis, schizophrenia and other forms of psychiatric disorder tend to have recurrences of their illness throughout their lives, even who they enjoy ready access to the finest professional care. And is it not still true, as Earnest Albert Hooton wrote in 1937, that "in spite of the advances of education and all the substantial progress in methods of social amelioration, crime is still increasing enormously, and that the discharged convict continues to return to his crime, like a dog to his vomit"?[24] Obviously human beings cannot always change their behavior as readily or as quickly as they would like to be able to, and this applies as much to members of the general population as it does to those who suffer from specific behavioral disorders of whatever sort. To be sure, humans of any psychological stature can easily be overcome with stress as they try to alter too much behavior, or take in too much information, in too short a period of time. (The phenomena of culture shock and 'future shock', the results of which can sometimes be devastating, are examples.) Of course, it cannot be denied that man *can* in fact change. But for man, change is rarely easy. And it is precisely the *need* to change—and the difficulties that are so often encountered in the process of trying to change—that constitute much of the hardship that is entailed in being a human being.

If one wishes to get some appreciation of the limitations of human adaptability, one need only study history. For history is replete with examples of whole peoples trying to change their environment because they could not adapt themselves to the environment they were given to inhabit. In human history, rebellion and revolution are the order of the day. They betray man's eternal uneasiness with his circumstances, and the limitations of his ability to adapt to them. For human beings, indeed, the struggle to change and adapt is endless: it goes on whatever the external conditions, whatever the time or place.

How adaptable is man? How intelligent is he? Clearly, these questions are still open to debate, and debated they will no doubt continue to be, long after these words have been committed to print. In any event, human adaptability, whatever its

precise extent, was not acquired without a cost. And the cost was a loss of specialized adaptations for any particular physical environment. Unlike most other creatures, man is supremely unspecialized, and he comes into the world almost totally unprepared to deal with the exigencies of survival in any particular physical habitat. Thus it is a strange irony that man, while he is the most adaptable of all creatures, often finds himself to be less adapted, both behaviorally and structurally, to his specific environmental circumstances. The precise reasons why this is apparently the case, and the ultimate evolutionary causes of its having come about, will be considered in greater detail in the next chapter.

Chapter Five
The Carefree Savage Revisited

*Man has become such a highly
artificial animal that he cannot
live by bread alone. His whole
existence is bound up in his
language, his social institu-
tions, his religious beliefs, his
habits of life, and his material
paraphernalia. Take these
away from him and he loses his
desire for life; the instinct for
perpetuation of the species
dies.*

Earnest Albert Hooton

Beginning in the late 1940s, and continuing into the 1950s, an American psychologist named James Calhoun conducted a series of laboratory experiments designed to test the capacity of domestic rats to adapt to conditions of abnormal crowding. Although few would have guessed it at the time, Calhoun's experiments would soon become classics in their field; they are still widely cited in the annals of behavioral science. In one of his experiments, Calhoun placed some 32 albino rats into a 10-by-14-foot room for a period of 16 months. At first the room was partitioned into four sections, with litter mates confined to each section. After 45 days, however, the mothers were re-moved, and connecting ramps were installed so that every animal had access to all four sections. Sufficient resources and

space were available to support a maximum population of 48;
but the rats continued to reproduce and soon increased their
numbers to 80. The results were in some ways predictable, in
other ways surprising. Contrary to Calhoun's expectations, the
rats did not distribute themselves evenly throughout the room,
but tended rather to assemble in one particular area, which he
dubbed the "behavioral sink". Two of the quarters were
monopolized by strong males, each of which guarded his
entrance and admitted only members of his own harem. All
others were invariably turned away and obliged to retreat to the
overcrowded sink. While the dominant males continued to
exhibit more or less normal behavior, the subordinates did not.
Some of the latter tended to avoid both aggressive and sexual
behavior; others became sexually hyperactive, constantly pur-
suing females but breaking the usual sequence of events, and
indulging in abnormal and bizarre copulations. Still others
became pansexual, mounting anything that moved, male or
female, receptive or no. A few withdrew entirely from social
activities, roaming about aimlessly while the others slept. Most
engaged in unprovoked fighting as a matter of course. Females
were often the target of fierce aggression, and as a consequence
were killed in large numbers. Those few that managed to
survive typically made for very poor mothers; in most cases
their nesting behavior was so disrupted that their offspring
could not be cared for properly. There was hardly a single
aspect of the rats' normal behavior that was not severely
perverted by their prolonged exposure to the highly artificial
and highly abnormal conditions created by Calhoun's experi-
mental manipulation.[1]

Since Calhoun first reported the results of his research, a
number of similar experiments have been conducted with other
species, and often with similar results. In the 1960s, animal
behaviorist Charles Southwick carried out a series of experi-
ments with captive rhesus monkeys and found that, through
skillful manipulation, he could easily increase both the inci-
dence and intensity of aggressivity among his simian subjects. In
one of his experiments, conducted in Calcutta, India,
Southwick built a colony cage of 111 square feet and deposited

into it a group of 17 monkeys, all of whom had been wild-trapped in the forests of North Central India. The group was then given several months to adjust to the new surroundings and to establish some sort of social unity. From the very beginning, however, it was clear that no complete adjustment would be possible. When the group was first formed, there was a very high frequency of aggressive interactions as a social hierarchy was established and other adaptations made. Over a period of about five weeks, the incidence of aggressive interactions declined—from an average of 26 to about 11 per hour. But even the latter is a much higher frequency of aggression than is to be found in natural populations: about 14 times more aggression than in a free-ranging group of city rhesus monkeys and 50 times more than in a free-ranging forest group. Moreover, Southwick was easily able to increase the already abnormal level of aggression by manipulating the population in a variety of ways. When two of the resident juveniles, for example, were removed from the cage and replaced by two others, the entire group erupted into violent attacks against the newcomers; total aggressive interactions per hour shot up from 11 to 47—a fourfold increase. An even more dramatic change occurred when two new females were introduced; this time aggressive interactions increased tenfold—from 11 to 110 per hour. The newcomers in each instance were persistently struck, bitten, and slashed. Such attacks were vicious and damaging, and would have resulted in severe wounds, or even death, had the strangers not been removed after two days.[2]

Experiments like these are not nearly as commonplace today as they were back in the 1950s and 1960s, but during their heyday dozens were carried out, and most yielded similar results. Time and time again it was shown that abnormal behavior is the usual consequence when animals are subjected to unfamiliar and unnatural conditions. Many zoological gardens, too, especially those of an earlier era when animals were often confined to tiny cages, provide equally telling illustrations. Within the highly artificial confines of their cement cages and enclosures, zoo animals typically exhibit a wide variety of neurotic symptoms. Subjected to the interminable boredom of

regular feeding schedules, sterile environments, and a general lack of challenge or stimulation, many zoo animals spend much of their time pacing aimlessly in their cages. In many cases they become overly aggressive, sexually hyperactive, or totally apathetic. Sexual hyperactivity is especially common among captive primates, who enjoy access to abundant food, freedom from the threat of predation, and who suffer from the ennui of having little else to do. Other animals reared in isolation have been known to adopt inanimate objects as sexual substitutes. Still others engage in frequent masturbation, self-mutilation, coprophagia (perversion of appetite), and a host of other aberrations.[3]

The obvious conclusion that suggests itself from examples such as these, and which most behavioral and evolutionary scientists have in fact drawn, is that no animal is infinitely adaptable, and that none can adapt with equal facility to any and all environmental conditions. Each species seems to have been endowed by its evolution with a specific set of behavioral and anatomical adaptations that fit it to a particular set of environmental circumstances. Each animal has a 'natural environment', or 'native habitat'. Generally speaking, an animal has a good chance of thriving so long as it remains within the confines of its natural habitat. But if the organism is displaced into an environment to which it is not adapted, or if its native environment undergoes sudden or catacylsmic change, it may not be able to adjust, and its responses may become maladaptive. This, as we have just seen, is apparently what happens when an animal is plucked out of its natural habitat and spirited away to the highly artificial conditions of captivity. The organism characteristically makes an attempt to adapt, both physiologically and emotionally, to the unfamiliar and abnormal conditions. But because those conditions fall outside its specific range of adaptive potential, its behavioral responses tend to be inappropriate. Displaced animals typically react to unfamiliar situations with unadaptive behavior. Often they become severely neurotic, adopting all manner of aberrant and self-destructive compulsions that are rarely observed in the wild.

The Human Zoo

And what about humans? Do we, like other animals, have a native environment? And do our current troubles ultimately stem from our having displaced ourselves from that environment? According to some authors, the answer is definitely 'yes'. In fact in recent decades it has frequently been argued that the kinds of neuroses and other behavioral abnormalities commonly exhibited by captive animals are precisely parallel to, and have the same ultimate roots as, their counterparts in modern urban man. It has been argued, in fact, that man's only natural environment is that of the nomadic hunter-gatherer, and that all his present ills are ultimately traceable to his having abandoned that way of life to take up existence as an agriculturalist. One of the best-known and most eloquent proponents of this point of view is British zoologist Desmond Morris. In the opening chapter of his book, *The Human Zoo*, Morris states that hundreds of thousands of years of selective pressures have gradually and inalterably adapted man, both physically and mentally, both structurally and behaviorally, to a simple, nomadic, hunting-and-gathering way of life. For at least a million years, the early human hunter-gatherers enjoyed immense success, outstripping their carnivorous rivals and spreading to cover a large part of the globe. Then, suddenly, a group of these hunter-gatherers took the step to farming and food-production, and most of the world's peoples quickly followed suit. This abrupt transition to food-production, Morris writes, "swept [humans] over an unexpected threshold and threw them so rapidly into an unfamiliar form of social existence, that there was no time for them to evolve new, genetically-controlled qualities to go with it." Biologically, Morris argues, man is still the same simple tribal hunter-gatherer he has been for over a million years. But because he has been inadvertently displaced into a social and physical environment for which he is not adapted, man suffers from all the behavioral abnormalities that are characteristic of any displaced animal. Modern man, forced to live in an environment that is hostile to his nature, readily succumbs to self-mutilation, child abuse, sexual perversion,

stomach ulcers, obesity, and hyperaggressivity. The human hunter-gatherer was a "magnificent animal," writes Morris, "but he evolved as a tribal hunter, not as a patient, sedentary farmer."[4]

This idea, as I have already suggested, is not new, and it is not unique to Morris. Dozens of anthropologists and other behavioral scientists, both before and since, have advanced a similar line of reasoning. In the writings of British anthropologists Elliot Smith and W.J. Perry, for example, one finds a thesis almost identical in form to that of Morris. According to Smith and Perry, man is descended from a long line of hominid ancestors, who lived in simple families or family groups for millions of years. The mere ten-thousand-year period of civilization which followed is of little evolutionary influence and cannot have affected man's biological constitution or psychological make-up in any fundamental way. By abandoning its traditional hunting-and-gathering way of life and adopting civilization, the human species has created an artificial environment that conflicts with its basic biological constitution. Civilization is essentially a corrupting influence; it disrupts man's natural development in the same way that the artificial confines of a zoo or laboratory disrupt the behavior of other animals.

Once again, this idea is not new. The notion of the corrupt nature of civilization has a long history, and may be as old as civilization itself. Even in the writings of the ancient Greeks and Romans one finds at least occasional references to so-called 'nature peoples', and expressions of the latter's way of life. The highly civilized Greeks and Romans were aware of the existence of aboriginal tribes in many parts of the world, and they sometimes expressed a longing for the latter's simpler, more natural mode of existence.[5] Since then their sentiments have been echoed by an endless parade of philosophers, literati, travellers, and romantic thinkers in general, whose dissatisfaction or disenchantment with civilized life has evoked in them a sentimental nostalgia for an earlier, less complicated existence. No one in this parade of romanticists, however, has been more outspoken or more adamant than the Swiss-born essayist and

philosopher Jean-Jacques Rousseau. In all of history Rousseau stands out as the single most ardent advocate of the Noble Savage. He was one of the first thinkers of the modern era to exaggerate the differences between primitive and civilized man and to conclude that those differences largely favor the former. His exaggerations have never been quite outdone. And his influence, for better or for worse, is still discernible in modern philosophy, social science, politics, and education. The genesis of his thought and the impact it has had on subsequent generations bear a close and careful examination.[6]

The Roots of Rousseauianism

For reasons that are far too complex to be delved into here, Jean-Jacques Rousseau seems to have been possessed of a life-long obsession to discern the ultimate origins of human suffering and, if possible, to suggest appropriate cures. After many years of anguished deliberation and personal struggle, involving a great deal of failure and disappointment, Rousseau eventually came to the conclusion that the ultimate source of all evil in human life was civilization, or as he preferred to call it, "society". And, having arrived at this conclusion, he did not hesitate to commit it to print. In 1750, he published his first indictment of civilization in an essay entitled *Discourse on the Sciences and the Arts.* Here Rousseau suggests that the alleged 'progress' of modern science is largely illusory, and that competition, as promoted by Western civilization, is the natural foe of man. Three years later, in his *Preface to Narcissus*, he continues his critique of Western culture, implying that he is prepared, given a suitable pretext, to deliver an even more comprehensive attack against the established order. Within a few months he had just the pretext he had hoped for. In the summer of 1753, the Acadamy of Dijon proposed for a new essay competition the question: 'What is the Origin of Inequality among Men and is this Inequality Authorized by Natural Law?' For Rousseau the question could not have been more appropriate or more timely,

so much so that in later years he was inclined to believe that fate had delivered it into his hands. With great zeal he took up his pen and drafted a reply. The result was his *Discourse on the Origin of Inequality,* published in 1755. It is perhaps his best-known essay, and one of the most virulent criticisms of civilization ever written.

The second part of Rousseau's famous discourse begins with the following proposition: "The first man, who after enclosing a piece of ground, took it into his head to say, *this is mine,* and found people simple enough to believe it, was the real founder of civil society. How many crimes, how many wars, how many murders, how many misfortunes and horrors, would that man have saved the human species, who pulling up the stakes and filling up the ditches should have cried to his fellows: Beware of listening to this imposter; you are lost if you forget that the fruits of the Earth belong equally to us all, and the Earth itself to nobody!"[7] Before the invention of private property, Rousseau insists, 'natural' man had led a free and happy existence. The imposition of society on this natural man created a situation of conflict, inequality, frustration, and misery. In society man's needs multiply and competitive struggle becomes eternal. Human dignity is lost, and happiness is forfeited.

Primitive men, according to Rousseau, had wanted for nothing. Satisfied with their rustic huts and animal skins, they enjoyed a brand of independence that has long since perished from the Earth. With no possessions to protect or covet, they knew neither want nor envy. But from the moment that one man began to stand in need of another's assistance; from the moment it appeared an advantage for one man to possess enough provisions for two, "equality vanished; property was introduced; labor became necessary; and boundless forests became smiling fields, which had to be watered with human sweat, and in which slavery and misery were soon seen to sprout and grow with the harvest."[8] Agriculture and metallurgy, in other words, transformed a free and happy animal into an enslaved and miserable one. Corn and iron, as it were, civilized man and ruined mankind. Had these changes never taken place, Rousseau argues, human beings today might yet live in the same

blissful state to which our ancestors were for so long accustomed and from which civilization has effectively delivered us.

Does Rousseau actually mean to suggest that life among pre-agricultural peoples is invariably peaceful and happy, and that primitive people know none of the hardships, conflicts, or anxieties so prevalent in the modern world? Apparently so. Indeed, he insists that it *could not* be otherwise. Among primitives, he writes, there is an unshakable balance between needs and the possibilities of fulfillment; the physical inequalities between individuals (such as differences in age, health, bodily strength, and intelligence) are scarcely noticeable. As a consequence, life is amazingly secure, so much so that it is literally impossible for the primitive to worry himself into a state of ill health. It is Rousseau's contention that the primitive is quite incapable of mental illness or even unhappiness. Physical disease, moreover, is also of social origin, so that the primitive has little to fear on that score either. Spared the corrupting influences of civilization, primitive man is protected from all evil by the good will of nature and the guarantee of satisfaction.

One could hardly have stated the case more radically or more unequivocally. Even Rousseau's admirers are sometimes embarrassed by his extravagances. They know that his exaggerations and superlatives have taken their toll on his credibility. A few apologists have gone so far as to suggest that Rousseau didn't really mean what he wrote. In their view, Rousseau did not intend for his description of primitive man to be taken literally. His 'natural man' was purely hypothetical, and was meant to serve only as a starting point for historical deductions. In any case, Rousseau's conclusions were based almost entirely on speculation rather than on empirical evidence. He knew almost nothing about the real nature of primitive existence. He made, as far as I can tell, no attempt to seek out such peoples, to study them, or to understand their way of life. He did not benefit from access to the kind of ethnographic literature that exists in abundance today, so he wrote in almost total ignorance of what life among uncivilized peoples was actually like. And the same can be said for almost any

European who lived prior to the dawn of the modern science of
ethnology.

Hobbes's Indictment of Primitive Society

Virtually all philosophers of Rousseau's era and before
based their conclusions about primitive man almost entirely on
speculation, or at best on hearsay and anecdotal accounts of this
or that aboriginal tribe. It is perhaps not surprising that such
writers have often come to markedly different conclusions
concerning the nature of primitive existence and the quality of
life among preliterate men. One pre-Rousseauian writer who
speculated on these matters at some length and who came to
conclusions diametrically opposite to those of Rousseau, was
the seventeenth-century English philosopher Thomas Hobbes.
In sharp contrast to Rousseau, Hobbes believed life among
primitives to be anything but idyllic and peaceful. In his
best-known book, *Leviathan,* he describes the life of primitive
man as being "solitary, poor, nasty, brutish and short."[9] With-
out the benefits of civilization, Hobbes insists, primitive peoples
live in a constant state of war and insecurity. Since every
individual is instinctively driven to self-preservation and per-
sonal safety, competition and mistrust are the natural state of
man. Thus, until such time as men live under a sovereign power,
they remain in a continual state of war. This natural state of war,
according to Hobbes, is a historical fact and can be seen for
example in America, where the natives "live at this day in that
brutish manner."[10] It is only through the organization of society
and the establishment of a Commonwealth that peace and order
can possibly be attained.

Rousseau, of course, was very much aware of Hobbes's ideas
and did everything he could to discredit them. But by no means
did he fully succeed in countervailing the Hobbesian view of
primitive life. On the contrary, it was the Hobbesian view that
enjoyed the more widespread acceptance, both before and after
the publication of Rousseau's works. At most Rousseau suc-
ceeded in creating some doubt as to the real nature of primitive

existence, and of the relative benefits of primitive, as opposed to modern, life. And for some decades after the publication of his writings, public opinion remained largely on the side of Hobbes. Indeed, it was not until more than a hundred years after Rousseau's death that the latter's conception of primitive life came to be taken seriously, and to win some general acceptance among, if no one else, professional anthropologists. In the meantime, it has become clear that neither Rousseau nor Hobbes was really qualified to pass judgment on the nature of primitive life. And it is now abundantly clear that the ideas of both Hobbes and Rousseau were at best grossly exaggerated and oversimplified.

If Rousseau and Hobbes had anything in common, it was that neither of them had any idea what life in primitive society was really like. Both were born much too late to have observed the prehistoric primitive. Both were born too early to benefit from the on-site observations and sophisticated interpretations of anthropological field workers. And neither had any first-hand experience with the hunting-and-gathering tribes that existed in their own time. It is little wonder, then, that both Hobbes and Rousseau were essentially incorrect. Unfortunately, their points of view have exercised considerable influence over the years, and the social sciences have never completely broken free from the stranglehold of their misconceptions. Anthropology in particular has long labored under the negative influences of Hobbes and Rousseau, accepting at first the mistaken notions of the former, and then those of the latter. It has taken more than a century of field work and a good deal of disinterested analysis to effectively discredit both the Hobbesian and Rousseauian conceptions of primitive existence.

The Flux of Anthropological Theory

It was not until the nineteenth century, with the dawn of the modern science of anthropology, that the first serious attempts were made to study and understand primitive peoples. And for a considerable period thereafter, anthropologists were

nearly unanimous in accepting the Hobbesian view of life in primitive society. Indeed, they could hardly have been expected to do otherwise. They knew, after all, that Rousseau himself had suffered widespread disapproval and ridicule for his attacks on civilized society. And they realized that to side with Rousseau would have been to bring upon themselves the same kind of disapproval and social banishment. Thus, in society after society, they saw exactly what their Hobbesian prejudices dictated they see: subsistence economies, meager and unreliable resources, a scarcity of leisure, and a host of unspeakable hardships. To the early anthropologists, primitive life seemed even nastier, shorter, and more brutish than Hobbes himself had imagined. Everywhere the Victorian explorers confirmed for themselves the preconceptions embodied in Hobbes's thought, and proliferated the dogma of the superiority of the modern world. Their attitude, in turn—although it has never gone completely unchallenged—has persisted well into the twentieth century. As recently as the 1950s, when Melville Herskovits was drafting his *Economic Anthropology*, it was still common practice to exaggerate the difficulties of the hunting-and-gathering way of life and to dismiss primitive existence as inherently inferior. Herskovits himself assumed a leading role in this endeavor, citing the Bushmen of the Kalahari and the Australian Aborigines as classic examples of deprived peoples, among whom "only the most intense application makes survival possible." Among hunter-gatherers, Herskovits reports, work is incessant and the quest for food is a continuous travail. His review of the available literature on South American hunter-gatherers led him to the following conclusion:

> The nomadic hunters and gatherers barely met minimum subsistence needs and often fell short of them. Their population of one person to 10 or 20 square miles reflects this. Constantly on the move in search of food, they clearly lacked the leisure hours for non-subsistence activities of any significance, and they could transport little of what they might manufacture in spare moments. To them, adequacy of production meant physical survival, and they rarely had surplus of either products or time.[11]

Meanwhile, in the non-professional literature, condemnations of the hunting-and-gathering way of life were even more unequivocal. To be sure, for more than a century travellers, missionaries, and adventurers have almost universally endorsed a distinctly Hobbesian view of primitive existence. And even among social scientists outside the field of cultural anthropology, Hobbesianism is not uncommon. In his book, *Work and Human Behavior*, psychologist Walter Neff has expressed what is still a popular conception of primitive life. Of hunter-gatherers in general he writes:

> These peoples live an extremely marginal existence, in highly inimical and impoverished environments. That they manage to exist at all in such hostile surroundings is a tribute to human ingenuity. Within the limits of Stone Age technology and with no motive power available other than human muscle, most of these isolated groupings have managed to develop techniques of living which are remarkably adaptive to their environments. Nevertheless, these environments are so terribly inadequate that the maintenance of life is extremely precarious. Compared to the physical size of the habitat, populations remain very small. Deaths from starvation and thirst are almost commonplace.[12]

Such, presumably, was the sorry plight of our prehistoric forebears, and such remains the plight of those few peoples who still live at the hunting-and-gathering level of subsistence. Were it not for the agricultural revolution—the 'great leap forward', as it has sometimes been called—it might well be the plight of all humans even today. According to this view, agriculture created the first economic surplus and rescued men from dependence on the errant whims of nature. Agriculture gave us a food surplus, leisure time, and all the accoutrements of civilized society. Rousseau had argued otherwise. And by the early part of the twentieth century, a new breed of cultural anthropologists was beginning to wonder if Rousseau hadn't been right after all. Put off by the harsh interpretations of their immediate predecessors, they asked whether the Hobbesian view of primitive life really had anything to recommend it. Many of them suspected that it did not. And when they took

their suspicions to the field, they found primitive existence to be very different from the way Hobbes had depicted it.

Challenges to Hobbesian Anthropology

Although he was by no means the first, one of the most influential anthropologists to challenge the Hobbesian view of primitive life was Richard B. Lee of the University of Toronto. Beginning in 1964, Lee spent several years doing field research among the !Kung San (Bushmen) of the Kalahari. His descriptions of !Kung life are now classics in their field, and they have often been cited by those eager to contradict the Hobbesian view of primitive existence. Unlike his Victorian predecessors, Lee did his best to approach his subjects without prejudice or preconception. He observed his subjects working, but he did not assume that their work went on round-the-clock, or that it was unduly arduous or dreary. He saw, on occasion, a scarcity of available resources, but he did not assume that the threat of starvation played a significant role in the daily lives of the !Kung. Unlike Hobbes, he did not assume in advance that life among primitives was 'nasty, brutish, and short'. And in fact he found that it was none of these things.[13]

According to Lee, the alleged harshness of the primitive's habitat is largely illusory. To an outsider the !Kung's desert environment may seem harsh and uninviting, but to the bushmen themselves such an impression is almost inconceivable. The !Kung know how to exploit every available resource in their habitat, and as such they enjoy a surprisingly reliable subsistence. Their food-getting, for the most part, is neither random nor sporadic. And their knowledge of the local environment is nearly exhaustive: they possess a through familiarity both with the habits of game and the growth phases of vegetation. Whatever the locale and whatever the time of year, they know where the food is and how to get it. Even during the brief period of scarcity at the end of the dry season, the available foodstuffs are never fully depleted, and hunger is rare. On occasion, the !Kung must satisfy themselves with notoriously

unattractive foods, like the bitter roots and melons that are universally disliked, but such occasions are relatively infrequent. For most of the year vegetable foods are plentiful, and the !Kung can afford to be selective in their diet. In any given season they tend to eat only the most attractive foods and disregard those that are less desirable in terms of palatability or ease of collection. Live game is generally less accessible and less predictable than plant food, yet a single kill often provides enough meat to keep a band of hunters satisfied for weeks. And even when the men return empty-handed from an unsuccessful hunt, there is usually enough gathered food at the camp to provide for all until better hunting prevails.

On the basis of observations such as these, Lee soon came to the conclusion that the life of the !Kung San (and, by extrapolation, the life of hunter-gatherers in general) is not nearly as rigorous or as demanding as earlier ethnographers—like Herskovits—had made it out to be. His defense of the primitive, which is both forceful and unqualified, runs as follows:

> It has become a commonplace in the anthropological and popular literature to regard the hunters and gatherers as living a life of constant struggle against a harsh environment. The nomadic round, the paucity of material goods, and the lack of food surpluses of these people are taken as *prima facie* evidence of the dreadful conditions endured by man in the state of nature. That the hunter's life is difficult is self-evident, the argument runs, for if it were not, surely the hunters would be able to settle down, lay in food reserves, and generally have the leisure time to 'build culture'.
>
> Data on the !Kung Bushmen of Botswana contradict this view. The people of the Dobe area are full-time hunters and gatherers in an unattractive and semi-desert environment, yet they appear to work less and live longer than do some peoples with more adequate economic systems. Their subsistence requirements are satisfied by a modest input of labor. . . . There is plenty of time to develop the public life of the community. Ritual curing dances with their elaborate trance performances are frequently held, bringing together fifty or more participants from miles around. At some water holes these all-night dances occur as often as two or three times a week.[14]

According to Lee, the !Kung actually devote a great deal of time to leisure activities, like feasting, visiting relatives, or just sitting around in camp and telling stories. They have no fixed daily routine, and they do not work extraordinarily long hours—no more than the 40 or so per week that is the average for a wage-laborer in the industrialized world.

These findings do not necessarily tell us anything about the nature of the hunting-and-gathering way of life in general. They tell us only about the experience of one particular tribe at one particular place and time. Obviously, any valid generalizations concerning the nature of primitive existence would have to be based on a much larger sampling of societies. Nevertheless, many anthropologists have recently argued that the !Kung San are a typical case, and that their way of life is representative of primitive existence in general. Even before Lee had conducted his studies of the !Kung, many other anthropologists had conducted similar studies elsewhere and had arrived at similar conclusions. By the time Lee had begun to publish his reports on the !Kung, the movement to rehabilitate the primitive was already in full swing, and had attracted such illustrious advocates as Claude Lévi-Strauss, Franz Boaz, Margaret Mead, Marshall Sahlins, and many others. In anthropological circles it was becoming ever more modish to elaborate the advantages of primitive life, and to disparage the alleged benefits of modern society. The agricultural revolution, once praised as man's greatest accomplishment, was now being condemned as his greatest blunder. Hobbes was being buried again; Rousseau resurrected.

Does Hunting Bring Happiness?

The neo-Rousseauian movement in anthropology has produced a number of outstanding spokespersons, but certainly none is more eloquent or less equivocal in his condemnation of traditional Hobbesianism than Marshall Sahlins. And without doubt the clearest statement of the neo-Rousseauian argument is to be found in his provocative essay, 'The Original Affluent

Society'. In this work, Sahlins argues strongly against the Hobbesian view that hunting-and-gathering systems condemn their inhabitants to a life of relentless toil and hopeless insecurity. This conception of primitive life, Sahlins insists, has absolutely no basis in fact. The traditional dismal view of the hunter's fate, he writes, is "pre-anthropological and extra-anthropological. . . . It goes back to the time Adam Smith was writing, and probably to a time before anyone was writing. Probably it was one of the first distinctly neolithic prejudices, an ideological appreciation of the hunter's capacity to exploit the earth's resources most congenial to the historic task of depriving him of same. . . . Having equipped the hunter with bourgeois impulses and paleolithic tools, we judge his situation hopeless in advance." Once these "bourgeois" prejudices are laid aside, Sahlins insists, it becomes clear that the hunter's life is not nearly as difficult as it appears to the untutored observer. In fact it is one of relative comfort and security, one might even say affluence.[15]

Perhaps better than any other author, Sahlins has succeeded in creating a new image of the hunter-gatherer—one that is remarkably reminiscent of Rousseau's hypothetical primitive. It is the image of a happy, carefree wanderer whose only concern is how to take the fullest advantage of nature's manifest bounty and who is completely unencumbered by the myriad stresses and problems of modern life. But how accurate is this image? Can it be that primitive hunter-gatherers are really as well-off as Sahlins makes them out to be? Well, perhaps—but then again, perhaps not. If it must be conceded that the life of hunter-gatherers is not nearly as drudgerous or as difficult as writers like Herskovits had imagined, it does not necessarily follow that the primitive is any more prone to happiness or contentment than is his modern counterpart. Indeed, when the question is asked, 'Are primitives really any healthier or happier than moderns?' neo-Rousseauians usually balk. It is a question that most of them would seemingly prefer to leave unasked. But it is a question that must inevitably be confronted if we are to gain any real understanding of the relative advantages and disadvantages of the hunting-and-gathering, as opposed to

modern, modes of subsistence. And on those few occasions when professional anthropologists have actually confronted this question openly, the answers they have given generally bear little resemblance to either Rousseauian or neo-Rousseauian rhetoric.

An excellent example of this occurred in the Spring of 1966, when a group of several dozen cultural anthropologists gathered on the campus of the University of Chicago. There, at a round-table conference, the question of the relative happiness or unhappiness of hunter-gatherers was addressed with uncharacteristic candor, and it was none other than Marshall Sahlins who inspired the discussion. The occasion was the international symposium on Man the Hunter, held at the University's Center for Continuing Education. In attendance were some 75 of the world's most prominent anthropologists, among them Richard Lee, Irven DeVore, James Woodburn, Colin Turnbull, Sherwood Washburn, and Claude Lévi-Strauss. The conference was devoted exclusively to a discussion of the hunting-and-gathering way of life, its ostensible purpose being to disseminate new data on hunter-gatherer groups and to stimulate further research while there still remained viable groups to study. In all 28 background papers were delivered, 12 formal discussions held, and ten hours of open debate conducted. The official transcript of the symposium, published in 1968, covers some 415 pages.[16]

One of the most provocative papers was that of Marshall Sahlins. In it he launched what was presumably his first public defense of the hunting-and-gathering way of life, introducing many of the ideas that would later be expounded in his aforementioned essay on the 'affluence' of hunter-gatherers. "By common understanding," Sahlins began, "an affluent society is one in which all the people's wants are easily satisfied; and though we are pleased to consider this happy condition the unique achievement of industrial civilization, a better case can be made for hunters and gatherers, even many of the marginal ones spared to ethnography."[17] Among typical hunter-gatherers, Sahlins insisted, wants are restricted, and the people are happy to consider what little they have to be quite enough.

For the most part, primitives are neither harrassed nor anxious. They possess a confidence born of affluence—a confidence that stays with them even during times of hardship. Hunger may vex them from time to time, but this is never a reason for despair or worry. When the supply of food runs short, it is always assumed that there is more just beyond the horizon.

These ideas were, to say the least, stimulating, and they sparked one of the symposium's many debates. The discussion centered on the following simple question: 'Does the hunting way of life bring happiness?' The respondents included nearly a dozen ethnographers, all of whom had had first-hand experience studying hunter-gatherer societies. The debate lasted, judging from the length of the transcript, not more than half an hour. Curiously, few of the respondents offered more than minimal replies. Some evaded the question altogether, seeming to prefer that it not be asked. Others didn't seem to know whether the peoples they had studied were happy or not, almost as if they didn't consider it an important issue. In spite of the evasions and ambiguities, however, at least one clear message shone through. Although there was no general consensus, few of the ethnographers involved in the discussion could offer any support whatever for Sahlins's idyllic conception of the hunter-gatherer.

One of the first ideas to be challenged was Sahlins's contention that hunter-gatherers don't worry about the future, because they are confident that it will take care of itself. Along these lines, June Helm suggested that the boreal forest peoples of northern India are more fatalistic than optimistic in their mental composure. If they seem unconcerned about the future, Helm suggested, it is not because they are confident it will provide for itself, but rather because they feel that there is little they can do about it. Another participant, Lewis Binford, was more blunt. He suggested that in no way could happiness be considered a feature of the hunting way of life. Happiness tends to prevail among those groups which have achieved a maximal exploitation of available resources, whatever their way of life or mode of subsistence. And he noted that the hunting way of life does not necessarily guarantee that this will happen.

James Woodburn pursued a similar point. In some contexts, he noted, ecological pressures that would have little or no effect on agriculturalists may be severely disruptive to nomadic hunter-gatherers. Among the Hadza tribe of Tanzania, the sick are often left behind to die while the rest of the group moves on in pursuit of food or water. Along these lines, Woodburn cited the case of a young Hadza boy who had become paralyzed from the waist down, presumably from poliomyelitis. For a while the boy was carried from camp to camp by other members of the group. But then, on one occasion, the people of the camp arrived at a site where they had expected to find water and found none. Although they desperately needed rest, they had no choice but to press on. They were perhaps only about four or five miles from new water when they reached a point where they were unwilling to bear the burden of carrying the crippled boy any longer. So they left him behind with a token offering of food and water and his bow and arrows—as if these would do him any good. The boy presumably lasted only as long as his scant supply of provisions held out.

This is the kind of incident that neo-Rousseauian anthropologists are wont to write off as a rare aberration that is in no way characteristic of hunter-gatherer peoples. But Woodburn argued strongly to the contrary. In fact, he insisted, such abandonments are a commonplace feature of Hadza culture, being closely linked to their nomadic way of life. And he suggested that similar patterns of behavior may also be characteristic of other hunter-gatherer groups, past and present. The possibility should at least be borne in mind, he argued, when considering why such populations tend to remain stable over vast periods of time.

Finally, Colin Turnbull brought up an extremely important point that is all too often overlooked by professional anthropologists, but that must be made if we are to gain any genuine understanding of the nature of life among hunter-gatherers. And it is a point that he was eminently qualified to make. During the years immediately prior to the Chicago symposium, Turnbull had spent considerable time living with two African peoples, the Mbuti Pygmies of northern Zaire and the Ik of

Uganda. He noted that both peoples, despite their many cultural differences, have at least one thing in common: they both laugh a lot, at times quite hysterically. But, Turnbull was quick to add, this does not necessarily mean that they are happy. Indeed, things are not always what they seem, and smiles are not always expressions of joy. If it is true that both the Pygmies and the Ik laugh a lot, Turnbull noted, it is also true that they cry almost as much as they laugh; and they fight almost continually.[18] Apparently the fact that the Ik and the Pygmies both laugh a lot can no more be taken as evidence that they are invariably happy than the fact that they both cry a lot can be taken as evidence that they are invariably miserable.

Are Primitive People Mentally Healthy?

Just what percentage of the Pygmies and the Ik are happy and what percentage unhappy I cannot say. And not even Turnbull has provided any definitive information in this regard —at least not to my knowledge. In the meantime, this much seems clear: we can never assume that hunter-gatherers are happy simply because they *seem* to be so, any more than we can assume that agriculturalists or industrialists are either happy or unhappy without some definitive evidence one way or the other. And yet traditionally, and to a certain extent even today, this is precisely the kind of assumption that pops up again and again in the writings of cultural anthropologists. Despite Turnbull's admonition, indeed, and others like it, belief in the inevitable contentment of hunter-gatherers has never complete-ly subsided. At least a segment of the anthropological communi-ty, like Jean-Jacques Rousseau, seems yet convinced that primitives are genuinely incapable of unhappiness; and it is widely presumed that hunter-gatherers rarely suffer from the kinds of psychological malaise that are commonplace in the modern world. Many anthropologists would probably still argue that depression and suicide are rare among primitive peoples, if they are not altogether unknown. And the two major forms of human psychosis, manic-depression and schizophrenia, are

usually written off as diseases of civilization, arising from the stresses generated by complex and unnatural social systems. Hard evidence to support such theories has never been forthcoming. And in fact much psychiatric research suggests that mental disorder is not at all uncommon in primitive society. We shall see that many of the so-called 'diseases of our time' have long since been found to occur even among the most isolated populations of hunter-gatherers.

The View from Ethnopsychiatry

Consider, first of all, depression. Among neo-Rousseauian anthropologists, of course, the prevalent view has been that depression is rare, if not entirely unknown, in non-Western societies. But much empirical evidence now suggests that this is simply not the case, and many experts have argued that the depressive syndrome is in fact a cultural universal. Among those who have challenged the neo-Rousseauian view is ethnopsychiatrist K. Singer of the University of Hong Kong. In 1975, Singer conducted a comprehensive cross-cultural survey of depressive disorders, drawing on data from 170 previous studies. On the basis of his exhaustive research, he concluded that depression is no less common among hunter-gatherers than it is in Western culture. "The evidence," he writes, "does not support the view that culture influences the morbidity of depressive disorders. When careful field studies are carried out, the prevalence rate of depressive disorder [among preliterate peoples] has generally been found to be well within the range accorded in the West." Singer also found that the symptoms of depression do not differ qualitatively from society to society: "A conglomeration of features—depressive mood, diurnal variation, fatigue, insomnia, loss of interest, weight loss, periodicity and the biphasic nature of the illness—appears to be found consistently in all cultures." He concludes that "the concept of depressive disorder as it is held in the West emerges as universally valid."[19]

In some cases the rate of depression has been found to be

even worse among primitives than it is in the modern world. Among the Ojibwa Indians, for example, the incidence of depression is said to be particularly high, even by Western standards. According to several reports, morbid depressions and anorexia are commonplace in this society. Elsewhere among aboriginal North Americans, a high frequency of depressive illness has also been found in the Mohave, the Dakota Sioux, and others. In Africa, too, depression has consistently been found to be common where it was once thought rare. In fact ethnopsychiatrists have yet to discover a single society in which depressive disorder is totally lacking. Even among the reportedly carefree San (Bushmen), numerous cases have been reported.

Suicide in Primitive Society

As to the alleged rarity of suicide among primitive peoples, this too seems to be pure myth. In fact numerous studies indicate that the incidence of suicide is at least as high among hunter-gatherers as it is in modern society. And reports of suicidal behavior among hunter-gatherer groups have had a long and continuous history. Clearly, there is nothing inherent in the hunting-and-gathering way of life that offers any kind of insurance against suicidal impulses. If anything, primitives seem to have invented more pretexts for suicide than we have.

One of the first authorities to document the prevalence of suicide in primitive society was the Dutch anthropologist S.R. Steinmetz. In the early 1890s, Steinmetz conducted a survey of suicide in preliterate culture, and subsequently published his findings in the newly-founded *American Anthropologist*.[20] In his report, he argues strongly against the romantic conception of the hunter-gatherer, suggesting that among primitive peoples suicide is at least as common as it is in civilized communities. He cites more than a dozen reports of primitive peoples with relatively high suicide rates, among them the Kamtshadals, the Fiji Islanders, the Hos, the Mandans, the Cherokees, the Creeks, and many others. If anything, Steinmetz insists, these peoples seem to have even more reasons to kill themselves than

we do. In some instances they commit suicide for familiar motives, such as sorrow over the loss of a loved one, depression or melancholy, fear of captivity, chronic sickness, family quarrels, and so forth. In other cases they apparently kill themselves for reasons that do not even exist in the modern world. Among tribes with arranged marriages, for example, girls sometimes kill themselves rather than marry men they do not love. This happens frequently in parts of New Guinea and in some North American Indian groups. Among the Cherokee, suicide for grief caused by the disfigurement of smallpox was reportedly quite frequent at one time. In some cultures people are often driven to self-destruction by events that seem to us altogether trivial. As an example Steinmetz cites the case of a lost Aleut who, after given up hope of finding his way back home, cut his throat. In some areas, like Melanesia and the Orient, people kill themselves rather than face public shame. In still others the discovery of an adulterous spouse is sufficient pretext for self-annihilation.

Subsequent research has tended to confirm Steinmetz's conclusions. In 1936 Gregory Zilboorg corroborated many of Steinmetz's findings in the *American Journal of Psychiatry*.[21] Zilboorg suggested that suicide was perhaps even more frequent among our hunting-and-gathering ancestors than it is today. Like Steinmetz, he found among such peoples no shortage of pretexts for self-destructive behavior. More recently a team of three Australian researchers has provided even more definitive proof that suicide is not at all rare in aboriginal society. In the late 1960s, ethnopsychiatrists John Hoskin, Michael Friedman, and John Cawte conducted a series of investigations designed to determine the incidence of suicide among the natives of various parts of New Guinea. Although previous observers had generally assumed the suicide rate to be uniformly low throughout these islands, Hoskin and his colleagues found this not to be the case. On the contrary, in some areas they were able to discern alarmingly high rates of suicide, particularly in the Kandrian district of Southwest New Britain. Here the incidence of suicide was found to be double that

usually reported for such Western countries as the United States, Australia, and Great Britain. Precise calculations revealed that in a model population of 5,170 Kandrian natives, there were 24 suicides committed during a particular 20-year period. This is equivalent to an annual suicide rate of 23 per 100,000—a figure which greatly exceeds the 12 per 100,000 rate given for modern Australia. Hoskin and his team of researchers conclude that "primitive culture of itself affords no protection against suicide. The dichotomy preliterate/primitive versus literate/Western is not strictly applicable to a consideration of suicide rates."[22]

Psychosis in Primitive Society

The same apparently holds true as regards the two major forms of human psychosis, schizophrenia and manic-depression. Here, too, ethnopsychiatric research provides little support for the Rousseauian image of the carefree hunter/gatherer. But Rousseauian anthropologists have not always allowed themselves to be bothered by these facts. As we have seen, by the 1950s and 1960s a great many anthropologist had enthusiastically embraced the Rousseauian view, assuming that the symptoms of modern psychosis are largely absent in the aboriginal world. But careful research by trained specialists has proven otherwise. Today there is widespread agreement among ethnopsychiatrists that, although the overt symptoms may vary from culture to culture, the major psychotic patterns known to Western psychiatry are found throughout the world.

One of the first comprehensive studies to document the incidence of psychosis among primitive peoples was carried out by psychiatrists Paul Benedict and Irving Jacks in the mid-1950s. The results of their research were published in the form of a review article entitled "Mental Illness in Primitive Society", which appeared in the journal *Psychiatry* in 1954. Benedict and Jacks were able to find numerous reports of schizophrenia and affective psychosis among the native popula-

tions of Oceania, Hawaii, New Zealand, Fiji, and many parts of Africa. In some cases the relative incidence of mental illness in these societies was found to be low by Western standards, but this was by no means always the case. The Maori, for example, were found to have an incidence of manic-depression significantly higher than is typical in the West, and a rate of schizophrenia roughly comparable to Europeans. In general, Benedict and Jacks found that severe mental disorder is no less a fact of life in preliterate society than it is among modern Western peoples.

This conclusion has since been reinforced by many other cross-cultural psychiatrists, among them Robert B. Edgerton. In the mid-1960s, Edgerton designed and executed a comprehensive study of psychosis as it occurs in four East African tribes, namely the Sebei of southeast Uganda, the Pokot of northwest Kenya, the Kamba of south central Kenya, and the Hehe of southwest Tanzania. He found that, in all four societies, both the nature and relative incidence of psychosis are comparable to those which generally obtain in the West. He also found that each of the four societies shares a broad area of agreement about the actual behaviors that cause a person to be called psychotic, and that these are amazingly similar to Western psychiatric criteria for psychosis. In sum, Edgerton found that the nature and frequency of psychosis do not differ much from culture to culture, regardless of the kind of culture involved.[23]

More recently, medical anthropologists George Foster and Barbara Anderson have been able to confirm Edgerton's findings:

> Many kinds of extraordinary behavior recognized by Western psychiatrists as constituting mental illness are widely found in non-Western societies. . . . within the parameters of cognitive, emotional, and psychological functioning shared by us as a single species we are dealing ultimately with limited possibilities in abnormal behavior, quite apart from cultural variation in its expression.[24]

Finally, Guy Dubreuil and Eric Wittkower note that the

trans-cultural similarities of mental illness go far beyond symptomatology, extending to include diagnosis, treatment, and prognosis:

> All cultures not only recognize abnormality, marginality, and crime, but also contrive appropriate techniques and specialists for curing, isolating, or killing individuals perceived as sick, marginal, or guilty. The cleavage between different types of healers in the assessment of insanity is not as large as is generally believed. They are likely to agree that a person is mentally ill if his behavior is grossly disturbing to others, if he is unable to function in various spheres for psychological reasons, and if he suffers severe psychological stress.[25]

Mental illness is everywhere. It is as much a part of Eskimo or Kikuyu society as it is a part of Euro-American society. And it is as commonplace among the Ojibwa or the Sebei as it is among the Germans or the Swedes. No one, anywhere in the world—be he hunter or farmer or factory worker—has ever been completely exempt from its threat. It is a mistake to assume that severe mental disease is nothing more than a side-effect of civilized life. As Margaret Field has noted, "there still lingers the idea that mental stress and mental illness are the prerogatives of 'overcivilized' societies: that the simple savage may have Ancylostomasis but cannot have Anxiety: that he may, in his innocence, believe his neighbour to be making bad magic against him, but he still sleeps like a top." Nothing could be further from the truth. "Whether the rural African has more mental illness than in the past—as he has, in the physical sphere, more venereal disease and more influenza—is another question. But mental illness, and plenty of it, is rooted in ancient tradition."[26]

Once again, medical anthropologists Foster and Anderson are in complete agreement with these conclusions. Here is how they put it:

> Western man has long believed—and wanted to believe—that in simple societies, uncorrupted by civilization, human beings live in a "natural" relationship with each other, a relationship

marked by love, co-operation, and mutual support. Since stress levels, logically, must be low in such a society, mental illness derived from stressful living must also be rare. This "noble savage" stereotype of primitive life has long since been destroyed by ethnographical fact, yet the image lingers on to color our views about mental illness. Although it is true that simple societies historically have lacked the stresses of civilization, a world peopled by vengeful deities and ghosts, witches and sorcerers, and angry neighbors and envious relatives, is not less stressful than is our own. Fear, which is certainly stress, is probably a more common experience in these societies than in modern life.[27]

The Roots of Malcontent

Anthropologists like Marshall Sahlins, Richard B. Lee and Claude Lévi-Strauss deserve credit. Thanks to them the popular notion of the inferiority of primitive peoples has largely been dispelled. To be sure, these anthropologists, and others like them, have succeeded admirably in showing that the primitive is basically no different from us and certainly not inferior, either emotionally or intellectually. But having shown that the primitive is no worse than we are, and no worse off, it must be added that he is no better off either. If the hunter-gatherer is no less ingenious, he is by the same token no less burdened by the exigencies of self-preservation and self-propagation. Like us, he is a creature of unbounded need and desire; and while he may be no less successful than us in satisfying his needs and wants, there is no reason to believe that he is any more successful either. If the ethnographic and ethnopsychiatric evidence presented here is anything to go by, then it would seem that, neither as regards its pleasures nor its hardships is the primitive's experience of life fundamentally different from our own.

Are hunter-gatherers happy? The answer to this question is simple enough: some of them are and some of them aren't. And it is naive to assume that they are *all*, without exception, exuberant and ecstatic. It is clear, in any case, that there is

nothing inherent in the hunting-and-gathering way of life that guarantees personal happiness, or for that matter even survival. Some ethnological evidence suggests that deaths due to starvation, disease, accident, interpersonal dispute, and suicide are at least as common in aboriginal society as they are in the modern world. And it has yet to be shown that there has ever existed a human group anywhere in the world, either past or present, primitive or modern, in which every last individual was totally satisfied with the nature of his existence and lived as long and as comfortable a life as he could have wished for. Contrary to what some Rousseauian thinkers (including Rousseau himself) have suggested, unhappiness exists not because humans have been displaced from their natural habitat into an artificial environment through their own misguided invention of agriculture. Unhappiness (which in my view is the greatest evil of life) exists ultimately because the biological capacity to be unhappy has evolved. And it would seem that this biological capacity has reached its culmination in *Homo sapiens.* Indeed, as I shall attempt to show in the next chapter, man may be the only animal that is capable of genuine unhappiness—and this at least in part because he has evolved, as compared with other animals, so much adaptability, so much intelligence, and therefore so much conscious awareness of the self and its needs.

Does man really have a natural habitat? Apparently many people, especially anthropologists, still think so. And many of them are still arguing that man's natural environment is that of the nomadic hunter-gatherer. But I wonder if this characterization really makes any sense. Given the evidence I have presented here, it would be at least as plausible to suggest that man really has no natural habitat at all; that, by becoming such an artificial and unspecialized animal, he has evolved himself right out of the only natural habitat he may once have had. In the course of his evolution, man has become adaptable to many different environments; but by the same token he has lost his adaptation to any one in particular. The problem with man is not that he has abandoned his native environment through the historical accident of agriculture, but that, as a consequence of his evolutionary development, he has abandoned virtually all

specialization in favor of adaptability. And this, not historical displacement, is the ultimate cause of his supreme susceptibility to psychological disorder and mental breakdown.

The Cultural Animal

In the early 1940s, a young Russian zoologist named B.F. Gause performed a series of behavioral experiments which, though apparently not designed to do so, illustrate quite nicely the inverse relationship between adaptiveness and adaptability. Having noted that paramecia normally live in fresh water, but that many of them are capable of surviving in saline solutions or even marine salt water, Gause decided to determine the mechanism by which certain paramecia are able to adapt to increases in the salt content of their environment. To do this, he isolated 26 pairs of paramecia, submitting clones of each species to gradually increasing amounts of salinity. Each clone was then evaluated on two counts: first, according to its resistance to the initial introduction of salt water; and second, according to its ability to adjust to subsequent additions of salt. Gause found that the same clones that showed the *lowest* initial resistance to salt water also exhibited the *highest* resistance if allowed to acclimate gradually to increases of salinity. Conversely, clones which showed high initial resistance to salt water were least able to adapt to subsequent additions of salt. Gause concluded that the relation of initial adaptation to adaptability is essentially negative within populations of paramecia. That is to say, the more adapted a paramecium is to a salt water environment, the less is it adaptable to changes in that environment. And the less adapted it is to a salt water environment, the more adaptable it is to varying concentrations of salt. From this Gause was able to conclude that, among paramecia at least, adaptiveness and adaptability tend to be inversely proportional and therefore mutually exclusive. And he strongly suggests that the same relationship between adaptiveness and adaptability obtains among all other species as well.[28]

An examination of other forms of life tends to bear out Gause's extrapolation. In general, animals that are highly adapted to a particular set of environmental conditions seem to be unable to cope with sudden or frequent change, while those that are highly adaptable often lack specialized traits that might otherwise be of great use to them in their native habitat. Throughout the course of evolution, it would seem, greater adaptability is never acquired except at the sacrifice of adaptiveness, and adaptiveness is never maintained except at the sacrifice of adaptability. The two simply do not mix, and the advantages of the one cannot be gained without the simultaneous loss of the advantages of the other.

Animals differ, of course, with regard to their degree of specialization. Some are highly adapted to a particular habitat; others are more flexible and can adjust to variable conditions. But no animal is as unspecialized or as unadapted as man. Throughout the course of his evolution, man has become increasingly less adapted biologically to the physical environment, and ever more dependent on artificial—that is to say, cultural—means of survival. As a consequence he has lost the physical features (and the instincts) that would otherwise render him genetically adapted to a particular physical habitat. For better or for worse, man has committed himself to a cultural existence, and in the process has in effect evolved himself out of the only natural environment he may once have had.

Hundreds of thousands of years ago, perhaps millions of years ago—it is impossible to say exactly when—man became dependent on cultural adaptations, and ever since then his continued survival has depended on his ability to maintain and continually heighten the cultural barrier that he has erected between himself and the selective forces of the physical environment. Without cultural adaptations, human beings would never have evolved and could not survive today. Unlike most other animals, man is not genetically prepared to adapt to any particular environment. Rather each developing human must adapt himself to whatever culture he happens to be born into. But because cultures vary from time to time and from place to

place, there is absolutely no guarantee that a proper integration of organism and environment will be effected, and the chances are always great that at least some maladaptation will occur.

We have seen that animals tend to become neurotic when they are displaced from their natural habitat. And the problem with man is that he has no natural habitat. Compared to other animals, his natural insulation against neurosis is minimal. No natural environment provides humans with immunity to the frustration that results from the deprivation of basic physical and psychological needs. Without specialized adaptations, man has no innate means of assuring a healthy adjustment to his own physical and social milieu. Rather he must plod along as best he can, forever struggling to maintain the cultural barrier that ensures his survival.

Most animals are adapted to one particular environment, but unadaptable to any others. Man is adaptable to many environments, but unadapted to any one in particular. It is largely because of this simple fact that the nature of human existence is so different from that of any other animal, and often so much more difficult.

Culture and Work

I once had a professor of anthropology who, in one of her more anthropocentric moments, offered the following argument in support of her belief in the superiority of the human mode of cultural adaptation as opposed to the animal mode of genetic endowment. Each animal species, she began, is born with a particular 'coat' or other natural insulation against the weather —be it fur, feathers, down, a layer of subcutaneous fat, or whatever—which suits it to its particular habitat. And while this protection usually serves well in the animal's native environment it may not be so suitable in alternate environments or under changing conditions. The animal is therefore not very readily adaptable to varying circumstances. Humans, by contrast, although they are born with no natural covering at all to speak of, are intelligent enough and flexible enough to construct

their own artificial apparel—apparel which, whenever necessary, can be altered, put on or taken off virtually at will, in accordance with whatever climatic conditions prevail at the time. This 'cultural' mode of adaptation, she argued, renders humans far more adaptable to a wide variety of climatic circumstances and to rapid or unpredictable changes in the weather. In other respects, too, she went on, the human mode of cultural adaptation renders us humans far more adaptable, and therefore much better off in the long run, than the 'lower' animals.

I do not know how impressed my fellow classmates were with this argument, but I was not at all impressed. The one-sidedness of her viewpoint was especially striking, and it seemed to me then (as it still does) that there are at least two major flaws in her argument. It is, first of all, not necessarily the case that nonhuman animals are completely unadaptable by dint of their native 'clothing'. Many, in fact, have the capacity to shed their fur, to molt, or otherwise to alter their coat to fit themselves to changing circumstances. Thus they are often capable of surviving quite well, even under relatively variable conditions. Adaptability, in sum, is not unique to humans; and human adaptability is not always so much greater than that of other animals. But there is an even more fundamental objection to her argument, and it is simply this. Like most anthropocentric rhetoric, it leaves completely out of account the disadvantages, as well as the advantages, of the so-called 'cultural' mode of adaptation and ignores the many problems and hardships that are associated with having to provide one's own clothing and other necessities of life. We humans may indeed be uniquely capable of manufacturing our own apparel and of changing that apparel to suit the circumstances. But the price we pay for this and other cultural capacities of adjustment is that we have to work for them. And this is by no means necessarily easy or automatic. In order to insulate ourselves against the weather and other hazards of the external environment, we—unlike other animals—have to fabricate our own coat; and this need itself brings with it many problems. What, for example, if the raw materials for making the coat are not available? Or what if

they are too costly? What if we are disabled and cannot do the work that is necessary to manufacture or purchase the clothes? Other animals, of course, are protected from these problems by their possession of a natural insulation. But humans are not.

Or take housing as another example. Few nonhuman animals need to erect any kind of elaborate domicile to protect themselves against the elements. Many require no 'housing' at all, while others need exert only minimum effort to construct a nest or prepare a bed. But humans not infrequently spend much of their lives either building, or trying to earn enough money to build, a house. In North America today, for example, it is not unusual for a man to spend thirty years of his life trying to pay off a home mortgage and most of the rest of his life trying to earn enough money to pay for utilities, taxes, and the many other expenses that are involved in maintaining a house and home. Perhaps there is a nonhuman species that devotes as much effort to the production and maintenance of a domicile, but if so I have yet to discover it in the zoological literature. In many other realms, animals are born with the paraphernalia they need to survive and earn a living, while humans—being much less well equipped naturally—are obliged to sweat and toil to compensate for their biological deficiencies. Other animals hunt with their talons, their claws, or their teeth; while humans, in order to hunt, must manufacture artificial weapons and tools, both to bring down the prey and to butcher it after the kill. Other animals can use their natural endowments— their wings, their legs, or their fins—to get themselves about, in the air, on the land, or in the water. But humans must construct airplanes, automobiles, and boats to effect the same mobility. Other animals can eat their food raw; humans have to spend time and effort cooking and otherwise preparing theirs. And so on it goes through the full panoply of our survival and reproductive activities. We humans often have to exert considerable time and effort to provide ourselves with the clothing, housing, food, transportation, and other necessities of life that other animals either don't need at all, or which have been provided to them by nature free of charge. Because humans are cultural animals, in sum, and because they have at least as many

biological needs as other species (and probably more, as I shall argue in the next chapter), they need to work in order to earn a living. And this need, in my view, is one of the single greatest sources of evil in human life.

The Evil of Obligatory Work

To some readers, I suppose, especially to those who enjoy what they do for a living, the very suggestion that the need to work is an evil will seem quite ludicrous. And I can imagine what their reply would be. In fact I have come across some version of it on numerous occasions, both in informal conversation and in formal philosophical discourse. Although there are variations, the basic idea runs something like this. It is a 'good' thing that we need to work in order to earn a living, because otherwise we would all die of boredom for lack of anything to do. Apparently the proponents of this line of thought cannot think of any way to occupy their time other than work and cannot imagine how anyone could possibly not enjoy what he does for a living. But I have no trouble at all imagining either of these things. My only difficulty, indeed, is in imagining how anyone could possibly be so naive as to take for granted that every human being on the planet looks forward to the ring of the alarm clock each morning. But apparently such naivety does exist. And it seems to be especially commonplace among professional academicians, who sometimes write books about work and who often express how much satisfaction they derive from their work, but who have absolutely no idea what it is like to spend eight to ten hours a day on an assembly line, or behind the wheel of a bus, or in the remotest recesses of a dank, carcinogenic coal mine, 50 weeks a year, year in and year out, decade after decade. Apparently there are some people who love what they do for a living and simply assume that everyone else does too. I can assure them that they are mistaken. Even a cursory examination of the literature on the psychology of work—not to mention a study of human history —clearly reveals that job dissatisfaction is widespread, and that

such dissatisfaction is a major contributor to unhappiness, interpersonal conflict, and suicide. In the mid-1970s, for example, no fewer than three major studies on this subject were published, in each of which it was suggested that disenchantment with work is rampant in the modern world, and which documented some of the many problems that tend to be associated with the need to earn one's living.[29] One of these publications was Studs Terkel's best-selling book, *Working,* which contains, among other things, several hundred verbatim interviews with workers representing a wide range of trades and professions. It is my rough impression that only about half of Terkel's informants reported that they were more or less satisfied with their work. The other half said that they either disliked it or hated it. Many complained of the drudgery, the boredom, and the meaninglessness of their occupations; others lamented the competitiveness, the hectic pace, and the adverse working conditions which rendered an activity that otherwise might be enjoyable (or at least tolerable) into one that is virtually insufferable. One of Terkel's informants opined that the Marxist promise of a 'workers' utopia' was a contradiction in terms. The only genuine utopia, he suggested, would be one in which work was not necessary. And one man who worked as a custodian in a high-rise apartment complex reported that at least three of his co-workers had committed suicide because of the stress of their job.[30] This is not surprising. In almost any textbook of abnormal psychology, in fact, it is usually pointed out that a man's dissatisfaction with his work, or his lack of success at it, or both, is a leading cause of suicide.

The evils that result from the need to work, moreover, go far beyond mere job dissatisfaction. They also include such things as crime, war, slavery, and various other forms of interpersonal conflict and exploitation. If everyone could have everything he needed and wanted in life without having to work for it, after all, then there would be little motivation for property crimes, no motivation for the taking of slaves, and no need for Marxist revolutions to liberate the workers from the oppression of the bourgeoisie, because there wouldn't be any workers to be

liberated. It would be difficult to calculate just how much human suffering has occurred because of such things as crime, slavery, and war; but it is clear that most such suffering would never have occurred if it were not necessary to work in order to earn one's living. And then there are the debilitating injuries and deaths that are sometimes suffered on the job, most of which would never occur in a world where jobs were not necessary. And finally there are the many problems that are associated with job security, job loss, job search, and so on. As life becomes increasingly more expensive (because of increases in the cost of land, housing, health care, and so forth), the absolute amount of time spent at work has tended to go up so that earning power can keep pace with the rising cost of living. Not surprisingly, many people nowadays complain that between their jobs and their domestic chores they scarcely have enough time left over to sleep, much less to engage in recreational activities. As a result that luxury that used to be known as 'leisure time' is now rapidly becoming a thing of the past. In short, there is really no end to the list of problems and hardships that result, directly or indirectly, from the need to work to earn a living.

Is it my contention, then, that work is an absolute evil, and that we would all be better off to do away with it completely if we could? Not at all. There is nothing wrong with work *per se,* and I fully appreciate that some people derive a great deal of satisfaction and sense of accomplishment from what they do for a living. No, it is not work in itself that is bad, but rather the *need* to work; because it is the need to work that forces people, whether they want to or not, whether they can or not, to labor on a daily basis and often to work at jobs they hate, under conditions they despise, for bosses they abhor. Even the industrious, indeed, are often constrained to work longer and harder than they would care to to make ends meet. And it is the evils that result from the obligatory nature of work, rather than work per se, that is the problem. This in turn brings us back to the original argument I cited several paragraphs ago, that the need to work is a 'good' thing because it saves us from the horrible death by boredom that we would supposedly all suffer in a

workless world. This argument conceives of work as being either mandatory or prohibited and leaves out of account the possibility of a world of *optional* work. Surely, of the three possibilities it is the world of optional work, and not the worlds of either mandatory or prohibited work, that would be by far the most desirable from all points of view. For in such a world the industrious would be free to work as long and as hard as they liked; while the lazy, the sick, the disabled, the elderly, and all others who either cannot or do not want to work, would not be required to do so. In a world of optional work, in other words, there would be none of the problems associated with mandatory work and none of the boredom or ennui that would supposedly be the result of work's prohibition.

But there is an even more fundamental objection to the whole idea that work is necessary to prevent boredom, and it is simply this. If the biological capacity for boredom did not exist in the first place, then there would be no need for constant activity (work or otherwise) to ward it off. Thus the argument in question presupposes both the existence of the human species and the existence of the human tendency to experience boredom in the face of inactivity, and this is far too much to presuppose. The truth is that if human beings had never evolved in the first place, or if they were differently constructed by nature—if they had never inherited the biological capacity to experience boredom—then boredom would never occur, and idleness would have no ill effects—just as, for example, it does not seem to bother those animals that spend most of their time sleeping and resting. In any case, boredom is nothing compared to the misery of a man who hates his job, or the evils of crime, slavery, war, and all the other plagues that result from the necessity of work. To a man who hates his job, there is no greater source of pain, suffering, and hardship in life than the need to work. And it is hard to see how the suffering of such a man is any less evil than the boredom that he might suffer in a workless utopia.

Chapter Six
The Self-Conscious Animal

What does it mean to be a
self-conscious animal? The
idea is ludicrous, if it is not
monstrous. It means to know
that one is food for worms.
This is the terror: to have
emerged from nothing, to have
a name, consciousness of self,
deep inner feelings, an excru-
ciating inner yearning for life
and self-expression—and with
all this yet to die.

Ernest Becker

In the seventeenth century, the French philosopher and mathe-
matician René Descartes expressed the belief that conscious
awareness is completely absent in all nonhuman animals. Ac-
cording to Descartes, man is the only animal capable of rational
thought or reflective reasoning. Man alone is consciously aware
of his own existence and of the existence of the world that
surrounds him. All other animals are mere machinelike automa-
ta, whose every response is controlled and directed by blind
instinct. Animals do not reason, nor do they think, nor do they
choose. Conscious thought, Descartes insisted, is uniquely
human and does not exist even in the most rudimentary form in
any nonhuman animal.

This point of view is no longer considered tenable. Today
almost all scientists and philosophers are in agreement that

Descartes's denial of animal awareness was premature, and that the alleged chasm between humans and nonhumans as regards conscious awareness simply does not exist. The consensus now is that many animals do indeed possess some degree of conscious awareness, and that such awareness is, in a few cases at least, remarkably pronounced. In fact the existence of various forms of animal awareness has been thoroughly documented by recent studies, the ultimate effect of which has been to demolish the extreme Cartesian view once and for all.[1] Animals may not think or reason in quite the human way, but it is clear that in some cases at least they know much more about themselves, and about their world, than Descartes could possibly have imagined.

Serious scientific research into the question of animal awareness has been going on for some time now, and in the last few decades in particular it has produced some rather startling results. Beginning in the early 1970s, for example, a psychologist named Gordon G. Gallup Jr. carried out a series of laboratory studies designed to determine the precise degree, if any, of self-awareness in certain nonhuman primates. His method was simple: one by one, he exposed a number of different species to a mirror to see if they could recognize their own images. Most of the animals promptly failed the test; almost without exception they responded to the mirror image of themselves as if the image were another animal. Even rhesus monkies, who otherwise seem to be quite clever, failed to recognize their own images in the mirror. And none of the other monkey species did any better: mandrills, baboons, spider monkies, and stump-tailed macaques all looked into the mirror and saw other individuals, not themselves. A notable exception, however, was the chimpanzee. Unlike the others, the chimps in Gallup's tests exhibited enough of a sense of self-identity to recognize their own image, even though they were able to make the distinction only after repeated exposure to the mirror. Subsequent experiments have shown that orang-utans, too, are capable of some degree of self-awareness, as exhibited by their ability to recognize their own mirror images. And there is much

evidence to indicate that numerous other animals also possess various kinds and degrees of conscious awareness.[2]

It seems pretty clear, then, that self-awareness is not unique to *Homo sapiens,* and for all we know there may be many other forms of conscious awareness that influence animal as well as human minds. Apparently awareness is not the all-or-nothing phenomenon that Descartes imagined it to be. Rather it seems to vary by degree from animal to animal, reaching its peak in the most intelligent species. The precise nature of conscious awareness among nonhuman animals, however, is still very much a matter of debate. In fact expert opinion is divided and will probably remain so for some time to come. In recent years some authorities have adopted the neo-Cartesian view, suggesting that animal awareness is relatively undeveloped by human standards, while others have argued that the gap between human and nonhuman forms of awareness is quite small. Thus at the present time it is impossible to say to exactly what extent animals are consciously aware of their own existence or of the existence of other aspects of reality. And until a completely reliable and universally acceptable method of measuring animal awareness has been devised, the question of animal awareness will remain an open one. In the meantime, this much at least seems fairly certain: if conscious awareness is not unique to man, it is certainly more pronounced in man than in any other animal. Thus to the extent that conscious awareness has an effect on the nature of an animal's existence, that effect—for better or for worse—must be felt more by man than by any other species. Let us proceed, then, to consider the ultimate evolutionary origins of various forms of human awareness and see to what end this evolutionary trend has brought us.

The Evolution of Self-Awareness

Why does self-awareness exist? Where did it come from? How did it evolve? Was it actively favored by natural selection because it possessed some positive adaptive value? Or was it

nothing more than the incidental by-product of the evolution of intelligence and conscious awareness in general? These are difficult questions to answer, and all attempts to answer them are necessarily speculative, since we have no direct evidence bearing on the matter and must base our conclusions on circumstantial clues. The ultimate origins of self-consciousness are obscure. Obviously, if we do not even know the extent to which self-awareness exists in living nonhuman animals, then we can hardly determine to what extent such awareness existed in our own extinct ancestors. Nor can we say for certain just how or why self-awareness first arose. As usual, however, this has not stopped scientists from speculating on the matter, and numerous scenarios for the evolution of human self-awareness have been suggested. One such scenario was proposed in 1978 by anthropologist Jerome Barkow and is discussed in some detail in an article published in *Current Anthropology*.[3] Barkow's scenario, as I understand it, is relatively simple. Self-awareness may have evolved, he suggests, as an extension of the individual's ability to recognize and identify other members of his social group. And Barkow discusses how this may have occurred in certain nonhuman primates. Most ground-dwelling primates, he points out, are dependent for protection on their fellow troop members; as such the individual's survival hinges in large part on his ability to recognize and remain in the proximity of other members of his troop. Because terrestrial primates depend so much on one another, their central nervous systems have evolved the capacity to map elaborate and long-lasting internal representations of fellow troop members, especially the larger and more dominant individuals. This is why the terrestrial monkeys and apes today possess a much greater ability than most mammals to recognize one another. Now obviously human beings also possess the ability to recognize one another, and to do so quite readily. And Barkow suggests that we may have evolved this capacity for essentially the same reasons that the other social primates did. In the course of our own evolution, Barkow notes, we—like many other primates—became terrestrialized. As we began to spend more and more time on the ground, and as we became increasingly more dependent on

one another, our internal representations of one another must have become proportionately more elaborate. In time individuals developed the ability to recognize their mothers and other caretakers, as well as the dominant males of the troop. Thus, Barkow writes, "during our evolution we were selected for the tendency to internalize our fellow troop members, with special reference to mother and the dominant individuals."[4] But if other individuals were well-represented in our cognitive maps, so too was an individual whose existence and wellbeing were of crucial importance to us—the self.

This is an interesting hypothesis, but it has a number of flaws. First, it does not explain why humans seem to have evolved more self-awareness than any other social primate. Second, it does not explain why a species like the orang-utan, which is basically solitary and arboreal, performs better on self-awareness tests than does a species like the rhesus monkey, which is more terrestrial and much more social. And it does not explain why many highly social animals outside the order of primates have little if any discernible conscious awareness of the self. Perhaps there is some germ of truth to Barkow's scenario, but it has some inconsistencies, and other possibilities should be entertained. One such alternate possibility has recently been suggested by Richard D. Alexander, whose ideas on the evolution of human intelligence were considered briefly in Chapter 4. As we saw, Alexander's theory concerning the evolutionary emergence of the human intellect is based on the hypothesis that, during much of human prehistory, the principal hostile form of nature affecting humans was other humans. As Alexander sees it, once proto-humans had evolved sufficient intelligence to cope with the physical environment and to outsmart all other animals, there would have been little selective pressure for the further evolution of intelligence, unless the early humans had had to outsmart one another as well. And in a world of limited resources, that may be precisely what they had to do. Under such conditions the survival and reproductive success of any individual (or of any group of individuals) would have depended on his ability to outthink or outsmart other competing individuals (or other competing groups). Thus every

time there was an increase in the intelligence of one individual (or of one group), there was selective pressure for increasing intelligence in every other, so that each could keep pace with his competitors. In this context the evolution of the human intellect is comparable to a chess tournament; this is because in chess, as in the game of life, each competitor must continually sharpen his wits (and thereby sharpen his game) if he is to stay in the contest long enough to be successful, while the least intelligent players are obliged to drop out. Under conditions such as these, according to Alexander, the evolution of conscious awareness in general, and self-awareness in particular, might have been of considerable biological utility; for as each individual became ever more consciously aware of his own needs and his own motives, and more aware of the needs and motives of his competitors, he would have been better prepared both to satisfy his own needs and to avoid being exploited or taken advantage of by others. Thus those individuals who were most keenly aware both of their own motives and the motives of their neighbors would have been favored by selection, for in general they would have been more successful at survival and reproduction. In his recent book, *The Biology of Moral Systems*, Alexander offers the following succinct synopsis of his scenario:

> Consciousness and related aspects of the human psyche (self-awareness, self-reflection, foresight, planning, purpose, conscience, free will, etc.) are here hypothesized to represent a system for competing with other humans for status, resources, and eventually reproductive success. More specifically, the collection of these attributes is viewed as a means of seeing ourselves and our life situations as others see us and our life situations, so as to outguess, outmaneuver, outdo those others— most particularly in ways that will cause (the most and the most important of) them to continue to interact with us in fashions that will benefit us and seem to benefit them.
>
> Consciousness, then, is a game of life in which the participants are trying to comprehend what is in one another's minds before, and more effectively than, it can be done in reverse.[5]

I have yet to come across an explanation for the evolution of self-consciousness that is any more plausible. Of course no one

really knows for sure just why self-awareness evolved, and the matter is open to speculation. It may very well be, as some writers have suggested, that self-awareness is not an independent trait that evolved to serve some specific adaptive function, but rather is simply an incidental by-product of the evolution of cognitive capacities that emerged for wholly different reasons. No doubt theorists will continue to speculate on this evolutionary puzzle long after these words have been written. The many effects that self-awareness has had on human cognition, human emotion, and human behavior are much less obscure. And unfortunately, as we shall see, these effects have not always been entirely to our benefit.

The Consequences of Self-Awareness

What does it mean to be a self-conscious animal? It apparently means a lot of things, some of them good, some of them bad. On the positive side, our awareness of the self has given us the capacity to monitor our own behavior and, when necessary, to restrain our own self-seeking impulses so as to lessen the likelihood of violent confrontation with our fellows. And obviously an awareness of the self gives us the capacity for self-satisfaction, the kind of which usually results from the accomplishment of some important task. But on the negative side this same capacity for self-restraint and self-fulfillment also brings with it some rather burdensome responsibilities and hardships. Along with our ability to monitor and restrain our own behavior, we have also inherited the *need* to do so. And this is by no means entirely to our advantage. By contrast to ourselves, animals that lack a distinct sense of self tend to give free vent to their natural drives and inclinations, at least insofar as they are not physically prevented from doing so, and even when, in the process, they take advantage of, or cause some harm to, other individuals. And they are able to do so without guilt, without remorse, and without self-reproach because they lack the sense of self-awareness upon which these and other similar emotions are predicated. As such the non-self-conscious animal is always

'innocent', even when it kills, because it cannot monitor a 'self' that it does not perceive. But human beings are different. Because humans are consciously aware of their own individuality, they are capable of experiencing self-reproach, guilt, and shame whenever their behavior does not live up to the moral standards which they have set for themselves or which have been set for them by the community in which they live. Man, in other words, differs from other creatures in that he needs to be an 'ethical animal'—one that must adhere to social norms even when such adherence involves the frustration of personal desires. This is a tremendously burdensome load to carry, one from which most other animals are completely exempt. And the need to bear it is in large part a consequence of man's having evolved a distinct self-concept.

There are of course certain advantages associated with our capacity for ethical restraint. Indeed, it is precisely our 'moral sense' or 'conscience', if you will, that allows us to restrain those self-seeking impulses that could get us into serious trouble with our fellows were we to give them free vent. Without this capacity, we humans might be condemned to live out the ruthless war of all against all that was so vividly depicted by Thomas Hobbes in his *Leviathan* and which he imagined to be the plight of man in an aboriginal state. It is not surprising that in the writings of many philosophers, theologians, and poets throughout the ages, the so-called 'moral sense' is lauded as man's sublimest natural endowment and as the single most important character which separates him from the 'lower' animals. According to this conception, the other animals are mere 'brutes', for unlike us they have no ethical principles, and unlike us they are intent only on the selfish pursuit of their own individual interests, without regard for their fellows. But this way of looking at things is distinctly one-sided, and more than a little anthropocentric, in that it takes into account only the advantages that are associated with the moral sense, while ignoring the many burdens and responsibilities that have been created by its evolutionary emergence. Once in a while, however, a writer who is insightful enough to recognize the *dis*advan-

tages, as well as the advantages, of the so-called moral sense, pops up and takes pen to paper in an attempt to set things straight. One such writer was Mark Twain, whose iconoclastic and often irreverent views permeate the pages of his later works, including for example a posthumous collection of essays published under the title *Letters from the Earth*. In one of these essays, Twain brilliantly satirized the majority viewpoint on this matter, suggesting that the moral sense is perhaps the *least* enviable of all human traits and one that, if anything, sets man below, rather than above, the other animals:

> It is plain that [Man] is constitutionally . . . afflicted with a Defect . . . [and] that this Defect is permanent in him, indestructible, ineradicable.
>
> I find this Defect to be the *Moral Sense*. He is the only animal that has it. It is the secret of his degeneration. It is the quality *which enables him to do wrong*. It has no other office. It is incapable of performing any function. It could never have been intended to perform any other. Without it, Man could do no wrong. . . .
>
> Since the Moral Sense has but the one office, the one capacity—to enable him to do wrong—it is plainly without value to him. It is as valueless to him as is disease. In fact, it manifestly *is* a disease. *Rabies* is bad, but it is not so bad as this disease. Rabies enables a man to do a thing which he could not do in a healthy state: kill his neighbor with a poisonous bite. No one is the better man for having rabies. The Moral Sense enables a man to do wrong. It enables him to do wrong in a thousand ways. Rabies is an innocent disease, compared to the Moral Sense. No one, then, can be the better man for having the Moral Sense. What, now, do we find the Primal Curse to have been? Plainly what it was in the beginning: the infliction upon man of the Moral Sense: the ability to distinguish good from evil; and with it, necessarily, the ability to *do* evil; for there can be no evil act without the presence of consciousness of it in the doer of it.[6]

There are yet other adverse consequences of man's having evolved such a distinct and vivid self-concept. One of these is that it has created in him an entirely new array of biological needs—needs which, if unfulfilled, can have devastating con-

sequences. These include, among others, the need for self-esteem, for self-fulfillment, and for a sense of personal immortality. Having evolved a self-concept, humans have inherited a profound need to maintain that concept in good order, and they often suffer tremendously, or even die, when they are unable to do so.

The need for self-esteem, of course, is one that has long been recognized by the human race and is acknowledged in the writings of sages and poets, as well as philosophers and scientists, for as long as writing has existed. Anyone who has ever practiced the subtle art of flattery (or the not-so-subtle art of insult) knows just how fragile is the human ego, and how easily that ego can be either inflated or destroyed by a few well-chosen words. Meanwhile, in academic circles, and especially with the coming of the modern science of psychology, the need for self-esteem has been widely acknowledged, and its fulfillment is considered by most to be crucial to the maintenance of good mental health. One of the first modern psychologists to express his views on this matter was Alfred Adler: around the turn of the twentieth century, Adler suggested that the need for self-esteem is basic to human nature, and that low self-esteem is the central problem in many forms of mental illness. Several decades later Gardner Murphy echoes the ideas of Adler, suggesting that the various psychological defense mechanisms have as their most important single objective the protection of self-esteem. In the meantime, psychologists in ever increasing numbers have turned their attention to the phenomenon of self-worth: most seem to agree that the need for self-esteem plays a dominant role in the motivational system of all human beings; and most agree that a lack of self-esteem is a major contributor to various forms of human psychological malaise. As Gordon Allport has put it, "If we are to hold to the theory of multiple drives at all, we must admit that the ego drive (or pride or desire for approval—call it what you will) takes precedence over all other drives."[7]

Few psychologists have bothered to speculate about the evolutionary origins of the need for self-esteem, however much they may be convinced of its importance in the motivational

system of contemporary humans. But this is not surprising, given that most psychologists are primarily interested in the proximate causes of human behavior and do not much concern themselves with ultimate evolutionary explanations. It is not difficult to imagine, however, an evolutionary scenario that might account for the existence of the need for self-esteem, or to explain why its lack of fulfillment can have such devastating consequences for the individual. Humans are highly social animals, and this apparently they have been throughout the long course of their phylogenetic development. Thus for most of human evolution the ability of any individual to survive and reproduce would have depended in large part on his ability to get along with, and maintain himself in good standing with, his neighbors. If he behaved in a way that was consistently anti-social and destructive to group welfare and harmony, he would have tended to be the target of social criticism, deprecation, or even banishment. By contrast, if he consistently behaved in socially acceptable ways and made major contributions to group cohesion, proving himself to be a co-operative and valued member of the social group, then he would probably have been the recipient of praise, adulation, and reward. In the former case, social disapproval and criticism might have evoked in him a painful sense of low self-worth, shame, and isolation; while in the latter case (in the case of social approval and approbation) he may have experienced benign or even euphoric feelings of high self-worth, accomplishment, and personal fulfillment. These feelings, then, would have served as a kind of internal barometer, informing the individual as to whether or not his social behavior met with the approval or disapproval of the other members of his group. In this context, a negative self-concept would have served as a warning that the individual was behaving improperly, and that his chances for survival and reproduction might be enhanced if he were to modify his behavior in the direction of social co-operation. By contrast, high feelings of self-worth, resulting from social approval, would have encouraged further co-operation, thus leading to enhanced probabilities of survival. In a highly social, highly self-conscious species such as our own, self-esteem could not

help but have become a profound biological need; and at least a partial fulfillment of that need is essential if the individual is to maintain his ability to function in society and ensure his survival and psychological health.

Having evolved the need for self-esteem, then, we humans have also evolved the capacity to suffer, and sometimes devastatingly so, when that need goes unfulfilled. When the individual fails to satisfy his need for self-esteem—when he is unable to live up to his own ideal self-image, or when he is subjected to unmanageable amounts of adverse criticism or denegration from his fellows—he may suffer from self-reproach, self-deprecation, or even self-hate. And when this happens there is no limit to the amount of devastation he may cause himself through his own feelings and behavior. He may torture himself with self-doubt, depression, paranoia, or self-abuse; or he may lash out against others who have criticized him and whom he feels are responsible for his own suffering. In extreme cases, he may even commit suicide. The word 'suicide', indeed, literally means the killing of the self, and ultimately the evolutionary endowment which makes this possible is the conscious awareness of that self. Such painful emotional reactions as embarrassment and humiliation can also be ultimately traced to our evolutionary heritage as self-conscious creatures.

The Awareness of Time

The various aspects of our conscious awareness are not always easy to separate one from the other, and in evolutionary terms they may have proceded hand in hand, so that any attempt on our part to rubricize them constitutes nothing more than a linguistic and philosophical convenience, rather than an accurate reflection of the events that must have taken place during the phylogenetic development of the human psyche. At all events, it seems doubtful that any aspect of human awareness, for whatever reasons it may have evolved, is quite as pronounced anywhere in the animal world as it is in us. Take for example the awareness of time. All animals, of course, live in a

world of the relentless passage of time; but not all are equally aware of it. Presumably the average paramecium is as blissfully unaware of the march of time as it is of quantum physics or the molecular structure of the human hypothalamus, and cares even less. And I doubt whether there are many jaybirds or squirrels that would be able to comprehend the meaning of a minute or an hour or a month if someone were foolish enough to try to teach the concepts to them. Among the so-called 'higher' animals, of course, some appreciation of time almost certainly does exist, and some recent experiments with chimpanzees and gorillas clearly show that these animals at least are more keenly aware of the ticking of the clock than are squirrels, jaybirds, or paramecia. It seems nevertheless clear, as is evidenced by our own total preoccupation with time and its passage, that we humans are more keenly aware of time than is any other species on the planet. As regards almost all forms of conscious aware-ness, indeed, we humans seem to be superlative; and this holds as much for the conscious awareness of time as for anything else. Apparently our unparalleled awareness of time is an inevitable outcome of our having evolved such an enormous intellect and along with it a superlative degree of conscious awareness in general. Thus to the extent that there are advantages—and disadvantages—associated with the conscious awareness of time, these are bound to play a bigger role in the life of man than in the life of any other animal. And of such advantages and disadvantages there are apparently a good many. On the positive side, the awareness of time has given us humans the ability to learn from experience and to make provision for the future; and it has created the capacity to experience the joy of anticipation that often precedes the attainment of desired goals and activities. On the negative side, however, time-awareness has also created certain distinct burdens: most significantly, it has created the problem of insecurity by generating the need to act today with the future in mind. Our supreme capacity to take cognizance of the future implies the ability to worry about it, as well as to anticipate it; and our ability to contemplate the past can be as disconcerting as it is sometimes pleasant. In particular our tendency to dread future possibilities has enormous ramifi-

cations both for our behavior and our mental state. Indeed, it has been argued, as we shall presently see, that man's superlative awareness of time is the crucial factor which makes him uniquely capable of experiencing such distressful emotions as worry, dread, and anxiety.

In 1949 a psychobiologist named Howard Liddell suggested that human beings are the only animals that are capable of experiencing genuine anxiety. And he argued that this fact is largely explicable in terms of man's supreme awareness of time. It is the human capacity to see into the future, and to see further into the future than any other animal, Liddell argued, that makes him such an anxious animal. Liddell's thesis is a compelling one, and what follows is a synopsis of his basic argument.[8]

According to Liddell, all animals experience occasional threats to their survival, to which they normally respond with appropriate alertness and, if necessary, defensive maneuvers. The arctic seal, for example, lives under the continual threat of predation whenever it ventures from the security of its underwater haven and has developed an effective—if radical—strategy to protect itself. When the sun becomes warm, the seal, which is a chilly animal, will emerge from its hole and stretch out on the ice. There, just a few feet from the opening, it sleeps—but only fitfully, for it must remain ever vigilant of Eskimo hunters and other predators. Every eight to ten seconds, the seal disturbs its own sleep to scout the surrounding landscape for hunters. At the slightest hint of danger, it quickly slips back into its hole. Similarly, when domestic sheep are susceptible to attack by hostile dogs or other canines, they will for some time remain wary of any untoward approach. Until the danger has subsided, they will resent being driven, and will even bunt their own shepherd dogs. Whenever an animal is in a situation that involves a possible threat, it poises itself to respond quickly and deliberately should the expected threat materialize. This 'investigatory reflex'—or 'vigilance', as Liddell calls it—is characterized by a general preparedness to react appropriately as soon as the precise nature of the potential danger is determined. At this point, according to Liddell, it is as if the animal is

asking itself two questions, namely 'What is it?' and 'What happens next?' The animal's nervous system constantly poses these questions and prepares itself to respond appropriately as soon as its perceptual system has determined the answers. In other words, the animal nervous system has two distinct but related functions. In its role as *sentinel*, the neurological system asks, 'What is it?' In its role as *planner*, the neurological system must continually ask, 'What happens next?' So long as the answers to these questions are forthcoming, the animal remains alive and, in most cases, healthy. But when, as in laboratory experiments designed to produce artificial neurosis, the animal gets no answers to these questions; when, in other words, it is forced to maintain an intense and unrelieved state of vigilance, the pent-up nervous tension disrupts the operation of the system, with the result that the animal's behavior becomes frantic, disordered, 'neurotic'. This, according to Liddell, is approximately parrallel to what happens when human beings break down under the burden of severe and constant anxiety. But there is one important difference. In nonhuman animals, the capacity to see into the future is severely limited. The sheep, for example, can plan only up to about ten minutes, the dog perhaps half an hour. But man's conception of the future is much more elaborate, such that his 'What happens next?' question takes in much more possibility than its counterpart in laboratory animals. It is as if man's neurological planner function must be kept on continuous hold, allowing him no release of pent-up nervous tension. And as this tension mounts, the experience of fear is transformed into genuine anxiety. Thus, as Liddell sees it, the uniquely human capacity to take cognizance of the distant, as well as the immediate, future is the distinctive factor which makes anxiety a uniquely human phenomenon. In the course of evolution, he writes, the planning function of the nervous system "has culminated in the appearance of ideas, values, and pleasures—the unique manifestations of man's social living. Man, alone, can plan for the distant future and can experience the retrospective pleasures of achievement. . . . But man, alone, can be worried and anxious."[9]

This conclusion is by no means Liddell's alone. Many other

writers, among them Lawrence Freedman and Anne Rowe, have expressed a very similar point of view.[10] Like Liddell, Freedman and Rowe believe that anxiety is a peculiarly human emotion; indeed, they have gone so far as to characterize the evolutionary emergence of man as the beginning of the 'age of anxiety'. And their sentiments have recently been echoed by psychologists Esther and William Menaker. Like Freedman and Rowe, the Menakers believe anxiety to be uniquely human; and like Liddell, they see a close connection between man's awareness of time and his capacity to be worried and anxious:

> Although reactions akin to anxiety, such as timidity, apprehension, and suspicion, have been observed in animals, anxiety proper is considered a human manifestation. Freedman and Roe say that 'the age of anxiety' may properly be said to have started with the emergence of *Homo sapiens.* This is because anxiety is an anticipatory phenomenon in awareness in which clues from the external environment or from the inner state of the human organism serve as signals of danger by touching off, through associative links, previously experienced states of fearfulness, pain, or displeasure. The capacity for storing experience in the form of symbolic memory traces and reawakening them through associative processes gives man the ability to experience anxiety and to heed its warning of danger by taking appropriate action. This capacity is obviously the product of the evolution of man's higher cortical centers which resulted in consciousness and the ability to internalize the environment through its symbolic representation.[11]

Along similar lines, it has recently been argued by a number of authors that the human capacity for mental depression may also be in large part attributable to man's having evolved such an acute awareness of the passage of time. One such author is psychiatrist Nathan S. Kline, who has suggested that man's awareness of time—along with his awareness of the self—is the crucial factor which makes mental depression primarily a human disorder. According to Kline, one of the characteristics of clinical depression is the concern that it will go on and on indefinitely. But only humans—because of their awareness of time—are capable of such concern. As Kline sees it, concern

for the future "requires not only consciousness but also self-consciousness, which perhaps is one of the reasons why depression as we know it seems largely limited to humans. Also typical is rumination about the past, so that to some degree depression and those parts of the psyche and possibly the brain itself that are involved with time may be the crucial ones."[12] In Kline's view, nonhuman animals are incapable of genuine clinical depression because they can neither worry about the future nor ruminate about the past. They may suffer from temporary feelings of 'sadness', but they do not become 'depressed' in the human sense.[13] Sadness, whether human or otherwise, is usually overcome without complication if it is not accompanied by anticipation of future misfortune. It is just such fear of future misfortune that adds a new dimension to mere sadness and transforms it into genuine clinical depression.

The Awareness of Death

In *The World as Will and Representation*, Arthur Schopenhauer wrote that every time a man swats a fly, he tacitly acknowledges that the fly suffers less from being killed than he suffers from being annoyed by it. The human capacity for suffering, in other words, is infinitely greater than that of the fly, as it is greater than that of any other species. There are, of course, many reasons why this is so, but certainly one of the most important of them is conscious awareness, including the awareness of time, of the self, and—as an inevitable consequence of these—the awareness of death. In one sense at least, nonhuman animals are really no better off than we are: like us, they have no guarantee of a long life or of good health, and their existence is every bit as precarious as is our own. In fact the great majority of all animals succumb to disease, starvation, accident, predation or aggression before they have reached maturity; and even those few that are 'lucky' enough to die of old age are often no more than a few years old when they do so. During their brief lives, what's more, animals often face many of the same hardships that we do as they struggle to stay alive in a

world replete with natural hazards. Like us, they face the problems of trying to find enough food, of finding a place to live, of securing a mate, of producing and caring for offspring, of avoiding predators and parasites, of escaping from aggression, and so on; and by and large they are no more successful than we—in many cases less so—in coping with these and other inherent problems of life. In this sense, then, we are really no different from them, and they are no better-off than we. But there is one crucial difference; and that difference, in a word, is awareness. When a fly that has been alive for only a week or so is swatted by a man, no one grieves for its loss—not even, presumably, its closest relatives—and no one suggests that its death is sorrowful or tragic in any way. We humans often rejoice in the death of a fly or other such vermin, because it signals the removal of an annoyance from our lives. But when a human being that has been alive for, let us say, 19 years, is killed by disease, by accident, or by another human, her death is universally regarded as a great tragedy. She has lived much longer than any fly, and longer than most animals, and yet everyone laments that she died too young. Humans are the only animals that complain about the brevity of life, even though we have a longer life span than the vast majority of species. Why this paradox? The answer, once again, is awareness. The fly which survives only a week or so does not suffer either from the threat of being killed or from actually being killed, because it is completely unaware of its own existence—it has no appreciation of the passage of time or of the brevity of its life or of its own mortality. It lives, and it dies, and no one cares. But humans, unlike flies, are very much aware of their own finitude, and this knowledge gives everything they do in their lives a kind of urgency that is unknown in the rest of the animal world. Humans, unlike other animals, are consciously aware that they have only so much time to accomplish their life's goals, whatever these may be, and then it is all over. And it is rare that this knowledge does not have at least some negative impact on the quality of life of the individual. It is indeed precisely the dimension of awareness, and especially the awareness of the self and of one's own mortality, that transforms mere misfortune—

such as the kind that is experienced by all animals—into genuine full-fledged tragedy.

There are some humans who are more resigned to the prospect of death than others. Some people claim to have no fear of death whatsoever. To such individuals, perhaps, death appears as no great tragedy, but merely a natural process of transition from one kind of existence to another—a transition which may be met with placid resignation, perhaps even anticipation. (Socrates might be cited as a historical example of such a person.) But others are less resigned. There are some who cannot bring themselves to believe in post-mortem paradises, and so do not have the option of adopting such a belief as a means of coping with the problem of their own mortality. To such persons the whole prospect of death may seem so tragic, indeed so obscene, as to defy description with words. The human awareness of death, in any case, makes a mockery of man's supposed superiority in the matters of resilience and adaptability. In the vernacular of anthropocentrism, man is sometimes referred to as the 'ultimate survival machine'. But it must be remembered that the same intellect that gave man the ability to survive also gave him the capacity to see the limits of his own survival. In this sense man is the only truly mortal animal, in that he alone *knows* death, and the anthropocentric conception of man as a 'superlative survival machine' must therefore be written off as a rather pathetic joke. However intelligent human beings may be, however clever at devising ways to prolong their lives and postpone their own ultimate demise, in the end it is the blissful ignorance of the nonhuman animal, and not the conscious awareness of the human one, that conquers death.

Man, the Necessitous Animal

Some scientists have recently advocated the view that, compared with other animals, humans have relatively few biological needs; and that human needs, precisely because they are so few, are relatively easy to satisfy. According to these

theorists (many of whom put forth their opinion in reaction to the publication of Edward O. Wilson's *Scociobiology: The New Synthesis* in the mid-1970s), the only universal human behaviors are eating, excreting, and sleeping, therefore these three activities must be the only basic biological needs that are inherent in human nature and shared universally by all men and women.[14] Other animals may be the captives of their biology, according to this point of view, but we humans, by having evolved such an enormous intellect and behavioral flexibility, have been 'liberated', as it were, from biological imperatives and are free to live our lives in any way we choose, almost completely without reference to biological demands.

I could hardly disagree more. I suggest that the opposite is closer to the truth. It may very well be the case, as Wilson's detractors so frequently argue, and as I myself have repeatedly suggested throughout this book (especially in Chapter 4), that humans have relatively few instincts as compared to other species, if by 'instinct' is meant a rigidly programmed behavior that is more or less automatically evoked by a particular environmental stimulus. But there is a big difference between an 'instinct', in the sense of a genetically programmed response, and a biological need, in the sense of an innate requirement (either physical or psychological) that must be fulfilled, in one way or another, if the organism is to maintain good health and homeostasis. And it is in this latter sense that human biological needs are at least as great as, and probably much greater than, those of any other species.

Like most other animals, humans have a basic need for food, water, living space, protection from the elements, and so on—not to mention the sexual and reproductive urges which, if the ever-increasing population of the Earth is anything to go by, impose themselves rather strongly on human conduct. But human needs, unlike animal needs, go far beyond this and include things that no paramecium or fruitfly would ever dream of. For humans, unlike paramecia and fruitflies, have evolved complexities of anatomy and psyche that are unknown in the remainder of the animal kingdom, and the evolution of which has brought with them entirely new urges, motives, and drives.

The evolution of conscious awareness, as we have just seen, has created in its wake all sorts of new needs, including the need for self-esteem, accomplishment, and a vicarious sense of immortality. Even at the basic level of food and water, human needs are often much more urgent and more elaborate than their animalian counterparts. As I noted in Chapter 2, we humans— like other mammals—are warm-blooded; and as a consequence we have much greater food requirements than the ectothermic species. And, as was noted in Chapter 3, because humans perspire at a relatively profuse rate, but have a lesser capacity than most mammals to ingest large amounts of water, we have a more urgent need than almost any other mammal for constant replenishment of lost body fluids. Human nutritional requirements are also much more elaborate than those of virtually any other animal. Because we have evolved such a complex physiology, we require a wide variety of nutrients, including vitamins, minerals, proteins, carbohydrates, and fiber, to keep our bodies in good working order. Even at the basic level of eating and drinking, human needs are relatively pronounced compared to those of other species. And that, unfortunately, is only the beginning.

In purely physical terms, we humans are really not all that different from other animals. In many respects of our anatomical structure and in the molecular composition of our DNA, we are scarcely distinguishable from chimpanzees and gorillas, and by the present criteria would have to be classified with them as members of the same genus. But psychologically we are enormously different from even our closest living relatives; and it is surely for this reason, rather than because of the purely physical differences, that we choose to distance ourselves from the African apes and look upon ourselves as a unique species. We have indeed evolved a unique psyche and along with it an entirely new array of psychical, and hence biological needs. Because of our heritage as social creatures, for example, we have evolved the need for companionship, love, and a sense of belonging. Because of our conscious awareness of the self, of time, and of death, we have inherited a need for self-worth, self-fulfillment, and a sense of personal immortality. On top of

all this, because of our evolution as cultural creatures, we have also acquired the need for artificial clothing, tools and weapons, cooking, housing, transportation, and many other cultural artefacts which are largely unnecessary in the rest of the animal kingdom. Taken together, these and other distinctly human needs far exceed anything that is to be found in any nonhuman animal.

Man, as Schopenhauer put it, "is . . . the most necessitous of all beings. He is concrete willing and needing through and through. He is a concretion of a thousand wants and needs. . . . Accordingly, care for the maintenance of [his] existence in the face of demands that are so heavy and proclaim themselves anew every day, occupies as a rule the whole of human life."[15] Schopenhauer's ideas are often written off because of his pessimism. But even a highly optimistic scientist like Abraham Maslow has in more recent times expressed a theory of human needs not greatly different from that of Schopenhauer. In the second edition of his *Motivation and Personality,* published in 1970, Maslow writes, "Man is a wanting animal and rarely reaches a stage of complete satisfaction, except for a short time. As one desire is satisfied, another pops up to take its place. When this is satisfied, still another comes into the foreground, etc. It is a characteristic of the human being throughout his whole life that he is practically always desiring something. . . . The human being is never satisfied, except in a relative or one-step-along-the-path fashion."[16] According to Maslow, the human animal is actually possessed of an elaborate hierarchy of needs, ranging from the simplest and the most basic (or what he calls the "lower" needs) to the so-called "higher" needs of self-fulfillment, accomplishment, and self-actualization. At the "lowest" or most basic level are the purely physiological needs, for food, water, and sleep. Next come the safety needs, including the need for stability, protection, freedom from fear, as well as the need for structure, order, strength in the protector, and so on. Next in the hierarchy are the so-called "belongingness" needs, the need for love, affection, companionship, and social interaction. Then there are the esteem needs, including the need for a sense of self-worth and acceptance by others. The

esteem needs also include, on the one hand, the desire for strength, achievement, adequacy, mastery, self-confidence, independence and freedom, and on the other hand the desire for reputation or prestige, status, recognition and attention, fame and glory, importance, dignity, respect and appreciation. Finally there comes the need for what Maslow calls "self-actualization" which, roughly defined, is the need of the individual to become all that he is capable of becoming, to achieve his life's goals and the fulfillment of his potential as a unique individual. In addition to these and other *conative* needs, as Maslow calls them, he also speaks of the *cognitive* needs, which include most notably intellectual curiosity, the need to know, to understand, and to comprehend the world. And then there are the aesthetic needs, for such things as order, symmetry, and beauty. This, to say the least, is an impressive inventory—and Maslow doesn't even mention the needs for sex and reproduction. I do not know of any scientist, either in the field of human psychology or ethology, who has even remotely suggested such an elaborate array of biological needs in any nonhuman species. And I strongly suspect that no scientist would be taken seriously if he were to suggest that earthworms, for example, have cognitive as well as conative needs, or that beetles devote most of their life striving to the attainment of self-actualization.

Maslow, as I have noted, was an optimist; and as an optimist he could not bring himself to regard human needs, however innate, as ineradicable. Nor could he look upon them as being inherently evil *per se*. Given the proper learning, training, and experience, he suggested, at least some of these biological needs can be squelched or sublimated to a point where they pose no serious danger of deprivation to the individual. (This, of course, is a highly debatable point of view, and one for which Maslow provided no definitive proof.) Nevertheless, even Maslow admitted that because human needs are so numerous, and often so difficult to satisfy, they almost inevitably give rise to a certain amount of frustration and interpersonal conflict. "At the very least," he wrote, "we must accept the inevitability of violence as part of the human essence, if only because basic

needs are absolutely doomed to be frustrated at times. And we know that the human species is constructed in such a manner that violence, anger, retaliation are quite common consequences of such frustration."[17]

It is no exaggeration to say that some human beings spend the greater part of every day trying to satisfy their biological needs and even in that much time don't succeed in fulfilling half of them. By comparison the African lion, who spends only a few hours each day, on the average, procuring his sustenance and most of the rest of his time sleeping, resting, and copulating, and who has no concerns about death or self-fulfillment or school or work or bills or taxes or any of the other thousand and one preoccupations which impress themselves upon the minds of humans, has an easy life indeed. And even lions, with their relatively modest needs, sometimes come into conflict with one another as each attempts to procure for himself the best hunting grounds or the best females. Human beings, with their myriad biological needs, come into conflict with one another even more often as each individual attempts to satisfy his needs in competition with others. The evolutionary genesis of this kind of interpersonal competition, and the many forms of suffering and hardship to which it has given rise, will be the subject of the next two chapters.

Chapter Seven
Man Against Man: The Genesis of Interpersonal Conflict

It is the essence and nature of everything, Spinoza told us, to endeavor to persist in its own being. In a world of things and processes different in character, difference and conflict-in-relation are just what we should expect. It is the essence of fire to set the green wood aflame, and it is of the essence of the moisture and the sap in the wood to delay flaming and to extinguish the fire. It is the nature of the invading horde of germs to take hold, multiply and take possession of the organism, and it is the nature of the organism to resist the infec- tion which threatens its health and life. It is as natural for a dog's ravenous hunger to cause it to snap the bone out of anoth- er dog's mouth as it is for our social sense and reason to con- trol appetite. The 'flesh' and the 'spirit' are both 'nature', each in its sphere persisting, each in relation of the other and overarching to dominate the other. Our life, and the world we live in, may be con- ceived as a vast concourse of activities self-persisting, coun- teracting, conflicting.

Radoslav A. Tsanoff

Schopenhauer once wrote that a very great part of the suffering inherent in human life has its constantly flowing source in the conflict of individuals.[1] He was quite right. Interpersonal con- flict is the ultimate root of much evil, manifesting itself in the forms of hatred, envy, murder, war, rape, theft, deceit, and the frustration that results when one person's needs or desires are frustrated by the actions of an unco-operative competitor. Clearly, human conflict and human suffering are intimately related, and as Schopenhauer suggested, this relationship is not at all a difficult one to explain. Whenever the strivings of two individuals clash, neither is likely to get what he wants, except at the expense of the other. In such cases each rival has little choice but to compromise his own interests, or to fight for what he wants. If he chooses compromise, he may suffer the depriva-

tion and frustration that are the usual consequences of thwarted desires. If he elects to fight, he may risk injury both to himself and his adversary. In neither case does he wholly avoid nefarious results. Wherever there is conflict, there is suffering. And, as I shall illustrate in the pages to come, all human conflict may ultimately be traced to general trends and specific events in the evolution of life.

Conflict, as is now widely acknowledged by evolutionary biologists, has been an integral part of living systems for perhaps the entire history of life on Earth. And life on Earth has existed for a very long time—at least three-and-a-half billion years. It would therefore be extremely difficult to outline with any degree of accuracy the ultimate origins of organic conflict. Nevertheless, many scientists have recently attempted to do just that. Armed with a certain amount of empirical evidence, and a good deal of educated guesswork, they have produced numerous scenarios to account for the origin of life itself, and for the ultimate emergence of organic conflict. Perhaps the most straightforward of these scenarios may be found in Richard Dawkins's *The Selfish Gene*. In the second chapter of that work, Dawkins attempts to reconstruct many of the events which led up to the origin of life and the origin of organic competition. My account in the next few pages largely follows Dawkins. This tentative reconstruction is necessarily speculative, and is based primarily on circumstantial evidence. In particular the scenario concerning the ultimate origin of life itself, as presented here, is at best uncertain. No one knows just how or when life first emerged, and it is quite possible that no one ever will. But the following scenario is at least as plausible as any that has yet been suggested.[2] If nothing else, it will serve as a convenient starting point from which to launch a discussion of the origin of organic conflict, which is the real theme of the present chapter.

The Origin of Life and the Origin of Conflict

If we could somehow be transported back in time some four to four-and-a-half billion years, we would find the Earth to be a

very different place from what it is today. It was, by our standards, a barren and inhospitable world, completely devoid of life, and quite unable to support the kinds of living things that we know today. There was no ozone layer in the primitive atmosphere, and very little, if any, free-floating oxygen. Ultraviolet radiation from the sun, in doses that would be lethal to us, easily penetrated to the surface of the planet. Along the shores of the Earth's ancient seas, there simmered a chemical-rich broth now known as the 'primeval soup'. Its principal ingredients—as well as can be determined from the geological record—were hydrogen sulfide, ammonia, formaldehyde, cyanide, formic acid, methane, and perhaps water vapor. It was anything but an appetizing mixture—quite toxic, in fact, to most things that live today. But it may have been just this combination of chemicals that gave rise to the first living things. (Some recent evidence suggests another possibility: that the first organic molecules, such as proteins, did not originate in the primeval soup but on the surfaces present within silicate clays. This is because the spontaneous formation of proteins is known to occur much more easily in such clays than in the kind of liquid environment that existed in the Earth's ancient seas. The first complex organic molecules may actually have formed in these clays, rather than in the organic soup.) Somewhere between three and four billion years ago—it is impossible to say exactly when—ultra-violet radiation from the sun and random jolts of electricity from lightning combined with the primeval soup's chemical ingredients to form the first organic molecules. These were probably amino acids, the building blocks of proteins. Having once formed, the primitive amino acids would have collided with one another again and again, absorbing energy from the sun, electricity, and volcanic heat. Often they would have been jolted apart, only to be re-united in their original form. On occasion, however, they must have combined in completely new ways, producing an ever-greater variety and complexity of forms. From this continual propagation of new and more intricate combinations, there eventually arose a particularly remarkable class of molecules—ones that possessed the ability to create more-or-less complete and accu-

rate copies of themselves. These 'replicator' molecules, as Dawkins has dubbed them, were the first self-reproducing beings, and may be loosely regarded as the first genuinely living things. With their emergence, life on Earth—for all intents and purposes—had begun.

In order to explain how the first replicator molecules may have acquired the ability to reproduce themselves, Dawkins compares the replicators themselves with molds or templates, each one consisting of a complex chain of various sorts of building block molecules. (This is actually an oversimplification, but for the present purposes it will do well enough.) Now let's suppose, as Dawkins suggests, that in the primeval soup each building block molecule was chemically attracted to its own kind. Then whenever a building block from the soup happened to land next to a similar component of the replicator, it would tend to stick there. Eventually building blocks would have attached themselves to every component of the replicator molecule, and in a sequence identical to the replicator itself. At this point the original replicator would be chemically attached to an exact copy of itself. Now, should the whole system be jarred by physical agitation of some kind—solar radiation or electrical sparks, for example—the two chains might split apart, leaving two replicators where there originally had been only one. This process could then go on to repeat itself indefinitely, the eventual result being an entire population of identical replicators, each of them ultimately descended from a single primordial parent.

Of course we know very well that this process of identical replication did not go on indefinitely. Had it done so, the world today might be inhabited by an immense population of identical organisms, instead of by the immense variety of life forms that have actually evolved and with which we are familiar. Obviously, at some point the early replicators must have begun to produce divergent offspring. And with each succeeding generation, more and more diverse forms were created. Why, then, should this have been the case? Why didn't the original replicators simply continue to reproduce exact copies of themselves *ad infinitum*? The answer seems to be that nothing in

nature is perfect or unvarying, so the process of identical replication was bound to go awry. Environmental stresses of various kinds, such as solar and other radiation, electrical sparks, or physical agitation of various sorts would have interfered from time to time with the replication process and rendered it less than completely faithful. In other words an occasional error was made as a replicator 'tried' to copy itself. In the course of time, such copying mistakes accumulated, with the result that the primeval soup became populated, not by an expanse of identical replicators, but by a mixture of several different varieties of organic molecules. Eventually certain types of molecules proved to be more efficient than others at making true copies of themselves, and as a consequence their numbers increased relative to the other types. Natural selection had begun to favor the more prolific replicators, so that the latter soon came to outnumber their less successful rivals.

Even the most efficient replicators, however, could not go on making new copies of themselves forever. The primeval soup simply wasn't expansive enough or rich enough to support an infinite number of replicator molecules. When the replicators became extremely numerous, the small building block molecules necessary to make new copies must have been used up at such a rate that they became a scarce and limiting resource. It was at this point that competition began to play a prominent role in the struggle for life. For as building block materials became ever scarcer, different varieties of replicators must have competed for them. At first the competition may have been indirect, with each replicator going its own way after available resources, avoiding all others in the process. Eventually, however, the competition must have become more direct and less peaceable. Some replicators may even have discovered how to break up molecules of rival varieties, using the chemical components so released for making their own copies. By thus 'killing' and 'eating' other molecules, these proto-predators fortuitously came upon a method of obtaining food while at the same time removing bothersome rivals. Soon enough their very survival depended on their ability to obtain their basic materials by breaking down other organisms in just this way.

Conflict had become an essential component of the organic world, and remains so even to this day.

We can't be sure to what extent the foregoing scenario is an accurate representation of the events that took place some three-and-a-half to four billion years ago, and I certainly do not claim that it be accepted as incontrovertible fact. It is impossible to determine with any certainty just how or when life began, or what the precise conditions were that gave rise to competition and conflict among organic beings. Even Dawkins, who proposed this scenario in the first edition of *The Selfish Gene*, would readily admit as much. Indeed, he has more recently suggested that life may not have begun in this way at all. It seems fairly clear, in any case, that something like the foregoing must have occurred at some point in the history of life, and it is a fair guess that conflict began to play a significant role in organic systems at a very early stage in evolution. It is also clear that this scenario, or some variety of it, has played itself out thousands of times over since the dawn of life. In one way or another, conflict has come to permeate the organic world, and the immense variety of conflict situations that actually occur among contemporary living beings strongly suggests that this phenomenon has had a long and continuous history.

I do not wish to suggest that conflict is ubiquitous in the organic world in the sense that every living being is wholly at odds with every other. This is anything but the case. As I mentioned in Chapter 2, there are any number of ecological factors which tend to mitigate the conflicts of interest that might otherwise completely pervade the organic sphere. As I suggested there, whenever there is some overlap in the reproductive interests of two individual organisms, those two organisms may be expected to co-operate with each other and to maintain peaceful relations, at least insofar as their reproductive interests coincide. Thus, not surprisingly, co-operative interaction is a commonplace phenomenon in the organic world. Indeed, in some ecological contexts, the best if not the only way for an individual to get what it wants is to co-operate with another individual that shares a common goal, or has similar reproductive interests. And in such cases co-operation may be the best

available means by which the individual is able to secure its own reproductive success. Even among typical co-operators, however, overlap of individual interests is rarely complete. And even among those relatively few organisms where the reproductive interests of one individual may be said to have completely merged with those of another, conflict has not necessarily been totally overcome. Among certain eusocial insects, for example, sisters almost always co-operate with one another because their reproductive interests and reproductive strategies are virtually identical. Thus we may actually have a case here where all conflict of interest between one organism and another has been eradicated. But this situation is very rare in nature, and seems to occur only among the eusocial species such as bees, wasps, and termites, and among asexual clones. And even where it occurs, the individuals involved do not necessarily lead conflict-free lives. For while it may be the case that pairs of sisters have identical reproductive interests, these interests do not necessarily coincide with the interests of the group as a whole, or with those of the species, or with those of other organisms. In fact whenever a bee hive is attacked from without—either by other bees, wasps, or humans—the members of the attacked hive will usually defend their home quite vigorously, even to the point of injuring or killing their enemies. In sum, there has probably never existed a living organism whose individual interests were completely coincident with those of every other organism with which it came into contact. And in this sense, conflict of interest may be said to play at least some role in the life of every living thing.

Conflict in the Animal World

Probably the most obvious expression of conflict in the animal world is killing, and this occurs on a grand scale, both *inter*specifically and *intra*specifically. Indeed, a conservative estimate would be that, on any given day, several billion living creatures are destroyed—and in many cases devoured—by several billion others. In many such instances, the victim is of a

different species from its killer, in which case the act is usually referred to as 'predation'. In other instances, both killer and victim are of the same species, in which case the act is alternatively referred to as 'murder', 'cannibalism', 'infanticide', and so on, according to the specific circumstances. Some authors have suggested that predation and other forms of interspecific killing are not examples of 'real' conflict, because they do not involved genuinely competitive relations. But this is a curious way of looking at things. If we use the word 'conflict' in its broadest sense, then predation must certainly come under this heading, whether or not it involves competition *per se*. Whether an animal is killed by a member of its own species, or by a member of a different species, it is in either case quite dead. And I would venture to guess that, to a dying antelope, it does not matter much whether the fatal blow came from a lion or from another antelope. As George C. Williams has argued, predation is every bit as much an expression of conflict as is murder, and giving it a different name doesn't make it any less deadly. When a mountain lion kills a deer, one may call it 'good' or 'harmonious', because it allegedly expresses nature's kindness in preventing deer from having to die of starvation. But the facts, as Williams argues, "are that both predation and starvation are painful prospects for deer, and that the lion's lot is no more enviable."[3] It is interesting to note that when a human being is stung to death by killer bees, or sawed in half by a crocodile, or devoured by a man-eating tiger, no one suggests that such occurrences are expressions of nature's 'harmony', and no one suggests that the real purpose of the bees, or of the crocodile, or of the tiger was to prevent the poor human being from having to starve to death. In all such cases, the death of the human victim is universally regarded as no less tragic than had the killer been another human being. In sum, there may indeed be some important differences between *inter*specific and *intra*specific killing, but clearly neither is any less an expression of conflict than the other. And from the victim's point of view at least, there is probably no difference at all.

Another example of interspecific conflict is parasitism. And this, too, is widespread throughout the organic world. In

general, parasitism takes on a much more subtle form than predation, but it is not always less destructive. In some instances, the host animal is but little affected by its parasite: many mammals, for example, are able to tolerate the infestation of their intestines by small worms that require relatively little nourishment. In other cases, however, the host is left severely weakened by the interaction and therefore rendered much more susceptible to predation or disease. Not infrequently, the host is infected with a disease transmitted directly by the parasite itself. (Many parasite species, like mosquitoes and tsetse flies, are infamous for being transmitters of harmful microbes.) In any case, the conflict of interest between parasite and host is almost always significant. With some exceptions, the host animal suffers as a consequence of being parasitized, and the parasite suffers when it has no host to invade.

Most predation and parasitism, of course, involve members of different species—although, as we shall see, this is by no means invariably the case. By contrast, conflict within species usually takes on a somewhat different form and typically involves competition for access to scarce resources such as food, water, living space and mates. And competition of this sort is widespread in the animal world. In fact there is probably no species in which there does not exist at least some competition between individuals over resources that are prerequisite to survival and reproduction; and documented examples of intraspecific competition can now be cited by the thousands. Competition for mates tends to be especially frequent and intense in nature, for reasons that are not difficult to explain. As I pointed out in Chapter 2, the essence of evolutionary success is *reproductive* success—the evolutionary 'aim' of every individual being to produce as many viable offspring as it can in competition with its reproductive rivals. Indeed, since reproductive success is always relative, reproductive competition is virtually inevitable. In any particular environment, at any particular point in time, there may be sufficient water, food, and living space to go around for everyone, and therefore no need to compete for these things. But reproductive opportunities are always limited, and almost never evenly distributed. In

fact in almost all populations of sexually-reproducing organisms, as we shall see in the next chapter, there is competition among members of one sex (usually the males) for access to members of the other sex. And this can be one of the fiercest kinds of competition known to occur among living things.

Animals frequently live in social groups, but rarely if ever are social groups completely harmonious in their interactions. Within the social group, individuals can be expected to co-operate whenever it is to their benefit to do so; but when they do not benefit from co-operation, because their reproductive interests clash, then conflict—not harmony—is the usual result. Most social groups in nature are characterized, not by universal co-operation and equality, but rather by dominance hierarchies (or 'pecking orders') in which each individual attempts to gain the upper hand over all others by attaining the highest possible rank. In such systems, dominant individuals typically enjoy priority of access to food, nesting sites, and mates, while low-ranking individuals are typically obliged to accept subordinate social status and a lesser access to all vital resources. In some dominance orders, a single individual may assume the role of tyrant and exercise his dominion over all other members of the group. More commonly dominance hierarchies take on a linear form, with the alpha individual dominating all others, the beta individual dominating all but the alpha, and so on down to the lowest member of society, who dominates no one. Typically the highest-ranking individuals keep the best resources to themselves and use threat, intimidation and, when necessary, aggression to ward off subordinates and other competitors. Not infrequently they actively displace the latter from food, mates, or nesting sites. The lowest-ranking individuals are usually obliged to accept a distinctly inferior way of life and may lease a marginal existence on the periphery of the group, struggling to maintain themselves with their meager ration of provisions, and in the case of males often enduring involuntary celibacy.

On occasion, of course, a subordinate may grow tired of his lowly status and, like a prize fighter, seek to improve his social standing by challenging a more dominant individual. In the

process, however, he risks injury or even death; and if he is indeed rebuffed, he may wind up in the end with an even lower status than he started with. Because of such inherent dangers, subordinates often resign themselves to their lowly position and bide their time until they can gain higher rank through stealth, trickery, or attrition. It is anything but a perfect system, and it is certainly not equitable or just in the human sense. But it is widespread throughout the animal kingdom. It occurs in scores of species and many different kinds of organisms, including insects, fish, amphibians, reptiles, and birds, and is almost universal among social mammals. Dominance orders have been documented in bumblebees, ants, crayfish, minnows, Galapagos tortoises, black grouse, voles, alpacas, llamas, mountain long-horn sheep, domestic chickens, dairy cattle, Japanese ma-caques, mangabeys, langurs, gorillas, chimpanzees and humans, to mention but a few.[4]

It is interesting to note that in some scientific writings, it is suggested that dominance hierarchies are 'adaptive' or 'good', because they supposedly serve to stabilize social relations and to reduce tensions and conflicts. According to this idea, without dominance orders animal societies would be chaotic and rid-dled with almost constant quarrels and aggression. Thus the evolutionary emergence of such systems represents a kind of 'advance' over a more primitive, more brutish state. But this is a circular argument if ever there was one. The fact of the matter is that dominance systems arise only as a result of conflict and there is nothing good about that. To wit, if there were no conflicts of interest between competing individuals to begin with—no scarcity of resources, either alimentary or sexual, to fight over—then there would be no need for dominance orders and no need for the sacrifice on the part of subordinate individuals that such systems inevitably entail. At best, then, dominance orders merely mitigate the violent nature of compe-tition and would not exist at all were it not for the underlying evil—conflict of interest—which gives rise to them. Domi-nance systems—whatever adaptive 'purpose' they might serve and however much they may reduce the incidence of violent aggression—are by no means wholly beneficial, especially from

the point of view of the lowest members of society. Competition does not necessarily have to be violent in order to be harmful; and even where no overt aggression exists, the ultimate results of conflict are not necessarily any less destructive. If an individual suffers hunger because of his low rank, his suffering is no less real than if his food had been stolen from him by a reproductive competitor. And a sexually disenfranchised underling suffers no less sexual frustration from being deprived of mates outright than if his mate (or mates) had been killed or abducted. What's more, even in an established hierarchy, where every individual knows its place and is aware of the risks involved, rank challenges do sometimes occur; and these are not necessarily non-violent. In some species of langurs, for example, groups of bachelor males may band together to attack and displace the alpha male. In other species, when an alpha individual is killed or displaced, peaceful relations may be abruptly suspended as lesser-ranking individuals fight amongst themselves for the top position in the hierarchy.

A good example of a species in which dominance disputes are by no means invariably non-violent is the common chimpanzee. During the course of her prolonged studies at Gombe, for example, animal behaviorist Jane Goodall observed a number of alpha males succeed one another for the top spot in the group. Sometimes, she found, this 'changing of the guard', as it were, is accomplished without violence; but such is by no means always the case. One ingenious male named Mike was able to attain alpha rank by intimidating the rest of his group with a noisy display, utilizing a pair of empty kerosene cans, and no blood was shed. Some years later, however, Mike's rule was terminated when he was viciously attacked by a challenger named Humphrey. The latter soon proved himself to be a highly aggressive despot who carried out unprovoked attacks on many members of the community. Eventually Humphrey himself was attacked by a male named Figan and was displaced after suffering serious injury.

On occasion dominance disputes can even be fatal. In at least one species of wasp, for example, namely *Polistes fuscatus*, two contestants vying for rank may grapple with each other and

attempt to sting each other. In some instances they may lose their hold on the nest and fall to the ground, suffering serious injury. And there is at least one recorded case of a death resulting from such a dominance dispute. When access to territory or fertile females is at stake, dominance battles can be particularly fierce and—as in the example just cited—even deadly.[5]

On one of the islands of the Hebrides, just off the west coast of Scotland, there lives a population of red deer that has been studied intently by Timothy H. Clutton-Brock and his colleagues.[6] In this population dominance rankings appear superficially to be quite labile and nondescript, and for much of the year the stags live together in what seems to be a more or less egalitarian herd. Come the annual rut, however, which begins in the early autumn, overtly peaceful relations break down and dominance struggles begin in earnest as each of the stags vies for access to the available supply of hinds (females). During the course of this competition, a few stags typically gain control of a sizeable harem, while other males remain solitary but ever desirous. In some cases a sexually disenfranchised male may attempt to acquire a hind by abducting her from a harem—a practice that is so common among red deer that it has acquired a name, 'kleptogamy'. If this strategy fails, as it often does, the solitary male may challenge the harem holder to a duel, in which case the two rivals engage themselves in pitched battle for control of the hinds. Typically the two contestants lower their heads and then attack each other with their antlers, each attempting to maneuver so as to push the other down a slope. During the course of these duels, injuries not infrequently occur, sometimes inadvertently, sometimes—it appears—with malicious intent. In fact as Clutton-Brock reports, a stag will, if he can, use his antlers to strike his opponent in the flank, and shows no apparent inhibition against doing so. More commonly, one of the contestants is injured in the eye (resulting in either temporary or permanent blindness) or in the forelimb (a not infrequent result of which is lameness). Deaths are apparently rare, although Clutton-Brock and his colleagues speculate that at least one of the stags they observed may have died of an

infection resulting from a battle wound. Almost all stags in the population suffer at least one injury during the course of their breeding career, and between 20 and 30 percent sustain permanent damage as a consequence of rutting fights.

Meanwhile, far to the South, on the endless plains of East Africa, prides of lions keep watch over the abundant herds of ungulates that constitute their supply of food.[7] Within their social groups, lions do not seem to have a dominance hierarchy *per se,* either among the males or the females; but they do not lead conflict-free lives. In fact they not infrequently compete, pride against pride, for access to territory; and among the males, there is more than a little competition when it comes to copulatory privilege. Normally a male lion is expelled from his native pride when he reaches the age of three and is obliged thenceforth to lead a more or less solitary existence, away from the social group. In time, however, two or more outcast males may band together and utilize their numbers to challenge the holders of a pride for possession of its females. The take-over may occur peacefully, if the resident males are too old, or too few, to resist; but if resistance is indeed offered, a fight may ensue, during the course of which injuries are sometimes sustained, occasionally with fatal results. Not infrequently lions also have to cope with competition from other species, especially from the other carnivores that share their habitat. Although lions normally hunt as a group, during certain seasons a lone individual may stalk and kill an antelope on her own and then sit down to enjoy her meal. If she is not wary or stealthy enough, however, she may find her dinner interrupted by a pack of hungry hyenas that would just as soon claim the meat for themselves as allow the lioness to have her fill. If they can, they will chase her away and appropriate her dinner. Conversely, a pride of lions may aggressively chase off a group of hyenas and effect a turnabout appropriation. Jackals and African wild dogs also sometimes join in this free-for-all, with the winner taking all. Leopards, too, live and hunt in this same area, and they sometimes drag their quarry up into a tree so as to avoid such nagging competition on the savanna floor.

We are getting closer to home now, and as far as extant

species are concerned we could not get any closer than the common chimpanzee. For several decades now chimpanzees have been the subjects of intense field research, and Jane Goodall is by no means the only one who has been observing them. Dozens of researchers from many different countries have flocked to the forests of Central and Western Africa in a frenzied attempt to learn more about the social behavior and ecology of our closest living relative before it ceases to be living. Only fairly recently, however, has it become known to what extent the social life of chimpanzees is characterized by conflict and quarrel, as well as peace and playfulness. In the early days of chimpanzee research, these animals were often depicted as frolicsome, carefree apes, who lived in a kind of Rousseauian idyll, protected and comforted by a boundless and bountiful forest. And so indeed it seemed to be for the first dozen years or so of scientific inquiry into their habits. Throughout this period Rousseauian anthropologists were delighted to hear the news coming from Africa about this peaceful, serene anthropoid, for it confirmed their image of the primeval innocence of the great forest apes, the kind of which, many millions of years ago, might have given rise to our own lineage. As naturalistic studies of the chimpanzee wore on, however, through the 1970s and into the 1980s, and as their political machinations were scrutinized at such places as the Arnhem Zoo, a strikingly different picture of chimpanzee life gradually emerged. As a result of these continuing studies, it was eventually revealed, to the shock and dismay of many, that chimpanzee life, after all, is not nearly so innocent or serene as early observations had suggested.[8] By the late 1960s and early 1970s, a variety of conflicts in chimpanzee social life had been observed, and such observations only became more frequent as time went on. Eventually the social life of chimps was found to include, in addition to grooming, playing and sharing, such things as stealing, fighting, raping, and killing—not to mention more subtle forms of competition, conflict, and aggression. By now, chimpanzees are known to engage in dominance battles, unprovoked assaults, murder, infanticide, cannibalism, abduction, forced copulation, and even a kind of inter-tribal warfare. Not all these behaviors, I

hasten to point out, are frequent; some are quite rare. But others are routine, and when taken together their occurrence now makes it clear that the social existence of chimpanzees is no less riddled with competition and conflict than is the life of any other free-ranging species, and in some ways might even be more so.

I have already given some examples of dominance battles among chimpanzees, but many other kinds of aggression also take place. On at least a few occasions adult chimps have attacked, killed, and even eaten infants of their own species. There are some isolated incidents of 'rape', usually involving siblings or other relatives. And there are many other examples of chimpanzee conflict and violence. Sometimes adult males attempt to 'abduct' females and may bite or otherwise attack them if they resist or if they do not follow along to the male's satisfaction. On occasion chimpanzees hunt, and when a successful hunter sits down to enjoy his meal, he may be obliged to share his kill, willingly or unwillingly, with a bevy of hungry onlookers, many of whom actively beg or pester him for a morsel of meat. If the supplicant happens to be a close relative, or an unrelated female who might eventually offer sexual favors in return for a gift, the owner of the meat may give more or less willingly of his quarry. But often enough he refuses to share outright, or does so only reluctantly or begrudgingly, and he may aggressively chase away any and all supplicants. The latter, in turn, if they are less than fully dissuaded by the rebuff, may return and attempt to steal meat from the owner on the sly. And so it goes, and the thread of conflict weaves its way through the social fabric of the 'innocent' African anthropoid.

What is even more remarkable, and certainly more sensational, is the 'warfare' behavior of Gombe chimpanzees that was first documented by Jane Goodall in the mid-1970s.[9] Common chimpanzees, as Goodall eventually discovered, are highly territorial, and each group lays claim to its own plot of land, from which outsiders are almost always excluded. In contrast to some territorial species, moreover, chimpanzees are not always content merely to defend their own home area. On the contrary, a given group will, if it can, attempt to expand the

boundaries of its territory by aggressive incursions into adjacent ranges. The story of one such aggressive expansion, as Goodall has documented, began in the late 1960s, when two groups living in the Gombe area, known as the Kasakela and Kahama groups, shared a common home range. By the early 1970s, these two groups had split from each other, the Kasakela group taking up residence in the northern portion of what had been the common territory, and the Kahama group putting down stakes in the South. In time, however, the Kasakela group grew weary of its geographic restrictions and began to cross over the border into the range of the Kahama in what turned out to be a deliberate attempt at military expansion. Throughout much of the 1970s, groups of Kasakela males invaded the range of the Kahama and, whenever they came upon a resident chimp isolated from the rest of his group, viciously attacked and killed him. Using their hands, their feet, and their teeth, the Kasakela males ferociously assaulted their victim until his body lay bloodied and lifeless on the forest floor. Between 1973 and 1978, Kasakela 'warriors' killed six of the seven Kahama males, as well as its aging matriarch, in just such group attacks. They have since annihilated the entire Kahama population and usurped its former territory.

In some ways chimpanzees are, admittedly, an extreme case. I know of few species in which social conflicts are quite so obvious or so violent. In much of the animal kingdom competition often takes on a much more subtle form and at times is even quite imperceptible to the casual observer. Apparently nature is not quite as "red in tooth and claw" as Tennyson's famous aphorism suggests, nor is it quite the ruthless war of all against all that Thomas Hobbes imagined it to be. As Darwin noted in the *Origin of Species*, competition does not necessarily lead to head-on conflicts between individuals.[10] In many cases, each animal simply goes its own way in pursuit of essential resources, without ever coming into physical contact with its reproductive competitors. The fact remains, nonetheless, that reproductive competition almost always has adverse consequences of one sort or another, whether it involves overt aggressiveness or not. To be sure, the subtle forms of competition to which Darwin

referred are no less real for being subtle, and they are not necessarily any less devastating in their ultimate effect. As zoologist Robert M. May has recently pointed out, the apparent peacefulness of nature can be very deceptive:

> Many observers feel that competition cannot be of much impor-tance in real communities, because direct evidence of it—blood on the ground, as it were—is rarely seen. To this argument Diamond has replied with an analogy; the Hertz and Avis attendants, each with their distinctive species colors, are rarely seen locked in physical combat at airports, yet their indirect competition for car renters is nonetheless real.[11]

It may well be, as Darwin suggested, that the struggle for life does not necessarily involve physical combat. But as the analogy just cited clearly shows, competition does not have to be violent in order to have deleterious consequences. If an animal dies because its competitors have beaten it to the food, it is just as dead as if it had died in battle; and its demise is not less definitive for having been bloodless. Animal conflict, in sum, whether subtle or overt, is virtually universal, and is always harmful. Once again, with the possible exceptions of asexual clones and eusocial sisters (and human beings, it might be noted, are the furthest thing from being either asexual or eusocial), some amount of reproductive competition is known to occur in all animal societies. And, directly or indirectly, that competition causes some amount of suffering, injury, or hard-ship to the individuals involved.

Human Conflict: The Rousseaulan View

And what of human beings? Are we the lone exception to this otherwise universal rule? At first blush, it would certainly seem not. Our social life seems to be even more characterized by competitive struggle than is the social life of other animals. Conflict among lions and chimpanzees is impressive, but there is nothing in it that compares to a Second World War or a Spanish Inquisition. It can hardly be denied that there are some striking

parallels between animal conflict and our own. Human conflict is analogous to animal conflict in almost every important respect; and, like animal conflict, it almost always involves competition over important resources. Since all such competition has a common source, it is apparent that both human and animal conflict have their ultimate roots in the earliest stages of evolutionary history. Curiously, however, this is a conclusion which many scientists, especially in the fields of psychology and anthropology, have been reluctant to draw. Many have argued vehemently against it. According to these scientists, animal conflict is *not* in fact analogous to human conflict, does *not* have a common source, and is *not* traceable to evolutionary influences. On this view, conflict is not inherent in human life and need play no significant role in the daily affairs of men and women. Unlike other animals, so the argument goes, we humans are uniquely endowed with a degree of intelligent self-control and behavioral flexibility which allows us to overcome any and all conflicts which may arise among us. In human life, conflict situations need not occur; and when they do, they need not manifest themselves in the form of violence or aggression. By evolving behavioral flexibility and the capacity for interpersonal co-operation, we have, as it were, 'risen above' such animal imperatives. Why, then, is human life today so marred by violence and aggression? Why is conflict such a universal and apparently integral component of human society? The answer, according to most anthropologists, is that modern peoples have been subjected to the highly artificial conditions of agricultural and industrialized societies. It is only these artificial conditions that have corrupted man's peaceable nature and transformed him into the belligerent being that the record of history shows him to be. The ultimate root of human conflict, these scientists argue, is not evolution, but the invention of agriculture. If man could somehow be returned to his pristine existence as a tribal hunter-gatherer, then all conflict would cease, and human beings would forever live in a state of unencumbered peace and opulence.

Perhaps the best-known spokesperson for this point of view is the East African anthropologist Richard Leakey. Like many of

his colleagues, Leakey seems to be convinced that all human conflict has historic rather than prehistoric roots. In his best-selling book, *Origins* (co-authored by Roger Lewin), he argues that man is essentially a peaceful creature, and that the capacity for interpersonal co-operation is deeply imbedded in human nature. Why, then, is recent human history characterized by conflict as much as compassion? The answer, according to Leakey, "lies in the change in way of life from hunting and gathering to farming." The nomadic hunter-gatherer, Leakey insists, "is a part of the natural order; a farmer necessarily distorts that order. But more important, sedentary farming communities have the opportunity to accumulate possessions, and having done so they must protect them. This is the key to human conflict, and it is greatly exaggerated in the highly materialistic world in which we now live."[12]

As evidence to support this interpretation of the origin of human conflict, Leakeyan anthropologists often point to the actual ethnographic record of a few hand-picked preliterate societies, where life is supposedly peaceful and harmonious, and where outward signs of conflict are seemingly rare. Typically cited as examples of this kind of people are the !Kung San of the Kalahari, the Mbuti Pygmies of Zaire, the Tasaday of the Phillipines, the Tasmanians, the Eskimos, the Semai of Malaya, and a number of others. Supposedly these peoples live in complete freedom from the kinds of conflict and aggression that are such commonplace fixtures of modern society. Supposedly they do not kill, wage war, or engage in any of the kinds of aggressive interactions with which we are so familiar. Their lives, for the most part, are characterized by co-operation rather than conflict, and they have all developed effective strategies for dealing with the rare occurrence of interpersonal dispute, usually through peaceful means, and with a minimum of bloodshed.

Extrapolating backwards in time, it is next argued that prehistoric man was almost certainly a peaceful creature, since he too was a tribal hunter-gatherer. Indeed, Ashley Montagu has gone so far as to suggest that prehistoric hunter-gatherers *must* have been peaceful and co-operative, or they would never

have survived each other's onslaughts. According to Montagu, there is simply "no evidence whatever" that prehistoric men were in any way violent or aggressive. "Populations in prehistoric times," he writes, "would have been few and far between, and when they met it is no more likely that they greeted each other with hostility than do gatherer-hunter peoples."[13] Anthropologist Bernard Campbell has expressed a very similar point of view, suggesting that in the sparsely populated world of prehistory, there was plenty of room for everyone, and therefore no need for aggression or war. Conflicts between neighboring bands, he insists, "must have been rare and unplanned in an uncrowded world that offered few natural examples of creatures systematically setting upon their own kind. It appears likely that war, greed and cruelty were later developments. They probably came after humans settled down on the land, became a more numerous species, and forged cultures that encouraged individual and group pride in possessions, territories, and beliefs."[14] Aggression and war are today's problems, Campbell writes, and there is little reason to suppose that they played a significant role in the life of our prehistoric forebears.

What are we to make of this idea? Is it plausible? Or is it just another version of the Rousseauian myth of the Noble Savage? I don't know—perhaps Leakey and Montagu and Campbell are correct, but my own credulity has always been strained by their arguments, and it is more strained now than ever, in the light of recent ethnographic evidence, much of which (as we shall see) starkly challenges the Rousseauian image of the peaceful hunter-gatherer. To be sure, I do not doubt that Richard Leakey is right when he says that co-operativeness is deeply imbedded in human nature. Of course it is; otherwise we wouldn't be able to live in social groups at all, and such things as friendship, love, generosity, and kindness would be unknown. But it is one thing to suggest that humans are *basically* co-operative by nature, quite another to suggest that they are *wholly* so. It is one thing to say that in human social life there are *few* sources of interpersonal conflict, quite another to say that there are *none*. It is one thing to argue that *much* conflict in the modern world has its roots in agriculture, quite another to argue that *all* of it does. It

may well be, I suppose, that in prehistoric times every human being, without exception, was able to get everything he needed and wanted in life without ever facing the slightest opposition from any other human being. But this possibility is so highly improbable, so counter-intuitive, and so contrary to the experience of most contemporary humans that it must be met with more than a little skepticism. Consider for a moment just what Rousseauian anthropologists like the ones just cited are asking us to believe. Their argument, in effect, runs something like this. For millions of years there existed some conflict of interest within any species and between any two individuals who were in competition for access to scarce resources and whose reproductive interests were not identical. Suddenly, with the evolutionary emergence of humankind, nature did an abrupt about-face and liberated one species, and one species only, from this otherwise universal rule. Then, just as suddenly, that one privileged species, through its own inadvertent invention of agriculture, recreated all the forms of competition and conflict that had previously permeated the animal kingdom and in so doing brought upon itself all the suffering and hardship from which nature had so benevolently exempted it. To say the least, this is a far-fetched scenario, and being far-fetched, it would seem to require nothing short of the most overwhelming buttress of supportive evidence to be rendered plausible. But in fact the supportive evidence is anything but overwhelming.

Conflict and Prehistoric Humans

Did prehistoric men fight one another? Did they compete for land, resources, and women? Did they wage war? Were they always able to get everything they needed and wanted without interpersonal conflict of any kind? No one can say for sure, because no one can go back in time to observe the behavior of prehistoric peoples and then return to the present to tell the rest of us what happened. Thus there is no way to prove just how our ancestors behaved or to what extent, if any, conflict played a role in their social life. Nevertheless, as we have just seen, some

anthropologists are apparently convinced, even without conclusive proof, that there was virtually no conflict in prehistory, and little reason to suspect that there might have been. Their views rest primarily on three assumptions: first, that there is no physical evidence of aggression of war during the prehistoric era; second, that in prehistory there was plenty of land for everyone and therefore no need to compete over it or fight for it; and third, that contemporary hunter-gatherers lead essentially conflict-free lives (and that, by extrapolation, prehistoric hunter-gatherers must have done the same). But is any of these things really true? Let us consider each in turn. Is it really true, as Ashley Montagu for example has suggested, that there is no evidence for prehistoric conflict or aggression? It depends on what he means by 'evidence'. If by this it is meant written documents, eyewitness accounts, photographs, television documentaries, and fossilized tanks and machine guns, then obviously there is no physical evidence of violence in prehistory. By definition, there are no historical documents from the prehistoric era and no 'weapons' in the modern sense. On the other hand, if we accept the argument that there is no physical evidence of prehistoric aggression, because there are no written records of war and no fossilized weapons of mass destruction, then by the same token there is no physical evidence of prehistoric peace either, and on the basis of archaeological evidence alone one cannot argue definitively one way or the other. Historical evidence, of course, is much more abundant, and much less equivocal. It is a well-documented fact that humans have shown some degree of aggressive behavior, and often quite a lot of it (not to mention the more subtle forms of interpersonal competition and conflict), throughout the historic era. And on the basis of this evidence, together with the evidence of conflict among nonhuman animals, it is by no means unreasonable to extrapolate that at least some degree of conflict characterized the lives of prehistoric humans. It is, as I have stated, far-fetched to suggest otherwise. For these and other reasons, it is not surprising that the traditional anthropological view of two million years of uninterrupted prehistoric peace has never gone unchallenged; and in recent decades it has been assailed with

increasing frequency in the scientific literature. One of many writers who has taken issue with the Rousseauian conception of prehistoric man, and who has advanced arguments similar to those put forth here, is evolutionary biologist Richard D. Alexander. In many of his writings, for example in his 1979 book *Darwinism and Human Affairs,* Alexander poses formidable challenges to the contention that there is 'no evidence whatever' for aggression and violence among prehistoric men. In sharp contrast to Ashley Montagu, Alexander insists that there is actually a good deal of evidence to support the notion of aggressive behavior in prehistoric times.[15] And while he admits that almost all such evidence is equivocal, and therefore debatable, it is nonetheless impressive. His arguments, at least, are worth considering.

As Alexander sees it, there are essentially two kinds of evidence that bear on the question of prehistoric conflict. One kind is physical evidence of aggression, such as spear points, arrowheads, and stone axes, all of which were apparently used with considerable frequency by our prehistoric ancestors. To this category one must also include such things as crushed skulls and other indications of warfare and cannibalism. Unfortunately, Alexander notes, none of this evidence is unequivocal. The weapons, after all, could have been used for hunting rather than waging war, and the skulls could have been crushed by predators or damaged after death. Furthermore, even if we assume that the skulls were indeed crushed by cannibals, this is not necessarily an indication of foul play. In fact many contemporary hunter-gatherers practice cannibalism as a ritual, and their behavior is not necessarily tied to warfare or aggression. Thus the presence of weapon-like instruments and damaged skulls at prehistoric sites does not in itself constitute proof of violent behavior. On the other hand, Alexander notes, even if we assume that our prehistoric ancestors were more or less continuously warlike, they would not necessarily have left any more physical evidence than what is in fact available. Even the most violent behavior and aggression do not always leave a record for archaeologists to trace. If there were no written records, Alexander asks, how could we possibly know, or what evidence

would there be to inform us, about what happened to the Tasmanians and the Tierra del Fuegians, both of whom were annihilated by European invaders? "Without written records," Alexander asks, "could we have been unequivocal thousands of years later about what the invading Europeans did to the Native Americans on both continents of the New World?" Or consider the most obvious cases of genocide in recent history. Could we be sure, in the absence of historical documents, that the atrocities committed in the twentieth century at Buchenwald and Auschwitz, and in Nigeria and Cambodia, would be properly interpreted by our descendants a million years hence? Yet more people may have been murdered in these places than existed in all the time prior to the dawn of history. "Such questions," Alexander insists, "cast doubt on the interpretation that equivocal evidence of human aggression, not to say the milder yet potentially continual and crucial forms of intergroup competition, must automatically be discarded."[16]

The second kind of evidence bearing on this matter comes from interpreting recent history and the behavior of modern humans. It is an undeniable fact, Alexander writes, that most of human history has been marred by the more or less frequent occurrence of war and murder, not to mention the countless other forms of violent and nonviolent conflict. Just what right do we have to assume, in the absence of conclusive evidence to the contrary (and there is no conclusive evidence to the contrary), that the life of prehistoric man was any less replete with conflict and aggression? Alexander insists that no such assumption is justified:

> . . . the facts of history. . . . are evidence, in my opinion, that when extrapolating into earlier times known only through fossil evidence, we cannot properly assume that humans were socially different then. I do not believe the burden of proof is upon those of us who see humans as evolving while behaving more or less as they do today. It is the other way around, and mere absence of unequivocal paleontological and archaeological evidence of aggressiveness and competition is not sufficient to suggest that these things did not occur; indeed, it is proper to demand instead that the evidence of no aggression be unequivocal, and it

is not. In my opinion, even equivocal evidence of aggression, when coupled with the events of recorded history, supports the argument that competition and aggression have indeed been powerful factors throughout human evolution.[17]

Alexander, it should be noted, is by no means alone in having come to this conclusion. In recent years many other scientists have expressed a similar point of view and adduced similar evidence. No one has argued more persuasively for this view than Robert Bigelow of the University of Canterbury, New Zealand. In a series of writings beginning in the late 1960s, Bigelow has put forth ideas on this matter that are very similar to those of Alexander. Bigelow recognizes the equivocal nature of much of the fossil evidence bearing on the question of prehistoric violence, but he suggests that such evidence should not be taken lightly simply because it is contestable. According to Bigelow, it would be extremely difficult to prove that hand-axes, spears, and arrows were *not* used for warfare as well as hunting, but those who take prehistoric peace for granted generally ignore this difficulty, or they attempt to circumvent it by demanding unequivocal proof that prehistoric weapons *were* used against other humans. According to Bigelow, no available evidence can prove prehistoric violence absolutely, but much of it strongly suggests that early humans did indeed kill one another. The prevalence of intrahuman violence during the Pleistocene can hardly be considered to have been disproven. Writes Bigelow, "The issue here is not whether claims of violence can be either proved or disproved unequivocally. Such disputes are a diversion from the fact that specialist opinion is divided, and hence that prehistoric *nonviolence* cannot be taken for granted as a well-established fact."[18]

Bigelow goes on to suggest that there is, in addition to the fossil evidence, a good deal of circumstantial evidence to indicate that prehistoric competition and warfare may have been fairly common. Consider for example the case of Neanderthal man, a sub-species of *Homo sapiens* that flourished between 100,000 and 35,000 years ago, and then vanished. What happened to the Neanderthals? One suggestion is that they were ancestral to modern man, having evolved into contempo-

rary humans over the course of several hundred generations. Another possibility is that the Neanderthals interbred with another sub-species of *Homo sapiens* that was living at the same time, and that some of the former's genes still survive in human populations today. A third possibility is that the Neanderthals simply became extinct because of competition from that other sub-species of *Homo sapiens*. If this last hypothesis is true (and much recent evidence strongly suggests that it is), then it is almost certainly the case that the Neanderthals and their *Homo sapiens* cousins came into competition with one another at least from time to time during the period of their co-existence. But the traditional view among anthropologists has always been that this competition, if it occurred at all, did not involve armed aggression or warfare. Rather it is simply assumed that the other *Homo sapiens* must have 'got the game first'. But as Bigelow argues, this is an unrealistic assumption because it implies that Neanderthal man starved peacefully while modern man ate his food. Is it not more likely that the Neanderthals at the very least made an attempt to survive by challenging their competitors? There are very few animals today that prefer starvation to aggression, and there is little reason to suspect that the Neanderthals were any different. Furthermore, if *Homo sapiens* was on occasion forced to defend his means of survival from hostile Neanderthals, then what was to prevent him from fighting competitors of his own sub-species? In the absence of conclusive proof to the contrary, Bigelow suggests, it is reasonable to suppose that he in fact did.[19]

But why should there have been any competition at all between Neanderthals and *Homo sapiens*, or between some *Homo sapiens* and other *Homo sapiens*? In the sparsely populated world of prehistory, wasn't there enough room, and therefore enough game, for everyone, as writers like Ashley Montagu and Bernard Campbell have suggested? The answer, it would seem, is: not necessarily. Bigelow explains:

> It is often assumed that prehistoric human groups were widely dispersed and only rarely met one another. This was very likely so, in a relative sense. People who live in teeming cities naturally

regard a few million people scattered over much of Africa and Eurasia as very widely dispersed. But we cannot assume that prehistoric human groups were always *evenly* dispersed. Flies congregate around decaying carcasses and other rich concentrations of food. Our hominid ancestors were more intelligent than flies and were able to perceive that some areas were more amenable than others to their way of life. They were surely intelligent enough to avoid deserts and mountaintops in favor of rich grasslands teeming with herds of game. Had there been no intergroup competition, one would expect fertile areas to have been very densely populated while more inhospitable regions were virtually uninhabited. It is unlikely that intelligent human groups would have left fertile areas voluntarily in order to take up permanent residence in deserts. It is most unlikely that they would have starved peacefully while the other groups were 'getting the game first'. If they were at all like modern humans, strong persuasion would have been required in order to induce them to leave a land of milk and honey for a wilderness. . . . It is therefore unreasonable to assert that early humans did *not* compete, group against group, for the most desirable territory.[20]

This conclusion is borne out by an examination of territorial behavior among both nonhuman animals and contemporary humans. Naturalistic studies conducted throughout the twentieth century have confirmed the existence of territorial behavior in hundreds of species and in a variety of classes. Throughout the animal world individuals, and sometimes groups, stake out a home turf and defend it against intruders. Territoriality differs somewhat in form from species to species and in the degree to which aggression is needed to stave off hostile incursions. But overcrowding is by no means a prerequisite to territorial competition. In fact some territorial species are quite sparse in their population, but this does not seem to dissuade them from establishing an exclusive domain. Lions, for example, are certainly not numerous; there are fewer of them in all of Africa than there are human beings in a single African city. And yet they are very territorial in their habits and sometimes engage in aggressive competition over the most fertile hunting grounds. A single pride of lions may require as much as a hundred square

kilometers to ensure itself a reliable source of meat and will not hesitate to chase off competitors which intrude upon their territory.[21] Similarly, chimpanzees are by no means numerous or overcrowded; on the contrary, there are so few of them left today that they stand in danger of imminent extinction. And yet the social life of these animals is certainly not without conflict, and territories are very much coveted and defended. There is at least one documented case, mentioned earlier, of a chimpanzee group invading the territory of another and annihilating its inhabitants. Examples such as these cast serious doubt on the argument that, during prehistory, there must have been plenty of room for everybody and therefore no incentive for territorial competition. The evidence of human behavior in historical times also poses a challenge to the assumption that density of population is a prerequisite to territorial violence. As I shall show, it is not the case that contemporary hunter-gatherer peoples invariably lack territories; and there is some historical evidence that aboriginal peoples in many parts of the world engaged in territorial disputes on a more or less regular basis before they were overwhelmed and subjugated by more technologically advanced peoples. Both of the pre-Columbian Americas, for example, were very sparsely populated, by contemporary standards, and yet warfare among rival tribes was fairly common. Even today, there is enough land in North America so that, were it evenly distributed among current residents, every individual could have several dozen acres to himself. Yet disputes over land and other property are amazingly frequent.

Even if it could be shown that there was absolutely no competition over land during the entire course of human prehistory, this does not necessarily rule out the possibility of competition over other important resources. Even among animals that are not territorial, there is often competition for the best food, the best sleeping sites, the best mates, the highest social status, and so forth. Similarly, among contemporary human beings, even when there is an absence of overt territoriality, there is typically competition for the best jobs, the most

money, the best mates, the highest social status, and so on. In the absence of any definitive proof to the contrary, it is reasonable to assume that our prehistoric ancestors behaved in an essentially similar manner.

There is, finally, an entirely different kind of evidence—this one highly circumstantial, but in many ways also highly compelling—that strongly suggests that competition and conflict were in fact very much a part of the social life of our ancestors throughout the formative stages of the evolution of the human psyche. And it has to do with the various kinds of emotions that we humans today are capable of experiencing. As many anthropologists have pointed out, human emotions such as love, compassion, and sympathy are basic to human nature and, under certain circumstances, can be readily evoked. As such it must be the case, they argue, that co-operation and sympathy were key elements in human social life throughout evolution, or else emotions such as love and compassion would never have evolved. I tend to agree, but by the same token such emotions as hatred, envy, and spite are also basic to human nature and, under certain circumstances, can be just as easily evoked. The existence of the biological capacity for emotions such as these strongly implies that competition was also very much a part of human social life throughout prehistory. In a social existence that is completely devoid of conflict, after all, hatred and envy would have no purpose and as such would never have evolved. Perhaps the abnormal and overcrowded conditions of modern life cause such emotions to be evoked somewhat more readily than they might have been in the small social groups of prehistoric times. But had they not possessed at least some utility, even in those times, then their biological basis would never have emerged in the first place. Of course whether emotions like hatred and jealousy ought to be encouraged is quite another thing; and I do not advocate their proliferation any more than I advocate the proliferation of cystic fibrosis, however biologically based it may be. But the very existence of such emotions, and their basis in human nature, strongly suggests an evolutionary past that was at least in part characterized by conflict of interest and competitive struggle.

Conflict Among Hunter-Gatherers

We come at last to the argument that contemporary hunter-gatherers represent a better model than we of how prehistoric humans must have lived, that hunter-gatherers are invariably peaceful, and that therefore our prehistoric forebears must also have been peaceful. Is it really true that today's hunter-gatherers live in much the same way that our prehistoric ancestors did? And is it true that hunter-gatherers are invariably peaceful and non-competitive? Apparently some anthropologists still think so. But as the years have gone by, more and more evidence continues to suggest otherwise. And more and more ethnographic data now challenge Rousseauian assumptions about the nature of preliterate life. Consider first the argument that prehistoric hunter-gatherers must have lived pretty much the way their modern counterparts do. The validity of this argument has frequently been called into question by experts from a number of fields, including Robert Bigelow.[22] As Bigelow sees it, there are actually quite a few differences between today's hunter-gatherers and prehistoric hunter-gatherers, including differences in relative standard of living and freedom of mobility. Modern hunter-gatherers, Bigelow suggests, survive only in the most impoverished habitats because all the better land has long since been usurped by other peoples. The San (Bushmen) tribesmen of the Kalahari desert, for example, once lived on richer land, but they were forced from their ancestral habitat by invading Europeans from the North and Bantu peoples from the South. In similar fashion American Indians, Australian Aborigines, and many other peoples were forcefully driven from lands that Europeans coveted. Even today hunter-gatherers survive only in those areas that are so devoid of arable land that the surrounding technological peoples have been unable to find any use for them. In short, contemporary hunter-gatherers are restricted by force or the threat of force to the habitats where they now exist. But the situation during prehistoric times was very different. Then there were no armed guards standing watch over the more fertile lands. Humans were free to roam wherever they chose, and to hunt wherever the hunting was good, provided they were

not driven away by other humans. Certainly they were intelligent enough to recognize good land when they saw it, and human enough to covet it when they didn't yet possess it. It is therefore unrealistic to assume that they did not compete, group against group, for access to the most desirable territory.

Even among modern hunter-gatherers who are surrounded by the threat of force from more advanced technologies, life is not always as peaceful or as harmonious as is sometimes assumed. In fact several recent studies suggest that warfare and aggression may be as common among hunter-gatherers as they are among other peoples. According to Carol Ember, who has conducted a worldwide survey of contemporary hunter-gatherers, it is simply a myth that these peoples are typically peaceful and noncompetitive. In her report, which was published in the journal *Ethnology* in 1978, Ember presents evidence to suggest that 90 percent of hunter-gatherer societies engage in aggressive behavior almost as frequently as do other kinds of people. Most hunter-gatherers, she notes, have engaged in warfare at least once every two years—a frequency that is not significantly different from the percentage in the rest of the world. She concludes that aggressive behavior tends to vary as the need for it, or the possibility of gaining by it, vary, and that this holds true as much for hunter-gatherers as it does for other peoples.

The German ethologist, Irenäus Eibl-Eibesfeldt has conducted similar surveys and derived essentially the same conclusion. In 1974, Eibl-Eibesfeldt published a curt but provocative article entitled 'The Myth of the Aggression-Free Hunter and Gatherer Society'. In it he presents evidence to indicate that hunter-gatherers are not necessarily any less inclined to conflict and aggression than we are. His conclusions are based largely on previously published studies of Eskimo behavior[23] and on his own observations of life among the !Ko San (Bushmen). On the basis of this and other evidence, he argues that the Rousseauian conception of hunter-gatherers simply does not hold up to critical examination. According to Eibl-Eibesfeldt, the reputedly peaceful Eskimos actually perform a variety of aggressive acts, including an occasional murder. (Indeed, many ethno-

graphic studies indicate that murder among Eskimos may actually be fairly frequent, at least in certain tribes and at certain times. Among the !Ko San, for example, Eibl-Eibesfeldt found that aggressive behavior patterns are "identical in form with those observed by people of other cultures in the same context." Among !Ko children, for example, one finds interpersonal squabbles and quarrels that are virtually the same as those that occur in our own society. On occasion !Ko children even attack one another for no apparent reason. Eibl-Eibesfeldt concludes that "the much-quoted cross-cultural 'evidence' for man's primarily peaceful and non-aggressive nature proves on examination to be a weak point in the environmentalists' argument. Among others, the oft-mentioned Bushmen certainly do not lack territories nor do they fail to be aggressive."[24] These conclusions, as I have noted, were published in 1974. Since then Eibl-Eibesfeldt has conducted an even more comprehensive survey of competitive behavior among hunter-gatherers, and in his 1989 book, *Human Ethology*, has reiterated his earlier conclusion that "the picture of the aggression-free, non-territorial primeval society is a myth. A survey of the ethnological literature leaves one surprised that the theory of the peaceful hunter/gatherer was ever seriously entertained, since it is not supported by data."[25]

In short, the life of hunter-gatherers is no more devoid of conflict than is our own. A careful study of the available literature reveals that no primitive society is unequivocally harmonious and peaceful. Even some anthropologists readily admit as much. According to Marvin Harris, "Every human society . . . no matter how simple the technology and sparse the population, has its share of interpersonal strife, aggression, and crime."[26] Everything that we would normally classify as violent behavior, including murder and rape, Harris concedes, has been known to occur even in the smallest and simplest hunting-and-gathering societies. Perhaps there is still some justification for the contention that there exists, or once existed, a human society in which there was no competition, no conflict of interest, and no frustration of personal desires. But I see no evidence to support such a notion.

Peace, Conflict, and the Suppression of Conflict

In some anthropological writings there is a tendency to equate aggression with conflict and to assume that, where there is little or no aggression there is little or no conflict. Supposedly peaceful behavior and conflict of interest are mutually incompatible, and the kind of overt co-operativeness that sometimes obtains among primitive peoples is taken as *prima facie* proof that conflict plays no significant role in their daily lives. A few ethnographers have gone so far as to suggest that there is essentially no reason for conflict to occur among such peoples. Morton Fried, for example, has suggested that quarrels among primitives are rare because such people have little to quarrel about, when they have few material possessions, lead much the same kind of life, and enjoy essentially the same status in society. Disputes seldom occur because the people have little incentive to transgress accepted standards.[27] Under such conditions, it is argued, man's 'natural' inclination to co-operate with his fellows is given almost automatic expression; and there is no reason to suppose that any sort of conflict simmers at a deeper level.

Or isn't there? At least one anthropologist, namely Elizabeth Colson, has not been fooled by outward appearances. In her review of law and order among primitive peoples Colson argues that, in relatively peaceful societies, violence is rare not so much because there is no motivation to initiate it, but rather because the possible adverse consequences of such behavior outweigh the possible benefits. In no society, she reports, are people allowed to give unrestrained expression to their basic urges. Even where there is an absence of formalized law or other overt form of external control, people realize that they cannot afford to act out spontaneous emotions without fear of retribution. No anthropologist has ever studied a society that did not have at its disposal at least some system of social sanctions against individuals who are too independent about taking care of their own needs. "We may be free to negotiate with our fellows about a great many things," writes Colson, "but one thing we are not free to negotiate is freedom to do as we will."[28] Colson maintains that where primitives live within

the confines of social custom, they do so more because they are afraid of the consequences of breaking the 'rules' than because they lack reason for conflict. Even those people who present themselves to the world as truculent warriors and fighters live with this fear of violence and they do their best to restrain behavior that leads to armed conflict with their neighbors.

Colson also takes issue with the view that hunting-and-gathering peoples attach little value to their personal possessions, or that they willingly share those possessions with their fellows. On the contrary, she suggests that sharing, where it occurs, is motivated more by a sense of 'duty' than any feelings of altruism:

> It is almost certainly false to assume, as . . . Fried apparently does, that people who have few possessions are inclined to place little value on what they have or that they give willingly simply because they give graciously. My own reading of ethnography, and my own experience in a number of American Indian and African societies whose members would be regarded as having had little in the way of material wealth, suggests rather that property is valued, that people are very much aware that possessions give rise to envy, and that they are fearful of the consequences of envy. They feel themselves constrained to share or to barter their possessions for what they regard as more essential: amicable relationships which ensure their personal safety. They give because they must, but by giving graciously they hope to obtain some benefit from the act. This seems a better explanation than either benevolence or a lack of attachment to possessions for the common practice of pressing an article upon the one who admires it. On the Makah Reservation in the early 1940s, I heard women complain because they had been forced to part with prized possessions because someone had pressured them with admiring comments. They did not want to give, but they gave because they felt they must.[29]

Apparently then, neither peace nor overt generosity poses a serious threat to the notion that human beings are, at least in part, self-interested by nature and that their interests sometimes conflict. Anthropologists should not be too quick to assume that interpersonal conflict does not exist simply be-

cause, among certain peoples and at certain times, there is little outward expression of it. As Colson has emphasized, appearances can be deceiving, and a lack of overt aggression does not necessarily indicate a lack of conflict: "Anthropologists have a liking for paradoxes and it should therefore be no surprise to us if some people live in what appears to be a Rousseauian paradise because they take a Hobbesian view of their situation: they walk softly because they believe it necessary not to offend others whom they regard as dangerous."[30] Contemporary hunting-and-gathering peoples do not live in a state of unrestrained freedom, indulging their biological urges whenever they feel the need. Powerful taboos are commonplace in preliterate society, and harsh penalties are often imposed on violators. The existence of such taboos among all peoples implies the existence of natural inclinations to violate them, and therefore a conflict between the interests of the individual and those of the collective members of the society to which he belongs. If there were no such thing as interpersonal conflict of interest in human society, then every individual would be free to pursue his own interests in completely unrestrained fashion, without fear of transgressing upon the rights of others; and there would be no need for rules, regulations, etiquette, ethics, law, or systems of justice. The fact that things such as these exist in all known human societies strongly suggests that interpersonal conflict, too, is pan-human.

Biology, Behavioral Flexibility, and Conflict

The idea has sometimes been put forth, as we have seen, that conflict is less inherent in human life than in animal life. The argument that lies behind this suggestion, as we have also seen, runs something like this. Animals may be 'driven' by biological imperatives, but humans are not. Because their behavior is instinctively programmed, animals cannot help but behave as they do; and so they cannot help but be uncooperative or aggressive whenever their genetic instructions propel them in such a direction. But humans are different:

unlike the behavior of other animals, our behavior is not driven by instinct and is therefore not 'biological'. By evolving the capacity for behavioral flexibility and intelligent self-control, we have 'overcome' interpersonal conflict and 'risen above' animal imperatives. But is this argument really valid? If it were, then we would perhaps expect the simplest organisms, those whose behavior is most intractably controlled by instinct, to exhibit the greatest amount of competition and conflict, while the so-called 'higher' animals, those that have evolved the greatest degree of intelligence and behavioral plasticity, would show the least. But this expectation is not borne out by an examination of competition as it occurs in animal and human society. On the contrary, if anything, it is the behavior of the so-called 'higher' animals which seems to show even more competition, more conflict, and more aggression. Chimpanzees, for example, are among the most intelligent and most flexible animals that have ever evolved; and yet, as we have seen, their social life is far from one of unmitigated co-operation and harmony. And the social life of *Homo sapiens* betrays, if anything, more interpersonal conflict, not less, than is to be found among most, perhaps all, animals. How can it be seriously maintained, then, that we are biologically less inclined toward competition and conflict? From my point of view, I don't think it can. In fact I would put forth precisely the opposite suggestion.

In the final section of the preceding chapter, I suggested that human beings, as a consequence of their peculiar evolutionary history, have inherited more, not fewer, biological needs than other species, and that it is therefore more difficult, not less difficult, for them to satisfy their needs. It is precisely for this reason that human beings are more likely, not less likely, to come into competition with one another as they seek to fulfill their biological requirements. It is all very well to argue that humans have been liberated from interpersonal conflict through the evolution of behavioral flexibility and intelligent self-control, but it must be remembered that this same evolutionary trend, the trend toward greater and greater intelligence and therefore more and more conscious awareness, has created in us

humans an entirely new array of biological needs. And it is precisely these new needs which, when coupled with the old ones, make us the most necessitous of all animals and which ultimately ensure that human conflict will actually be more frequent and more severe, and not less so, than anything that occurs in the nonhuman world.

We humans, to be sure, have acquired a greater capacity than any other animals to suppress our natural inclinations and to restrain our aggressive impulses. But this capacity has at least as many negative as positive implications. The advantage of our intelligent self-control is that it allows us to suppress our self-seeking impulses and thus to avoid violent confrontation with our fellows; but the disadvantage is that it obliges us to suffer the frustration of thwarted desires that tends to result whenever we choose this option. If I desire something from another person, and she does not wish to give it to me, I am not obliged by my genes to take it by force. But if I suppress the desire, I may suffer as much frustration and disappointment as my adversary would have suffered injury had I taken from her the desired object without her consent. In either case, with or without aggression, one of us suffers. My evolved capacity for intelligent self-control, in other words, may be of some benefit to her, and to others, but in some ways at least it is of equal detiment to me. And, ironically, if I had never evolved so much intelligence and conscious awareness in the first place, and therefore so many biological needs, I might never have desired the object to begin with.

The evolution of human intelligence has brought with it many unique capacities; but, as we have seen, not all those capacities are entirely salutary. Perhaps, as some anthropologists so fervently argue, man has evolved a greater capacity than any other animal to suppress his aggressive impulses, but so too has he evolved a greater capacity to suffer the emotional distress that such suppression often implies. In the process of human intellectual evolution conflict has not been conquered—it has merely acquired a new form. In one way or another, it still exercises its nefarious influence; and it still takes its toll on human survival and welfare.

Are Humans Evil?

Are human beings aggressive by nature? Are they innately depraved? Or is social evil entirely the product of learning and experience? Perhaps one of the reasons that professional scholars have had such a hard time trying to answer these questions is that they are the wrong questions. For the truth is that social evil results neither from innate depravity nor from improper learning; it results from the clash between the innate needs and desires of one individual and those of his fellows. It is conflict of interest, in other words, rather than aggressiveness *per se* that is the root cause of our social unrest. This, of course, is not a novel point of view; and in recent years more and more scientists have put it forth, often to the dismay of those who insist that genetic factors must not be blamed for anything. But there are many advantages to this way of looking at things, and one of them is that it makes it possible to account for social evil without having to assume that it is all a matter of 'environment', and without having to attack or condemn the human spirit. It is possible to believe, in other words, that evil is inherent in human nature without necessarily believing that humans are inherently evil by nature. Human beings may not be innately depraved, but they do seem to have been endowed by evolution with a host of needs and desires, such that it is often difficult, at times impossible, for one person to pursue his needs and desires without coming into conflict with other people.

Perhaps, despite this disclaimer, some readers will feel degraded or insulted by the general tone of my argument. I see no reason why they should be. On the contrary, I see nothing at all degrading in the proposition that the innate needs and desires of one human are not entirely confluent with those of all other humans. And I see nothing cynical or insulting in the question whether any one person might be innately predisposed to behave in ways that are not entirely consistent with the needs and wants of every other human being. And I certainly do not blame humans for this being so. I blame nature, and more specifically the process of evolution by natural selection. Human beings, after all, are not the authors of the evolutionary process; they are its products. And they are no more ultimately

responsible for how it works, or what behavioral inclinations it has favored or disfavored, than they are responsible for the inherent defects in the design of the human skeletal system. Ultimately, any indictment of human nature is an indictment of nature, not of humans. And it is in this spirit, rather than in one of misanthropy, that the present indictment is intended.

Some scientists have recently advanced the view, as we have seen, that humans are almost *wholly* co-operative by nature, and that it is only corrupt cultures, arbitrarily established, that promote competition and conflict. But in my view this position is untenable; for in the complex interplay of human social life, any action that helps one individual or group almost always hurts some other, so that complete co-operation is a practical impossibility. Indeed, there is no social behavior or ideal, be it abortion, contraception, pornography, prostitution, homosexuality, drug use, free speech, gun control, animal rights, capitalism, socialism, feminism, trade unionism, and all the other 'isms,' that is not approved by some and opposed by others, so that it is impossible to co-operate with everybody all the time. Human beings, of course, have an amazing ability (perhaps even a profound need) to regard themselves as kind, decent, and sharing; so that is precisely what they do, even when their behavior is blatantly unco-operative or even openly hostile. And so they fight with religious zeal against their ideological and military adversaries and all the while continue to look upon themselves as completely pacific and compassionate creatures. For after all, it is the other side that is in the wrong and that must be crushed if 'justice' is to be attained. I would venture to suggest that throughout human history, more people have been slaughtered by the advocates of fellowship and brotherhood than have ever fallen victim to the wantonly malicious. During the Thirty Years War, the Crusades, the Inquisition, and the European conquest of the Americas, for example, millions of people were slain in the name of the 'Prince of Peace'. And not so very long ago, a Soviet leader named Josef Stalin, in his fervor to create a conflict-free society, murdered a greater number of human beings than historians have been able to calculate. Some people, it would seem, are so committed to the ideal of

universal brotherhood that they will go to any lengths, includ-ing mass murder, to stamp out all opposition to their militant pacifism. There is, unfortunately, no end to the evils that men will do once they have become convinced that all interpersonal conflict is eradicable, and that complete co-operativeness is the essence of human nature.

Chapter Eight
Sex and Violence: The Evolutionary Origins of the War between Men and Women

> *What I shall try to show, without carping, will be that there is a very good reason why the erotic side of Man has called forth so much more discussion lately than his appetite for food. The reason is this: that while the urge to eat is a personal matter which concerns no one but the person hungry (or as the German has it, der hungrig Mensch), the sex urge involves, for its true expression, another individual. It is this "other individual" that causes all the trouble.*
>
> E.B. WHITE

Anyone who has ever experienced a sexual desire knows that sexual desires can be difficult, at times impossible, to satisfy. Men in particular know how hard it can be to raise their sexual accomplishments to the level of their desires or to lower their sexual desires to the level of their accomplishments. In the male psyche, sexual craving tends to arise spontaneously, with or without external provocation, and without reference to perceived opportunity. To the man with lust on his mind, there are any number of potential impediments which may stand in the way of sexual gratification, not the least of which is the unavailability of a willing partner. The desirous female, on the other hand, is much more likely to get sex when she wants it, but not necessarily with the emotional commitment or intimacy that she would like to go along with it. And, unlike her male

counterpart, she may have to cope with superfluous sexual advances that she would just as soon live without. That both men and women often experience considerable difficulty in establishing the kind of sex life that they would like is no secret to anybody, either male or female. Both sexes seem to be aware of the disparity between what each sex wants and what the other is willing to give. Both seem to know that their specific sexual desires often conflict, resulting in some degree of compromise or sacrifice on the part of at least one, usually both sexes. In every known human society, sexual conflicts continually manifest themselves in the form of sexual frustration, male-male competition, deception, mutual distrust, sexual harrassment, exploitation, prostitution, and rape.

What, then, is the ultimate source of all this conflict? Why should there be such a huge disparity between the sexual desires and inclinations of one sex and those of the other? One possibility, of course, is that it is all a matter of learning; and this is what a great many social scientists believe. Pick up any recent textbook on human sexuality written by a sociologist or a psychologist, and somewhere in its pages you are likely to find the proposition that human sexual conflicts as we know them are almost entirely the product of social indoctrination. According to these authors, sexual desires and emotions are learned, not inherited. Men and women think and feel differently because they are taught to think and feel differently. And whatever disparity may exist between male and female sexual inclinations is completely explicable in terms of differences in the way the two sexes are brought up. Sexual conflict, in sum, is completely devoid of biological basis; and the war between the sexes is nothing more than an accident of history—one which need never have occurred and which need not continue. With the proper training, so it is claimed, men might easily learn to acquire a taste for the kinds of sex that women now crave, or *vice versa*. If we wish to understand why sexual conflicts exist at all, we need study neither human history nor prehistory, but need only examine the cultural mores and expectations that prevail in our own contemporary societies.

This, I suppose, is a perfectly plausible idea—when it is

considered in isolation from what we otherwise know about nature's general lack of concern for human welfare. But as soon as nature's record is taken into account, the idea immediately loses most of its plausibility. The whole notion suffers from the same weakness that is inherent in the point of view of the Rousseauian anthropologists discussed in the previous chapter, according to whom nature really is benevolent, and interpersonal conflicts are nothing more than the products of human stupidity. Consider this: because sexual conflicts are widespread in the animal kingdom (as we shall see), it is virtually certain that among our prehuman ancestors, sexual conflicts of various kinds were very much a part of social life. And it is highly probable that such conflicts took on pretty much the same form as they do among contemporary nonhuman mammals. Are we to believe, then, that at some point in human prehistory all male-female differences in sexuality were eradicated, and that human sexual conflicts as we now know them are wholly the products of social and cultural conditioning by which man has inadvertently and unwittingly created anew the full panoply of sexual conflicts which for so long had permeated mammalian life? Are we to believe that the same Nature that regularly visits upon humankind such disasters as tornadoes, hurricanes, tidal waves, floods, earthquakes, fires, famines, diseases, and thousands of other hardships and calamities has, so to speak, 'gone out of its way' to ensure that the sexual proclivities of men and women are so completely complementary to each other and so mutually compatible that no human being need ever be deprived of a sexual opportunity which he or she desires or ever forced to engage in a sexual act which he or she does not desire? I am skeptical. The whole idea is so improbable that it calls for nothing short of the most overwhelming evidence to be rendered plausible. And yet the evidence in its support is anything but overwhelming, and there is a great deal that argues strongly against it. Much scientific evidence now suggests that the influence of the social environment in shaping human sexual desire is far less decisive than is sometimes assumed, and this evidence is of essentially four sorts. First, there is the comparative/evolutionary evidence,

almost all of which suggests that humans may be typically mammalian, and therefore basically polygynous, in their sexual proclivities. Second, there is the cross-cultural and historical evidence, much of which suggests that, despite considerable local and temporal variation in overt sexual behavior, humans seem nevertheless to have inherited certain basic sexual inclinations that are probably universal. Third, there is an ever-growing body of evidence from brain science and biochemistry, much of which tends to indicate that differences between male and female behavioral predispositions have a definite biological basis. Finally, there is the fact—often overlooked, disparaged, belittled, or ignored by social scientists—that human sexual desires, including and especially male desires, often seem to develop quite independently of experiential influences. Indeed, male sexual wants and needs often seem to stand diametrically opposed to prevailing normative standards and often persist despite considerable societal efforts to repress or extinguish them. It is only with reference to evolutionary causes that facts such as these can be explained.

One expert who is convinced that human sexuality was shaped largely by the forces of natural selection, rather than by environmental influence, is anthropologist Donald Symons of the University of California. In his 1979 book, *The Evolution of Human Sexuality,* and in several subsequent writings, Symons has argued cogently against the view that sex differences in sexual psychology are entirely the products of social conditioning. According to Symons, men are different from women, both physically and psychologically, because millions of years of evolution have made them different, because the two sexes have evolved in response to different selective pressures, and because, throughout the evolutionary history of the human species, inclinations and behaviors that were adaptive for one sex were for the other 'tickets to reproductive oblivion'. If the two sexes often fail to get along, if their desires often clash, it is not because they have been transformed by social influence into unnatural opponents, but because each sex has been endowed by evolution with its own characteristic set of sexual inclinations and predispositions. With respect to sexuality, Symons writes,

"there is a female human nature and a male human nature, and these natures are extraordinarily different."[1]

Symons posits seven major differences between male and female sexuality,[2] and in the body of the book he suggests several more. By far the most important for the purposes of the present discussion are the following: 1. Men are by nature somewhat more prone than women to desire a variety of sexual partners purely for the sake of variety; 2. male sexual desires are more persistent and less easily suppressed than their female counterparts; as a result 3. it is almost always men who approach, proposition, court, and seduce women, rather than the other way around; 4. it is almost always men who fight amongst themselves for sexual access to women, rather than the reverse; 5. women tend to be much choosier than men in their selection of sex partners; 6. women are much more likely to accept or reject a potential sex partner or mate on the basis of his social status or economic prowess; and 7. women are more likely than men to demand some sort of non-sexual payment in return for their sexual favors.

Symons, of course, is by no means the first person to have suggested sex differences such as these. In fact it is a commonly held folk belief in aboriginal societies throughout the world that men are by nature more promiscuous than women; and throughout the history of Western letters quite a few philosophers, scientists, and literati (in addition to great numbers of ordinary people) have come to the conclusion, on the basis of their personal experience, their observations of the behavior of others, and in some cases on scientific data, that there is a fundamental disparity between male and female sexuality. (See for example Arthur Schopenhauer's essay 'The Metaphysics of Sexual Love' in Part II of *The World as Will and Representation*, the books *Sexual Behavior in the Human Male* and *Sexual Behavior in the Human Female* by Alfred C. Kinsey et al., and the writings of Strindberg.) But few writers have stated the case more forcefully than Symons, and none has marshalled a greater array of empirical evidence in support of his point of view. Assuming for the moment that Symons's thesis is essentially correct and that it is supported by the scientific and historical

evidence (much of which will be considered presently), the question that immediately suggests itself is: why? Why should there be so many differences between male and female sexuality? Why are there so many conflicts between the sexual needs women and those of men? And how could sexual behavior that is so adaptive for one sex be so unadaptive for the other? In a sense, the answer to all these questions is relatively simple. As I have repeatedly suggested throughout this book, natural selection almost by definition tends to favor reproductive success. But because the two sexes reproduce themselves in fundamentally different ways (females by becoming pregnant, giving birth, and suckling their young, and males by inseminating females), each sex has in the course of its evolution developed its own peculiar reproductive anatomy and reproductive strategy. To understand fully why this is the case, and to see just how the two sexes have arrived at their present state, we must go back to the very origins of sexuality itself and observe just how the two sexes first embarked on their divergent paths.

The Origin of Sex and the Origin of the Sexes

There was a time, billions of years ago, when there was no such thing as sex; and all organisms reproduced themselves through asexual means. For more than half of the history of life on Earth, in fact, asexual reproduction was the *only* means of reproduction; and it was not until about a billion and a half years or so ago that reproduction by sex first began to assert itself in the organic world. Even today, asexuality is not at all uncommon, being still universal among the bacteria and widespread among other single-celled forms. In such species, reproduction is a simple and straightforward affair and lacks all the complications (and many of the conflicts) that are so characteristic of sexual species. Among asexual organisms there is no need for courtship or dating, marriage or domesticity; there are no in-laws, no divorces, no custody battles, no alimony; there is no sexual frustration, no rejection, no rape, no prostitution, no intrasexual competition, no unwanted pregnancies, no venereal

disease. It is simply done, and it is done with. When the banal bacterium 'grows up', it simply splits in two, resulting in two 'daughter' cells, each a miniature replica of the original. The two daughter bacteria then go on to grow and mature until they reach full size, at which time each divides again, thus producing four cells where there originally had been only one. And so on it goes, for as long as the conditions of life and growth are favorable. In every case reproduction is accomplished without any kind of sexual preliminaries and without the need for one individual to compromise itself with another. By comparison with sexual reproduction, asexuality is quick, simple, efficient, and trouble-free. Bacteria and other asexual reproducers are capable of multiplying at a rate that far exceeds anything that is to be found among sexually-reproducing forms. It has been estimated that if a single bacterium or amoeba were allowed to grow and proliferate without limit, its offspring would cover the face of the Earth within a month.

There are more than a few advantages associated with the asexual mode of reproduction. Not only do asexual organisms propagate themselves quickly and efficiently, but they are free from the need to seek out, and compromise their interests with, a mate. Since each individual can reproduce on its own, the problems of finding and keeping a mate are completely avoided. In addition, the asexual reproducer does not need to 'pollute' its offspring with the genes of less adaptive or less fit individuals. And for an organism that is highly attuned to its particular environment, this is a clear 'advantage'. Indeed, there are so many 'advantages' inherent in asexuality that it is somewhat of a wonder why this mode should ever have been replaced by other methods of self-replication. And even professional biologists have yet to come up with a definitive solution to this puzzle, although numerous theories have been advanced. One oft-cited suggestion is that sexual reproduction creates a genetic diversity which may be more adaptive under conditions of rapid or unpredictable environmental change.[3] The primary 'drawback' associated with asexual reproduction, as many biologists have noted, is that all the offspring produced by this method are genetically identical to the parent (except of course in the case

of a mutation); and while this may be a perfectly adaptive strategy under environmental conditions that are completely stable, it may be very unadaptive when the environment is in a state of flux or when the organism itself has been forced to migrate into a new environment where conditions are different and unpredictable. In the latter case, an organism may be more biologically fit if it switches to sexual reproduction. This is because, by combining its genes with those of another individual and thereby creating a brood of genetically diverse offspring, it increases the probability that at least some of those offspring will survive the rigors of the new and untried conditions. The offspring may all die anyway, but their genetic diversity at least adds to the likelihood that a few will make it. And while this may not be an ideal reproductive strategy, it is certainly more adaptive than producing a batch of genetically identical but unadaptive progeny.

Another possibility, and one that is strongly supported by some recent evidence, is that sex evolved as a means of warding off invasion by parasites or pathogens.[4] The very idea may seem ludicrous at first blush since, in today's world, sexual intercourse is one of the principal means by which viruses, bacteria, and other pathogens are transmitted from one individual to the next. But in primordial populations, the situation may have been quite different. Imagine, for example, a primeval population of asexual reproducers that is not susceptible to any kind of pathogenetic invasion. Suppose further that it suddenly becomes exposed to just such a threat. What will be its chances of warding off the pathogen? At first, not very good. Because all the offspring of a given individual are genetically identical, no individual will be any more resistant to the infection than any other, and the pathogen will make a wholesale killing. But if the organism in question can switch to sexual reproduction and thereby produce a batch of genetically diverse progeny, then at least some of those progeny may have a genetic resistance to the infection. If the genetic diversity created by sex is broad enough, the pathogen may be almost entirely thwarted. And even if the pathogen is successful at picking out the least resistant individuals, so long as sexual reproduction continues,

at least some varieties will make it, and the host population will always be one step ahead of the evolving parasite.

Assuming that this was the original adaptive significance of sexual reproduction, the question remains as to how such reproduction got started in the first place. How did asexual organisms ever learn how to reproduce themselves by sexual means? Unfortunately, this question cannot be answered with any certainty, since we have no direct evidence concerning the ultimate origins of sexual behavior, and I will not speculate about it. But this much seems pretty clear. In the early days of sexual union, when the whole business was still in its trial stages, there were no clearly defined genders as we now know them, no males or females as such. Rather all the individuals within a population were more or less alike and, theoretically at least, there were no restrictions on who could mate with whom. This situation still obtains among many forms of life, including numerous fungi, for example. It is technically known as *isogamy*. In isogamous species, the individuals cannot be distinguished into separate sexes, and there is no such thing as maleness or femaleness. Rather each sex cell—or *gamete*—is a potential mate for any other, and any gamete can fuse with any other, at least in theory, to produce a new individual. In isogamous populations, in other words, there is sex, but there are no sexes. And originally, it may be presumed, this held true for all sexually reproducing populations.

Why, then, did the two distinct sexes ever evolve? Why did males and females go their separate ways, each developing its own peculiar brand of anatomy, behavior, and reproductive strategy? Once again, there are no definitive answers to these questions, and there may never be. As in so many other cases, the evidence bearing on this matter is entirely circumstantial, and therefore inconclusive. Nevertheless, experts are largely agreed as to the circumstances which are likely to have brought about the divergence of males and females during the early stages of sexual evolution. And in the following hypothetical scenario I have tried to capture the essence of their consensus. What follows may not be true, but it is at least plausible, and it has the backing of many biological scientists.[5] At the very least

it should serve to illustrate just how the two sexes *may* have emerged, even if they did not do so in precisely this manner.

Let us suppose that in a certain prehistoric population of isogamous organisms all the individuals produce gametes of roughly equal size and structure, but that there is at least some individual variation, with a few sex cells being slightly larger than average, a few somewhat smaller, while most are of intermediate size. Under such conditions, we might expect natural selection to favor the largest gametes, since these would be able to supply the largest amount of food to their embryos. Gametes of greater size, in other words, would tend to be fitter than those of lesser size, and as such there would be an evolutionary trend toward bigger gametes. Gametes of smaller size would be proportionately less successful and would therefore be selected against—at least in the beginning. At some point, however, selective pressures could be expected to change and begin to favor the smallest gametes as well as the largest. This is because, in sexual reproduction, it is not the size of any one individual that counts so much as the combined size of the two parental gametes. This being the case, even a tiny gamete might be successful if it could manage to find a very big one with which to mate. At this stage, then, selective pressures would actually be operating in two different directions at the same time (a process technically known as *disruptive selection*). On the one hand, the biggest gametes would be favored because of the size of their food supply, while the smallest would be favored because of their greater mobility, or simply because of their greater numbers and hence their greater likelihood of finding multiple mates. In the course of time the very largest and the very smallest would become the most successful, with average-sized specimens dying out. At this point gamete size would have become *bimodal* and two basic types would have emerged. The larger type would be the 'eggs' or 'females', and the smaller the 'sperm' or 'males'. (In fact this is how the two basic types have come to be known, and the relative size of the gametes is still the fundamental distinction between males and females. In every species that has two sexes, the females have the larger gametes and the males the smaller.)

Once the difference between males and females had become established, a number of consequences must have followed. First of all, unisex matings must have become less and less common, and eventually impossible. Since two sperm cells together could not produce enough cytoplasm to feed a potential offspring, they could hardly have engaged in successful matings with each other. And an egg cell could only rarely have been able to mate with another egg, since each was too slow and could easily have been beaten to her goal by faster, more numerous sperm. Second, the two proto-sexes must have become ever more divergent in their structure and behavior, since they were evolving to very different kinds of selective pressures. On the one hand, eggs were being favored because of their large size and their ability to discriminate against and reject the smallest sperm, while at the same time sperm were being favored for their small size, their mobility, and their greater numbers. As a consequence sperm must have continued to evolve smaller size and faster mobility while eggs continued to evolve greater size and more sophisticated methods of rejecting undesirable mates. As time went by, the differences between the two sexes could only have gotten bigger and bigger.

Males, Females, and Reproductive Strategy

From the very beginnings of maleness and femaleness selection has tended to favor very different kinds of structure and behavior in the two sexes. And although some evolutionary developments have mitigated to a degree such differences, bringing males and females closer together, more often the trend has been in the opposite direction, and male-female differences have become more pronounced as evolution has 'progressed'. In all sexually-reproducing species today (except in the case of isogamy mentioned above), the basic male-female difference in gamete size and number obtains, and in most such species this basic sex difference has given rise to many others. Because eggs are always larger than sperm, and thus energetically more expensive, they tend to be produced in relatively

small numbers; while sperm, which are tiny and energetically inexpensive, are typically propagated at a much higher rate. In fact in the great majority of species the females produce far fewer eggs than the males do sperm, and their reproductive potentials differ accordingly. In the case of females, as has just been suggested, it is usually a severe limit to the number of eggs an individual can produce in her lifetime, and an even greater limit to the number of offspring she can successfully bear. But males are much less restricted. Because sperm cells are so much smaller than eggs, a typical male can produce many thousands or even millions of them in a very brief period of time. And—theoretically at least—his reproductive potential is limited only by the number of eggs he can fertilize, or by the number of females he can inseminate.

Not surprisingly, this considerable difference in reproductive potential between males and females has led to the evolution of proportionate differences in male and female reproductive behavior. Generally speaking, the male's best reproductive 'strategy' is to spread his sperm around as liberally as possible, so as to fertilize as many eggs as he can. By so doing he may greatly increase his reproductive success. Thus, in general, it pays a male to be hasty, polygamous, and, if he can get away with it, nonparental. With females, on the other hand, the story is a very different one indeed. For the most part it does a female no good whatever to adopt a promiscuous or polygamous lifestyle. In fact for her such inclinations can be downright harmful. After all, a female can be fertilized by only one male during each reproductive period of her life. Once she has been impregnated, she may copulate with dozens or even hundreds of suitors and gain nothing by it. Indeed, the time and energy she wastes on useless copulations might better be spent looking for food and providing for her offspring. Moreover, the typical female stands to gain a great deal by being as selective as possible about whom she mates with. This is because, unlike males, she may lose a great deal by mating with an inappropriate or unfit partner. If a male is unsuccessful in inseminating his partner, he has lost very little—a few drops of semen perhaps,

but in most cases this is a negligible expenditure. Even if he inadvertently mates with a female of another species, he is none the worse for it. But females have a much greater stake in any one reproductive act. Unlike sperm, which tend to be cheap and abundant, eggs are generally costly and in short supply. A female often risks months of time and a great deal of energy in attempting reproduction. For her a reproductive failure is much more costly than it is for a male. If she copulates with the wrong male, she may reduce her reproductive success by a significant margin. She may even die. In some species of fly, in fact, mating with a male from a different species often results in the death of the female. And among birds, a similar error in judgment by the female can lead to the production of sterile eggs. Small wonder, then, that in most species females have evolved a much greater degree of coyness and choosiness than have their male counterparts.

In the discussion to this point I have repeatedly used such qualifying terms as 'in general', 'typically', 'usually', 'in most cases', 'in the majority of species', and so forth, because I wish to highlight the fact that these trends are not universal. There are, in fact, some exceptions. As we shall see, under certain ecological conditions, or given certain anatomical peculiarities of the species, sex differences can sometimes be mitigated, bringing males and females closer together in their structure, behavior, and reproductive strategy. Especially in those species that are usually called 'monogamous', male and female reproductive strategies are often quite similar, and the two sexes do not differ very much in their size or their appearance. There are even a few rare cases of complete sex reversal of otherwise 'typical' sex roles, the males being the choosy, coy, and unaggressive sex, and females the promiscuous and aggressive one. But as we shall also see, even the apparent exceptions are not always so exceptional as they appear at first sight; and there is not a shred of evidence to suggest that human evolution has in any way been characterized by the kinds of ecological conditions or anatomical features that have on occasion given rise to a total reversal of the usual sex roles. With this caveat in mind, let

us go on to consider in greater detail some of the typical sex differences, beginning with the greater choosiness of females, that are much more the rule than the exception in animal life.

Female Choice

If females are indeed choosier than males, then one might ask on what basis they normally exercise their choosiness. How, precisely, do they distinguish good mates from bad ones? As we have seen, among primordial unicellular organisms this may be simply a matter of size, with the largest male gametes being preferred over smaller ones. When we come to multicellular animals, however, the criteria of male sexual attractiveness are generally much more complex and in fact tend to vary somewhat from species to species. Even here, however, certain common features are discernible across vast numbers of organisms.[6] Perhaps as often as anything else, males seem to be selected on the basis of their ability (or apparent ability) to provide resources for the female and her prospective young. Alternatively, a male may be chosen because he is able to secure and hold a territory where the pair can give birth and rear their offspring. Or some combination of these and other similar factors may be involved. In any case, the female's proximate goal is a 'good provider', and she will not hesitate to discriminate against poor providers in the interest of promoting her own reproductive success. Not surprisingly, the female's choosiness can have definite reproductive payoffs. In several species of birds it has been shown that when a female chooses a mate that can offer her an unusually large nuptial gift of food, there is an increase in the size and/or number of eggs she can produce and therefore in the number of chicks she can hatch.[7]

It is by no means always the case that a male animal is selected on the basis of his ability to provide resources or living space. In many species the male has absolutely nothing to offer to the female or her offspring on either score, and in such species the female must make her choice on the basis of other

criteria. In some species, especially among birds, females are sometimes impressed by colorful feathers and showy displays and make their choice accordingly. In general, the brighter the color of the male's plumage, or the more spectacular his display, the greater is his desirability as a mate, and the more likely he will be preferred to others in the game of sexual selection. The peafowl and the bowerbirds present good examples in this regard. In the former, as is well-known, the peacock usually attempts to attract a female through a fanfare display of his long iridescent tailfeathers; and peahens do indeed seem to be attracted by this kind of display. Meanwhile, among many other avian species, it is typically the most brightly colored males that catch the eye of the desirous female and appeal to her nuptial instincts. Just why this should be the case, it is difficult to say; and the matter is still being debated in scientific circles. Some recent evidence suggests that the most brightly colored males also have the greatest resistance to parasitical infection and therefore represent a healthier, more resilient stock than do their more cryptically colored competitors.[8] Thus the females in question may be shopping for 'good genes' when they make their selection; and in such cases the most brightly colored males (and therefore those with the highest resistance to parasitical infection) may be their best bet.

An interesting variation on the theme of brilliant plumage and bodily display is provided by the bowerbirds, for in these species it is not the brightness or the elaboration of the feathers that counts, but rather the architectural splendor of the bower and its adornments.[9] In bowerbirds, indeed (of which there are about a dozen and a half species), males in general are not much more brightly colored than females and often scarcely distinguishable from them. Yet they differ very much from females in their behavior and reproductive strategy. It seems that in the course of bowerbird evolution the sexual significance of elaborate plumage has been transferred to the bowers themselves, which are often meticulously constructed and maintained by their owners. The bowers, which sometimes resemble miniature huts or fortresses, vary somewhat from species to species in

their structural design; but they are usually quite gaudy and sedulously maintained. In some cases their elaboration has become so pronounced that they almost resemble works of art. When European explorers in New Guinea and Australia first stumbled upon these remarkable structures, they were assumed to be the handiwork of humans, not birds. And all the meticulous work involved, as we shall see, is performed for no other reason than to impress the female.

Some bowerbirds construct towers up to nine feet high by weaving sticks around a sapling or a fern, embellishing the display with a circular raised court. Others construct miniature huts or houses with a domed roof and internal chambers. Still others construct the so-called 'avenue bower', consisting of a pair of adjacent walls and often decorated with brightly colored objects and enclosing a central lane. At least one species even goes so far as to 'paint' its bower, using a brightly colored compost of saliva and crushed berries. Surrounding or in front of the bower one often finds a lawn or a garden, carefully maintained and often garishly decorated with golden rosins, colorful berries, iridescent insect skeletons, feathers, fresh flowers, and in the areas of human settlement, pieces of glass, coins, thimbles, earrings, and other similar ornaments. Needless to say, these remarkable structures do not grow of themselves, and male bowerbirds are often kept quite busy in building them, maintaining them, decorating them, and protecting them against the vandalism of competitors. In fact it is not unusual for a male bowerbirds to attempt to vandalize or even destroy the bowers of his rivals, in the process making his own look all the more appealing by comparison. And all this he does for no other reason than to attract mates. The bowers are neither domiciles nor nesting sites; they are not lived in, and the young are not reared in them. They are nothing more than elaborate courtship displays, constructed specifically to appeal to female tastes. And apparently they work. Come breeding season, females fly into the area of the bowers and begin their meticulous inspection of the local architecture; each in turn reviews her choices carefully and in time selects a particular

male whose display has appealed most to her aesthetic and fastidious eye. Once she has made her choice, mating takes place either in or near the bower itself, after which the female flies off to lay her eggs and rear her young elsewhere.[10] The process then repeats itself until every female in the population has been inseminated and every male has collapsed from the sheer exhaustion of bower construction, maintenance, and protection.

Just what, if anything, is the adaptive value of this sort of mate choice, it is by no means clear. But one plausible suggestion, recently put forth by Gerald Borgia (who has spent some time studying these curious creatures), is that the female may get better genes when she selects the best bower builder; and this apparently because the best bowers are usually built by the most dominant, the most vigorous, and the most longevous males. Such individuals may be genetically 'superior' to their competitors (in evolutionary terms) and therefore represent the most adaptive choice available for the females at hand. In any case, the selectivity of the female, however much it may pay off for her in reproductive terms, has some definite drawbacks from the point of view of the male. This is because in a typical breeding season, one or a few of the most successful males, those with the most attractive bowers, may secure matings from a large number of females, while the least talented architects get no mates at all. Thus in any given bowerbird population, a male may exert a tremendous amount of time, energy, and effort to the construction of his bower, only to be rejected in the end because he cannot live up to female expectations and because his rivals have thus beaten him to the reproductive punch. In this regard, it might be noted, bowerbirds are somewhat unusual in the avian world. The great majority of bird species, in fact, do not build bowers and are not polygynous. Most kinds of birds are basically monogamous, and their males spend far more time caring for young than building useless display structures. But as we shall also see, the pattern of mate selection that obtains among bowerbirds is not at all uncommon in the rest of the animal kingdom. And it is especially common in mammals.

Female Selection and Male-Male Competition

One of the inevitable concomitants of female choice, it would seem, and as the example just cited makes clear, is male-male competition. For obviously if the females in a given population choose to mate only with certain males, then many males will attract no mates at all, and each will have to struggle to compete with all the others for access to limited reproductive opportunities. In some cases this competition may be relatively nonviolent and involve little or no direct confrontation: each male simply goes his own way in search of the best food resources, or territory, or bower-building material, with the hope that his resources will prove more sexually alluring than those of his rivals. Male bowerbirds, for example, rarely fight with one another, and the violence of their competition goes no further than their attempts to destroy or vandalize one another's bowers. But male-male competition (or *intrasexual competition,* as it is more technically known) is by no means always so indirect or so nonviolent. Often it involves direct confrontation and aggressive attack, and this is especially true among mammals, where polygyny is widespread and competition for females often intense and bloody. In much of the mammalian world, in fact, males are bigger, stronger, and more pugnacious than females and have apparently evolved these traits precisely because of intrasexual competition.

The ultimate evolutionary basis for intrasexual competition, as we have seen, is the enormous disparity between the number of male and female gametes. As I pointed out just a few pages ago, egg cells tend to be relatively few in number by comparison with sperm, which are often plentiful to a ludicrous excess. Thus egg cells (and the females that encase them) almost always constitute a limiting resource from the point of view of the males that need them in order to reproduce. And in nature a limiting resource almost always gives rise to competition for access to it. Thus it is no surprise that in the majority of mammals males compete for access to females, rather than the other way around. And many of the structural and behavioral differences between the sexes may ultimately be traced to this simple fact.

There are, however, some exceptions. Apparently nature is a bit too multifarious and at times, it would seem, too capricious, to allow us to categorize all her workings, readily and conveniently, without having to worry about a few puzzling inconsistencies that, when discovered, force us to abandon previous paradigms or at least significantly revise our scientific theories. And so it is in the realm of animal mating systems and mate choice. It is not the case that in *every* species females are the limiting resource and males the competitive sex. In some species males and females are approximately equal in their competitiveness and their choosiness. And in a very few species it is the females that compete for access to males and the males that do the picking and choosing. Even these apparent exceptions, however, can be accounted for without having to abandon the general thesis if we simply introduce into the equation a certain factor which, though not wholly synonymous with either gamete size or number, is closely related to both. The factor referred to has come to be known in scientific circles as *relative parental investment.* As we shall see, this concept makes it possible to account for the apparent exceptions to typical sex roles without throwing out the idea that in general it is the sex with the smaller, more numerous gametes (the males) which usually competes for access to the sex with the larger, scarcer gametes (the females). The only universal sex difference is that in all species it is the females that produce the larger gametes and the males that produce the smaller ones. As a consequence it is almost always the females that contribute the greater amount of time and effort to the production of gametes as well as to the production and nurturance of young. In other words, it is almost always the females that have the greater *parental investment.* On occasion, however, because of unusual ecological circumstances or peculiar features of anatomy and physiology, the male's parental investment may be equal to or greater than that of the female. When this happens, we can expect males to behave in a way that is otherwise typically female, while females become more male-like in their reproductive strategy. In the end, then, even the exceptions prove the rule, and parental investment theory helps explain why this is so.

Parental Investment and Sexual Selection

In the early 1970s a young biologist named Robert L.
Trivers, impressed by the widespread occurrence of male-male
competition in nature, but also aware of some apparent devia-
tions from this rule, devised a way to explain the regularity
while also accounting for the exceptions.[11] Basing his conclu-
sions in part on the classic works of Charles Darwin and A.J.
Bateman, Trivers soon conceived the parental investment the-
ory and, in 1972, published a landmark article in which he
expounded his idea at length. According to Trivers, which sex
competes for the other, and which exercises the greater selec-
tivity in mate choice, depend in large part on which sex devotes
the greater amount of time and energy to the production and
nurturance of the young. In most cases, he noted, especially in
mammals, it is the females that have by far the greater parental
investment, for in such species it is almost always the females
that gestate the young, give them birth, and suckle them after
parturition. The males, by contrast, often invest little or no
parental care at all, their entire contribution to the production
of young consisting in many cases in no more than a 'donation' of
sperm. In such species, therefore, the female and her enormous
parental investment constitute a kind of limiting resource for
which the males must compete. As a consequence males are
often much larger, much stronger, and much more aggressive
than their female counterparts. Often they are also much more
promiscuous, showing a readiness to mate with any available
female, for in doing so they take advantage of the parental
investment conveniently supplied by the opposite sex. The
female, in turn, precisely because her parental investment is so
much greater, must be much more cautious in her choice of
mates, lest she wind up devoting a lot of time and energy to
useless copulations or to the generation of an unfit offspring.
Meanwhile, in those species in which the parental investment
of males and females is approximately equal (as in many species
of birds), we can expect the two sexes to be more similar in their
size, their appearance, and their reproductive behavior. And
finally, in those rare species in which the male actually contrib-
utes a greater parental investment, we should not be surprised

to find a reversal of typical sex roles, with the males being coy and choosy and the females promiscuous and aggressive. To put the matter in more generalized terms, the more the two sexes differ in their relative parental investment, the more they tend to evolve different reproductive strategies, as well as different anatomical traits. In particular, the bigger the difference in parental investment, the more intense is the competition among the members of the sex with the lesser investment (usually the males), and the more intensely natural selection favors traits such as large body size, impressive weaponry, an aggressive disposition, and any other structures and behaviors that are of use in intrasexual competition. Where the gap between the relative investment of the sexes is especially wide, males and females may be expected to exhibit markedly disparate behaviors, and competition among males for access to females is likely to be especially fierce.

All this is purely theoretical. Does it hold up to empirical investigation? The answer, for the most part, is 'yes'. In fact Trivers's parental investment theory has stood the test of time pretty well, even though it has had to be revised and refined on more than one occasion in light of subsequent research.[12] And verifications of the theory in the natural world are not at all difficult to come by. A particularly instructive example—and one that is often cited in the behavioral science literature—is that of the Northern elephant seal, a large aquatic mammal that spends most of its time at sea but that breeds once a year on the beaches of selected islands off the coast of California and Mexico.[13] In this species, the difference between male and female parental investment is enormous; in fact it could hardly be more pronounced. Typically the male contributes very little to the production and care of his offspring. His entire parental investment, in most cases, consists in nothing more than the insemination of the female. He is about as nonparental as he can be, contributing absolutely nothing to the nurturance of his own pups. In fact he sometimes crushes them inadvertently as he drags his huge body through the crowded rookeries where these animals breed. The female, by contrast, must contribute a great deal to her offspring if she is to achieve any kind of

reproductive success at all. For her, the production of a single pup normally requires a full year of effort, including eleven months of gestation and one month of post-natal care. All things considered, then, we would expect sexual dimorphism to be extraordinarily pronounced in the Northern elephant seal—if Trivers's theory possesses any validity. And this is just what we find. Male and female elephant seals differ enormously in size, disposition, and sexual behavior. The average male elephant seal, for example, weighs nearly three tons, making him almost four times bigger than his female counterpart, and immeasureably stronger. In matters of behavior, the two sexes are even more disparate. The female elephant seal, for her part, is basically monogamous and not very aggressive. She shows no inclination to share her body with a horde of lusty males, and has no interest in indiscriminate sexual escapades. Once a year the female will submit to a series of copulations from her harem master and, if pressed, from perhaps one or two other males. But in any case she does not actively seek out a variety of sex partners. And if she is approached by too many males, especially subordinate ones, she will actively resist their attempts to mount her. As for intrasexual competition, there seems to be relatively little of this among females, although they may on occasion compete with one another for favored spots on the rookery and thus for a better chance to be mated with by a dominant male. In any case, females need exert no special effort to get their eggs fertilized: sooner or later every cow is bound to be approached by at least one desirous bull, so that she is almost guaranteed the opportunity to mate. For the male of the species, however, the situation is very different. Unlike the female, the male elephant seal is guaranteed nothing, and he must fight for everything he can get. In December of each year, the huge male seals make their way to the beaches, where they remain without feeding until March. Almost immediately they begin to threaten and fight one another, as each attempts to gain dominance over the rest. And the stakes are quite high; for dominant males usually win access to the greatest number of cows and therefore have the greatest prospects for reproductive success. For the most part, dominance battles among male

elephant seals are brief and bloodless: as often as not, the weaker of the two males in an agonistic encounter simply withdraws and accepts, however begrudgingly, his subordinate status. On occasion, however, a low-ranking male refuses to be intimidated by a mere display of force and steadfastly holds his ground. The usual result is a violent skirmish, which may be bloody, and which is always deadly serious. Typically the two combatants thrash away at each other for up to a quarter-hour, until one of them concedes defeat and slithers away in ignominy, leaving the victor to his spoils. The competition takes its toll on winners and losers alike. It is not unusual for a bull to die immediately after his most successful reproductive year, presumably from the cumulative effect of the injuries he has sustained and the stress he has endured during his incessant struggle to maintain high rank. The vast majority of male seals never attain dominance over a harem and spend most of their lives in a state of involuntary bachelorhood. Most males never sire any offspring at all, and relatively few even live long enough to join in the breeding competition.

The example of the Northern elephant seal is admittedly an extreme one. There are few species in which polygyny is quite so pronounced, sexual dimorphism so extreme, and intrasexual competition so intense. Apparently one of the factors that has given rise in this species to such intense male-male competition is the crowding together of dozens of females at one particular place and at one particular time. The dense congregation of cows that forms once a year on the breeding beaches constitutes a kind of grand reproductive prize that promotes male-male competition (the stakes being so high) and that renders it so inordinately fierce. In other mammalian species, where the females are more widely scattered in space and/or time, there is less of an opportunity for any particular male to gain exclusive control over a large number of reproductive opportunities, and intrasexual competition is proportionately mitigated. Nevertheless, the basic polygynous pattern exhibited by elephant seals is not at all unusual and is in fact the general rule among mammals. It is fairly common in other vertebrate classes, too. In countless other species, polygynous males battle amongst them-

selves for access to more or less monogamous females, while the latter pick and choose their mates but need not fight for them.

This is not, however, the universal pattern. As I have already suggested on more than one occasion, there are exceptions. There are some species, for example, in which the typical parental investment of the two sexes is approximately equal, and where this occurs, sex differences in anatomy and behavior are much less pronounced and monogamy in both sexes is the usual strategy. Among birds, there are a great many species in which the male contributes almost as much to the production and nurturance of offspring as does the female, and the parental investment of the two sexes is therefore equal, or very nearly so. Among mountain bluebirds, for example, the nestlings grow so fast that both parents are kept frantically busy trying to feed them. Predictably, in this species there is little sexual dimorphism, and both males and females are essentially monogamous in their habits. The same holds true for many other birds as well: robins, eagles, ducks, warblers, swans, and sparrows all share the similarity that the male contributes almost as much as the female to the nurturance of the offspring. Significantly, most of these species are *basically* monogamous, and in them sexual dimorphism is minimal.

I stress the word 'basically' because, even in these species, males sometimes attempt to copulate with females other than their primary mate, and they may very well increase their reproductive success by doing so.[14] The females, by contrast, rarely attempt 'extra-marital' matings, and there is some question as to whether they would really increase their reproductive output if they did. It would seem that even in so-called 'monogamous' species, where male and female parental investments are about equal, the basic male-female difference in gamete size and number (and therefore reproductive potential) still obtains; and in reproductive terms at least, it still pays the male more than the female to spread his gametes around in a less than completely monogamous fashion. In certain species of ducks and swallows a 'monogamous' male will, if he can get away with it, mount and inseminate a female or females other than his own mate. Significantly, in many such cases the female

actively resists being mounted by the strange male and will try to escape if she can. Apparently even in supposedly monogamous species the male has often maintained a greater evolutionary penchant for sexual variety than has the female, and nature has not fully 'succeeded' in making males and females exactly alike. As Trivers summed up this point in the closing lines of his 1972 paper, on parental investment, "Sexual selection favors different male and female reproductive strategies, and . . . even when ostensibly co-operating in a joint task, male and female interests are rarely identical."[15]

We come at last to those relatively few species in which the typical sex roles seem to have gotten themselves almost entirely reversed. These are the so-called *polyandrous* species, which include, among others, a small percentage of birds and a few pipefishes of the family *Syngnathidea*. Among the latter are several species of seahorses, creatures which are celebrated for their unusual appearance and behavior.[16] Seahorses are almost unique in the animal world in that, in them, it is the male, rather than the female, that gives birth. In the front of his body the male seahorse possesses an adaptation that few other male creatures possess, a 'brood pouch', and it is here that he harbors his young before giving them birth. Passage into and out of the pouch is accomplished by means of a small slit in the male's belly. Fertilization begins when the female transfers her eggs through the slit and into the pouch. After fertilization, the male gestates the fry for a few weeks, nourishing them with the help of a placental connection to his bloodstream. After the young have developed to a certain stage, they are expelled from the male's belly in a series of sudden ejaculatory bursts.

Unfortunately, it is difficult to tell whether the parental investment of the male seahorse is really greater than that of the female, because the period of gestation is relatively brief, and for all we know the female devotes as much energy to the production of eggs as the male does to their gestation. There is some indication, however, that the male's investment is greater than, or at least comparable to, that of the female. And there is some evidence that the female's reproductive success is limited, not by the number of eggs she can produce, but rather by the

number of males she can 'impregnate'. Assuming, then, that the male's parental investment is indeed greater, we might expect these animals to exhibit a reversal of normal sex roles—and to a certain extent at least, this seems to be the case. Female seahorses are unusually aggressive and showy in courtship, and they often exhibit a willingness to mate with more than one male. Females are also more brightly colored, more competitive, and more vigorous in courtship.

Sex-role reversal is even more apparent in polyandrous birds, including for example certain species of phalaropes and jacanas.[17] In some such species, the typical mating sequence is almost exactly the reverse of that found in most mammals, and it goes something like this. When it comes time for reproduction, the female copulates with her first mate, lays her eggs, and then leaves the father to brood and care for the offspring as she flies off in search of another mate. This process then repeats itself until as many as three or four males are engaged in rearing the offspring of a single female. In this particular case, the parental investment of the male is almost certainly greater than that of the female. And not surprisingly it is associated with a definite sex-role reversal in structure and behavior. In these species it is the females that compete with one another and fight over access to males, rather than the other way around. And it is the females, rather than the males, that are the more aggressive and the more brightly colored sex.

To some people the existence of polyandrous pipefishes and phalaropes poses a fundamental challenge to the whole parental investment theory. At least this is a point of view that has been put forth in some scientific writings, although it is not widespread and seems to be confined primarily to psychologists and sociologists rather than biologists. The idea, in any case, is quite mistaken. It was precisely the occurrence of apparently exceptional species—monogamous and polyandrous ones— that largely inspired the parental investment theory in the first place, and Trivers is quite explicit in discussing polyandry in his original 1972 paper on sexual selection. Anyone who argues that polyandrous birds constitute a fundamental challenge to Trivers's theory either has not read his 1972 article or has not

understood it. But apparently such people do exist and have not yet got the message. I have reviewed several textbooks on human sexuality, for example, all published during the 1980s, and written by environmentalist psychologists and sociologists, in which just this objection is stated.[18] According to these authors, Trivers's parental investment theory is wrong because, in polyandrous birds, it is the males that are the more parental and females the more promiscuous sex. There is no way to criticize this argument except to point out that it is a blatant misinterpretation of Trivers's theory, for reasons that I have just explained. To be sure, if there could be found a species in which the females were both the more promiscuous *and* the more parental sex, rather than one or the other, then this would pose a serious challenge to Trivers's theory. But polyandrous phalaropes and jacanas do not constitute such species. In any case, sporadic examples of polyandry in certain birds, insects, and pipefishes, however remarkable they may be, and however susceptible to misinterpretation by those who do not comprehend such concepts as *relative* parental investment, have little if anything to tell us about the evolution of *human* sexuality—for at least five reasons. First, although polyandry does occur in nature, it is extremely rare and seems to have arisen only under certain very unusual circumstances. There is no evidence to suggest that human evolution has been characterized by such circumstances. Second, polyandry seems to be most common in birds and occurs only sporadically in other vertebrate classes. It is especially rare in mammals and is completely unknown among Old World primates. Since humans are directly descended from Old World primates, and not from phalaropes or seahorses, it is the former, and not the latter, that serve as the more plausible model of human evolution. Third, typical mating patterns among human beings have virtually nothing in common with polyandrous species. In fact I do not know of a single society anywhere in the world in which men get pregnant, or in which women lay eggs. But I know of many human societies where men impregnate women and where women gestate, give birth to, and nurse their offspring. Fourth, polyandry as a marriage system is extremely rare among humans and seems to

occur only under highly unusual and unnatural circumstances. What's more, even where it does occur, it is often actively resisted and resented, especially by men. Fifth, in most human societies, the parental investment of men is not greater than the parental investment of women. On the contrary, typically the female investment is at least somewhat greater, and in many cases much greater, than that of the male. So virtually all available evidence from evolutionary science and from cross-cultural studies strongly suggests that humans are the furthest thing from being polyandrous by nature. And a great deal of evidence suggests that they are more or less typically mammalian in their basic inclinations. Let's now look at some of that evidence in detail.

Parental Investment and Sexual Selection In Humans

Consider the difference in minimum parental investment between human males and human females. For the male, the minimum investment may consist in no more than a single copulation. For the human female, on the other hand, the minimum investment goes far beyond mere copulatory activity and usually includes, in addition, nine months of pregnancy, the rigors of childbirth, and several years of nursing, provisioning, and other intensive post-natal care. In short, the difference between the minimum male investment and the minimum female investment is enormous. Typically the sex difference in parental investment is not so great. In most cases a father's contribution to the production and nurturance of his own offspring goes far beyond a single copulation and may include quite a lot of parental care and provisioning over many years' time. But this is by no means invariably so. And given that it is always the female that gets pregnant, the woman in most cases invests at least somewhat more, and in many cases much more. It has probably always been true, moreover, throughout the course of human evolution that a man could increase his reproductive output by adding a second or even a third wife or mistress, each of whom could be simultaneously impregnated

by him, while a woman's reproductive output would not neces-
sarily be increased by adding a second or third husband, since
she would need only one in order to be impregnated. Because of
these and other inherent sex differences in humans, it would be
surprising indeed if men and women had not evolved at least
some differences in their sexual and reproductive inclinations.

It is sometimes argued, or simply assumed, that man is by
nature a monogamous animal because, in most modern socie-
ties, monogamy is the legal norm. But legal norms can be highly
deceptive, for more often than not laws are passed to restrict
natural human inclinations rather than to serve as expressions of
them. Although the evidence is not entirely unequivocal, as has
been argued, much of it suggests that human monogamy is an
artificial, rather than a natural state. There are indications that
polygyny was at one time far more common than it is today, and
most contemporary hunting-and-gathering societies still prac-
tice official polygyny. Even where monogamy is the established
ethical and legal norm, it is rarely accepted wholeheartedly and
unhesitantly by all men. Almost every human society, in fact,
including those that are usually described as being 'monoga-
mous', features various forms of extra-marital strategem, such as
concubinage and prostitution, and other indications of a latent
distaste on the part of men for complete sexual fidelity to a
single partner. Perhaps even more telling are the responses that
men give when they are asked directly—as they have been on
frequent occasions in recent years—how they feel about the
matter of sexual variety. Almost all sex researchers, in fact,
including those that conducted the famous Kinsey and Hite
surveys, have found the male penchant for sexual variety to be
far more pronounced than its female counterpart. In *The Hite
Report on Male Sexuality,* for example, which appeared in 1981,
the vast majority of men admitted to being polygynous, in
practice or at heart and usually both.[19] Most expressed a basic
dissatisfaction with the sexual limitations of monogamy, and
most admitted to having had sex outside of marriage. At least a
few men said that they had taken on multiple wives in open
defiance of legal and moral injunctions, and despite the consid-
erable risks and costs involved. By contrast, virtually none of

the respondents to the original Hite survey on female sexuality expressed any autonomous interest in sexual variety for its own sake; almost none said that they disliked monogamy, and none had openly defied the law by taking on a multiplicity of husbands. These results, moreover, are by no means atypical. In fact almost all recent sex surveys have produced similar findings. On not a single one that I have been able to uncover do women consistently express a greater interest in sexual variety than do men.

According to anthropologist Weston La Barre, polygyny always has been, and to a certain extent still is, the prevailing cultural norm in the vast majority of human societies.[20] In *The Human Animal,* he estimates that in around three-fourths of all known societies the taking of multiple wives is customary and socially approved. Polygyny is especially widespread in the preliterate world. It is commonplace in all parts of Africa and in many parts of Asia and Oceania. With a few exceptions, polygyny has always been the traditional standard among the native tribes of both North and South America. And although many tribes place a restriction on the number of wives a man may accumulate, in most instances the legal limit far exceeds the practical one. LaBarre notes that the King of Ashanti in West Africa was "strictly limited" to a maximum of 3,333 wives, and that he "had to be content with this number."

In sharp contrast to this, the number of husbands a woman may accumulate is generally restricted to a maximum of one. Polyandry, indeed, is sanctioned in less than one percent of all known human societies; and even where it occurs, it seems to be brought about and maintained by economic or social circumstances that are highly unusual and highly artificial. According to Symons, "Unlike polygyny, polyandry is extremely rare among human societies, is not common among any known hunter-gatherer peoples, and probably was virtually absent throughout most of human evolutionary history."[21] There are also indications that it is highly unstable and is readily abandoned whenever the peculiar conditions that tend to give rise to it are mitigated. According to Peter, Prince of Denmark, for

example, who has conducted an extensive survey of polyandrous cultures, "Having appeared as the product of very special economic and social circumstances, polyandry disappears again with great facility when more usual conditions are present."[22] There is also evidence that polyandry is at best tolerated, rather than eagerly accepted, and that both sexes resign themselves to it only because of its concurrent economic advantages, rather than because the men are especially fond of the idea of sharing a wife or because the women are interested in sexual variety. In fact in polyandrous households tensions and conflicts between co-husbands can often lead to intense sexual jealousy, or even violent confrontation. In his ethnography of the Netsilik Eskimos, for example, Knud Rasmussen reports that two men may on occasion be obliged to share a wife because of a shortage of women in the population and because of the difficulty of surviving in a harsh climate without a spouse. But he is quick to add that such marriages seldom run smoothly and that, not infrequently, one of the men involved makes an attempt to "alleviate" the situation by killing the other co-husband.[23] Similarly, with reference to polyandry in Sri Lanka, Prince Peter writes, "Jealousy: always below the surface, although repressed in the interest of polyandry 'working'; knifings occur among husbands . . . because of jealousy."[24] Finally, in his discussion of this phenomenon, anthropologist L.R. Hiatt refers to a study of 17 polyandrous marriages in Sri Lanka and notes that in exactly three of them, the two co-husbands were not closely related to each other. Marriages of this sort, he writes, are "unstable and sometimes explosive. In two of the three case studies a co-husband committed suicide."[25]

Assuming that these historical and cross-cultural consistencies are not merely coincidental, but do indeed reflect natural human inclinations, one might ask: why is it so? Why have human males apparently inherited a greater penchant for sexual variety than females have? Consider the difference between men and women in reproductive potential. A man with several wives or mistresses could conceivably, in few days' time, sire as many offspring as he had partners. But a woman, in most cases,

would only be able to produce about one or possibly two children in a whole year. If this difference is then multiplied by the 25 years or so of a woman's reproductive career, and the 30 or 40 years of a man's reproductive career, then the sex difference in reproductive potential becomes quite enormous. Because the female is much more restricted than the male in the number of offspring she can produce, and because she can be impregnated only once during each reproductive period of her life, she generally stands to gain very little, if anything (in reproductive terms), by pursuing sexual variety for its own sake. But for the human male the situation is very different. Because a man produces far more gametes, because he can impregnate more than one woman per day, and because his minimum parental investment is much less he may indeed gain reproductively by procuring more than one sex partner, or more than one mate, or both. Assuming that this was the case throughout much of human prehistory, selective pressures can be expected to have acted somewhat differently on men and women and produced in them somewhat different sexual proclivities. In *The Evolution of Human Sexuality,* Symons elucidates the evolutionary logic of male-female differences in sexual inclination:

> A male hunter-gatherer with one wife (who will probably produce four or five children during her lifetime) may increase his reproductive success an enormous 20 to 25 percent if he sires a single child by another woman during his lifetime. If he can obtain (and support) a second wife, he may double his reproductive success. The reproductive realities facing his wife are very different. She will bear four or five children during her lifetime whether she copulates with one, ten, or a thousand men. In general, the more men a married woman copulates with (and in a state of nature almost all fertile women are married) the more likely she is to be abandoned or harmed by a jealous husband or angry brothers, the more time and energy are diverted from reproductively significant activities such as nursing, gathering, arranging her children's marriages, etc., and the less likely she is to have an offspring sired in an adulterous liaison with the fittest available man. . . .
>
> Thus selection can be expected to operate in very different

ways on human males and females. Since a man may benefit reproductively from copulating with any woman (except his wife) during her fertile years, and since, other things being equal, the greater the number of sexual partners the greater the benefit, selection universally favors the male desire for a variety of partners, although this desire may be satisfied only rarely. The waning of lust for one's wife is adaptive both because it promotes a roving eye and . . . because it reduces the likelihood of impregnating one's wife at times when an offspring cannot be reared and will have to be aborted or killed at birth. . . .

A woman has nothing to gain reproductively, and a very great deal to lose, by desiring sexual variety *per se*.[26]

As stated, of course, all this is pure theory; and however intuitively obvious it may seem, cannot be accepted as established fact without corroborative evidence. Unfortunately, direct evidence is difficult, since we cannot travel back in time to prehistory to observe firsthand the reproductive behavior of our Pleistocene ancestors. A good deal of indirect evidence, however, does indeed support Symons's analysis. In the past several decades, a number of anthropologists, working among aboriginal peoples that still practice official polygyny, have attempted to determine if there is indeed a correlation between mating behavior and reproductive success. In many cases they have found that such a correlation does indeed exist. Among the Xavante Indians of the Brazilian Mato Grosso, for example, it has been determined that a man with several wives (usually the chief of the tribe) generally leaves more offspring than men with two wives, while the latter are usually somewhat more prolific than men who have only one spouse.[27] In another South American people, namely the Yanomamo, a similar correlation has also been discerned. In this tribe, too, a headman can enjoy enormous reproductive success by attracting a multiplicity of wives and spreading his genes around in a liberal fashion.[28] At least a few such headmen are known to have produced a dozen children or more and scores or even hundreds of grandchildren and great-grandchildren.

Some anthropologists, it should be noted, have expressed their reservations about findings such as these because, they

say, groups like the Xavante and the Yanomamo are sedentary agriculturalists, not nomadic hunter-gatherers, and therefore don't really tell us much about the behavior of prehistoric humans. According to these authorities, in hunting-and-gathering tribes it is rarely possible for a man to obtain sufficient material resources to support more than two wives, and in such societies a man with a multiplicity of mates is an extreme rarity. Their point is well taken, and yet it may nevertheless be the case that tribes like the Xavante and the Yanomamo represent an extreme case of a natural disposition. Even among hunter-gatherers, it has frequently been found that men with two wives usually produce more offspring than men with only one. Meanwhile, it is much more difficult to determine emprically whether monogamously married men generally increase their reproductive success through extra-marital liaisons since such affairs are normally kept secret and therefore hidden from the attention of any resident ethnographer. But it is difficult to imagine how such behavior would not yield at least some reproductive benefit in at least some cases. Once again, Donald Symons explains: "A male obviously stands to benefit genetically from adultery in that he may sire offspring at almost no cost to himself in terms of time and energy, even when he cannot obtain or support additional wives. Males can be expected to experience a persistent, autonomous desire for extra-marital sex because this desire functions to create low-cost reproductive opportunities. . . . Human communities probably always have been complex enough that reproductive opportunities could occur at almost any time to almost any adult male; if the desire for variety were satisfied even once in a lifetime, it might pay off reproductively."[29]

And what about women? Is Symons correct when he suggests that in women a taste for sexual variety might actually be antithetical to evolutionary success? And is it really true that women are basically monogamous by nature? Apparently there is some question about this, and at least one scientist, Sarah Blaffer Hrdy, has expressed some reservations about the matter. In her book, *The Woman that Never Evolved,* she takes issue with some of Symons's contentions about human sexuality in

general and female sexuality in particular and suggests that women might not be quite so monogamous by nature as some male writers have argued.[30] According to Hrdy, there is reason to believe that human females may have inherited at least some penchant for sexual dalliance from their primate forebears. As evidence for her point of view, Hrdy points to several primate species in which females normally copulate with a variety of males, including chimpanzees, barbary macaques, several species of langurs, and a number of others. According to Hrdy, in some primate groups, an adult male is much less likely to attack, abuse, or kill an infant if he believes himself to be the father of that infant, or at least suspects as much. By copulating with several males, then, the female deceives each of her suitors into believing that he is the father of her offspring and thus decreases the likelihood that those offspring will be attacked or murdered. Hrdy then goes on to intimate, in a most roundabout way, that this situation may also have obtained during the formative years of human evolution. Thus, she suggests, it is possible that human females even today still possess some remnant of this promiscuous proclivity, however much it may have been repressed by jealous husbands, who use whatever cultural means they can conjure up, or take advantage of, to sequester their wives from all sexual contact with other men.

Is Hrdy's hypothesis correct? I find it difficult to argue with her, if for no other reason than that she is a woman and therefore undoubtedly understands female psychology much better than I do. And I am willing to entertain the possibility that women might not be *quite* so monogamous as male writers have sometimes implied. It is interesting to note, however, that Hrdy presents relatively little in the way of concrete evidence to support her point of view and openly admits that it is a highly speculative one. Even assuming that Hrdy is at least partly correct, however, I see little evidence that the female proclivity for sexual variety comes anywhere close to matching its male counterpart, and I see a great deal of evidence that it does not. In the course of my researches I have perused at least two dozen ethnographies, and I have yet to find a single society in which women consistently show a greater interest in sexual variety

than men do. (This could of course be due to a reluctance on the part of women to admit whatever promiscuous inclinations they may have. But there is reason to suspect that this is not the whole story.) Apparently other researchers have found the same. On the basis of his survey of the ethnological evidence, for example, the pioneer sex researcher Alfred C. Kinsey came to the conclusion that, in all known societies, whether primitive or modern, "it is understood that the male is more likely than the female to desire sexual relations with a variety of partners."[31] I have sifted through more than a score of sex surveys, including those of Kinsey and Shere Hite, and have not found one in which there is a reversal of these typical male-female feelings on the matter of sexual variety. As I mentioned earlier, in the Hite survey the majority of men said that they were basically dissatisfied with monogamy and that the desire for variety was a major source of motivation in their sex lives. By contrast, almost none of Hite's female informants said that they enjoyed sexual variety for its own sake, and most that had actually experimented with casual sex or 'bed hopping' said that they found it to be very unsatisfying.[32] Many of Hite's female respondents also said that they resented and were angered by constant pressure from men to have sex.

Perhaps one of the most convincing kinds of evidence for a definite sex difference in this regard, as both Alfred Kinsey and Donald Symons have argued, is the intuitive inability of many women to comprehend the male psyche and its craving for sexual variety. In many ethnographic reports and sex surveys, in fact, women have expressed their total bewilderment at the male penchant for sexual experimentation and cannot understand what is the cause of it. Among the Kgatla, for example, a Bantu tribe of South Africa, women accept the fact that men are naturally inclined to be promiscuous, but they nevertheless have a hard time understanding why this should be so. As one Kgatla woman put it, "We wonder what it is that a husband wants, for his wife's body is there every day for him to use."[33] Some Western women apparently have similar feelings. According to Kinsey, many American women find it difficult to understand why any man who is happily married should want to

have intercourse with any female other than his wife.[34] Kinsey himself suggests that this lack of intuitive appreciation on the part of women stems from the fact that they do not share typically male desires, such as the desire for sexual variety, and therefore cannot empathize with them. Some women, indeed, find the male penchant for extra-marital escapade so incomprehensible that they assume it to be some kind of disease. Many female psychologists, for example, still regard male infidelity as a symptom of waning love, or of repressed hostility, or of immaturity. (An alternative possibility, one that is seldom considered by such scientists, is that the male inclination to seek sexual variety may not be a disease, but an adaptation.)

There is yet other evidence that the male 'sex drive' is indeed stronger, more persistent, more autonomous, and more ambitious than its female counterpart. Despite recent trends toward sexual egalitarianism, for example—in education, in the workplace, and in social affairs in general—it is still very much the case that men approach and attempt to make the acquaintance of women (and thus potential sex partners) much more often than the reverse. (An observation of the behavior of men and women at singles' bars can attest to this.) It is still the case that most sexual invitations are extended by men (and not infrequently rejected by women). Most seductions are still attempted by men. Women, far more often than men, complain of sexual harrassment or pressure. Almost all bigamists are men. Almost all prostitutes' customers are men. Almost all rapists are men. Almost all fetishists are men. Almost all voyeurs are men. Almost all exhibitionists are men. Almost all pornography is made by and for men. Among heterosexual men and women, the former much more often than the latter resort to homosexuality as an outlet for their unsatisfiable heterosexual desires. Men, in short, are much more likely than women to seek out sex partners, to initiate sexual activity, and to resort to desperate, illicit, or illegal means to satisfy their persistent and irrepressible sexual cravings.

All this, of course, could be merely arbitrary, I suppose, or perhaps an intentional plot on the part of men to ensure that their sexual desires are never fully satisfied, and that their lives

are as miserable, as degrading, and as expensive as possible. But is it also arbitrary, and not biological, that it is always women, and never men, that get pregnant? Finally, I know of at least one empirical study, conducted in the mid-1980s, in which it was found that women who engage in promiscuous sex actually put themselves at a reproductive 'disadvantage' *vis-à-vis* their more sexually faithful competitors. The survey in question was conducted by two researchers from Southern California, Susan M. Essock-Vitale and Michael T. McGuire.[35] Proceeding from the assumption that there is some connection between a woman's sexual behavior and her reproductive success, Essock-Vitale and McGuire studied this correlation in a random sampling of 300 women from the greater Los Angeles area. The survey group was relatively homogeneous, being all of them white (not Hispanic), all middle class (broadly defined), and all between the ages of 35 and 45. The methodology of the study was relatively simple. Each of the 300 women was interviewed to determine her sexual habits and her reproductive output. Eventually it was found that there were some definite connections between the two. It was found, for example, that (except for women who had had a homosexual affair) it was precisely the most promiscuous women who were the *least* likely to be successful reproductively. By contrast, those women producing the greatest number of offspring (and rearing them to maturity), on average, were those who had had the *fewest* extra-marital partners, if any. Reproductive success also tended to be associated with women who were in a stable marriage relationship and who had a good family income. In other words, care in the choice of a husband and relative sexual fidelity were far better indicators of successful reproduction than sexual promiscuity.

Just why the promiscuous women in this survey should have been less reproductively successful than the others, it is hard to say. And in fact Essock-Vitale and McGuire were not able to determine a definite reason for this result. But they speculate that the matter probably has something to do with the fact that sexually venturesome women are less likely than others to attract and keep a mate and thus to secure from that mate resources that are vital to the production and nurturance of

young. To put the matter bluntly, most men do not consider promiscuous women to be good marriage material, because such women can offer little confidence of paternity to their husband (or potential husband) and are thus more likely to be rejected or abandoned in the long run. Perhaps selection has favored men who avoid being cuckolded by avoiding marriage to sexually unfaithful women, since such marriage tends to be counter-productive to their own reproductive interests. Conversely, if a man has confidence in his paternity, because his wife is sexually faithful, then he is more likely to offer material goods and other assistance to his wife and his joint offspring. For this reason sexually venturesome women may be less likely to keep a husband, and therefore less likely to obtain the male parental investment that may be crucial to the successful rearing of their own children.

Mate Choice and Reproductive Success in Women

The study just cited raises an interesting question: could it be that human females, like the females of other species, have inherited an inclination to be highly selective in their choice of a mate and to prefer, other things being equal, a mate that offers the best genes, or perhaps the best resources, or both? The results of the Essock-Vitale and McGuire study are suggestive. As we have seen, among the 300 women who participated in this survey, those who were most careful in their choice of a husband (those who chose the man who offered the most in the way of commitment and material resources) also tended to be the most reproductively successful. And these findings are by no means unique. Many other surveys, conducted in both modern and aboriginal society, show a definite inclination on the part of women to prefer high-status males, other things being equal, as potential marriage partners. And this should not be surprising. As I pointed out earlier, in many nonhuman animals, females show a definite predilection for certain males over others and often exercise extreme selectivity in their choice of a mate. Typically they prefer a male that offers them the best genes, the

best territory, the best resources. And there is at least some evidence that their selectivity pays off in reproductive terms. It would be odd indeed if human females had not inherited at least some evolutionary proclivity to prefer certain males over others and especially to prefer those males who offer them the best genes or the best resources. Consider this: the human female, like the females of most species, has a limited supply of eggs, a limited reproductive career, and an enormous parental investment in each offspring; thus she constitutes, from the point of view of men, a scarce reproductive resource. The human female, like the females of other species, can well afford to be choosy, and as in other species, if she chooses a male with good resources, she may benefit reproductively from having done so. If anything, selectivity on the part of human females would seem to be even more crucial than it is in other species, because the human infant, compared to that of other animals, is so helpless at birth and has such a prolonged period of maturation.

There was a time in prehuman evolution, many millions of years ago, when paternal care of the young was not nearly so essential as it is today. And in those distant times, the prehuman mother may have been more than capable of providing for her offspring without parental assistance from any male. This situation still obtains among our closest living relative, the chimpanzee. In this species, the mother usually assumes the task of caring for her young quite on her own and receives little or no help from the father. In most cases it is not even known precisely who the father is. This is presumably exactly the situation that obtained during a much earlier stage of our own evolutionary history, when our ancestors were still living in the forest and were still more chimpanzeelike than humanlike. In those days, it may be presumed, mothers provided almost all the parental care, while males busied themselves with other things. In the course of evolution, however, all that changed. As the human lineage began to diverge from the other apes and forge its separate path to the present, at least half a dozen monumental changes took place. Of these by far the most important, and the most characteristically human, was the

explosive expansion of the brain. Probably as a consequence of this peculiar evolutionary development (or perhaps for other reasons), there was a considerable prolongation of the period of intellectual maturation and thus a proportionate prolongation of the period of infant dependency. As a consequence there was an enormous increase in the need for parental care of the young. At some point in human evolution, that need became so crucial that it could no longer be met by the mother alone. She needed help. And the very fact that the human race survives is proof that she must have got it. And whom did she get it from? Perhaps at first from close kin, such as sisters and parents, but eventually, it seems, the father of the child was increasingly brought into play to provide the necessary parental assistance.

Just how prehistoric women first acquired the trick of securing and keeping mates is anyone's guess. Quite a few ingenious theories have been proposed to account for the origin of human mating systems. One common suggestion is that women began to offer sexual favors, and perhaps exclusive sexual privelege, to a particular man in exchange for his conjugal and parental aid. In conjunction with this strategy, the female may have lost her oestrus cycle, so that she remained more or less continuously attractive and copulable to her mate. This would have made possible (and perhaps necessary) more frequent sex, and thus a more continual supply of provisions from the male. But however it happened, it is almost certain that the adoption of this strategy had some crucial effects on the subsequent evolution of the female psyche. Women seem to have inherited a tendency to reject sexual advances from men who are unwilling (or unable) to offer them anything in the way of emotional or economic commitment. Also, human females have apparently inherited a greater inclination than men to choose a partner on the basis of the latter's ability to provide economic support and to discriminate against potential mates who possess little or no economic prowess. In conjunction with this, women seem to have evolved the capacity to distinguish a potentially good provider from a poor one and to prefer, other things being equal, the former. For this reason women today are at least somewhat more selective than men when choosing sex

partners and highly discriminating in their choice of a potential mate. This sort of selectivity is still very evident in both aboriginal and modern cultures.

Women do not always have the privilege of choosing their husbands freely. In some societies, especially preliterate ones, marriages are arranged, and each woman is more or less obliged to accept the man to whom she has been betrothed by her parents or other relatives. In many societies, however, women make this kind of decision on their own; and even in cultures with arranged marriages, there is evidence that a girl can sometimes strongly influence just whom her parents choose for her. It is not uncommon in such societies for a woman to elope with, or carry on a clandestine affair with, the man of her own choosing. Women rarely if ever select their paramours on a completely indiscriminate basis. In general, a woman does not accept a marriage proposal, or for that matter even a casual invitation to share an evening, from just any man who cares to make the offer. The specific criteria by which women exercise their discriminatory prerogative are many and varied, and include such things as physical appearance, personality, common interests, and so forth. But these, apparently, are not the only measures of a man's romantic or sexual desirability. When given the choice (once again, other things being equal), women usually prefer males who control the best possible resources.[36] In society after society, primitive and modern alike, socioeconomic status is a prime measure of a man's sexual attractiveness and desirability. Throughout the world women customarily marry men of equal or greater economic standing than themselves—a practice that is so common that it has acquired a name: *hypergamy*. And this strategy seems to have some definite adaptive benefits. Especially in preliterate society, there is evidence that women who marry high-status men tend to enjoy better reproductive success than other women. Even in modern society, where the adaptive value of hypergamy has been mitigated by such things as social welfare programs (which often make it possible for the poor as well as the rich to bear and rear children), the practice of 'marrying up' has by no means gone completely out of style. As many studies show (including

that of Essock-Vitale and McGuire cited earlier), hypergamy can still have adaptive benefits.

Female Choice and Male Frustration

When female elephant seals gravitate toward dominant males and reject the sexual advances of subordinates, they are no doubt serving their own genetic interests well. And when female bowerbirds select males with the most elaborate bowers, they are perhaps promoting their reproductive success as best they can. But one of the unfortunate consequences of this sort of female choosiness is that it produces a lot of involuntary celibacy in the male population. In Northern elephant seals, almost all the mating is done by a few dominant males, and most males are condemned to a more or less celibate existence on the periphery of the herd. Similarly, among bowerbirds, a small number of males usually monopolizes the entire female population, leaving those males with the poorest bowers to suffer sexual disenfranchisement. The exercise of female choice in humans often produces similar results. Especially among aboriginal peoples where polygyny is still in practice, hypergamy tends to produce a class of sexually disenfranchised and therefore frustrated males at the lowest rungs of society. In such tribes the least successful hunters are usually debarred from marriage entirely, while the most successful not infrequently attract a multiplicity of mates.[37] In modern society, where monogamy has become the legal norm, a somewhat smaller percentage of males is debarred completely from courtship and marriage. But even in the modern world, if a man is poor enough, destitute enough, or unsuccessful enough, he may experience considerable difficulty in attracting, securing, and keeping a mate. If a man cannot even earn enough money to go out on a date, then he is at a great disadvantage in the sexual marketplace. (A woman who is equally poor is not necessarily debarred from dating or sex.) In sum, because women tend to 'marry up', economically deprived males tend to be sexually deprived as well. In his book, *Down and Out in Paris and*

London, George Orwell has explored the implications of this unfortunate state of affairs. Describing the life of the English tramp, Orwell notes that, below a certain economic level, society is exclusively male, and that, because tramps usually don't even have enough money to feed themselves, they are almost entirely cut off from intercourse with women, both social and sexual:

> . . . any presentable woman can, in the last resort, attach herself to some man. The result, for a tramp, is that he is condemned to perpetual celibacy. For of course it goes without saying that if a tramp finds no women at his own level, those above—even a very little above—are as far out of his reach as the Moon. The reasons are not worth discussing, but there is no doubt that women never, or hardly ever, condescend to men who are much poorer than themselves. A tramp, therefore, is a celibate from the moment when he takes to the road. He is absolutely without hope of getting a wife, or a mistress, or any kind of woman except—very rarely, when he can raise a few shillings—a prostitute.

Of course most men are not tramps. But most are not opulently rich either. And even the wealthiest and most attractive men are not always able to satisfy their every sexual urge without difficulty. In fact it is probably safe to say that a majority of all men's sexual advances are rejected, especially those not backed up by the promise of emotional and/or economic commitment. One result is that almost all men are obliged to endure occasional 'dry spells', during which they obtain little or no sexual gratification at all. And as a consequence they suffer from 'sexual frustration', a condition which seems to be primarily a male prerogative.

Male Sexual Frustration

The term 'sexual frustration' is difficult to define, but the condition it is meant to express seems to be a reality, and there is general agreement that sexual frustration, however one chooses to define it, is much more a male reality than a female one. It is a

popularly held belief, both in our own culture and in many others, that men are much more likely than women to experience feelings of sexual deprivation when they are without sexual opportunity for extended periods of time. Much scientific evidence tends to support this popular belief. In the Hite survey, the vast majority of female respondents said that they experienced little or no discomfort when they were obliged to do without sex for long periods of time.[38] A few women said that they actually thrived on sexual abstinence and that the 'freedom' from sexual responsibility was something of a relief to them. In sharp contrast to this, almost none of Hite's male informants said that they enjoyed sexual abstinence; only a few said that they didn't mind it; and most said that they regarded it as a major source of frustration and suffering in their lives—something to be avoided at all costs.[39] These sentiments, moreover, seem to be widespread across time and cultures. On the basis of his extensive cross-cultural research, anthropologist William Davenport has come to the conclusion that "in all societies, some individuals experience extreme sexual frustration, either because a desired partner is legally forbidden, inaccessible or is not equally interested. Usually, as with the comparative strengths of sexuality that are ascribed to the sexes, it is men who appear more frequently to be the sufferers in these dire situations."[40] Even female writers, who often seem disinclined to acknowledge the existence of any peculiarly male form of suffering and hardship, have on occasion conceded the predominance of sexual frustration among males. In her book, *The Sex Game*, for example, Jesse Bernard writes that "women are just as 'sexy' as men . . . But not necessarily in the same way. They appear to have greater tolerance than men for long periods of sexual deprivation."[41] Along similar lines H.J. Eysenck and Glenn Wilson have noted that "whereas the sex drive of the male is a steady imperative, women may have the capacity to turn off and become sexually quiescent for a long time if they are without a partner. This kind of variability in the female sex drive according to current biochemical and environmental conditions has frequently been postulated by keen

observers—for example, it is widely supposed that women make better nuns than men do priests.''[42]

Men are not always able to endure their sexual frustration quietly and stoically. Some have apparently resigned themselves to the fact that their sexual desires are simply too ambitious to be fully satisfied and have either cultivated the ability to suppress those desires to a subliminal level or found some other non-sexual outlet for their energy. But others are less resigned, and for them sexual gratification of some sort is imperative, even if it involves resorting to desperate or unusual means. Such men may, of course, enlist the services of professional prostitutes, at least whenever the latter are available and can be afforded. Less frequently, they may turn to homosexuality or some brand of fetishism as an outlet. Or, even more rarely, they may rape.

Rape, Violence, and Sex

In recent years it has come to be popularly believed that rape is not motivated by sexual desire, but rather represents an attempt on the part of men to dominate, terrorize, or humiliate women. (Susan Brownmiller, author of *Against Our Will,* is perhaps the best-known advocate of this point of view.) The evidence that has been adduced to support this hypothesis, however, has always been rather tenuous and has repeatedly been challenged by scientists from a variety of fields. Unfortunately, the idea that rape is primarily a crime of violence, rather than of sex, has considerable popular appeal—especially among women who, understandably enough, see nothing sexual about it. Thus it is not surprising that the idea has been so readily and uncritically accepted by a large segment of the general populace, especially the female populace. In the meantime, the obvious sexual components of rape have alternately been written off as 'merely' secondary or facilely dismissed as inherently improbable. But as I shall show, the sexual motives of rape are anything but improbable, and the alleged 'functions' of rape as a weapon of intimidation, or as an abstract expression of male dominance, are at best questionable.

In the opening chapter of *Against Our Will,* Susan Brownmiller writes: "From prehistoric times to the present, I believe, rape has played a critical function. It is nothing more or less than a conscious process of intimidation by which all men keep all women in a state of fear."[43] Perhaps the most straightforward objection to this hypothesis is that it leaves quite unexplained the sexual penetration which, by definition, is an integral component of every act of rape. If it is true, as Brownmiller suggests, that rape has nothing whatever to do with sexual desire, then why should the rapist bother to make an attempt at sexual penetration at all? Since there are many ways that a man can terrorize a woman without necessarily engaging her in sexual intercourse, no explanation of rape is adequate unless it accounts specifically for the rapist's decision to use sex, rather than some other means, to accomplish his ends. And this Brownmiller's thesis does not do. Another objection to her hypothesis is that it dismisses far too lightly the very possibility that men might ever consider taking sex by force. The idea that rape is *never* motivated by sexual desire seems to me to imply the validity of at least one of the following three propositions: 1. that no man ever experiences sexual desires that he is unable to satisfy in a completely legitimate fashion; or 2. that no man who experiences sexual desires that he cannot satisfy legitimately ever considers the possibility of taking sex by force; or 3. that no man who considers the possibility of taking sex by force ever actually does so. All three of these propositions strike me as being extraordinarily improbable. Just what reason do we have to suppose that sex is somehow different from any other thing which men desire and, on occasion, take by force? I see no reason for such a supposition. On the contrary, since sex is one of the *most* desirable things that men desire, one would expect their motivation to take sex forcibly to be, if anything, greater than their motivation to take other things. And there is hardly any other thing which they do not on occasion take by force. Perhaps we would all like to believe otherwise, but a sober study of history and ethnography clearly shows that whenever men are unable to get what they want or need by legitimate means, they at least consider

the possibility of taking what they want outright, with or without the owner's consent. Whether the desired commodity be money or property or food or sex, there is always the possibility that men will resort to desperate means to attain their ends whenever more legitimate methods fail.

There are yet other objections to Brownmiller's thesis. For example, in the preface to her book, she suggests that rape is an exclusively human phenomenon. This contention, apparently, is intended to lend credence to the idea that rape is primarily an expression of power and dominance and that it has little to do with the disparity between the sexual inclinations of men and women. As Brownmiller apparently realizes, if it can be shown that rape does not occur in nature, where the sexual proclivities of males and females are often widely divergent, then there is little reason to suppose that human rape is a function of the disparity between male and female sexual appetites. But is rape exclusively human? Much recent scientific evidence suggests that it is not. And many experts now believe that rape-like behavior may actually be a widespread pattern in the nonhuman world. Throughout nature, females have been observed to resist sexual advances with varying degrees of intensity; and males have been observed to persist despite such resistance. Patterns of this sort are now known to occur in a great variety of species, including scorpionflies, swallows, gulls, herons, albatrosses, ducks, orang-utans, chimpanzees, and rhesus monkeys.[44]

Human behavior is extremely complex, and it is probably true that rape, like any other human behavior, is influenced by a complex mixture of motives. But it is probably also true that a desire for sexual gratification, as often as not, is a part of that mixture. An autonomous urge to intimidate or terrorize may in some cases also be involved; but I see little reason to suspect that it is the *only* or even the primary factor. It is true that most rapists use violence (or the threat of violence) to subdue their victims, but then, how else would they accomplish their act? If they displayed no inclination whatsoever to use force of any kind, then most intended victims would simply walk away, and there would be no rape. Indeed, by its very definition *forcible*

rape involves the use of force; so to argue that because force is always involved, therefore sex is not the issue, is in effect to argue that obtaining sex in this way is not even a theoretical possibility, and that all human behavior is motivated by means rather than ends. One might just as well argue that because prostitutes always charge a fee for their services, therefore men who frequent prostitutes must be motivated by a desire to spend money, rather than by a desire for sex. Or consider by way of analogy other crimes that are far more often committed by men than women. Is it not true that most armed robbers, kidnappers, and extortionists—once again, almost by definition—use violence (or the threat of violence) to subdue or intimidate their victims? Yet I do not know of anyone who has seriously suggested that armed robbery, kidnapping, and extortion are motivated primarily by an autonomous desire to intimidate rather than by a desire to gain access to the booty which the perpetrators of these crimes have found to be inaccessible through more legitimate means. Is it so unreasonable to suggest that rapists, too, use violence primarily as a means to an end, rather than as an end in itself? Even if we assume that many or even most rapists are motivated by a genuine anger with women, and a desire to terrorize or humiliate them, this does not necessarily mean that their sentiments are completely unrelated to sexual emotion. It may very well be, after all, that the rapist's generalized anger with women stems ultimately from his inability to get from them the sexual gratification that he so fervently craves. Even a rape that is motivated entirely by a desire to degrade and humiliate (if there really is such a thing) may ultimately have its roots in sexual conflict.

From the point of view of the victim, rape is almost always more violent than sexual in nature (just as, from the point of view of the victim of an armed robbery, the act is more violent than 'financial'), and most women probably find it difficult to appreciate intuitively how a sexual desire could possibly result in a forcible rape. Hence the popular female consensus that rapists are not impelled by sexual motives. When rapists are allowed to speak for themselves, however, they often contradict this consensus. Several of the men who responded to the Hite

survey, for example, said that they had either committed rape or contemplated the possibility of doing so. Of these at least a few said that they were motivated *entirely* by sexual desire. And many others said that sex was very much a part of what propelled them, even if it was not the whole story.[45] Moreover, many of those who had actually committed rape said that they had chosen as their victim specifically someone who had rejected them *sexually*. One man provided the following incidental insights into the sexual (and possibly adaptive) nature of forcible rape: "Rape behavior in males today probably exists because it has been selected for . . . in the Darwinian model of natural selection; as much as our contemporary society despises the rapist, we must admit that in man's history the rapist's genes were naturally selected because the behavior had survival value."[46]

This may or may not be literally true, and scientists are still disagreed as to whether human rape is really adaptive in the Darwinian sense. Perhaps it is; perhaps it isn't. The matter is still being debated, and both sides have made some good points. It may well be, as some scientists have suggested, that the rapist does not really improve his evolutionary success through his sexually aberrant behavior—but it has yet to be shown conclusively that he doesn't. And until such proof is forthcoming, emotional rejections of the possible adaptive significance of rape remain just that—emotion, not disinterested science. (Rape, of course, is an issue about which it is very difficult to be disinterested.) It would be quite wrong to suggest—and I certainly do not wish to imply—that men possess a rape 'instinct'. But men sometimes (if not always) exhibit a tendency to resort to desperate means when they are unable to satisfy their natural desires in legitimate ways, and this seems to apply as much to sexual desires as any other kind. Rape is not an isolated thing-in-itself—a *sui generis* phenomenon that is somehow explicable in terms that ignore the greater context of human sexuality. Rape is but one expression of the conflict between male and female sexual desires. We may some day be able to eliminate rape entirely, but by so doing we will not necessarily have eliminated the underlying disparity between

male and female sexual cravings. In a rapeless society, sexual conflict might very well make itself all the more conspicuous in other ways. Unless male and female sexual inclinations can somehow be brought into closer harmony with each other, some degree of male sexual frustration and/or sexual aggression is likely to continue. In the meantime, those who deny the sexual aspects of rape might only mislead efforts to control or eradicate it and might actually be contributing, however unwittingly, to its prolongation.

Intrasexual Competition among Humans

Rape is by no means the only form of violent behavior that has its ultimate roots in sexual conflict. There is also intrasexual competition—competition among men for access to desirable women. And this seems to be yet another source of conflict and aggression in human affairs. Donald Symons has gone so far as to suggest that intrasexual competition is the single most frequent cause of violent behavior throughout the aboriginal world, and in his *Evolution of Human Sexuality,* he presents an impressive array of empirical data in support of his point of view.[47] According to Symons, an examination of the ethnological literature reveals that, in society after society, from the Eskimos of Pelly Bay to the Mundugumor of New Guinea, the great majority of disputes and conflicts are directly or indirectly sparked by competition over women. And he presents some evidence to suggest that, in aboriginal society in general, as much as 20 to 25 percent of all men are killed as a consequence of such competitive struggle.

Almost without doubt the most extreme example of intrasexual competition known to ethnography occurs among the Yanomamo Indians, who inhabit the dense tropical forest along the border between Venezuala and Brazil. In this tribe violent competition over women is virtually epidemic, and it occurs in myriad forms, ranging from personal duels to open inter-group warfare. Few if any Yanomamo are completely unaffected by the violence that has become such a trademark of their culture.

Most actively participate in it on a more or less regular basis. And all Yanomamo men seem to be agreed that fights over women are the primary cause of their disputes and their frequent wars. (Actually, there is some evidence that competition for desirable land is also involved, although the Yanomamo themselves may not wish to admit this.) According to Napoleon Chagnon, the American ethnographer who has spent many years living among and studying the Yanomamo, conflict among these people usually breaks out when one man is discovered trysting with another man's wife. In such a case the aggrieved husband normally responds by challenging his opponent to a duel. This usually means a club fight, during which the two men take turns striking each other on the skull with heavy ten-foot poles. As soon as blood starts to flow, almost every man in the village chooses sides and joins in the skirmish. If someone is badly injured in one of these fights, the hostilities may escalate into full-fledged war. More commonly, war breaks out when one group levels charges of sorcery against another. Or a group of men may start a war for the express purpose of trying to abduct women. Whatever the original cause of the war, however, the men always hope to acquire women as a side benefit. At all events, Yanomamo warfare, even by our standards, is tremendously destructive. According to Chagnon's estimates, fully one-fourth of all Yanomamo men die as a direct result of violent competition.[48]

The Yanomamo are an extreme case. I do not know of a single tribe anywhere on Earth in which intrasexual competition is quite so intense or so deadly. But on the other hand, such competition is by no means atypical either. In fact open disputes over women are fairly routine in a wide range of aboriginal societies throughout the world. Even the Eskimo, who are sometimes depicted as being unusually peaceful, are not always averse to fighting when access to women is at stake. Much historical and ethnographic evidence suggests that, among certain aboriginal Eskimo tribes, competition over women once constituted a major catalyst leading to violence. This for example seems to have been the case among the Netsilik tribe, who have been studied and written about by, among others,

Asen Balikci.[49] According to Balikci, intrasexual competition was often quite violent in Netsilik society, and such things as husband-murdering and wife-stealing were once common among them. He notes that travelling couples were particularly vulnerable to this kind of predation: typically the man would be killed and his wife (or wives) abducted. In most such cases, Balikci notes, the decision to kill was quite deliberate, and the murder itself meticulously executed. In one such instance, described in some detail in Balikci's book, *The Netsilik Eskimo*, a young bachelor named Oksoungutaq and his brother-in-law, Ikpagitoq, plotted to kill a stranger named Saojori, who had come into their area sporting a pair of wives. One morning the two conspirators approached Saojori, who was in the process of catching a seal. As the latter knelt down at the edge of a beach, Ikpagitoq and Oksoungutaq attacked him, stabbing him repeatedly until he had died. Later that day, one of Saojori's wives, frightened and disconcerted by the news of her husband's death, tried to run away. But Oksoungutaq had no trouble catching her and soon thereafter made her his wife.[50]

Coolidge's Law

In *The Evolution of Human Sexuality* Donald Symons has, I think, captured the essence of the most fundamental irony of human sexuality. Most men, he writes, would like to have sex with many women, but it is very difficult for them to do so. Most women could easily have sex with enormous numbers of men, but don't want to. This "biological Catch-22", as Symons calls it, has its ultimate origins in reproductive competition. One expression of this Catch, Symons writes, is 'Coolidge's Law', which he states thus: "With respect to those areas of life in which intense reproductive competition has occurred in ancestral populations, it is relatively difficult to get what you want and relatively easy to get what you don't want."[51] Indeed, he goes on, "it was the difficulty of 'getting' that led to selection for 'wanting'. There has been no reproductive competition over access to oxygen, and hence—although we require it to survive

—oxygen is obtained unconsciously: we don't have to want it to get it." But sex, of course, is a very different matter. Unlike oxygen, sex has never been so readily available or easily obtainable—especially not for men. Generally speaking, men have never been able to get sex without wanting it, and the result is that they still want it more than they get it. Women, in the meantime, are no less victims of Coolidge's Law, albeit in a very different way. For women, wanting has never been so essential, since for them the 'getting' has always been inherently easier. But an unfortunate consequence is that most women continue to be bothered by redundant sexual advances which are of absolutely no use to them. And they are much more likely than men to be the victims of sexual aggression.

But perhaps all this is wrong. Perhaps I am mistaken and Symons is mistaken, and those social scientists are correct who say that men and women are psychologically identical by nature and have only been driven apart by cultural expectations that promote sex differences in attitude inclination, and behavior. Perhaps, as these scientists seem to believe, humans are so stupid (or so masochistic) that they have inadvertently (or intentionally) created sexual conflicts so as to make their lives as difficult and as painful as possible. But even if they are right, this does not leave evolution off the hook as the ultimate culprit. Evolution is still the ultimate cause of the problem, because it created sexuality in the first place (without which there would be no sexual needs, no sexual frustration, and no sexual conflicts) and because it created the adaptability, and hence the maladaptability, which allows men and women to develop such disparate sexual inclinations as they actually exhibit.

Chapter Nine
The Social Creature

We find ourselves in a curious double-bind vis-à-vis *our colleagues and our society. While we need society in order to function successfully, society itself cannot work effectively unless its members restrain their self-seeking impulses. Society therefore requires that we set aside at least some portion of our individuality, if the larger human unit is to function at all. The result is conformity, by which we all in a sense perjure ourselves simply because "no man is an island."*

David Barash

Man is not willingly a political animal. The human male associates with his fellows less by desire than by habit, imitation, and the compulsion of circumstance; he does not love society so much as he fears solitude. He combines with other men because isolation endangers him, and because there are many things that can be done better together than alone; in his heart he is a solitary individual, pitted heroically against the world. If the average man had had his way there would probably never have been any state. Even today he resents it, classes death with taxes, and yearns for that government which governs least. If he asks for many laws it is only because he is sure that his neighbor needs them; privately he is an unphilosophical anarchist, and thinks laws in his own case superfluous.

Will Durant

One of the most obvious facts about human beings is that they are social animals. Indeed, sociality is perhaps the most fundamental of all human universals. Everywhere humans live in social groups of one kind or another, ranging in size from tiny hunter-gatherer bands of 30 or 40 members to huge nation-states of several hundred millions, and within those groups they engage in social relationships of dozens of different sorts. In some societies, the prevailing social structures are so complex that they defy description, even by trained professional ethnographers. In others, they are less complicated and easier to

delineate. But they are always significant, and they always form a major component of the group's cultural inventory. Clearly, sociality is a basic fabric of human existence. And gregariousness is as much a part of man's nature as are his consciousness, his sexuality, and his intelligence.

Humans are by no means unique in this respect. Social behavior is one of the most commonplace features of animal existence. It has evolved independently in dozens of lineages and in a vast array of ecological contexts. The great majority of vertebrate species exhibits some form of co-operative behavior, as do many insects, including wasps, bees, ants, and termites. Everywhere animals live in communal groups of one sort or another, and engage in many of the same types of social interaction that characterize human society. Birds live in flocks, insects in swarms, fish in schools, mammals in herds or packs. A truly solitary animal, like the mountain lion or the moose, is relatively uncommon in nature.

Why have so many animals become social? And what is the adaptive value of living in groups? The first of these questions is the more difficult to answer, since we have only indirect evidence, in most cases, and because we cannot travel back in time to observe the origins of sociality firsthand. Circumstantial evidence suggests, however, at least three possible routes from a solitary to a more social way of life. In some cases, especially among single-celled organisms, an individual may be more or less forced into sociality for the simple reason that it cannot separate itself from its fellows. Among bacteria, for example, reproduction normally occurs when one cell simply fissions into two, after which each goes it separate way. In some instances, however, the two 'daughter cells' may stick together after reproduction, thus forming a rudimentary social group. If after further reproduction the cells continue to coagulate, they may eventually evolve into a much larger society, consisting of hundreds, thousands, or even millions of individual cells. Alternatively, two or more organisms may stay together in a group because each is so closely related to the others that each serves its own genetic interests by helping its relatives to reproduce as well as by reproducing itself. This arrangement is technically

referred to as 'kin selection', and is now known to be a widespread phenomenon in the organic world. Kin selection reaches its most elaborate form in the so-called 'eusocial' species, which include many kinds of insects and at least one mammal, namely the naked mole rat. Finally, two or more distantly related or even unrelated individuals may come together in a social unit if by so doing they can accomplish some task that no individual could ever manage on its own. If the task at hand becomes crucial to the survival and reproductive success of its practitioners, then the latter may be more or less obliged to give up their independent existence and take up social living as a full-time pursuit. At this point the animal will have crossed the threshold from solitariness to sociality, and only a reversal of the environmental trend that encouraged its social development in the first place can cause it to revert to a more solitary way of life.

This immediately brings up the question as to what sorts of environmental circumstances tend to encourage social grouping in unrelated or only distantly related individuals. There are apparently not a great number of these, but each of them occurs rather frequently in nature, and this is perhaps one of the reasons that sociality has become such a commonplace phenomenon in the organic world. In the third chapter of his monumental book, *Sociobiology: The New Synthesis*, Edward O. Wilson discusses some of the various ecological factors that have tended to induce the evolution of sociality in animals and man. Among the 'prime movers' of social evolution, according to Wilson, are: 1. defense against predators; 2. increased competitive ability; 3. increased feeding efficiency; and 4. increased reproductive efficiency. Let's take a look at several of these factors in turn to see just how they have encouraged social evolution, and then go on to consider some of the many repercussions that such evolution has had for animals in general and for humans in particular.

Defense Against Predation

Consider, first of all, defense against predators. By all accounts, this is one of the most important ecological determinants leading to social evolution. In fact such diverse species as baboons, caterpillars, baitfish, and humans have all found some kind of adaptive benefit in grouping together to defend themselves against their enemies. In the case of baboons and other ground-living monkeys, the need for group defense seems to have come about as a consequence of their shift in habitat from the forest to more open country, where they are much more highly exposed to the danger of feline predation. In their open country environment, baboons not infrequently come into contact with leopards, lions, and other stealthy killers. As such they are under a more or less continual threat of attack. In response they have apparently developed a number of behaviors designed to cope with this threat.[1] Perhaps the most straightforward (and most frequent) of these is flight. As often as not, when a group of terrestrial monkeys is foraging on the forest fringe, or near a clump of trees, and a cry of alarm goes up from one of its members, the whole group quickly scampers up into the trees and out of harm's way. When a troop is foraging in more open country, however, away from the convenient refuge of the trees, it must resort to a more confrontational strategy. When such a troop is approached by a leopard or other feline, a group of adult males may band together in a show of force and attempt to repel the oncoming intruder. If the latter is sufficiently impressed, he may simply withdraw without so much as a fight. On the other hand, if he is undissuaded and continues his advance, he may be mobbed from all sides by perhaps half a dozen monkeys and may be bitten and slashed repeatedly by his would-be victims. If he is not careful, he may even become the victim himself. In fact there are at least a few documented cases of a leopard sustaining fatal injury at the hands of—or more correctly, at the teeth of—an angry mob of baboons.

Just how frequently baboons have to resort to this kind of confrontational strategy, it is not at all clear. And primatologists are disagreed concerning how significant a role the threat of

feline predation plays in the everyday life of these terrestrial monkeys. In fact only on rare occasions have leopards been observed to attack baboons, and in general they seem to prefer other prey, especially the kind that does not fight back. Observations such as these have led some primatologists to the conclusion that group defense in baboons is not really an evolved strategy at all and is not the principal impetus behind their social living. Rather, these experts contend, baboon defense is nothing more than an incidental by-product of group cohesion that originally evolved to serve some other purpose entirely. On the other hand, it may well be that baboons seldom fall victim to feline predation for the precise reason that they have developed such an effective strategy for warding it off. Or it may be, as at least one primatologist has suggested, that the principle predators of African primates are actually other primates, rather than felines.[2] And species like baboons, vervets, and chimpanzees may have evolved their social habits, not to defend themselves against lions or leopards, but rather to defend themselves against one another. Or it may be that social living evolved in these species so that each group could defend itself against competing groups of its own kind. We have seen that chimpanzees sometimes gang up to kill other chimpanzees and that such attacks are especially likely to occur when the victim has been caught on its own, away from the protective safety of its group. Whatever the original impetus for group living may have been in African primates in general, and in the terrestrial baboons in particular, these animals on occasion use group defense as a means of self-protection in the predator-rich environs of the African woodlands and savanna.

Meanwhile, among other plains-dwelling mammals, adaptive strategies of group defense are less equivocal. Consider for example the musk ox and the North American elk, both of which are susceptible to predation from wolves. When a group of musk oxen is approached by a hungry canine, the former will set up what is called the 'perimeter defense'. In this pattern a small number of adult males—perhaps four or five—remains standing at the perimeter of the herd, facing the wolves. The

remainder of the herd may simply lie down and rest, usually forming a protective flank around the calves. If a wolf should manage to break through the perimeter and try to attack one of the calves, all the adult oxen jump to their feet and try to drive off the predator. In most cases they are successful, and the wolf flees. Similar modes of defense are also practiced by the eland (a giant African antelope) and the water buffalo of Asia.

The other species of social ungulate mentioned above, the elk, usually protect themselves by grazing in what is known as the 'windrow formation'. In this strategy, the elk spread out in staggered rows which present a broad front to the wind, so that they can detect the scent of predators from one direction while maintaining visual surveillance in nearly all others. Sometimes 'calf pools' are formed in the meadows, with one or two cows alternately guarding the calves while the others move off at intervals to graze. A comparable form of group surveillance is employed by red deer. When these animals rest together, they form a rough circle facing outward, so that approaching predators can be seen from any direction.

In some instances, animals group together not so as to be able to ward off predators, but because by grouping together they decrease the likelihood that they will be encountered by predators at all. It is for this reason that many fish swim in large aggregates known as schools. Apparently most marine predators have no way of tracking their prey, and must depend on chance encounters with the latter in the course of random searching. Otherwise they would not be able to feed at all. The adaptive response of the prey species is to coagulate into larger and larger schools, thus increasing the distance between schools, and decreasing the likelihood of chance encounters with predators. The result is that each individual gains an added degree of safety simply by remaining close to the group. Meanwhile a similar strategy has been adopted by some land-living species, some of which live in groups that maintain more or less constant mobility.

Among birds too there are many species which increase their resistance to predation by forming social aggregations of

various kinds. When flying in groups, starlings usually respond to the sighting of a hawk or a peregrine falcon by drawing close together in a dense formation. Such a formation is dangerous to the falcon, which normally takes its prey by stooping with great speed—it risks injury or even death if it collides with any birds other than the target, because its body is very fragile. In order to secure its prey, the falcon must usually carry out a series of sham attacks, until one of the starlings temporarily loses contact with the others because it has swerved the wrong way. Then a real swoop is executed. The adaptive value of starlings' flocking behavior is perhaps even better illustrated by their reaction to the presence of a sparrow hawk. In such an event, if the starlings are flying above the hawk, and thus out of harm's way, they remain relatively dispersed. It is only when the hawk flies *above them* that they assume a tight formation.

Yet another way for social animals to avoid predators is to use marginal individuals of the group as a kind of shield. Since predators normally strike the first individual they encounter, those at the center of the group are much less likely to be taken. It is apparently for this reason that many species have evolved a so-called 'herd instinct', the function of which is to impel individuals to seek the relative safety of numbers and, where possible, to gravitate toward the center of the social group. This kind of behavior is especially common among plains-dwelling mammals, like wildebeestes and zebras, which are more or less continually susceptible to predation. But it also occurs among fish, squid, birds, insects, and many other species.

Predatory Efficiency

On the other side of the coin, predators can often find some benefit of their own in group living. In fact many predatory animals are highly social and depend almost entirely on co-operative hunting techniques for their survival. A good example is the North American wolf. Like most social carnivores, wolves hunt much more effectively when they do so in groups. And this

is true almost everywhere wolves live, and whatever the nature of the prey they pursue. In Alaska, for example, the wolf's principal large prey is Dall's sheep, but this animal is very elusive and is captured only with great difficulty. When a lone wolf stalks a Dall's sheep, it is usually unsuccessful; the sheep is a much better climber and easily outdistances the wolf by running up a slope. But when wolves pool their efforts they are able to hunt with much greater success. Acting in tandem, two or more wolves can spread out and maneuver the sheep into a downhill race or force it out onto flat land. In this way the wolves gain the advantage and in so doing greatly increase the likelihood of capture. In another locale, Isle Royale National Park of Michigan, wolves hunt in packs in order to bring down large game like moose. No single wolf is big enough or strong enough to kill an adult moose, but when the moose is attacked *en masse*, it can often be subdued.

Another carnivorous species that hunts socially is the African wild dog. In fact this animal is totally dependent on co-operative hunting, since individuals are much too small to bring down the kind of large game that is available to them. When hunting, a pack of African dogs usually takes aim at a single animal and chases it at full speed. Sometimes the prey animal will circle back—a strategy that can be effective against a lone pursuer. But this maneuver is usually fatal when used against a wild dog pack: the dogs lagging behind the leader simply swerve toward the turning animal and cut off its escape. Once they have caught up to their quarry, the dogs seize it on all sides and quickly rip it to pieces. Afterwards they band together to protect their catch against hyenas, which often follow the dogs and try to steal their food. For the African wild dog, co-operative behavior is required not only to capture game, but also to protect it against scavengers. And the same, in turn, applies equally to hyenas. These animals, too, are highly social, hunting in packs and remaining together to protect their quarry from lions and other competitors.

The African lion is a prodigious hunter and a highly social one too. Unlike most other felines, which are essentially solitary in their habits, African lions almost always live in hunting

groups. It appears that they have become too large to depend on speed and stealth alone, which are the hallmarks of most other feline predators, and have turned to social hunting as a substitute. When a group of lions approaches its prey—a herd of wildebeest, for example—the individuals usually fan out along a broad front, extending laterally for perhaps a couple of hundred yards. As they get closer to their quarry, the lions in the middle either halt or slow their advance while the others walk rapidly to their positions on either flank. Then they all move forward in tandem. As soon as the wildebeest become aware of the lions' presence, they become frightened and scamper in all directions to avoid attack. This usually brings them right into the path of one of the surrounding lions. As soon as a catch is made, all the lions converge on it and help kill it. Through their concerted efforts, the lions are thus able to bring down much game which might otherwise elude their individual pursuits.

Increased Competitive Ability

Social grouping can also be 'advantageous' when members of the same species must compete for access to territory or resources. In such cases individuals may combine their efforts in order to fight off competitors. Two individuals that share a territory, for example, can almost always defeat a lone challenger. And a group of three or more is usually able to win out against a single pair. In sum, groups can generally be expected to prevail against individuals, and larger groups against smaller ones. Thus wherever intraspecific competition is significant, selection can be expected to favor not only social behavior but also large group size. Consider as an example the rhesus monkey of northern India. When competing groups of this species come into contact, they usually fight each other for the possession of territory. In almost all such cases it is the smaller group that gives up first and retreats. A similar pattern has been observed among wolves, baboons, and many other species.

Increased Feeding Efficiency

In some cases—especially those involving insectivorous and herbivorous species—social co-operation can lead to enhanced feeding efficiency. This is because, in general, flocks are better able than individuals to find food and may also be able to harvest it more effectively. Some insectivorous birds, for example, stir up their prey by flapping their wings in the grasses where flying insects hide. By foraging in flocks, they are able to stir up a much greater number of insects per bird than could scattered individuals working each on its own. Among the many birds that practice this kind of group foraging are cattle egrets, anis, parulid warblers, tyrannid flycatchers, and ant thrush. When groups of these birds pool their efforts, they are able to harvest much more food than independently acting individuals would ever be able to do. And many other insectivorous and herbivorous species derive a similar benefit from group foraging.[3]

Is Growing Sociality Inevitable?

Given that sociality has arisen in so many lineages and in so many different kinds of animals, and given the varied ecological factors which tend to give rise to it, one might ask whether there is any limit to the adaptive benefits of social existence. Is there indeed any reason that a solitary animal might not evolve social behavior? At least one scientist, the late W.C. Allee, apparently couldn't think of any. In the 1930s, Allee compared the biological fitness of solitary birds with that of birds that breed in colonies and noticed that, for the most part, the social birds enjoyed a greater reproductive success. On the basis of this and other similar observations, he came to the conclusion that the need for social contact is a basic characteristic of life. And he suggested that there is an *inherent* tendency for solitary animals to become more and more social as they continue to evolve.[4]

Allee's conclusions were premature. Most evolutionary scientists today seem to agree that there is no *inherent* trend of any kind in evolution, either toward increasing sociality or anything

else. According to most contemporary evolutionists, the 'advantages' of sociality, like those of any other biological trait, are entirely contingent upon specific environmental circumstances. And it is a mistake to assume, as Allee apparently did, that the evolution of sociality is inevitable or that it entails no inherent disadvantages for the organisms in which it evolves. According to Edward O. Wilson, the evolution of sociality is *not* inevitable; it is *not* invariably adaptive; and it does *not* occur in all lineages. In fact there are many ecological conditions that actually militate *against* the evolution of social behavior.[5] One such 'antisocial factor', according to Wilson, is chronic food shortage. This occurs among many species and is especially common among mammals. Consider for example the North American moose. In contrast to many other great horned ungulates, the moose is essentially solitary in its habits. Except during the rutting season, moose generally avoid one another entirely. Even a nursing cow will tolerate the company of her calves only as long as she has to and generally drives them away as soon as they have reached the age when they are able to fend for themselves. Why this peculiar curtailment of social behavior, which might otherwise confer added protection against wolves? Apparently the antisocial trend has been encouraged in evolution by the species' opportunistic feeding habits. Moose, it would seem, depend to a great extent on second-growth forage, especially that which emerges after fires. But the distribution of this food is patchy and subject to periodic shortages. If moose searched for their forage in large groups, most of them would die of starvation before coming to a patch big enough to feed the entire herd.[6]

A similar antisocial pressure apparently obtains among populations of coatis inhabiting the forests of Central America. The adult males of this species join the bands of females and juveniles only when large quantities of food are available in the trees. At other times, when food is scarce, the males are actively driven off by the matriarchal bands. The females and young then forage for invertebrates on the forest floor, while the solitary males go off on their own to search for larger prey. A similar antisocial trend, caused by scant food supply, has also

been noted among many species of rodents and some primates. In the latter group, adult males are sometimes added to the society, but only when they perform some essential function, such as defense or parental care, that contributes significantly to the fitness of the offspring.

Social behavior can also be curtailed when males become too large, too aggressive, or too conspicuous to justify their continued presence in the group. In such instances they are simply not tolerated by the bands of females and juveniles, except during the rutting season. Among African elephants, for example, herds consist entirely of adult females and their offspring. The bulls, for the most part, lead a separate existence and are tolerated by the females only for a brief period during the mating season. This pattern is fairly common among terrestrial mammals, where society is often female-centered, and where males are generally excluded, except during the annual rut.[7]

Yet another antisocial factor—and one that is particularly characteristic of colonial insects, such as bees and wasps—is the so-called 'reproductivity effect'. Among such colonial insects, in general, individual reproductive success tends to go down as the size of the colony goes up. In other words, the larger the colony, the lower the rate of production of new members per individual. As the colony gets larger, individual reproductive success goes down, so that whenever the colony size reaches a certain critical level, selective pressures will tend to favor a curtailment of sociality. And this curtailment may continue indefinitely, in some cases to the total elimination of any social interaction. Wilson explains it this way: "Large colonies . . . usually produce a higher total of new individuals in any given season, but the number of such individuals divided by the number already present in the colony is less. Ultimately, this means that social behavior can evolve only if large colonies survive at a significantly higher rate than small colonies and if individuals protected by colonies survive better than those left unprotected. Otherwise, the lower reproductivity of larger colonies will cause natural selection to reduce colony size and perhaps to eliminate social life altogether."[8]

Wilson cites several cases in which social species have actually become less social as they have continued to evolve. Among allodapine bees of the genus *Exoneurella,* for example, there are several species that have apparently abandoned social habits or one sort or another. According to Wilson, these bees are a little less than fully social, since the adult females leave the nest before being joined by their daughters. But this condition seems to have evolved from a more social habit—still displayed by the closely related genus *Esoneura*—in which the mother and daughter remain in close association.[9] A similar reversal of evolution seems also to have occurred in the halictine sweat bee. The 'antisocial' factor in this instance was apparently a relaxation of pressure from such nest parasites as multillid wasps. Elsewhere, antisocial evolution has also occurred among certain members of the vertebrate class, especially the birds. Among ploceine weaverbirds, the species that nest in forests and feed on insects are usually solitary in their behavior. But they have evolved from other ploceines that inhabit savannas, eat seeds, and nest in colonial groups, in some cases very large ones.

The Drawbacks of Social Living

These examples of antisocial evolution serve to illustrate two important facts: 1. that social existence is in no way *inherently* superior to solitary existence; and 2. that there is no inherent drive in evolution toward greater sociality. Like any other adaptation, sociality is a specific response to specific environmental circumstances. Like hands or wings or flippers, it tends to be favored only in those ecological contexts where it serves some particular adaptive function. Even where sociality can be said to be adaptive, it is adaptive only in the sense that it contributes in some way to the reproductive success of the organisms in which it occurs. Where it is favored by selection, it is favored only because it possesses some competitive significance, not because it contributes to the comfort or contentment of the organisms in which it evolves. In fact sociality actually

carries with it certain distinct burdens for the individual—
burdens from which solitary animals are largely exempt. This is
a point which Alexander, in his 1974 article 'The Evolution of
Social Behavior' and in a number of subsequent writings, has
brought home with particular precision and clarity. As Alexan-
der notes, there are no automatic or universal benefits to be
derived from group living. In fact the opposite is true: social
behavior actually entails certain automatic and universal detri-
ments, among which are an increased intensity of competition
for resources—including mates—and an increase in the likeli-
hood of disease and parasite transmission. The conspicuousness
that group living brings with it can also be detrimental, as when
it renders a species less effective as a predator or more vulnera-
ble as prey. Social living tends to evolve only where the
immediate benefits, in terms of reproductive success, outweigh
what appear to be inherent drawbacks. And the drawbacks, all
other things being equal, will only tend to be exacerbated by a
continued growth of sociality.

In the writings of some contemporary scientists, it is still
sometimes suggested that any evolutionary movement from
lesser to greater sociality is of absolute benefit to the species
and to every individual that comprises the species, because all
such evolution (supposedly) tends to lead to increases in social
co-operation and decreases in competition and conflict. But
does it really? The opposite may actually be closer to the truth.
There would perhaps be some validity to the viewpoint just
cited if, every time two organisms became dependent upon
each other, or every time they combined their efforts to achieve
some mutually beneficial goal, there resulted a complete merger
of their individual interests. But as should be clear by now, this
is anything but the case. The truth of the matter is that
individuals tend to maintain their unique reproductive inter-
ests, and therefore their unique biological needs, even as they
are constrained by ecological circumstance to coagulate into
social groups for their mutual benefit. In fact the need to live
socially may actually create new forms of competition and
conflict that would otherwise not even exist. Many of the
examples of social and sexual conflict cited in the two previous

chapters serve as ample evidence of this. Elephant seals, for example, are never more competitive or more aggressive than when they are most social. So long as they remain at sea, and relatively dispersed, they do not often come into contact with one another and presumably do not fight. But when they are packed tightly together on the crowded rookeries that form each breeding season, the bulls engage in fierce combat for access to cows, and the latter compete with one another for preferred spaces on the breeding beach. African lions also live in social groups, as we have seen, but they not infrequently fight over territory and females. And on occasion lion cubs starve to death because, after a kill, there is not enough meat to go around for all the members of the pride. Most social groups, too, as we have seen, are characterized by some sort of dominance hierarchy, so that subordinate individuals are obliged to accept an inferior status and thus to content themselves with inferior resources. Or consider once again the example of the chimpanzee. As we saw in Chapter 7, chimpanzees are highly gregarious animals, and yet their social evolution has by no means eliminated, or even mitigated, inter-individual conflict. As we saw, their social life is marred by such events as dominance battles, unprovoked aggression, stealing, murder, infanticide, cannibalism, rape, and even war. If increased sociality tends to lead to increased co-operation and a diminution of conflict, as some scientists still contend, then the social life of chimpanzees provides very poor support indeed for this line of argument.

Primate Models for Human Sociality

In the early days of chimpanzee study, before the more violent aspects of their behavior were discovered, many anthropologists unhesitantly embraced the chimp as an excellent model for the social life of early humans. But as the sobering details of chimpanzee conflict have made their way out of Africa, this species is not always as heartily embraced as a model for human evolution. Some anthropologists, to be sure, still regard chimpanzees as the best available example of what

the life of our distant ancestors might have been like, although these same anthropologists often also suggest that it is only the more benign and peaceful aspects of chimpanzee social life that are suggestive of our own ancestors, who certainly were not aggressive in any way. And then there are the baboons. Traditionally, although to a much lesser extent nowadays, African baboons have also been proposed as plausible models of early human evolution. The rationale behind this choice is relatively simple. Although chimpanzees are much more closely related to humans genetically, and although they resemble humans much more in certain crucial aspects of their social behavior, the baboons have a more similar evolutionary history. The chimps have never quite left the forest. But the baboons, like our own ancestors, have pretty much abandoned the thicket to make a go for it on the open grassland. Thus in the course of their own recent evolution, the baboons have had to adjust to a new kind of habitat in much the same way that our ancestors did when they made their irrevocable descent to the ground. And it is possible that, in making this adjustment, they have undergone changes in their social structure that are comparable to the changes our own ancestors must have undergone during the period of their transition from the trees to the ground. The baboons seem to have adapted pretty well to their terrestrial habitat and their highly social way of life has almost certainly influenced the success of their transition. Some primatologists, to be sure, are not at all convinced that the baboons evolved on the savanna, or that they are especially adapted to a terrestrial way of life. According to these experts, the baboons have only recently come to the ground, probably because of the destruction of much of their arboreal habitat by human intervention. In this view, the current social systems of the baboons are nothing but slightly revised versions of their earlier, forest adaptations. In either case, as we shall see, the adoption of sociality by baboons has no more eliminated, or even mitigated, conflict in these animals than it has in any other species. On the contrary, their distinctive social habits are more the cause of, than the solution to, their many conflicts and quarrels.

Today there are about a half-dozen varieties of baboons that

inhabit the plains and cliffs of Eastern and Southern Africa; and all of them are highly social, living in groups that vary greatly in size but that under certain conditions may exceed several hundred individuals. Whenever possible, baboon troops stay close to clumps of trees, into which they can scamper at the first sign of danger. At least in certain areas, however, baboon troops not infrequently venture far out onto the plains, where no arboreal retreat is readily at hand. Under such conditions, individuals are reluctant to venture too far from the nexus of the troop, for in some sense they seem to know that their survival depends in large part on social cohesion. A lone baboon, indeed—especially a subadult or a female—possesses neither the speed to outrun its feline enemies nor the strength to repel them. By staying close to the troop, however, predators can be avoided and relative safety assured. Group living in these animals may have other adaptive 'advantages' as well, including an increase in the efficiency with which food can be located and harvested. Whatever the 'benefits' of baboon social life may be, however, such existence is by no means without its drawbacks and has in the end created problems and hardships that otherwise might not exist. Sociality among baboons has brought with it a serious reduction in individual freedom and mobility, and, as we shall see, it has created tensions and conflicts that render baboon life something less than completely tranquil.

One of the disadvantages of being a baboon is that you have to stay close to your fellow baboons, whether you want to or not, and whether or not your individual interests might better be served by independent action. When a troop of baboons moves, it moves as a group. Individuals do not have the luxury of choosing when to travel and when not to. However tired the individual may be, he must keep going when the troop moves on; however thirsty he may be, he must wait until the group moves as a unit to a source of water. If he lags behind the group, or if he strikes out ahead of it, he loses the protective shield of his fellows and becomes an easy target for predators. The restrictions, moreover, do not stop there. In the case of female Hamadryas baboons, for example, there is at least one more restraint, the male. For the latter, in the course of his evolution,

has become somewhat of a tyrant as well as a protector. Typically female Hamadryas are forcibly kept in harems by large dominant males and are required to stay close to their masters at all times. If a female strays too far from her overlord, she may be severely punished by being bitten on the back of the neck. She may also be required to groom her master from time to time and to perform other domestic duties, whether it is her inclination to do so or not. Male baboons, in turn—especially the more subordinate ones—have their own restrictions to live by. The male baboon, however desirous he may be, must suppress his drive to copulate with the females of another male's harem when his own females (if he has any) are unreceptive. Otherwise he may evoke the wrath of the aggrieved male and in so doing bring serious injury or death upon himself. As for the most subordinate males in the troop—these are usually obliged to accept a life of involuntary bachelorhood, at least until they are able to acquire females of their own, which may or may not happen. The individual baboon, in short, is not a free animal. His behavior is very well-regulated. And his life is characterized by continual compromise between his own interests and those of the group to which he belongs.[10]

Life on the savanna may have been rendered possible by baboon sociality. But it is by no means an ideal solution to an adaptive problem. And the example of the baboons gives some inkling as to the problems and difficulties our own ancestors may have had to face as they, too, left the relative security of the forest to forge a new life on the African plains.

The Evolution of Human Sociality

The details of the evolution of human sociality are unfortunately obscure. Because of the paucity of the fossil record, we do not know exactly when or why our ancestors first began to evolve the kinds of social relationships and institutions which are today such characteristic features of human life. Nor can we determine with any certainty the precise ecological factors that encouraged the rise of human society. Nonetheless, circum-

stantial evidence suggest that at least five factors may have played some significant role in shaping the emergence of human sociality. These probably included: 1. defense against predators; 2. group hunting; 3. inter-group competition; 4. increased infant dependency; and 5. the advent of reciprocal food sharing. The end product of all these factors (and there may have been others) was the modern human, a creature whose very survival is now entirely dependent upon social living.

Almost without question one of the key factors that gave rise to human social evolution was the gradual shift in habitat from the forest to the open plains. Having abandoned the security of the trees, our ancestors would have needed some way to protect themselves from the many predators that lived on the ground. Their response was probably not very different from that taken by other plains-dwelling mammals, such as musk oxen, elk, and baboons. They banded together into groups, and by so doing were able to develop a system of surveillance to keep themselves informed of any predatory approach. They may also have defended themselves actively by throwing stones or other projectiles at their enemies, or by fending them off with sticks. Social banding may also have been of some use in the context of scavenging. According to some authorities, for example, the early terrestrialized hominids did not depend on vegetation alone for their daily nourishment. Rather they scavenged meat from the carcasses of whatever dead animals they happened to come across. But the meat was not simply theirs for the taking. On the contrary, there must have been considerable competition from other scavengers: hyenas, wild dogs, and saber-toothed cats, for example. Individually, the small hominids would have been no match for these packs of wild carnivores. By banding together into co-operative groups they may have been able to drive away the competition and keep the meat for themselves.

Group co-operation may have taken on even greater significance when hunting became a part of the hominids' behavioral repertoire. And this seems to have occurred only after their shift to life on the open plains. Some circumstantial evidence suggests that our ancestors had already begun to hunt small

game while still in the forest. But it is almost certain that hunting did not become an important subsistence activity in their lives until they had left the forest and moved to more open country. And it was apparently on the open plains that they became hunters, eventually bringing down prey many times larger than themselves, including zebra, antelope, and even huge elephantlike creatures such as the now-extinct dinothere. Obviously individual hominids would have been much too small to bring down such huge game. By hunting in groups, however, they may well have been able to capture just such prey. And the benefits they derived from their successes could only have encouraged further co-operative hunting.

The trend toward increasing sociality did not end there. The change to a hunting way of life seems to have influenced human social evolution in many crucial ways. As proto-humans became more and more dependent on hunting, they may have begun to compete, group against group, for access to the most desirable game. (As I argued in Chapters 4, 7, and 8, it is probable that the early human hunters occasionally engaged in inter-tribal warfare over territory, women, or both. Such competition would have encouraged, among other things, the continued growth of group size, since larger groups were more likely to be successful in aggressive encounters. As intergroup competition became more and more frequent, then, selection would have tended to favor ever larger groups and ever greater social cohesiveness within those groups. At the same time human intelligence apparently continued to grow as cleverer hunters were able to outsmart their enemies, defeat them in battle, and usurp their land.

The continuing growth of human intelligence, in turn, brought with it further developments in the evolution of human sociality. For as human intelligence grew, so too did the absolute size of the human brain, and this growth precipitated numerous changes in social relationships. As we saw in Chapter 4, one of the consequences of the rapid expansion of the human brain was that the human fetus began to be expelled at ever earlier stages of its development, so that its skull could fit through the mother's relatively narrow birth canal. As a result

there was a substantial increase in the length and intensity of infant dependency. This meant that mothers had to spend more and more time caring for their offspring. And eventually men too were brought into the picture, being obliged to help provide for the helpless infants they had fathered. Thus when men returned to their 'families' from a successful hunt, they brought back with them a portion of the kill and shared the meat with the women and children. Their sharing behavior, what's more, was reciprocal; for often enough they would return from the hunt empty-handed, and in such cases they survived only by receiving a share of the wild vegetation that had been gathered by the women in the meantime. In this way men and women became ever more dependent on each other, and the social bonds between them grew ever more important and more complex. By the time of the advent of the classic hunting-and-gathering way of life, our ancestors had developed a complex network of interdependences as intense and as expansive as any that had evolved in the history of the primates. Children had become hopelessly dependent on their parents, women dependent on men, men on women, and every individual on the society as a whole. Man had become one of the most intensely and most irrevocably social of all animals. Ever since then, virtually every aspect of his thinking and behaving has been influenced by his inherently social nature.

The Consequences of Human Sociality

The view is still sometimes held that animals 'gain' by pooling their efforts, because it helps them to find food, to avoid predators, or to defeat competitors. But this, as we have seen, is true only in a relative sense, for the ostensible 'gains' of sociality are always offset by concurrent loses and detriments, among these being a reduction in individual autonomy, a greater need for self-restraint, and increased competition for food, mates, nesting sites, and living space. Perhaps humans, too, have 'gained' by becoming such a highly social species, but our social evolution has brought with it anything but a complete merger of

the personal interests of all the individuals within society. And among humans, disputes, quarrels, and conflicts—both within groups and between them—are at least as frequent and at least as intense as anything that occurs in the rest of the animal kingdom.

At this juncture, I suppose, some would argue that our evolution as social beings has brought with it some definite advantages (in both the biological and colloquial senses), because it has created in us the capacity to experience such things as friendship, camaraderie, romance, and other similar pleasures, as well as the capacity for such positive emotions as love and compassion, which tend to reinforce bonds between individuals who depend on each other. And perhaps this is true. But it is equally true that we owe many of our profoundest troubles and sorrows to our having evolved such a highly social nature. For if sociality has endowed us with the capacity for love and compassion, so too has it given us the capacity for many painful emotions—such as grief, sorrow, and loneliness—all of which tend to plague individuals whose important social relationships have been torn asunder by death or estrangement or who, for whatever reason, have been unable to establish the kinds of relationships that the human psyche so fervently craves. Finally, our social evolution has played a major role in creating the biological capacity for guilt and shame—a pair of closely related emotions, the destructive potential of which is enormous.

In the sixth chapter of this book, I suggested that the human capacity for guilt is largely a consequence of man's having evolved a distinct sense of self-awareness. But self-awareness is not the only evolutionary endowment that brought about this capacity. Sociality, too, made an important contribution. Indeed, guilt could never have evolved in completely asocial animals. Guilt, after all, is the emotion that we humans experience when we feel that we have done wrong to 'others'. Were there no 'others', were there no society, then guilt would make no sense. It is only in a social context that guilt has meaning. And in the case of a highly gregarious, highly intelligent, highly self-conscious animal such as *Homo sapiens*, it is virtually

inevitable. As psychologist Felix Goodsen has put it, guilt "is the input that forces individuals to abide by rules that are (or were at one time) essential to the welfare of the group. Without guilt, human society could not have developed and human beings could not exist."[11] Guilt, in other words, serves an adaptive function in that it acts as a warning signal to the individual that his unco-operative social behavior might ultimately result in punitive retribution, which in turn represents a threat to his own survival and wellbeing.

But however 'adaptive' guilt may be in the evolutionary sense, it is certainly not an unmitigated blessing for human beings. Two very serious problems are associated with it. First, it is painful; it can at times be so painful as to be unbearable. In some human societies people can be shamed into killing themselves; and in our own society guilt is often a major component of mental depression and other disorders. The second problem with guilt is that it does not always occur where it should or in doses that are proportionate to the crime. This is because the precise expression of guilt can be highly influenced by learning and indoctrination, so that people can be taught to feel guilt when they ought not to, or not to feel it when they ought. Thus some persons torture themselves with senseless guilt as the result of trivial offenses, while others are able to commit the most heinous crimes without experiencing the slightest tinge of remorse.

The biological capacity for such painful emotions as guilt, shame, grief, sorrow, and loneliness, what's more, is but a small part of the price that man has had to pay for his survival as a social being. And it is but one expression of the kind of interpersonal conflict that has remained a central component of human existence throughout the long course of our evolution as social beings. It is ironic but nonetheless true that we humans, precisely by becoming such highly social and therefore highly co-operative creatures, have brought about more kinds of conflict than would ever exist had we remained more solitary and more independent. The whole problem with social evolution, as we have seen, is that it makes individuals dependent on one another without necessarily bringing their individuals interests

into complete accord. The most intense conflicts among social animals, including ourselves, often occur between individuals who are most dependent on each other and therefore most likely to remain in close contact with each other over long periods of time. Thus it is no mystery that, among human beings, domestic conflicts—especially those involving parent and offspring or husband and wife—are among the most frequent and the most violent that occur anywhere. Peaceful relations can sometimes be established in human society, even between married couples. But in the human realm peace is generally maintained only at the price of great individual restraint. Indeed, a society of highly interdependent individuals can only survive insofar as each individual is ready to compromise his own interests with those of his fellows. Grudging conformity thus becomes the order of the day and personal sacrifice essential to group welfare. The rules of organized society, as they are expressed in the notions of law, justice, ethics, and morality, to a large extent illustrate the behavioral limitations that are placed on the individual by the collective members of the society. The frequency with which individual human beings tolerate such restrictions is an index of the degree to which they depend on the society. The frequency with which the restrictions are resented or even ignored is an index of the degree to which individual humans would prefer that they did not exist.

The fundamental problem of social living is the reduction in personal freedom that group living inevitably entails. Of all the inherent drawbacks of sociality, this is the most basic and the most universal. For better or for worse, it is a fact of life that, in uniting with its fellows to form a society, the individual organism must sacrifice to some degree its unique interests if it is to avoid violent conflict and possible extermination. Dependence is the antithesis of autonomy, and the more intensely dependent the individual is on group co-operation, the greater is the reduction of its personal freedom. In general, selection tends to favor those behaviors which promote individual fitness. But the overall group pattern is unlikely to be ideal for any particular group member. Rather the optimal strategy of the

group tends to be the result of a certain amount of compromise between individuals with different interests. On the one hand, biological evolution tends to promote the individual's selfish interests, while on the other it favors behaviors which are helpful to the survival of the group upon which the individual depends. For some biological traits, these two trends may be mutually supportive, but for others they may be diametrically opposed. In the latter case, the individuals involved are coerced into a gruding co-operation—a sort of reluctant compromise struck in the interest of survival. They make the compromise, not because they want to, but because they have to, and because living a life of conflict and compromise is—from an evolutionary point of view—better than living no life at all.

The Roots of Evil

In the second chapter of this book, I suggested that progressive evolution is a myth; that evolutionary changes are not improvements, but simply adjustments; that they are 'adaptive' or 'advantageous' only in the sense that they contribute to the reproductive success of the organisms in which they occur; and that they do not necessarily promote comfort or contentment and may even be antithetical to both. I also suggested that each evolutionary change tends to bring with it new forms of pain and suffering that had not existed before, so that the cumulative effect of the process is to create organisms with an ever greater capacity for suffering and hardship. In each of the succeeding chapters I gave specific examples of this evolutionary trend. In the third chapter I argued that bipedalism, for example, is by no means absolutely superior to quadrupedalism, and that in fact the evolution of a two-legged gait in *Homo sapiens* has brought with it countless adverse side effects that are the ultimate cause of many peculiarly human forms of physical suffering. In Chapters 4, 5, and 6 I suggested that intelligence and behavioral flexibility, although commonly regarded as unmitigatedly advantageous traits, are by no means absolutely superior to instinctive behavior, and that their evolution has in fact brought

with it many forms of emotional pain that are virtually unknown in the nonhuman world. In Chapter 8 I argued that sexuality is not absolutely superior to asexuality, and that the evolution of the former has actually brought with it many forms of conflict and suffering that do not exist in organisms that reproduce without sex. And in the present chapter I have argued that sociality is not absolutely superior to solitary life, and that its evolution has in fact created new forms of competition and conflict that are less frequent, or even unknown, among asocial animals. As for Chapter 7, it may be that everything I wrote there is incorrect, and that humans do not have any 'bad' innate behavioral inclinations at all. But even if this is true, as so many scientists and philosophers through the ages have insisted, and as many are still insisting, it does nothing to refute the general thesis of this book: that all evil has evolutionary roots. I point this out explicitly because, in the writings of many evolutionary and behavioral scientists today, especially those who are vehemently opposed to the idea that human problems have evolutionary causes, it is frequently suggested that because humans allegedly have no 'bad' instincts, evil cannot therefore be said to have evolutionary roots. Of course it means nothing of the kind. In fact the more the intelligence and behavioral flexibility of human beings are asserted, the more it confirms rather than refutes my thesis. For, as I suggested in Chapters 4 through 6, it is precisely the evolution of human intelligence and behavioral flexibility that is the ultimate cause of most peculiarly human problems.

Those scientists who are opposed to the idea that evil has evolutionary causes sometimes argue that humans are far different from any other animal. I quite agree. And one of the most important differences is that we have inherited a far greater capacity for pain and suffering. Such scientists sometimes argue that humans are much more intelligent and more behaviorally flexible than all other species. I quite agree. And it is precisely because of this that we have a much greater capacity for maladaptation and for mental as well as physical suffering. Such scientists sometimes argue that the evolutionary process is not at all a perfect one and that many of the traits created by it

are not even adaptive. I quite agree. And it is precisely because of this that we suffer from such unadaptive traits as back pain, fallen arches, impacted wisdom teeth, varicose veins, appendicitis, cystic fibrosis, sickle-cell anemia, Huntington's disease, schizophrenia, manic-depression, alcoholism, painful childbirth, and a host of other maladies which genetic evolution has created, but which natural selection has done nothing to eliminate. In sum, contrary to what is often suggested in the recent scientific literature, it is not necessary to show that humans have innate behavioral inclinations in order to prove that human problems have evolutionary causes. Even a *tabula rasa* theory of human nature is not incompatible with the thesis that the ultimate root of all evil is to be found in evolution. For the ultimate root of all evil is the capacity for suffering; and this exists with or without innate behavioral inclinations. Indeed, the capacity for suffering exists in more pronounced form in humanity than in any other species precisely because, in the course of our evolution, we have substituted intelligence and behavioral flexibility for instinct.

In the second chapter of this book, I suggested that the capacity for pain and suffering tends to be favored rather than disfavored by natural selection because it often aids the genes in shielding themselves from environmental hazards and in perpetuating themselves through the generations. Sensitivity to pain, in other words, tends to increase, rather than decrease, as the evolutionary process 'progresses'. No animal has undergone more major changes during the course of its evolution than *Homo sapiens,* and no animal has inherited a greater capacity for pain and suffering. With every evolutionary change we have sustained, we have discovered new ways to protect our genes and new ways to suffer for their benefit. With every passing generation, the aggregate price paid for their preservation has become dearer and dearer. Our genes may well last forever, or they may destroy themselves by destroying us. In either case, our welfare will always play a subordinate role to their mere existence, and they—unlike us—will remain ever blissfully ignorant of the staggering mass of suffering that has been endured for the sake of their perpetuation.

Chapter Ten
Epilogue: The Mystery Solved

All great philosophical issues that have been discussed since the time of Parmenides to our present day are of one of two kinds; we can either give them a definite meaning by careful and accurate explanations and definitions, and then we are sure that they are soluble in principle, although they may give the scientist the greatest trouble and may even never be solved on account of unfavorable empirical circumstances, or we fail to give them any meaning, and then they are no questions at all. Neither case need cause uneasiness for the philosopher. His greatest troubles arose from a failure to distinguish between the two.

Moritz Schlick

In the closing paragraphs of his *Origin of Species*, Charles Darwin wrote that "natural selection works solely by and for the good of each being."[1] Darwin was right about a lot of things, but about this he could hardly have been more wrong. As I have repeatedly suggested throughout this book, the essence of evolutionary fitness is reproductive success. But the same traits that promote reproductive success are not necessarily 'good'— at least not in the sense in which this term is normally used—and those traits which are 'good' do not necessarily promote reproductive success. Apparently Darwin got the two concepts a bit confused, and for this reason he was misled into believing that natural selection works wholly for the good of every individual being. Having committed himself to such a

romantic conception of nature, Darwin was unlikely to have recognized any correlation between evolution and the genesis of evil. And in fact he didn't. On one of the few occasions where he actually confronted the question, "Why does evil exist?", the best answer he could come up with was no answer at all. In a letter to his friend Asa Gray, written in 1867, he expressed his total bewilderment concerning the mystery of evil: "I feel most deeply," he confessed, "that the whole subject is too profound for the human intellect. A dog might as well speculate on the mind of Newton. Let each man hope and believe what he can."

Darwin's peculiar agnosticism concerning the mystery of evil was by no means his alone. On the contrary, countless scientists and philosophers, both before and since Darwin, have adopted a similar attitude, insisting that the existence of evil is far too profound a mystery to be solved by mere human beings. According to these thinkers, no metaphysical or theological explanation for the existence of evil yet proposed can be accepted as wholly adequate, while no scientific explanation is even theoretically possible, since science alone is quite impotent to deal with this or any other ultimate ontological question. If these writers are correct, then the 'mere' scientific explanation I have presented in the foregoing pages is no explanation at all. And it does not really solve the riddle. I may ostensibly have explained *how* evil came into being, such theorists might argue, but I have not explained *why* it did so. Evolution may explain the origin of evil, but it does not explain *why* evil has an origin. After all, is it not at least theoretically possible that evolution could proceed in some way other than the way it does? And if so, why doesn't it? Why is reproductive success the crucial criterion of biological fitness, rather than comfort or happiness? Why does evolution proceed at all? Why, for that matter, did life itself—or anything else in the world—ever come into existence in the first place? And how can science alone possibly resolve such profound mysteries?

As it turns out, there is no need for me to excogitate a formal reply to objections such as these, because one has already been provided for me by philosopher Paul Edwards. In a brief but pregnant article originally published in the *Encyclopedia of*

Philosophy in 1967, Edwards poses cogent challenges to the belief that science is inadequate to explain the 'why' of observable phenomena.[2] In sharp contrast to many other authors who have written on this subject, Edwards insists that science can indeed provide ultimate ontological explanations, and this without the aid of either theology or metaphysics. The philosophical argument which he adduces to support his point of view, and which he expounds at length in his article, will be summarized in the following several paragraphs.

The How and the Why: What's the Difference?

Edwards begins his article with a historical overview, suggesting that, throughout the history of Western thought, it has frequently been opined that science alonge is quite inadequate to deal with the profound ontological mysteries of life and the universe. According to Edwards, such questions as 'Why does the world exist?', 'Why do we exist?', and 'Why does evil exist?', have generally been considered to belong to the domain of either metaphysics or theology, because they are supposedly too profound to be resolved by scientific inquiry alone. Even scientists themselves, Edwards notes, have on occasion adopted this point of view. British psychiatrist David Stafford-Clark, for example, has argued that confusion between the how and the why is the "fundamental fallacy" behind "the whole idea that science and religion are really in conflict at all."[3] As Stafford-Clark sees it, psychological theories—such as those as Sigmund Freud—maintain their plausibility only so long as they confine themselves to the how of psychological phenomena. But such theories, he insists, cannot begin by themselves to answer a single question as to why the human psyche is constructed in the peculiar way that it is.

A similar point of view may be found in the writings of a great many philosophers, both ancient and modern. Alfred North Whitehead, for example, has expressed doubt as to whether Newton's theory of gravitation really explains *why* gravity exists. Whitehead concedes that Newton "made a

magnificent beginning by isolating the stresses indicated by this law of gravitation," but that [Newton] "left no hint, why in the nature of things there should be any stresses at all."[4] In like fashion, Étienne Gilson has confidently declared the limitations of science, insisting that "scientists never ask themselves *why* things happen, but *how* they happen. . . . Why anything at all is, or exists, science knows not, precisely because it cannot even ask the question." According to Gilson, nothing can be ultimately explained unless we first determine why anything exists at all. That is to say, the why of particular phenomena cannot be determined until we first answer the question, "why this world, taken together with its laws . . . is or exists."[5] And this question, Gilson insists, science cannot answer.

Belief in the relative impotence of science, of course, is precisely what one would expect from professional metaphysicians like Gilson and Whitehead. But their attitude, according to Edwards, is by no means restricted to members of their class. Even among philosophers who are on the whole unfriendly to both religion and metaphysics, he observes, there is a strong tendency to write off why-questions as profoundly mysterious or unanswerable. And many anti-metaphysicians reluctantly concede that science is no better equipped than either theology or metaphysics to provide ultimate explanations. This point of view, which Edwards labels "agnostic positivism", goes at least as far back as the eighteenth century. As early as 1748 David Hume wrote that, while milk and bread are proper nourishment for men and not for lions and tigers, we cannot "give the ultimate reason why" this should be the case.[6] Several writers in the latter half of the nineteenth century echoed Hume's position, declaring that the task of science is to describe phenomena, not to explain them. One of the most influential advocates of this view was the British physicist Karl Pearson, who argued that there is no harm in speaking of "scientific explanations", but only so long as the term "explanation" is used "in the sense of the descriptive-*how*." We can indeed "describe how a stone falls to the earth", he wrote, "but not why it does." "No one knows why two ultimate particles influence each other's motion. Even if gravitation be analyzed

and described by the motion of some simpler particle or ether-element, the whole will still be a description, and not an explanation, of motion. Science would still have to content itself with recording the how." No matter how far physics may progress, according to Pearson, the why will always "remain a mystery."[7]

This line of argument is not nearly as fashionable as it once was, but it has not yet completely died out. As recently as 1967, for example, W.T. Stace declared, with apparent confidence, that "scientific laws, properly formulated, never 'explain' anything. They simply state, in an abbreviated and generalized form, what *happens*. No scientist, and in my opinion no philosopher, knows *why* anything happens, or can 'explain' anything."[8] Similarly, the English biologist Joseph Needham has argued that "the scientific method can tell us nothing" about why living beings should exist or why they behave the way they do. Living beings, according to Needham, "are what they are because the properties of force and matter are what they are, and at that point scientific thought has to hand the problem over to philosophical and religious thought."[9]

Or does it? Paul Edwards believes otherwise. As I have already suggested, it is Edwards's contention that science is in fact competent to deal with the 'why' no less than the 'how', if for no other reason than that the words 'why' and 'how' are often used to ask the very same questions. As Edwards sees it, the supposed impotence of science to provide ultimate explanations is based on misunderstanding and a lack of clarity about the many uses of the word 'why'. In some contexts 'how' and 'why' are indeed used to ask different kinds of questions, but in some cases their meanings are identical. And when their meanings are identical, why-questions are no more mysterious and no less answerable than how-questions.

Why?

In order to illustrate his point, Edwards cites several examples of how we use the words 'why' and 'how' in ordinary

conversation. He begins by discussion the theft of the Star of India sapphire and other gems from the Museum of Natural History in New York, which apparently took place shortly before he began work on his essay. In this particular case, Edwards notes, we can easily distinguish the question *why* the burglary was committed from the question *how* it was carried out. The latter question would concern itself with the details of the crime—how the thieves gained entry into the building, how they disengaged the alarm system, how they eluded the guards, and so forth. The why-question, by contrast, would inquire into the aim or purpose of the theft—was it the thieves' sole intent to make a vast amount of money, or did they have some other goal in mind, such as proving to rival gangs how skillful they were? Whatever the answer to this question, it is clear that the interrogative pronoun 'why' in this case is being used to inquire about human motives. And that is how the word is often used. But sometimes 'why' is asked even where no human motivation is involved, and where none is presumed to exist. Consider for example the question, 'Why does it get so cold in New York in the winter?' Certainly when we ask a question like this one, we are not trying to determine why the weather has decided to be cold in New York during the winter months, and not at most other times of the year. We know very well that the weather is not a purposeful agent, and that it therefore has no aims or goals in the human sense. Rather what we really mean when we ask 'Why does it get so cold in New York in the winter?' is 'How does the cold weather in New York come about?' or 'How do atmospheric conditions combine to produce cold weather in New York in the winter?' To these questions almost any competent meterologist could give a satisfactory answer, without the aid of either religion or metaphysics. Edwards explains:

> It is sometimes maintained or implied . . . that why-questions are invariably inquiries about somebody's purpose or end—if not the purpose of a human being, then perhaps that of some supernatural intelligence. This is clearly not the case. There can be no doubt that 'why' is often employed simply to ask questions

about the cause of a phenomenon. Thus the question 'Why are the winters in New York so much colder than in Genoa, although the two places are on the same geographical latitude?' would naturally be understood as a request for information about the cause of this climatic difference; and it is not necessary for the questioner to suppose that there is some kind of plan or purpose behind the climatic difference in order to be using the word 'why' properly.[10]

Why-questions often inquire about the cause of a state or condition without necessarily implying that any purpose or plan is involved. In such cases it is in principle possible to answer why-questions no less than how-questions, without reference to supernatural or metaphysical entities.

Edwards goes on to argue that almost all why-questions are actually how-questions in disguise, and are therefore neither mysterious nor unanswerable. The question 'Why does the world exist?', for example, is synonymous with the question 'How did the Earth come into being?' and as such may be answered scientifically. Similarly, the question 'Why do we exist?' is just another way of asking 'How did the human species evolve?' And so forth. Indeed, to interpret these questions in any other way is to render them meaningless and therefore unintelligible. Consider once again the question 'Why does the weather get so cold in New York in the winter?' If this is taken to mean 'How does the cold winter weather in New York come about?' then the question is both intelligible and answerable. But if it is understood as an inquiry into the weather's motives for being cold at this particular time and at this particular place, then the question is clearly absurd, and its unanswerableness is nothing more than a function of its very absurdity. It is Edwards's contention that all why-questions are either 1. meaningless, or 2. answerable, at least in principle, by means of science. In neither case has religion of metaphysics anything to add to what science can or cannot explain.

Now consider the oft-cited philosophical question, 'Why does life exist?' If by this we mean 'How did life begin?' then the question is both meaningful and answerable. But if it is

asked by an unbelieving scientist who implies that he would continue to ask it even after he had in his possession a complete scientific account of the origin of life, then it is utterly nonsensical. "Just what is such a questioner looking for?" Edwards asks.[11] The truth is that if we wish to know why life exists, we need only determine how it came into being, and we will have our answer. There is no need to suppose that a 'deeper' mystery lies beyond the scientific explanation. The same applies equally to any observable phenomenon in the organic world. Thus if we wish to know why elephants exist or why bananas exist or why any other living thing exists, we need only trace their origins to the beginning of life and explain how they evolved. Similarly, if we wish to understand why the capacity for pain and suffering exists, we need only ascertain how it evolved. Once again, there is no mystery beyond that which scientific investigation can reveal. The questions 'Why does evil exist?' and 'How did evil come into being?' are synonymous, and any satisfactory answer to the one constitutes an equally satisfactory answer to the other.

A Summary of My Conclusions

Although not all suffering in human life is wholly evil, a great deal of it is, and the ultimate source of all evil is the biological capacity for suffering. The biological capacity for suffering, in turn, exists because it has evolved. It has evolved because it often served an adaptive function, or because it was the inextricable concomitant of traits which were in some way adaptive. It was adaptive because it contributed to the reproductive success of its possessors. Because it contributed to the reproductive success of its possessors, it was favored by natural selection. And selection always favors reproductive success because the most reproductively successful organisms, by definition, leave more offspring and become more numerous in succeeding generations, while their less fecund competitors tend to become less numerous and gradually fade into oblivion.

One does not add anything to this explanation by positing

the existence of some kind of metaphysical entity, such as Schopenhauer's Will to live; and one certainly does not add anything to it by suggesting that all the evils engendered by evolution are ultimately for the good, or that their existence is an insoluble mystery.

There is little doubt that the vast majority of human beings will either ignore or misapprehend the arguments that I have advanced in this book and will continue to cling to their various theological apologies for the existence of evil or will continue to deny that any such explanation is possible. And perhaps their attitude is not entirely unwise. After all, it is not always better to acknowledge the truth than to deny it. And untruths can be very comforting, if they are not absolutely essential, to human survival. Unfortunately, untruths always have their price, and there are some very grave dangers in denying the true causes of our suffering. History has shown, for example, that when human beings misdiagnose the causes of their problems, the solutions they prescribe are almost always misguided and at best ineffectual. Social, political, ethical, and medical solutions based on false interpretations of human nature and human pathology have a tendency to cause more problems than they solve. Thus it behooves anyone who is genuinely interested in alleviating human suffering to understand as fully as possible the ultimate evolutionary causes of that suffering. And those who continue to ignore such causes or to insist that the existence of human suffering is not ultimately explicable, either in evolutionary terms or in any other terms, have little to contribute to the human race but bad advice and designs for the perpetuation of human misery.

Notes

1. The Roots of Evil

The first epigraph is from Edward M. Keating's *The Broken Bough* (1975), 245. The second epigraph is the opening sentence of Aristotle's *Metaphysics.*

1. The Wendy Doniger O'Flaherty quotation is from her *The Origin of Evil in Hindu Mythology* (1976), 17.
2. For a more detailed discussion of the Stoic cosmology and theodicy, see for example B.A.G. Fuller's *A History of Philosophy* (1938), 203–235.
3. The paraphrase of Schopenhauer is from the book *The Will to Live: Selected Writings of Arthur Schopenhauer* (edited by Richard Taylor, 1967), 216.
4. Frederick Copleston's apology for the existence of the pain of tooth decay (and, by extrapolation, other forms of physical suffering) may be found on page 134 of his *A History of Philosophy: Volume I, Greece and Rome, Part 2* (1962b).
5. Schopenhauer, *The World as Will and Representation: Volume I* (translated by E.F.J. Payne, 1966a), 309.
6. Frederick Copleston's defense of Schopenhauer may be found in his *A History of Philosophy: Volume I, Greece and Rome, Part 1* (1962a), p. 23.
7. Auguste Comte's 'Law of Three Stages' is discussed in detail in his *Cours de Philosophie Positive* (1830–1842).
8. For a discussion of Anaximander's 'evolutionism', see Charles H. Kahn's *Anaximander and the Origins of Greek Cosmology* (1960), 109–113.
9. For a discussion of the 'evolutionism' of Empedocles, see Ernst Mayr's *The Growth of Biological Thought* (1982), 302. Discussions of Aristotle's anti-evolutionism may be found in the work just cited, 305–06, and in H.B. Torney and F. Felin's 'Was Aristotle an Evolutionist?' (1937). Lamarck's theory of evolution is discussed in Mayr (1982), 343–360; it was originally proposed in 1800, and is expounded at length in Lamarck's 1809 book, *Philosophie zoologique.*
10. One author who has recently suggested that the existence of evil is an insoluble mystery is Martin Gardner. See Chapters 15 and 16 in his *The Why's of a Philosophical Scrivener* (1983).

2. Natural Selection: Good or Bad?

The first epigraph (that of George Eliot) is cited by Sarah Blaffer Hrdy in her *The Woman that Never Evolved* (1981), 1. The second epigrah is from David Barash's *The Whisperings Within* (1979), 230.

1. The first two quotations of Jean Baptiste de Lamarck are from his *The Zoological Philosophy* (translated by Hugh Elliot, 1914), 60, 71. The indented quotation is a translation of Lamarck by George Gaylord Simpson; it appears in his article 'The Concept of Progress in Organic Evolution' (1974), 29–30.
2. *The Origin of Species* (1962), 93.
3. *The Growth of Biological Thought* (1982), 532–33.
4. *Adaptation and Natural Selection* (1966), 22.
5. Both quotations are from the work just cited, the first from page 34, the second from page 35.
6. Op. cit., 47.
7. Op. cit., 49.
8. The 'Red Queen' principle is discussed by Leigh Van Valen in his article 'A New Evolutionary Law' (1973).
9. *The Growth of Biological Thought* (1982), 532–33
10. David Lack, 'Of Birds and Men' (1969).
11. I have enclosed the word 'advantage' in quotation marks to highlight the fact that the adaptations referred to by this word are 'advantageous' only in the sense that they contribute to the biological fitness—the reproductive success—of the organisms in which they occur. They do not necessarily contribute to the comfort or contentment of the organisms involved, and may even detract therefrom. This is important, because in the writings of some evolutionary scientists, the everyday use of the word 'advantage' and the use of that same word to designate biological adaptation are often confused and intertwined. Thus it is sometimes suggested or implied that because a particular trait is 'advantageous' over another, any evolutionary change in the direction of the 'advantageous' trait represents an evolutionary advance. By enclosing the word 'advantage' in quotation marks whenever it refers to biological adaptation and omitting the quotation marks when the word is used in its colloquial sense, I wish to avoid any such confusion. As should be clear by now, and as will become even clearer as this inquiry progresses, there are many biological traits (endothermy being just one of them) that I do not at all consider to be advantageous in the vernacular sense,

however much they may be 'advantageous' in the strictly biological sense.

12. For more detailed discussions of sickle cell anemia, see F.B. Livingstone (1958) and A.C. Allison (1956).

13. For a more comprehensive discussion of genetically transmitted diseases in humans, see Nyhan and Edelson (1976).

14. The literature on the possible genetic causes of schizophrenia, depression, alcoholism, and other such syndromes is now enormous. For a nearly comprehensive list of references on this subject as of the early 1980s, see Note 11 on pages 428–430 of Peter A. Corning's *The Synergism Hypothesis* (1983).

15. Williams's discussion of the possible selective 'advantages' of early aging may be found in his article 'Pleiotropy, Natural Selection, and the Evolution of Senescence' (1957) and in his *Adaptation and Natural Selection* (1966), 226–28.

16. The influence of Malthus on Darwin is discussed by Ernst Mayr in *The Growth of Biological Thought* (1982), 487–88. See also Bowler (1976) and Darwin (1958), 42–43.

17. For a discussion of Darwin's individual selectionism and his attempts to reconcile examples of co-operative interaction with this view, see Michael Ruse's article 'Charles Darwin and Group Selection' (1980).

18. Wynne-Edwards's revision of his group selection hypothesis may be found in his article 'Intrinsic Population Control: An Introduction' (1978).

19. For some recent arguments in favor of individual selectionism, see the following: Williams (1966, 1985), Alexander (1987, 1989), and Alcock (1988).

20. Wilson's discussion of some of the possible adverse effects of group selection may be found on page 115 of his *Sociobiology: The New Synthesis* (1975).

21. *The World as Will and Representation: Volume I* (translated by E.F.J. Payne, 1966a), 276.

22. 'Group Selection, Altruism, and the Levels of Organization of Life' (1978), 450.

23. The Symons comments about the primacy of reproductive success as a criterion of biological fitness may be found on page 3 of his *The Evolution of Human Sexuality* (1979). The Barash quotation is from his 'Human Reproductive Strategies: A Sociobiologic Overview' (1980), 143.

24. *The Economy of Nature and the Evolution of Sex* (1974), 263.

25. All the Mill quotations are from his essay 'Nature', in his *Three Essays on Religion* (1874).
26. All the Thomas Henry Huxley quotations are from his *Evolution and Ethics and Other Essays* (1897).
27. *Apes, Men, and Morons* (1937).

3. The Mechanical Misfit

The epigraph is from Earnest Albert Hooton's *Apes, Men, and Morons* (1937).

1. Cartmill's ideas on the origin of primate adaptation may be found in his 1974 article 'Rethinking Primate Origins'.
2. See for example Darwin (1871), Chapter 2; and Washburn (1960).
3. Lovejoy's theory of the origin of bipedalism in humans is discussed in his article 'The Origin of Man' (1981); see also Johanson and Edey (1981), Chapter 16. For a representative sampling of criticisms, along with Lovejoy's replies, see the article 'Models of Human Evolution', which appeared in *Science* in July of 1982 (Volume 217), 295–306. For other critiques, see Hrdy and Bennett (1981) and McHenry (1982), 157.
4. The hypothesis of Henry McHenry and Peter Rodman is presented in their article 'Bioenergetics and the Origin of Human Bipedalism' (1980). The idea that carrying behavior may have influenced the evolution of human bipedalism has also been put forth by Gordon W. Hewes (1961, 1964). For the suggestion that hunting behavior and bipedalism may have evolved in tandem, see K. Hill (1982), Merker (1984), and Geist (1978), 251–55. The theory that our ancestors stood on their hind legs in order to avoid exposing too much of their tender skin to the African sun is advanced by P.E. Wheeler in his article 'The Evolution of Bipedality and the Loss of Functional Body Hair in Hominids' (1984). For alternative ideas on the origin of bipedalism, consult the review article by H.M. McHenry (1982); see also Zihlman (1978).
5. For the ideas of Prost, Stern, and Susman on the origin of bipedalism, see Prost (1980) and Stern and Susman (1983). For a less technical account of this idea, see Cherfas (1983).
6. Napier is quoted by Bernard Campbell in the latter's *Human-*

kind Emerging (third edition, 1982), 43. See also Napier's 1967 article 'The Antiquity of Human Walking'.

7. The anatomical complexities associated with human bipedal walking are discussed by Bernard G. Campbell in his *Humankind Emerging* (second edition, 1979), pp. 37–38.

8. Wilton M. Krogman, 'The Scars of Human Evolution' (1951).

9. *On the Edge of the Primeval Forest* (1961), 62.

10. For a concise statement of the traditional 'cooling device' theory, see David Pilbeam's *The Ascent of Man* (1972), 82–83.

11. 'Why Man is Such a Sweaty and Thirsty Naked Animal' (1970).

12. 'Allometry of Primate Hair Density and the Evolution of Human Hairlessness' (1981).

13. 'The Loss of Functional Body Hair in Man: The Influence of Thermal Environment, Body Form and Bipedality' (1985).

14. 'The Skin' (1965), 66.

15. *Apes, Men, and Morons* (1937), 243.

4. The Maladaptable Species

The first epigraph is from Carl Sagan's *The Dragons of Eden* (1977), 4. The second is from Stuart Chase's *The Tyranny of Words* (1938).

1. For the possible influence of hunting behavior on the growth of human intelligence, see for example Krantz (1968, 1971), and Brown and Lahren (1973). Recently many scholars have taken issue with this view, suggesting that scavenging was more important than hunting in the lives of terrestrialized hominids.

2. Leakey's ideas on the evolution of human intelligence are discussed in Chapter 9 of his book, *People of the Lake* (co-authored with Roger Lewin, 1978). The Leakey quotation is from pages 166–67.

3. The possible influences of linguistic behavior on the evolution of human intelligence are discussed in Krantz (1980), Parker and Gibson (1979), and Falk (1980), 101–02.

4. Darwin discusses the possible connection between male-male competition and the growth of human intelligence in *The Descent of Man and Selection in Relation to Sex* (1871), Chapters 19–20. Keith's ideas on this subject are discussed in his *A New Theory of Human Evolution* (1949).

5. For Alexander's ideas on the growth of human intelligence, see Alexander and Tinkle (1968), and Alexander (1971, 1987, 1989). For alternative ideas on the evolution of human intelligence, see: Fiakowski (1978), Gabow (1977), Parker (1978), and Lumsden and Wilson (1981, 1983). For reviews of various theories, see Falk (1980), and McHenry (1982).

6. Dobzhansky's arguments in favor of the superiority of behavioral flexibility over rigidly programmed instinct may be found in his *The Biological Basis of Human Freedom* (1956), Chapter 4.

7. *The Nature of Human Aggression* (1976), 82.

8. *Sociobiology: The New Synthesis* (1975), 156.

9. *The Evolution of Human Sexuality* (1979), 17.

10. Op. cit., 17–18.

11. *Animal Behavior: An Evolutionary Approach* (1975), 256.

12. *The Evolution of Human Sexuality* (1979), 48, 307–08.

13. *The Human Animal* (1954), 238.

14. La Barre's discussion of the Chinese 'cure' for sparganosis may be found on pages 240–41 of the work just cited. The Dinka Crocodile clan is discussed on page 241, and the custom of dog sacrifice among the Koryak on pages 242–43. Primary sources are listed in La Barre (1954), 366.

15. Op. cit., 246.

16. Op. cit., 259.

17. Op. cit., 258–59.

18. Schopenhauer's discussion of the relation between intelligence and the capacity for suffering may be found on page 310 of his *The World as Will and Representation: Volume I* (1966a).

19. Hartmann's discussion of the relationship between intelligent awareness and the capacity for pain may be found in his *The Philosophy of the Unconscious* (1869).

20. *Nature, Culture, and Human History* (1977), 157.

21. *Behaviorism* (second edition, 1930), 301.

22. 'The Brain of Pooh: An Essay on the Limits of Mind' (1971), 21.

23. The nest-finding behavior of *Philanthus triangulum* is described by John Alcock on pages 239–240 of his *Animal Behavior: An Evolutionary Approach* (1975). The provisioning behavior of *Ammophila pubescens* is discussed in the same work, 241–42.

24. *Apes, Men, and Morons* (1937).

5. The Carefree Savage Revisited

The epigraph is from Hooton's *Apes, Men, and Morons* (1937).

1. Calhoun's experiments with albino rats are discussed in his articles, 'A Behavioral Sink' (1962a) and 'Population Density and Social Pathology' (1962b).
2. Southwick's experiments with captive rhesus monkeys are described in his article 'Genetic and Environmental Variables Influencing Animal Aggression' (1970).
3. For a discussion of the many kinds of behavioral aberration exhibited by captive animals, see Meyer-Holzapfel's *Abnormal Behavior in Animals* (1968).
4. *The Human Zoo* (1969), 17, 19.
5. For a discussion of the idea of the 'noble savage' as held by the Greeks and Romans, see Lovejoy and Boas (1935), Chapter 11.
6. For a discussion of the life and writings of Rousseau, see J.H. Broome's *Rousseau: A Study of His Thought* (1963). See also C.H. Dobinson (1969).
7. *The Social Contract and Discourse on the Origin and Foundation of Inequality among Mankind* (edited by Lester G. Crocker, 1967), 211.
8. Op. cit., 220.
9. *Leviathan* (edited by Michael Oakeshott, 1962), 100.
10. Op. cit., 101.
11. *Economic Anthropology* (1952).
12. *Work and Human Behavior* (second edition, 1977), 73.
13. Lee (1968, 1972, 1979).
14. 'The !Kung Bushmen of Botswana' (1972), 364–65.
15. *Stone Age Economics* (1972), 3–4.
16. The transcript of the 1966 Chicago Symposium comprises the book *Man the Hunter*, published in 1968 and edited by Richard B. Lee and Irven DeVore.
17. 'Notes on the Original Affluent Society' (1968), 85.
18. For the comments of Binford, Helm, Woodburn, and Turnbull, see *Man the Hunter* (edited by Richard B. Lee and Irven DeVore, 1968), 89–92.
19. 'Depressive Disorders from a Transcultural Perspective' (1975), 291.
20. 'Suicide among Primitive Peoples' (1894).
21. 'Suicide among Civilized and Primitive Races' (1936).
22. 'A High Incidence of Suicide in a Preliterate-primitive Society' (1969), 209.

23. 'Conceptions of Psychosis in Four East African Societies' (1977).
24. *Medical Anthropology* (1978), 84.
25. 'Primary Prevention: A Combined Psychiatric-Anthropological Appraisal' (1976), 133.
26. *Search for Security: An Ethno-Psychiatric Study of Rural Ghana* (1960), 13.
27. *Medical Anthropology* (1978), 93.
28. B.F. Gause, 'The Relation of Adaptability to Adaptation' (1940).
29. The three studies alluded to in which rampant job dissatisfaction is documented are discussed by Neff in his *Work and Human Behavior* (1977), 48–57.
30. *Working* (1974), 123.

6. The Self-Conscious Animal

The epigraph is from Ernest Becker's *The Denial of Death* (1973), 87.

1. For evidence in favor of the notion of conscious awareness in nonhuman animals, see Griffin (1976, 1984).
2. For the results of Gallup's self-recognition experiments, see the following: Gallup (1970, 1975, 1977, 1979a, 1979b, 1980), Suarez and Gallup (1981), Gallup and McClure (1971), and Gallup et al. (1977). For other evidence of self-awareness in nonhuman primates, see Meddin (1979), and Lethmate and Dücker (1973).
3. 'Social Norms, the Self, and Sociobiology: Building on the Ideas of A.I. Hallowell.'
4. Op. cit., 100–01.
5. *The Biology of Moral Systems* (1987), 112–13. For an alternative theory of the evolution of self-awareness, see Anthony Shafton's *Conditions of Awareness* (1976).
6. *Letters from the Earth* (1938), 181.
7. Alfred Adler's ideas on the importance of self-worth may be found in his *The Practice and Theory of Individual Psychology* (1923). The Allport quotation is from his *Pattern and Growth in Personality* (1961), 155–56. Another psychologist who has placed heavy emphasis on the need for self-worth is Nathaniel Branden. See for example his *The Psychology of Self-Esteem*

(1969) and *The Disowned Self* (1971). For a good review article on this subject, see Viktor Gecas's 'The Self-Concept' (1982).

8. 'The Role of Vigilance in the Development of Animal Neurosis' (1964).

9. Op. cit., 189.

10. Freedman and Rowe's characterization of the emergence of man as the beginning of the 'age of anxiety' may be found in their essay, 'Evolution and Human Behavior' (1958).

11. *Ego in Evolution* (1965), 144–45.

12. *From Sad to Glad* (1974). For an alternate viewpoint, see Colotla (1979).

13. Not all authorities agree with Kline that depression is uniquely human. In fact some experts believe that genuine clinical depression can and does occur in at least a few nonhuman animals. It seems almost certain, in any case, that the human capacity for depression is much more pronounced than that of any other animal. And, as Kline suggests, man's greater awareness of time is at least in part to blame for this being the case.

14. Many of the articles in which Wilson's detractors expressed the view that human biological needs are relatively few in number are reprinted in *The Sociobiology Debate* (edited by Arthur L. Caplan, 1978). See especially selections 22 and 25.

15. *The World as Will and Representation: Volume I* (1966a), 312.

16. *Motivation and Personality* (1970), 24–25. Maslow's theory of human needs is also discussed in his *Toward a Psychology of Being* (1962).

17. *Motivation and Personality* (1970), 129.

7. Man Against Man: The Genesis of Interpersonal Conflict

The epigraph is from Radoslav S. Tsanoff's *The Nature of Evil* (1931), 391–92.

1. *The World as Will and Representation: Volume I* (1966a), Section 62.

2. My discussion of the origin of life on Earth is indebted to Dickerson (1978). For alternative theories see Cairns-Smith (1985) and Crick (1981).

3. *Adaptation and Natural Selection* (1966), 255.

4. For a more detailed discussion of dominance hierarchies among social animals, see Wilson (1975), Chapter 13.
5. For examples of dominance battles among common chimpanzees, see Goodall (1979, 1986). For a discussion of dominance struggles among wasps, see E. O. Wilson (1975), 284.
6. T.H. Clutton-Brock et al., 'The Logical Stag: Adaptive Aspects of Fighting in Red Deer (*Cervus elaphus* L.)' (1979).
7. For discussions of competition among African lions, see Bertram (1975) and Schaller (1972).
8. For a comparison of the 'peaceful' pongid of the early days of chimpanzee research with the more belligerent chimp of recent studies, contrast Jane Goodall's 1965 article, 'The Chimpanzees of the Gombe Stream Reserve' with some of her later writings, for example Goodall (1979, 1986).
9. The war between the Kahama and Kasakela chimps is described in Goodall's 1979 article 'Life and Death at Gombe'. For more information on this and other chimpanzee warfare, see Goodall (1986).
10. Darwin's discussion of the often subtle nature of organic competition may be found in Chapter 3 of his *The Origin of Species* (1962); see especially pages 77 and 89.
11. 'The Evolution of Ecological Systems' (1978), 85.
12. *Origins* (co-authored by Roger Lewin, 1977), 11.
13. *The Nature of Human Aggression* (1976), 165.
14. *Humankind Emerging* (second edition, 1979), 298.
15. Alexander's arguments in favor of the possibility of aggression among prehistoric humans may be found on pages 220–233 of his *Darwinism and Human Affairs* (1979). See also his 1989 article, 'Evolution of the Human Psyche'.
16. Alexander (1979), 227.
17. Op. cit., 228–29.
18. 'The Evolution of Co-operation, Aggression, and Self-control' (1972), 7.
19. Op. cit., 8.
20. Op. cit., 9–10.
21. Bertram (1975).
22. 'The Evolution of Co-operation, Aggression, and Self-control' (1972), 10.
23. A relatively high murder rate among the Netsilik Eskimoes, for example, is reported by both Knud Rasmussen (1931) and Asen Balikci (1970).

24. 'The Myth of the Aggression-free Hunter and Gatherer Society' (1974), 455.
25. *Human Ethology* (1989), 408.
26. *Culture, Man, and Nature* (1971), 369–370.
27. *The Evolution of Political Society* (1967); see especially Chapters 2 and 3.
28. Elizabeth Colson, *Tradition and Contract* (1974), 4.
29. Op. cit., 44–45.
30. Op. cit., 37.

8. Sex and Violence: The Evolutionary Origins of the War between Men and Women

The epigraph is from E.B. White's essay, 'Frigidity in men', which constitutes Chapter 8 of James Thurber and E.B. White's *Is Sex Necessary?* (1929), 161–62.

1. Symons (1979), v.
2. Symons's list of the seven major differences between male and female sexuality may be found on pages 27–28 of *The Evolution of Human Sexuality* (1979).
3. For a discussion of the possibility that sexual reproduction may be an adaptation to novel or unpredictable circumstances, see George C. Williams's *Sex and Evolution* (1975). See also Daly and Wilson (1983), 63–68.
4. For the hypothesis that sex may have evolved as a strategy for warding off pathogenetic invasion, see W.D. Hamilton (1975, 1980), and Hamilton, Henderson, and Moran (1981). See also Daly and Wilson (1983), 68–70. Some independent corroboration of the pathogen hypothesis may be found in Tooby (1982) and Lively (1987).
5. My discussion of the origin of anisogamy is based largely on Parker, Baker, and Smith, 'The Origin and Evolution of Gamete Dimorphism and the Male-Female Phenomenon' (1972); see also Bell (1978). The possibility that the adaptive value of sperm cells may have had to do more with their absolute number, rather than their size or mobility, is discussed in Baylis (1981). For the possibility that 'opposite sexes' may have existed even in ancestral isogamous populations, see Wiese (1981) and Charlesworth (1978). For an alternative hypothesis on the origin of anisogamy, see Cosmides and Tooby (1981).

6. For general discussions of the phenomenon of female choice and its possible adaptive significance, see Daly and Wilson (1983), Chapter 6, and Alcock (1988), 421–441. See also Darwin (1871).

7. For evidence that the females of some bird species increase their reproductive output by choosing males with large nuptial gifts, see Royama (1966), Nisbet (1973), Tasker and Mills (1981), and Wiggins and Morris (1986).

8. The hypothesis that in some bird species the most brightly colored males are also the most resistant to parasitical infection (and as a consequence preferred by females) was proposed by William D. Hamilton and Marlene Zuk in their 1982 article, 'Heritable True Fitness and Bright Birds: A Role for Parasites?' For some independent corroboration of this idea, see Read (1987).

9. For a general introduction to the evolution and behavior of bowerbirds, see Gilliard (1963).

10. For female choice in the satin bowerbird and its possible adaptive value, see the following: Borgia (1985a, 1985b, 1986), and Borgia and Gore (1986).

11. Trivers first proposed his parental investment theory in his 'Parental Investment and Sexual Selection' (1972). The classic works of Darwin and Bateman which provided some of the inspiration for this theory are, respectively, *The Descent of Man and Selection in Relation to Sex* (1871), and 'Intra-sexual Selection in *Drosophila*' (1948). For a more elaborate and more up-to-date version of the parental investment theory, see Trivers's 1985 book, *Social Evolution*, Chapters 9–14.

12. The most important revisions of the parental investment theory were suggested in 1977 by Stephen Emlen and Lewis Oring, 'Ecology, Sexual Selection, and the Evolution of Mating Systems'.

13. For discussions of reproductive behavior in the Northern elephant seal, consult the following: Le Boeuf and Peterson (1969), Le Boeuf (1972, 1974), Le Boeuf, Whiting, and Gantt (1972), Cox and Le Boeuf (1977), Cox (1981), and Reiter, Panken, and Le Boeuf (1981).

14. For examples of promiscuity in so-called 'monogamous' male birds and attempts by females to resist extra-pair bond copula-

tions, see Gladstone (1979), Beecher and Beecher (1979), McKinney et al. (1983), and Trivers (1985), 203–04.

15. 'Parental Investment and Sexual Selection' (1972), 174. For a general discussion of sex role-reversed species, see Trivers (1985), 215–19.

16. For polyandry in seahorses, consult Fiedler (1954) and Trivers (1985), 215–16.

17. For polyandry in phalaropes, see Höhn (1969). For more general discussions of avian polyandry, see Jenni (1974) and Oring (1985).

18. One of the environmentalist psychologists alluded to in the text who takes issue with the parental investment theory is Hilary M. Lips. See her *Sex and Gender: An Introduction* (1988), 42.

19. Shere Hite's male informants discuss their basic dissatisfaction with monogamy on pages 176–185 in *The Hite Report on Male Sexuality* (1981). Hite's female informants, meanwhile, express their basic lack of interest in sexual variety in *The Hite Report* (1976), 303, 310–12, and 327–333. See also Bengis (1973).

20. Weston La Barre's discussion of the cross-cultural prevalence of polygyny may be found on page 112 of his *The Human Animal* (1954).

21. *The Evolution of Human Sexuality* (1979), 225.

22. *A Study of Polyandry* (1963), 540.

23. *The Netsilik Eskimoes* (1931), 195.

24. *A Study of Polyandry* (1963), 529.

25. 'Polyandry in Sri Lanka: a Test Case for Parental Investment Theory' (1980), 587.

26. *The Evolution of Human Sexuality* (1979), 207–08.

27. For evidence of the greater fecundity of polygynous men among the Xavante Indians, see Neel et al. (1964) and Salzano et al. (1967).

28. For evidence of the greater reproductive success of polygynous headmen among the Yanomamo, see Chagnon (1979).

29. *The Evolution of Human Sexuality* (1979), 239.

30. *The Woman that Never Evolved* (1981); see especially Chapters 7 and 8.

31. Kinsey et al. (1953), 682. Other sex surveys in which women consistently express a lesser interest than men in sexual variety and/or 'casual sex' include the following: Terman (1938), Johnson (1970), Sigusch and Schmidt (1971), Hite (1976, 1981),

Tavris and Sadd (1977), Antonovsky (1980), and Carroll, Volk, and Hyde (1985).

32. Hite's female informants express their general lack of interest in casual sex or 'bed-hopping' in Chapter 7 of *The Hite Report* (1976). See also Bengis (1973).

33. Isaac Schapera, *Married Life in an African Tribe* (1940), 207.

34. *Sexual Behavior in the Human Female* (1953), 409.

35. Susan Essock-Vitale and Michael McGuire discuss the results of their study in 'What 70 Million Years Hath Wrought: Sexual Histories and Reproductive Success of a Random Sample of American Women' (1988).

36. For evidence that in aboriginal society women generally prefer the best hunters as sex partners and/or mates, see Symons (1979), 158–162, Holmberg (1950), Sisskind (1973), and Hill and Kaplan (1988). For evidence that in modern society high-status males are still preferred by women over low status ones, consult the following: Sigusch and Schmidt (1971) Udry (1974), Taylor and Glenn (1976), Buss (1985), and Buss and Barnes (1986).

37. For evidence that in polygynous societies it is usually the best hunters and the most politically powerful men who attract multiple wives, while the poorest men attract none at all, see Symons (1979), 158–162, Neel et al. (1964), Holmberg (1950), Sisskind (1973), and Chagnon (1979).

38. *The Hite Report* (1976), 339–343.

39. *The Hite Report on Male Sexuality* (1981), especially Chapter 5, Section 1. See also pages 377–390.

40. 'Sex in Cross-cultural Perspective" (1977), 130.

41. *The Sex Game* (1968), 53.

42. *The Psychology of Sex* (1979), 80.

43. *Against Our Will* (1975), 15.

44. For a general discussion of forced copulation or 'rape' in nonhuman animals, see Daly and Wilson (1983), 164–66. For specific examples of this kind of behavior in various worms, insects, birds, and mammals, see MacKinnon (1974), Abele and Gilchrist (1977), Barash (1977), Gladstone (1979), Beecher and Beecher (1979), Thornhill (1980), McKinney et al. (1983), and Goodall (1986), 467–68.

45. The Hite informants who said that their rape behavior (or rape fantasies) were motivated *entirely* by sexual desire are cited in

The Hite Report on Male Sexuality (1981), 713, 717–18, and 729. The comments of those men who cited a mixture of sexual and other motives may be found on pages 712–13, 715, 717, 720–23, 727–730, and 745. The informants who said that they had raped women by whom they had previously been rejected sexually are cited on pages 718, 721–23, and 729–730.

46. The quotation of the Hite informant who suggested a Darwinian fitness value for rape behavior is from Hite (1981), 719.

47. *The Evolution of Human Sexuality* (1979), Chapter 5. For similar ideas see Darwin (1871), Chapters 19 and 20, and Berndt and Berndt (1951), 22. For other evidence of a relatively high mortality among the males of aboriginal tribes caused by violent competition, see Livingstone (1967). For specific ethnological examples of men fighting over women, consult the following: Lumholtz (1890), Warner (1930), Rasmussen (1931), Middleton (1965), Hiatt (1968), Balikci (1970), Deng (1972), Lee (1979), Chagnon (1983), Hart, Pilling, and Goodale (1988), and Heider (1990).

48. For a discussion of intra-sexual competition and warfare among the Yanomamo, see Chagnon (1983), especially Chapters 5 and 6. Not all anthropologists agree with Chagnon that fighting among the Yanomamo is motivated largely by competition over women. Marvin Harris has suggested that the Yanomamo are actually fighting over land and therefore over sources of meat protein. See his *Cannibals and Kings* (1977), Chapter 5. For Chagnon's replies, see his 'Is Reproductive Success Equal in Egalitarian Societies?' (1979) and *Yanomamo: The Fierce People* (1983), 81–89. More recently, Irenaus Eibl-Eibesfeldt (1989: 415–16) has argued that both Chagnon and Harris may be partly correct. I do not know who is right in this debate, and I do not know whether the Yanomamo fight over women, over land, or both. But I do know that, whatever the motivation for their violence, it is equally deadly in any event.

49. For evidence of violent intra-sexual competition among the Netsilik, see Balikci (1970) especially pages 155–57 and 180–83. See also Rasmussen (1931).

50. *The Netsilik Eskimo* (1970), 180–81.

51. *The Evolution of Human Sexuality* (1979), 270.

9. The Social Creature

The first epigraph is from David Barash's *The Whisperings Within* (1979); the second is from Will Durant's *Our Oriental Heritage* (1954), 21.

1. For examples of baboon defense against predators, see Washburn and Moore (1980), 58–59; and Kummer (1971), 16–17, 50–55, 60, 75, 78, 83, and 92. For examples of leopards being killed by baboons, see Jolly (1985), page 76 and references cited there.
2. Alison Jolly, *The Evolution of Primate Behavior* (1985), 73.
3. Almost all the examples of social behavior discussed in the text are taken from Chapter 3 of Edward O. Wilson's *Sociobiology: The New Synthesis* (1975); for primary sources, consult Wilson's book.
4. 'Concerning the Origin of Sociality in Animals' (1940); see also his book, *Co-operation Among Animals* (1951).
5. *Sociobiology: The New Synthesis* (1975), 36–37.
6. Op. cit., 36.
7. Op. cit., 36.
8. Op. cit., 36.
9. Op. cit., 62.
10. For examples of social conflict among baboons, see Kummer (1971), 20–22, 28, 56, 59, 69, 78, 93, and 98.
11. *The Evolutionary Foundations of Psychology* (1973), 53–54.

10. Epilogue: The Mystery Solved

The epigraph is from Moritz Schlick's essay 'Unanswerable Questions?' (1973), 795.

1. *The Origin of Species* (1962), 484.
2. Paul Edwards's article 'Why?' originally appeared in 1967 in *The Encyclopedia of Philosophy*. It has since been reprinted, with some revisions, in *A Modern Introduction to Philosophy* (edited by Paul Edwards and Arthur Pap, 1973). All the Edwards quotations in Chapter 10 are taken from this revised edition.
3. Stafford-Clark is cited by Paul Edwards in the latter's 1973 essay 'Why?', 797.
4. *Modes of Thought* (1938), pages 183–84.

5. *God and Philosophy* (1959), 140 and 72.
6. *An Inquiry Concerning Human Understanding* (edited by Charles W. Hendel, 1955), 43.
7. *The Grammar of Science* (1937), 97, 103, and 105.
8. *Man Against Darkness* (1967), page 213.
9. *Science, Religion and Reality* (1925), 245.
10. The indented quotation is from Edwards (1973), page 801.
11. Op. cit., 807.

Bibliography

Adler, Alfred. 1923. *The Practice and Theory of Individual Psychology*. London: Routledge.

Abele, Lawrence G., and Sandra Gilchrist. 1977. Homosexual Rape and Sexual Selection in Acanthocephalan Worms. *Science* 197, 81–83.

Ajami, Ismail. 1976. Differential Fertility in Peasant Communities: A Study of Six Iranian Villages. *Population Studies* 30, 453–463.

Alcock, John. 1975. *Animal Behavior: An Evolutionary Approach*. Sunderland, Ma: Sinauer Associates.

————. 1988. *Animal Behavior: An Evolutionary Approach* (fourth edition). Sunderland, Ma: Sinauer Associates.

Alexander, Richard D. 1971. The Search for an Evolutionary Philosophy of Man. *Proceedings of the Royal Society of Victoria* 84, 99–120.

————. 1974. The Evolution of Social Behavior. *Annual Review of Ecology and Systematics* 5, 325–383.

————. 1975. The Search for a General Theory of Behavior. *Behavioral Science* 20, 77–100.

————. 1979. *Darwinism and Human Affairs*. Seattle: University of Washington Press.

————. 1987. *The Biology of Moral Systems*. New York: Aldine De Gruyter.

————. 1989. Evolution of the Human Psyche. In *The Human Revolution*, edited by Paul Mellars and Chris Stringer. Edinburgh: University of Edinburgh Press.

Alexander, Richard D., and Gerald Borgia. 1978. Group Selection, Altruism, and the Levels of Organization of Life. *Annual Review of Ecology and Systematics* 9, 449–474.

Alexander, Richard D., and Donald W. Tinkle. 1968. Review of *On Aggression* by Konrad Lorenz and *The Territorial Imperative* by Robert Ardrey. *BioScience* 18, 245–48.

Allee, W.C. 1940. Concerning the Origin of Sociality in Animals. *Scientia* 67, 154–160.

————. 1951. *Co-Operation Among Animals*. New York: Henry Schumann.

Allison, Anthony C. 1956. Sickle Cells and Evolution. *Scientific American* 195 (2), 87–94.

Allport, Gordon. 1961. *Pattern and Growth in Personality.* New York: Holt, Rinehart, and Winston.

Antonovsky, Helen F. 1980. *Adolescent Sexuality: A Study of Attitudes and Behavior.* Lexington, Ma: Lexington Books.

Ardrey, Robert. 1961. *African Genesis.* New York: Atheneum.

————. 1966. *The Territorial Imperative.* New York: Atheneum.

Attenborough, David. 1979. *Life on Earth.* Boston: Little, Brown.

Balikci, Asen. 1970. *The Netsilik Eskimo.* Garden City, NY: Natural History Press.

Barash, David P. 1977. Sociobiology of Rape in Mallards (*Anas platyrhynchos*): Responses of the Mated Male. *Science* 197, 788–89.

————. 1979. *The Whisperings Within.* New York: Harper and Row.

————. 1980. Human Reproductive Strategies: A Sociobiologic Overview. In *The Evolution of Human Social Behavior,* edited by Joan S. Lockard. New York: Elsevier, 143–164.

————. 1982. *Sociobiology and Behavior* (2nd edition). New York: Elsevier.

Barkow, Jerome H. 1978. Social Norms, the Self, and Sociobiology: Building on the Ideas of A.I. Hallowell. *Current Anthropology* 19, 99–118.

Bateman, A.J. 1948. Intra-sexual Selection in *Drosophila. Heredity* 2, 349–368.

Becker, Ernest. 1973. *The Denial of Death.* New York: The Free Press.

————. 1975. *Escape from Evil.* New York: The Free Press.

Baylis, Jeffrey R. 1981. The Evolution of Parental Care in Fishes with Reference to Darwin's Rule of Male Sexual Selection. *Environmental Fish Biology* 6, 223–251.

Beecher, Michael D., and Inger Mornestam Beecher. 1979. Sociobiology of Bank Swallows: Reproductive Strategy of the Male. *Science* 205, 1282–85.

Bell, Graham. 1978. The Evolution of Anisogamy. *Journal of Theoretical Biology* 73, 247–270.

Benedict, Paul K., and Irving Jacks. 1954. Mental Illness in Primitive Society. *Psychiatry* 17, 377–389.

Bengis, Ingrid. 1973. *Combat in the Erogenous Zone.* New York: Bantam.

Bernard, Jessie. 1968. *The Sex Game.* Englewood Cliffs, NJ: Prentice-Hall.

Berndt, Ronald M., and Catherine H. Berndt. 1951. *Sexual Behavior in Western Arnhem Land.* New York: Viking Fund.

Bernstein, Irwin S., and Thomas P. Gordon. 1975. The Function of Aggression in Primate Societies. *American Scientist* 62, 304–311.

Bertram, Brian C.R. 1975. Social Factors Influencing Reproduction in Wild Lions. *Journal of Zoology* 177, 463–482.

Betzig, Laura. 1988. Mating and Parenting in Darwinian Perspective. In *Human Reproductive Behaviour: A Darwinian Perspective,* edited by Laura Betzig, Monique Borgerhoff-Mulder, and Paul Turke. Cambridge: Cambridge University Press.

Bigelow, Robert S. 1969. *The Dawn Warriors: Man's Evolution Toward Peace.* Boston: Little, Brown.

————. 1972. The Evolution of Co-operation, Aggression, and Self-control. In *Nebraska Symposium on Motivation,* edited by J.K. Cole and D.D. Jensen, Lincoln, Ne: University of Nebraska Press, 1–57.

Bootzin, Richard R., and Joan Ross Acocella. 1988. *Abnormal Psychology: Current Perspectives* (fifth edition). New York: Random House.

Borgia, Gerald. 1985a. Bower Destruction and Sexual Competition in the Satin Bower Bird (*Ptilonorhynchus violaceus*). *Behavioral Ecology and Sociobiology* 18, 91–100.

————. 1985b. Bower Quality, Number of Decorations, and Mating Success of Male Satin Bower Birds (*Ptilonorhynchus violaceus*): An Experimental Analysis. *Animal Behaviour* 33, 266–271.

————. 1986. Sexual Selection in Bower Birds. *Scientific American* 254:(6), 92–100.

Borgia, Gerald, and Mauvis A. Gore. 1986. Feather Stealing in the Satin Bower Bird (*Ptilonorhynchus violaceus*): Male Competition and the Quality of Display. *Animal Behaviour* 34, 727–738.

Bowler, P. 1976. Malthus, Darwin, and the Concept of Struggle. *Journal of the History of Ideas* 37, 631–650.

Branden, Nathaniel. 1969. *The Psychology of Self-Esteem.* Los Angeles: Nash.

————. 1971. *The Disowned Self.* Los Angeles: Nash.

Broome, J.H. 1963. *Rousseau: A Study of His Thought.* London: Edward Arnold.

Brown, Carl, and S.L. Lahren. 1973. More on Hunting Ability and Increased Brain Size. *Current Anthropology* 14, 309–310.

Brownmiller, Susan. 1975. *Against Our Will: Men, Women, and Rape.* New York: Simon and Schuster.

Buss, David M. 1985. Human Mate Selection. *American Scientist* 73, 47–51.

Buss, David M., and Michael Barnes. 1986. Preferences in Human Mate Selection. *Journal of Personality and Social Psychology* 50: 559–570.

Cairns-Smith, A.G. 1985. *Seven Clues to the Origin of Life.* Cambridge: Cambridge University Press.

Calhoun, J.B. 1962a. A Behavioral Sink. In *Roots of Behavior*, edited by E.L. Bliss. New York: Harper and Brothers.

————. 1962b. Population Density and Social Pathology. *Scientific American* 26, 139–146.

Campbell, Bernard G. 1979. *Humankind Emerging* (second edition). Boston: Little, Brown.

————. 1982. *Humankind Emerging* (third edition). Boston: Little, Brown.

Caplan, Arthur L. 1978. *The Sociobiology Debate.* New York: Harper and Row.

Carroll, Jannell L., Kari D. Volk, and Janet Shibley Hyde. 1985. Differences between Males and Females in Motives for Engaging in Sexual Intercourse. *Archives of Sexual Behavior* 14, 131–39.

Cartmill, Matt. 1974. Rethinking Primate Origins. *Science* 184, 436–443.

Chagnon, Napoleon. 1977. *Yanomamo: The Fierce People* (second edition). New York: Holt, Rinehart, and Winston.

————. 1979. Is Reproductive Success Equal in Egalitarian Societies? In *Evolutionary Biology and Human Social Behavior: An Anthropological Perspective*, edited by Napoleon A. Chagnon and William Irons. North Scituate, Ma: Duxbury Press.

Chagnon, Napoleon, and R.B. Hames. 1979. Protein Deficiency and Tribal Warfare in Amazonia: New Data. *Science* 203, 910–13.

Charlesworth, Brian. 1978. The Population Genetics of Anisogamy. *Journal of Theoretical Biology* 73, 347–357.

Chase, Stuart. 1938. *The Tyranny of Words.* New York: Harcourt, Brace.

Cherfas, Jeremy. 1983. Trees Have Made Man Upright. *New Scientist* (January 20), 172–78.

Cloak, F.T., Jr. 1975. Is a Cultural Ethology Possible? *Human Ecology* 3, 162–182.

Clutton-Brock, Timothy H., S. Albon, R. Gibson, and F. Guinness. 1979. The Logical Stag: Adaptive Aspects of Fighting in Red Deer (*Cervus elaphus* L.). *Animal Behaviour* 27, 211–225.

Clutton-Brock, Timothy H., and Paul H. Harvey. 1978. Primate Ecology and Social Organization. In *Readings in Sociobiology*, edited by T.H. Clutton-Brock and Paul H. Harvey. Reading: Freeman, 342–380.

Colotla, V.A. 1979. Experimental Depression in Animals. In *Psychopathology in Animals*, edited by J.D. Keehn. New York: Academic Press, 223–238.

Colson, Elizabeth. 1974. *Tradition and Contract: The Problem of Order*. Chicago: Aldine.

Coombs, Robert H., and William F. Kenkel. 1966. Sex Differences in Dating Aspirations and Satisfaction with Computer-selected Partners. *Journal of Marriage and the Family* 28, 62–66.

Copleston, Frederick, S.J. 1962. *A History of Philosophy*. Garden City, NY: Image Books.

Corning, Peter A. 1983. *The Synergism Hypothesis: A Theory of Progressive Evolution*. New York: McGraw-Hill.

Cosmides, Leda Murlas, and John Tooby. 1981. Cytoplasmic Inheritance and Intragenomic Conflict. *Journal of Theoretical Biology* 89, 83–129.

Cox, Cathleen R. 1981. Agonistic Encounters among Male Elephant Seals: Frequency, Context, and the Role of Female Preference. *American Zoologist* 21, 197–209.

Cox, Cathleen R., and Burney J. Le Boeuf. 1977. Female Incitation of Male Competition: A Mechanism in Sexual Selection. *American Naturalist* 111, 317–335.

Crick, Francis. 1981. *Life Itself: Its Origin and Nature*. New York: Simon and Schuster.

Crook, John Hurrell. 1980. *The Evolution of Human Consciousness*. Oxford: Clarendon.

Daly, Martin. 1978. The Cost of Mating. *American Naturalist* 112, 771–74.

Daly, Martin, and Margo Wilson. 1978. *Sex, Evolution, and Behavior*. Belmont, Ca: Wadsworth.

Darrow, Clarence. 1973. The Delusion of Design and Purpose. In *A Modern Introduction to Philosophy*, edited by Paul Edwards and Arthur Pap. New York: The Free Press, 446–453.

Darwin, Charles. 1871. *The Descent of Man and Selection in Relation to Sex*. London: John Murray.

————. 1962 [1859]. *The Origin of Species by Means of Natural Selection or the Preservation of Favoured Races in the Struggle for Life*. New York: Collier.

————. 1958. *The Autobiography of Charles Darwin*. New York: Dover.

Davenport, William H. 1977. Sex in Cross-cultural Perspective. In *Human Sexuality in Four Perspectives*, edited by F.A. Beach. Baltimore: Johns Hopkins University Press, 115–163.

Davison, Gerald C., and John M. Neale 1978. *Abnormal Psychology: An Experimental Clinical Approach* (second edition). New York: Wiley.

Dawkins, Richard 1976. *The Selfish Gene*. New York: Oxford University Press.

————. 1977. Replicator Selection and the Extended Phenotype. *Zeitschrift für Tierpsychologie* 47, 61–76.

————. 1982. *The Extended Phenotype*. Oxford: Oxford University Press.

Deng, Francis Matting. 1972. *The Dinka of the Sudan*. New York: Holt, Rinehart, and Winston.

Dickemann, Mildred M. 1979. The Ecology of Mating Systems in Hypergynous Dowry Societies. *Social Science Information* 18, 163–195.

Dickerson, Richard E. 1978. Chemical Evolution and the Origin of Life. In *Evolution* (A *Scientific American* Book). San Francisco: Freeman.

Dobinson, C.H. 1969. *Jean-Jacques Rousseau: His Thought and Its Relevance Today*. London: Methuen.

Dobzhansky, Theodosius. 1956. *The Biological Basis of Human Freedom*. New York: Columbia University Press.

————. 1962. *Mankind Evolving*. New York: Yale University Press.

Doolittle, W.F., and C. Sapienza. 1980. Selfish Genes, the Phenotype Paradigm, and Genome Evolution. *Nature* 284, 601–03.

Dubreuil, Guy, and Eric D. Wittkower. 1976. Primary Prevention: A Combined Psychiatric-anthropological Appraisal. In *Anthropology and Mental Health*, edited by Joseph Westermeyer. The Hague: Mouton.

DuBrul, E. Lloyd. 1962. The General Phenomenon of Bipedalism. *American Zoologist* 2, 205–08.

Durant, Will. 1954. *Our Oriental Heritage*. New York: Simon and Schuster.

Durden-Smith, Jo, and Diane de Simone. 1983. *Sex and the Brain*. New York: Arbor House.

Edgerton, Robert B. 1977. Conceptions of Psychosis in Four East African Societies. In *Culture, Disease, and Healing: Studies in Medical Anthropology*, edited by David Landy. New York: Macmillan.

Eibl-Eibesfeldt, Irenäus. 1974. The Myth of the Aggression-free Hunter and Gatherer Society. In *Primate Aggression, Territoriality, and Xenophobia*, edited by Ralph L. Holloway. New York: Academic Press, 435–57.

————. 1989. *Human Ethology*. New York: Aldine de Gruyter.

Ember, Carol R. 1978. Myths about Hunter-gatherers. *Ethnology* 17, 439–448.

Emlen, Stephen T., and Lewis M. Oring. 1977. Ecology, Sexual Selection, and the Evolution of Mating Systems. *Science* 197, 215–223.

Essock-Vitale, Susan M., and Michael T. McGuire. 1988. What 70 Million Years Hath Wrought: Sexual Histories and Reproductive Success of a Random Sample of American Women. In *Human Reproductive Behaviour: A Darwinian Perspective*, edited by Laura Betzig, Monique Borgerhoff-Mulder, and Paul Turke. Cambridge: Cambridge University Press.

Eysenck, H.J., and Glenn Wilson. 1979. *The Psychology of Sex*. Toronto: Derat.

Falk, Dean. 1980. Hominid Brain Evolution: The Approach from Paleoneurology. *Yearbook of Physical Anthropology* 23, 93–107.

Fiakowski, K.R. 1978. Early Hominid Brain Evolution and Heat Stress: A Hypothesis. *Studies in Physical Anthropology* 4, 87–92.

Fiedler, Kurt. 1954. Vergleichende Verhaltensstudien an Seenadeln, Schlangennadeln, und Seepferdchen. *Zeitschrift für Tierpsychologie* 11, 358–416.

Field, Margaret. 1960. *Search for Security: An Ethno-Psychiatric Study of Rural Ghana*. Evanston, Il: Northwestern University Press.

Fisher, Helen. 1982. *The Sex Contract: The Evolution of Human Behavior*. New York: Morrow.

Foster, George, and Barbara Gallantin Anderson. 1978. *Medical Anthropology*. New York: Wiley.

Freedman, Lawrence, and Anne Rowe. 1958. Evolution and Human Behavior. *Behavior and Evolution*, edited by Anne Rowe and G.G. Simpson. New Haven: Yale University Press, 455–479.

Fried, Morton. 1967. *The Evolution of Political Society: An Essay in Political Anthropology.* New York: Random House.

Fuller, B.A.G. 1938. *A History of Philosophy.* New York: Holt, Rinehart, and Winston.

Gabow, Stephen L. 1977. Population Structure and the Rate of Hominid Brain Evolution. *Journal of Human Evolution* 6, 643–65.

Gallup, Gordon C., Jr. 1970. Chimpanzee Self-recognition. *Science* 167, 86–87.

———. 1975. Towards an Operational Definition of Self-awareness. In *Socioecology and Psychology of Primates,* edited by Russell H. Tuttle. The Hague: Mouton, 309–341.

———. 1977. Self-recognition in Primates: A Comparative Approach to the Bidirectional Properties of Consciousness. *American Psychologist* 32, 329–338.

———. 1979a. Self-awareness in Primates. *American Scientist* 67, 417–421.

———. 1979b. Self-recognition in Chimpanzees and Man: A Developmental and Comparative Perspective. In *Genesis of Behavior, Volume II: The Child and its Family,* edited by M. Lewis and L.A. Rosenblum. New York: Plenum Press.

———. 1980. Chimpanzees and Self-awareness. In *Species Identity and Attachment: A Phylogenetic Evaluation,* edited by M.A. Roy. New York: Garland STPM Press.

Gallup, Gordon G., Jr., J.L. Boren, G.J. Gagliardi, and L.B. Wallnau. 1977. A Mirror for the Mind of Man, or Will the Chimpanzee Create an Identity Crisis for *Homo sapiens? Journal of Human Evolution* 6, 303–313.

Gallup, Gordon G., Jr., and M.K. McClure. 1971. Preference for Mirror-image Stimulation in Differentially-reared rhesus monkeys. *Journal of Comparative and Physiological Psychology* 75, 403–07.

Gardner, Martin. 1983. *The Whys of a Philosophical Scrivener.* New York: Quill.

Gause, G.F. 1942. The Relation of Adaptability to Adaptation. *Quarterly Review of Biology* 17, 99–114.

Gecas, Viktor. 1982. The Self-Concept. *Annual Review of Sociology* 8, 1–33.

Geis, G. 1977. Forcible Rape: An Introduction. *Forcible Rape: The Crime, the Victim, and the Offender,* edited by D. Chappell, R. Geis, and G. Geis. New York: Columbia University Press, 1–44.

Geist, Valerius. 1978. *Life Strategies, Human Evolution, Environmental Design.* New York: Springer.

Ghiselin, Michael. 1974. *The Economy of Nature and the Evolution of Sex.* Berkeley: University of California Press.

Gilliard, E. Thomas. 1963. The Evolution of Bower Birds. *Scientific American* 209 (8), 38–46.

Gilson, Étienne. 1959. *God and Philosophy.* New Haven: Yale University Press.

Gladstone, Douglas E. 1979. Promiscuity in Monogamous Colonial Birds. *American Naturalist* 114, 545–557.

Goodall, Jane. 1965. Chimpanzees of the Gombe Stream Reserve. In *Primate Behavior: Field Studies of Monkeys and Apes,* edited by Irven De Vore. New York: Holt, Rinehart, and Winston.

———. 1979. Life and Death at Gombe. *National Geographic* 155, 592–620.

———. 1986. *The Chimpanzees of Gombe.* Cambridge, Ma: Belknap Press.

Goodson, Felix E. 1973. *The Evolutionary Foundations of Psychology.* New York: Holt, Rinehart, and Winston.

Greenwood, Davydd J., and William A. Stini. 1977. *Nature, Culture, and Human History: A Bio-cultural Introduction to Anthropology.* New York: Harper and Row.

Griffin, Donald R. 1976. *The Question of Animal Awareness.* New York: Rockefeller University Press.

———. 1984. *Animal Thinking.* Cambridge, Ma: Harvard University Press.

Gross, Daniel R. 1973. *Peoples and Cultures of Native South America: An Anthropological Reader.* Garden City, NY: Natural History Press.

———. 1975. Protein Capture and Cultural Development in the Amazon Basin. *American Anthropologist* 77, 526–549.

Haldane, J.B.S. 1966. *The Causes of Evolution.* Ithaca, NY: Cornell University Press.

Hamilton, William D., 1975a. Gamblers Since Life Began: Barnacles, Aphids, and Elms. *Quarterly Review of Biology* 50, 175–180.

———. 1975b. Innate Social Aptitudes of Man: An Approach from Evolutionary Genetics. In *Biosocial Anthropology,* edited by Robin Fox. New York: Wiley.

———. 1980. Sex Versus Non-sex Versus Parasite. *Oikos* 35, 282–290.

Hamilton, William D., Peter A. Henderson, and Nancy A. Moran. 1981. Fluctuation of Environment and Co-evolved Antagonist

Polymorphism as Factors in the Maintenance of Sex. In *Natural Selection and Social Behavior*, edited by Richard D. Alexander and Donald W. Tinkle. New York: Chiron Press.

Hamilton, William D., and Marlene Zuk. 1982. Heritable True Fitness and Bright Birds: A Role for Parasites? *Science* 218: 384–87.

Harris, Marvin. 1971. *Culture, Man, and Nature*. New York: Crowell.

———. 1977. *Cannibals and Kings*. New York: Random House.

Harrison, Charles. 1977. *The Neurotic Primate*. London: Wildwood House.

Hart, C.W.M., Arnold R. Pilling, and Jane C. Goodale. 1988. *The Tiwi of North Australia* (third edition). New York: Holt, Rinehart, and Winston.

Heider, Karl G. 1990. *Grand Valley Dani: Peaceful Warriors* (second edition). New York: Holt, Rinehart, and Winston.

Herskovits, Melville. 1952. *Economic Anthropology*. New York: Knopf.

Hewes, Gordon W. 1961. Food Transport and the Origin of Hominid Bipedalism. *American Anthropologist* 63, 637–710.

———. 1964. Hominid Bipedalism: Independent Evidence for the Food-carrying Theory. *Science* 146, 416–18.

Hiatt, L.R. 1968. Gidjingali Marriage Arrangements. In *Man the Hunter*, edited by Richard B. Lee and Irven DeVore. Chicago: Aldine.

———. 1980. Polyandry in Sri Lanka: A Test Case for Parental Investment Theory. *Man* 15, 583–602.

Hill, K. 1982. Hunting and Human Evolution. *Journal of Human Evolution* 11, 521–544.

Hill, Kim, and Hilliard Kaplan. 1988. Trade-offs in Male and Female Reproductive Strategies among the Ache. In *Human Reproductive Behaviour: A Darwinian Perspective*, edited by Laura Betzig, Monique Borgerhoff-Mulder, and Paul Turke. Cambridge: Cambridge University Press.

Hite, Shere. 1976. *The Hite Report*. New York: Macmillan.

———. 1981. *The Hite Report on Male Sexuality*. New York: Knopf.

Hobbes, Thomas. 1962. *Leviathan: Or the Matter, Forme and Power of a Commonwealth Ecclesiasticall and Civil* (edited by Michael Oakeshott). New York: Collier.

Höhn, E. Otto. 1969. The Phalarope. *Scientific American* 220 (6), 104–111.

Holmberg, Allan R. 1950. *Nomads of the Long Bow: the Siriono of*

Eastern Bolivia. Washington, DC: U.S. Government Printing Office.

Hooton, Earnest Albert. 1937. *Apes, Men, and Morons.* New York: Putnam.

Hoskin, John O., Michael I. Friedman, and John E. Cawte 1969. A High Incidence of Suicide in a Preliterate-Primitive Society. *Psychiatry* 32: 202–210.

Hrdy, Sarah Blaffer. 1979. The Evolution of Human Sexuality: The Latest Word and the Last. *Quarterly Review of Biology* 54, 309–314.

————. 1981. *The Woman that Never Evolved.* Cambridge, Ma: Harvard University Press.

Hrdy, Sarah Blaffer, and William Bennett 1981. Lucy's Husband: What Did He Stand For? *Harvard Magazine* (July–August), 46, 77–79.

Hume, David. 1955. *An Inquiry Concerning Human Understanding,* edited by Charles W. Hendel. New York: Liberal Arts Press.

Huxley, Thomas Henry. 1897. *Evolution and Ethics and Other Essays.* New York: Appleton.

Irons, William. 1979. Cultural and Biological Success. In *Evolutionary Biology and Human Social Behavior: An Anthropological Perspective,* edited by Napoleon A. Chagnon and William Irons. North Scituate, Ma: Duxbury Press

Jenni, Donald A. 1974. The Evolution of Polyandry in Birds. *American Zoologist* 14, 129–144.

Johanson, Donald C., and Maitland Edey. 1981. *Lucy: The Beginnings of Humankind.* New York: Simon and Schuster.

Johnson, Ralph E. 1970. Some Correlates of Extramarital Coitus. *Journal of Marriage and the Family* 22, 449–456.

Jolly, Alison. 1985. *The Evolution of Primate Behavior* (second edition). New York: Macmillan.

Jolly, Clifford J. 1970. The Seed Eaters: A New Model of Hominid Differentiation Based on a Baboon Analogy. *Man* 5, 5–27.

Kahn, Charles H. 1960. *Anaximander and the Origins of Greek Cosmology.* New York: Columbia University Press.

Keating, Edward M. 1975. *The Broken Bough* New York: Atheneum.

Keith, Sir Arthur. 1949. *A New Theory of Human Evolution* New York: Philosophical Library.

Kinsey, Alfred C., Wardell B. Pomeroy, and Clyde E. Martin. 1948. *Sexual Behavior in the Human Male.* Philadelphia: Saunders.

Kinsey, Alfred C., Wardell B. Pomeroy, Clyde E. Martin, and Paul H.

Gephardt. 1953. *Sexual Behavior in the Human Female.* Philadelphia: Saunders.

Kleiman, Devra G. 1977. Monogamy in Mammals. *Quarterly Review of Biology* 52, 39–69.

Kline, Nathan S. 1981. *From Sad to Glad: Kline on Depression.* New York: Ballantine.

Krantz, Grover S. 1968. Brain Size and Hunting Ability in Earliest Man. *Current Anthropology* 9, 450–51.

————. 1971. Reply to 'On Brain Size in Earliest Hunters' by L. Ceci. *Current Anthropology* 12, 392.

————. 1980. Sapienization and Speech. *Current Anthropology* 21, 773–79.

Kraus, Bertram S. 1964. *The Basis of Human Evolution.* New York: Harper and Row.

Kraus, Gerhard. 1977. *Man in Decline.* New York: St. Martin's Press.

Krogman, Wilton M. 1951. The Scars of Human Evolution. *Scientific American* 185:(12), 55–57.

Kummer, Hans. 1971. *Primate Societies.* Chicago: Aldine

La Barre, Weston. 1954. *The Human Animal.* Chicago: University of Chicago Press.

Lack, David. 1969. Of Birds and Men. *New Scientist* 41 (January 16th): 121–22.

Lamarck, Jean-Baptiste. 1914. *The Zoological Philosophy* (translated by Hugh Elliot). London: Macmillan.

Landy, David. 1977. *Culture, Disease, and Healing: Studies in Medical Anthropology.* New York: Macmillan.

Laughlin, William S. 1968. Hunting: An Integrating Biobehavior System and its Evolutionary Importance. In *Man the Hunter,* edited by Richard B. Lee and Irven DeVore. Chicago: Aldine-Atherton.

Leakey, Richard E. and Roger Lewin. 1977. *Origins.* New York: Dutton.

————. 1978. *People of the Lake.* New York: Doubleday.

Le Boeuf, Burney J. 1972. Sexual Behaviour in the Northern Elephant Seal, *Mirounga angustirostris. Behaviour* 41, 1–26.

————. 1974. Male-male Competition and Reproductive Success in Elephant Seals. *American Zoologist* 14, 163–176.

Le Boeuf, Burney J., and Richard S. Peterson. 1969. Social Status and Mating Activity in Elephant Seals. *Science* 163, 91–93.

Le Boeuf, Burney J., Ronald J. Whiting, and Richard F. Gantt. 1972.

Perinatal Behavior of Northern Elephant Seal Females and Their Young. *Behaviour* 43, 121–156.

Lee, Richard B. 1968. What Hunters Do for a Living, or, How to Make Out on Scarce Resources. In *Man the Hunter*, edited by Richard B. Lee and Irven DeVore. Chicago: Aldine-Atherton.

————. 1972. The :Kung Bushmen of Botswana. In *Hunters and Gatherers Today*, edited by M.G. Bicchieri. New York: Holt, Rinehart, and Winston.

————. 1979. *The !Kung San: Men, Women, and Work in a Foraging Society.* New York: Cambridge University Press.

Lee, Richard B., and Irven DeVore (editors) 1968. *Man the Hunter.* Chicago: Aldine-Atherton.

Lethmate, J., and G. Dücker. 1973. Untersuchungen zum Selbsterkennen im Spiegel bei Orangutans und einigen anderen Affenarten. *Zeitschrift für Tierpsychologie* 33, 248–269.

Lewin, Roger. 1983. Were Lucy's Feet Made for Walking? *Science* 220, 700–02.

Liddell, Howard. 1964. The Role of Vigilance in the Development of Animal Neurosis. In *Anxiety*, edited by Paul Hoch and Joseph Rubin. New York: Hafner.

Lips, Hilary M. 1988. *Sex and Gender: An Introduction.* Mountain View, Ca: Mayfield.

Lively, Curtis M. 1987. Evidence from a New Zealand Snail for the Maintenance of Sex by Parasitism. *Nature* 328, 519–521.

Livingstone, Frank B. 1958. Anthropological Implications of Sickle Cell Gene Distribution in West Africa. *American Anthropologist* 60, 533–562.

————. 1962. Reconstructing Man's Pliocene Pongid Ancestor. *American Anthropologist* 64, 301–05.

————. 1967. The Effects of Warfare on the Biology of the Human Species. In *War: The Anthropology of Armed Conflict and Aggression*, edited by Morton Fried, Marvin Harris, and Robert Murphy. Garden City, NY: Natural History Press.

Loemker, L.E. 1967. Pessimism and Optimism. In *The Encyclopedia of Philosophy: Volume VI*, edited by Paul Edwards. New York: Macmillan.

Lovejoy, A.O., and G. Boas. 1935. *Primitivism and Related Ideas in Antiquity.* Baltimore: Johns Hopkins University Press.

Lovejoy, C. Owen. 1981. The Origin of Man. *Science* 211, 341–350.

Lumholtz, Carl. 1890. *Among Cannibals.* London: John Murray.

Lumsden, Charles, and Edward O. Wilson. 1981. *Genes, Mind, and*

Culture: The Coevolutionary Process. Cambridge, Ma: Harvard University Press.

————. 1983. *Promethean Fire: Reflections on the Origin of the Mind.* Cambridge, Ma: Harvard University Press.

MacKinnon, John. 1974. The Behaviour and Ecology of Wild Orangutans (*Pongo pygmaeus*). *Animal Behaviour* 22, 3–75.

Malcolm, Norman. 1973. Thoughtless Brutes. *Proceedings and Addresses of the American Philosophical Association* 46, 5–20.

Marks, Stuart A. 1977. Hunting Behavior and Strategies of the Valley Bisa in Zambia. *Human Ecology* 5, 1–36.

Maslow, Abraham H. 1962. *Toward a Psychology of Being.* Princeton: Van Nostrand.

————. 1970. *Motivation and Personality* (second edition). New York: Harper and Row.

May, Robert M. 1978. The Evolution of Ecological Systems. In *Evolution* (A *Scientific American* Book). San Francisco: Freeman.

Mayr, Ernst 1982. *The Growth of Biological Thought.* Cambridge, Ma: Belknap Press.

McHenry, H.M. 1982. The Pattern of Human Evolution: Studies on Bipedalism, Mastication, and Encephalization. *Annual Review of Anthropology* 11, 151–173.

McKeon, Richard (editor). 1941. *The Basic Works of Aristotle.* New York: Random House.

McKinney, Frank, Scott R. Derrickson, and Pierre Mineau. 1983. Forced copulation in water fowl. *Behaviour* 86, 250–294.

Mead, Margaret. 1967. *Male and Female: A Study of the Sexes in a Changing World.* New York: Morrow.

Meddin, Jay. 1979. Chimpanzees, Symbols, and the Reflexive Self. *Social Psychology Quarterly* 42, 99–109.

Menaker, Esther, and William Menaker. 1965. *Ego in Evolution.* New York: Grove Press.

Merker, Björn. 1984. A Note on Hunting and Hominid Origins. *American Anthropologist* 86, 112–14.

Metchnikoff, Élie. 1903. *The Nature of Man.* New York: Putnam.

Meyer-Holzapfel, Monica. 1968. *Abnormal Behavior in Animals.* Philadelphia: Saunders.

Middleton, John. 1965. *The Lugbara of Uganda.* New York: Holt, Rinehart, and Winston.

Mill, John Stuart. 1874. *Three Essays on Religion.* New York: Holt.

Montagna, William. 1965. The Skin. *Scientific American* 202 (2), 56–66.

Montagu, M.F. Ashley. 1976. *The Nature of Human Aggression*. New York: Oxford University Press.

Morris, Desmond. 1969. *The Human Zoo*. New York: McGraw-Hill.

Napier, John. 1967. The Antiquity of Human Walking. *Scientific American* 216(4), 56–66.

Needham, Joseph. 1925. *Science, Religion, and Reality*. New York: Macmillan.

Neel, J.V., F.M. Salzano, P.C. Junqueira, F. Keiter, and D. Maybury-Lewis. 1964. Studies on the Zavante Indians of the Brazilian Mato Grosso. *Human Genetics* 16, 52–140.

Neff, Walter S. 1977. *Work and Human Behavior* (second edition). Chicago: Aldine.

Newman, Russell W. 1970. Why Man is Such a Sweaty and Thirsty Naked Animal: A Speculative Review. *Human Biology* 42, 12–27.

Nisbet, I.C.T. 1973. Courtship Feeding, Egg Size, and Breeding Success in Common Terns. *Nature* 241, 141–142.

Nyhan, William L., and Edward Edelson. 1976. *The Heredity Factor*. New York: Grosset and Dunlap.

O'Flaherty, Wendy Doniger. 1976. *The Origin of Evil in Hindu Mythology*. Berkeley: University of California Press.

Orgel, L.E., and F.H.C. Crick. 1980. Selfish DNA: The Ultimate Parasite. *Nature* 284, 604–07.

Orians, Gordon H. 1969. On the Evolution of Mating Systems in Birds and Mammals. *American Naturalist* 103, 589–603.

Oring, Lewis W. 1985. Avian Polyandry. *Current Ornithology* 3, 309–351.

Orwell, George. 1961. *Down and Out in Paris and London*. New York: Harcourt, Brace.

Parker, Christopher E. 1978. Opportunism and the Rise of Intelligence. *Journal of Human Evolution* 7, 597–608.

Parker, G.A., R.R. Baker, and V.G.F. Smith. 1972. The Origin and Evolution of Gamete Dimorphism and the Male-female Phenomenon. *Journal of Theoretical Biology* 36, 529–553.

Parker, Sue Taylor, and Kathleen Rita Gibson. 1979. A Developmental Model for the Evolution of Language and Intelligence in Early Hominids. *The Behavioral and Brain Sciences* 2, 367–408.

Pearson, Karl. 1937. *The Grammar of Science*. London: Blade.

Peter, Prince of Greece and Denmark. 1963. *A Study of Polyandry*. The Hague: Mouton.

Pilbeam, David. 1972. *The Ascent of Man: An Introduction to Human Evolution.* New York: Macmillan.

Pospisil, Leopold J. 1963. *The Kapauku Papuans of West New Guinea.* New York: Holt, Rinehart, and Winston.

Prost, J.H. 1980. Origin of Bipedalism. *American Journal of Physical Anthropology* 52, 175–189.

Rasmussen, Knud. 1931. *The Netsilik Eskimoes.* Copenhagen: Gyldendalske Boghandel-Nordisk Forlag.

Read, Andrew F. 1987. Comparative Evidence Supports the Hamilton and Zuk Hypothesis on Parasites and Sexual Selection. *Nature* 328, 68–70.

Reiter, Joanne, Kathy J. Panken, and Burney J. Le Boeuf. 1981. Female Competition and Reproductive Success in Northern Elephant Seals. *Animal Behaviour* 29, 670–687.

Rodman, Peter S., and Henry M. McHenry. 1980. Bioenergetics and the Origin of Hominid Bipedalism. *American Journal of Physical Anthropology* 52, 103–06.

Rose, M.D. 1976. Bipedal Behavior of the Olive Baboons (*Papio anubis*) and its Relevance to an Understanding of the Evolution of Human Bipedalism. *American Journal of Physical Anthropology* 44, 247–262.

Rosenberg, Morris. 1979. *Conceiving the Self.* New York: Basic Books.

Rosenhan, David L., and Martin E.P. Seligman. 1989. *Abnormal Psychology* (second edition). New York: Norton.

Rousseau, Jean-Jacques. 1967. *The Social Contract and Discourse on the Origin and Foundation of Inequality among Mankind,* edited by Lester G. Crocker. New York: Washington Square Press.

Royama, T. 1966. A Re-interpretation of Courtship Feeding. *Bird Study* 13, 116–129.

Sagan, Carl. 1977. *The Dragons of Eden.* New York: Random House.

Sahlins, Marshall. 1968. Notes on the Original Affluent Society. In *Man the Hunter,* edited by Richard B. Lee and Irven DeVore. Chicago: Aldine-Atherton.

———. 1972. *Stone Age Economics.* Chicago: Aldine-Atherton.

Salzano, Francisco M., James V. Neel, and David Maybury-Lewis. 1967. Further Studies on the Xavante Indians I. Demographic Data on Two Additional Villages: Genetic Structure of the Tribe. *American Journal of Human Genetics* 19, 463–489.

Schaller, George B. 1972. *The Serengeti Lion: A Study of Predator-Prey Relations.* Chicago: University of Chicago Press.

Schapera, Isaac. 1940. *Married Life in an African Tribe.* London: Faber and Faber.

Schlick, Moritz. 1973. Unanswerable Questions? In *A Modern Introduction to Philosophy:* third edition, edited by Paul Edwards and Arthur Pap. New York: The Free Press.

Schopenhauer, Arthur. 1966a. *The World as Will and Representation, Volume I.* Translated by E.F.J. Payne. New York: Dover.

———. 1966b. *The World as Will and Representation, Volume II* Translated by E.F.J. Payne. New York: Dover.

———. 1967. *The Will to Live: Selected Writings of Arthur Schopenhauer,* edited by Richard Taylor. New York: Frederick Ungar.

Schwartz, Gary G., and Leonard A. Rosenblum. 1981. Allometry of Primate Hair Density and the Evolution of Human Hairlessness. *American Journal of Physical Anthropology* 55, 9–12.

Schweitzer, Albert. 1961. *On the Edge of the Primeval Forest.* New York: Macmillan.

Service, Elman R. 1967. War and our contemporary ancestors. In *War: The Anthropology of Armed Conflict and Aggression,* edited by Morton Fried, Marvin Harris, and Robert Murphy. Garden City, NY: Natural History Press.

Shafton, Anthony. 1967. *Conditions of Awareness: Subjective Factors in the Social Adaptations of Man and other Primates.* Portland, Or: Riverstone Press.

Sigmon, B.A. 1971. Bipedal Behavior and the Emergence of Erect Posture in Man. *American Journal of Physical Anthropology* 34, 55–60.

Sigusch, Volkmar, and Günter Schmidt. 1971. Lower-class Sexuality: Some Emotional and Social Aspects in West German Males and Females. *Archives of Sexual Behavior* 1, 29–44.

Simpson, George Gaylord. 1974. The Concept of Progress in Organic Evolution. *Social Research,* 28–51.

Singer, K. 1975. Depressive Disorders from a Transcultural Perspective. *Social Science and Medicine* 9, 289–301.

Sinsheimer, Robert L. 1971. The Brain of Pooh: An Essay on the Limits of Mind. *American Scientist* 59, 20–28.

Sisskind, Janet. 1973. Tropical Forest Hunters and the Economy of Sex. In *Peoples and Cultures of Native South America: An Anthropological Reader,* edited by Daniel R. Gross. Garden City, NY: Natural History Press.

Southwick, Charles H. 1970. Genetic and Environmental Variables

Influencing Animal Aggression. In *Animal Aggression: Selected Readings*, edited by C.H. Southwick. New York: Van Nostrand.

Stace, W.T. 1967. *Man Against Darkness.* Pittsburgh: University of Pittsburgh Press.

Steinmetz, S.R. 1894. Suicide among Primitive Peoples. *The American Anthropologist* 7, 53–60.

Stern, Jack T., Jr., and Randall L. Susman. 1983. The Locomoter Anatomy of *Australopithecus afarensis. American Journal of Physical Anthropology* 60, 279–317.

Suarez, Susan D., and Gordon G. Gallup, Jr. 1981. Self-recognition in Chimpanzees and Orang-utans, But Not Gorillas. *Journal of Human Evolution* 10, 175–188.

Symons, Donald. 1979. *The Evolution of Human Sexuality.* New York: Oxford University Press.

————. 1980. The Evolution of Human Sexuality Revisited. *Behavior and Brain Sciences* 3, 203–214.

————. 1987. An Evolutionary Approach: Can Darwin's View of Life Shed Light on Human Sexuality? In *Theories of Human Sexuality*, edited by James H. Geer and William T. O'Donohue. New York: Plenum Press.

Tasker, C.R., and J.A. Mills. 1981. A Functional Analysis of Courtship Feeding in the Red-billed Gull, *Larus novaehollandiae scopulinus. Behaviour* 77, 222–241.

Tavris, Carol, and Susan Sadd. 1977. *The Redbook Report on Female Sexuality.* New York: Dela Conte Press.

Taylor, Patricia Ann, and Norval D. Glenn. 1976. The Utility of Education and Attractiveness for Female Status Attainment through Marriage. *American Sociological Review* 41, 484–498.

Terkel, Studs. 1974. *Working: People Talk about What They Do All Day and How they Feel about What They Do.* New York: Pantheon.

Terman, Lewis M. 1938. *Psychological Factors in Marital Happiness* New York: McGraw-Hill.

Thornhill, Randy. 1980. Rape in *Panorpa* Scorpionflies and a General Rape Hypothesis. *Animal Behaviour* 28, 52–59.

Thornhill, Randy, and Nancy Wilmsen Thornhill. 1983. Human Rape: An Evolutionary Analysis. *Ethology and Sociobiology* 4, 137–173.

Thurber, James, and E.B. White. 1929. *Is Sex Necessary?* New York: Harper and Row.

Tooby, John. 1982. Pathogens, Polymorphism, and the Evolution of Sex. *Journal of Theoretical Biology* 97, 557–576.

Torney, H.B., and F. Felin. 1937. Was Aristotle an Evolutionist? *Quarterly Review of Biology* 12, 1–18.

Trivers, Robert L. 1972. Parental Investment and Sexual Selection. In *Sexual Selection and the Descent of Man 1871–1971*, edited by Bernard Campbell. Chicago: Aldine.

————. 1985. *Social Evolution.* Menlo Park, Ca: Benjamin/Cummings.

Tsanoff, Radoslav A. 1931. *The Nature of Evil.* New York: Macmillan.

Twain, Mark. 1938. *Letters from the Earth,* edited by Bernard De Voto. New York: Harper and Row.

Udry, J. Richard. 1974. *The Social Context of Marriage* (third edition). Philadelphia: Lippincott.

Van den Berghe, Pierre, and David P. Barash. 1977. Inclusive Fitness and Human Family Structure. *American Anthropologist* 79, 809–823.

Van Valen, Leigh. 1973. A New Evolutionary Law. *Evolutionary Theory* 1, 1–30.

Wade, Michael J. 1978. A Critical Review of the Models of Group Selection. *Quarterly Review of Biology* 53, 101–114.

Warner, W. Lloyd. 1930. Murngin Warfare. *Oceania* 1, 457–494.

Washburn, Sherwood L. 1960. Tools and Human Evolution. *Scientific American* 203 (3), 62–75.

Washburn, Sherwood L, and Ruth Moore. 1980. *Ape into Human: A Study of Human Evolution* (second edition). Boston: Little, Brown.

Watson, John B. 1930. *Behaviorism* (second edition). Chicago: University of Chicago Press.

Wheeler, P.E. 1984. The Evolution of Bipedality and Loss of Functional Body Hair in Hominids. *Journal of Human Evolution* 13, 91–98.

————. 1985. The Loss of Functional Body Hair in Man: The Influence of Thermal Environment, Body Form and Bipedality. *Journal of Human Evolution* 14, 23–28.

Whitehead, Alfred North. 1938. *Modes of Thought.* New York: Macmillan.

Wiese, L. 1981. On the Evolution of Anisogamy from Isogamous Monoecy and on the Origin of Sex. *Journal of Theoretical Biology* 89, 573–580.

Wiggins, David A., and Ralph D. Morris. 1986. Criteria for Female Choice of Mates: Courtship Feeding and Paternal Care in the Common Tern. *American Naturalist* 128, 126–29.

Williams, George C. 1957. Pleiotropy, Natural Selection, and the Evolution of Senescence. *Evolution* 11, 398–411.

————. 1966. *Adaptation and Natural Selection: A Critique of Some Current Evolutionary Thought.* Princeton, NJ: Princeton University Press.

————. 1975. *Sex and Evolution.* Princeton, NJ: Princeton University Press.

————. 1985. A Defense of Reductionism in Evolutionary Biology. *Oxford Surveys in Evolutionary Biology* 2, 1–27.

Wilson, Edward O. 1975. *Sociobiology: The New Synthesis.* Cambridge, Ma: Harvard University Press.

Wilson, James Q., and Richard J. Herrnstein. 1985. *Crime and Human Nature.* New York: Simon and Schuster.

Wynne-Edwards, V.C. 1962. *Animal Dispersion in Relation to Social Behaviour.* Edinburgh: Oliver and Boyd.

————. 1978. Intrinsic Population Control: An Introduction. In *Population Control by Social Behaviour,* edited by F.J. Ebling and D.M. Stoddart. London: Institute of Biology.

Zihlman, A.L. 1978. Interpretations of Early Hominid Locomotion. In *Early Hominids of Africa,* edited by C.J. Jolly. London: Duckworth.

Zilboorg, Gregory. 1936. Suicide among Civilized and Primitive Races. *American Journal of Psychiatry* 92, 1347–369.

Index